Cistercian Studies Series: Number Sixty-nine

STUDIES IN CISTERCIAN ART AND ARCHITECTURE

Volume Two

CISTERCIAN STUDIES SERIES: NUMBER SIXTY-NINE

STUDIES IN CISTERCIAN ART AND ARCHITECTURE

VOLUME TWO

Edited by Meredith Parsons Lillich

CISTERCIAN PUBLICATIONS INC.
KALAMAZOO, MICHIGAN
1984

+1026+

The work of Cistercian Publications
is made possible in part by support from
Western Michigan University

Available in Britain and Europe from

A. R. Mowbray & Co Ltd
St Thomas House Becket Street
Oxford OX1 1SJ

Available elsewhere from the publisher

Cistercian Publications
WMU Station
Kalamazoo, Michigan 49008

Library of Congress Cataloguing in Publication Data
(Revised for volume 2)
Main entry under title:

Studies in Cistercian art and architecture.

 (Cistercian studies series ; no. 66, 69)
 Includes bibliographical references.
 1. Art, Cistercian—Addresses, essays, lectures.
2. Architecture, Cistercian—Addresses, essays, lectures.
I. Lillich, Meredith P., 1932– . II. Series.
N7853.S8 1982 704.9'482 82-159214
ISBN 0-87907-866-9 (pbk.)

This volume is dedicated to

Marie–Anselme Dimier

TABLE OF CONTENTS

MARIE-ANSELME DIMIER, 1897-1975: A Recollection
François Bucher

In one of his visions Caesarius of Heisterbach wandered through Paradise in search of his cistercian brethren. Terrified to find none he approached the Virgin who opened her mantle to show him the white monks happily ensconced under her protection. When the monks of Notre Dame de Scourmont announced the death of Marie-Anselme Dimier on May 4, 1975 and asked for prayers for his soul, most of us instead may have envisioned Père Anselme close to the *Schutzmantelmadonna* praying for us.

No one who worked on cistercian art and architecture could escape his help, nor his letters (written with wide, medieval margins) in which he always offered tightly organized information on topics ranging from the resettlement of ruined monasteries to the acoustics of bernardine spaces.

Most of us met him first at the St Bernard Congress in Dijon in 1953, which was largely dominated by Marcel Aubert and Emile Mâle. At first we barely noticed the nimble figure of the slight monk who was to become the clearing house and collegial mentor of everyone concerned with cistercian culture—including Karl Heinz Esser, who had developed the idea of the bernardine plan, and Henri-Paul Eydoux who had just published *L'Architecture monastique*, the proceedings of the first, truly creative postwar encounter of French and German art historians. Frère Anselme was more often than not arbitrating discussions which were then sometimes still colored by deep-seated national hatreds.

Above all M.-A. Dimier was a scholar monk in the essential reformed benedictine mold. He had come from a highly educated intellectual family—the man in one of Daumier's paintings bowing over the stall of the *bouqiniste* was his grandfather—and had joined the order at age thirty-one. In Scourmont, located in softly rolling, often fog-shrouded hills near Forges-lez-Chimay close to the Belgian-French border, he lived the ascetic life with the radiant satisfaction of a man who has discovered the secret of internal peace. We would meet him after the early morning services, survey the fields, and hotly discuss the advantages of American versus European tractors. He could not repress a chuckle talking about the blessed Peter, abbot of Morimond, who in 1193 had been punished for driving a *carruca*, a four-wheeled carriage, on one of the farms.

Few of us found their way to the remote Scourmont, but all of us were brought together through the intermina-

x

ble flow of Dimier's correspondence, and his innumerable, lovingly dedicated offprints which always informed us on the international *état de la question cistercienne.* Through him J. A. Schmoll gen. Eisenwerth, R. H. Delabrouille, F. de Montesquiou, A. C. de Breycha-Vauthier, Lelia Fraccaro, Jean Morlet, Hildegarde von Beuer, Ilse Trowe-Bickel, Hanno Hahn, and many others were continuously brought into contact. His material was at our complete disposal, and it was difficult for us to respect his vow of humility, as did Archdale King in his *Cîteaux and Her Elder Daughters* in which he mentions Dimier after the name of his abbot, almost as an afterthought. Above all, Père Anselme (who to the end called himself Frère) tried to re-establish and to open up ways of publication for our colleagues in the other Europe, bringing to our attention the work of K. Bialoskorska on Wachock, Marijan Zadnikar's study of Sticna and reopening contacts between scholars of a divided Germany.

His published work was richly three dimensional, and one would hope that a full bibliography—including essays often published in relatively obscure periodicals —will soon become available. His classic *Recueil de plans d'églises cisterciennes,* a herculean work published in two volumes (1949, 1967), filled him with anxiety. He found it to be imperfect and hoped there would be time for a revised and updated edition. It would take another monk to undertake the task. Each of his innumerable essays contains a new discovery. Be it a study of the foundation legends of the Order (1970), of ambulatories with non-protruding radiating chapels (1957) or several discussions of St Bernard's philosophy of art and architecture, they are a delight for the reader. The many guides and excavation reports he authored, such as those for Troisfontaines, Alcobaça, Tamié, Foigny, Abbaye des Dunes and many others are models of brevity and tightly organized, elegantly presented information.

In spite of this monumental and basic output it is difficult to visualize Frère Marie-Anselme as an awesome, clearly defined personality. He wanted to be the lens through which the efforts of his colleagues and friends, equally fascinated by the cistercian world, could not only be focused, but also put into the perspective of a larger framework. Perhaps even more than the often rigid Bernard de Clairvaux he deserves the epitaph "Corde bono, vultu laeto, non pectore tristi".

Florida State University, Tallahassee

CONSTRUCTING UTOPIA
Meredith Parsons Lillich

Père Dimier, to whose memory this volume is dedicated, wished to be the lens through which cistercian architectural studies were focused and "directed", as François Bucher has so eloquently remarked. The degree of Dimier's success can be gauged by this volume, not a study of which escapes his giant shadow. A second generation of scholars is now working in his image. This volume of cistercian architectural studies attempts, in microcosm, to be a lens through which their varied and divergent lines of research may begin to converge to form an image of cistercian architecture.

Von Simson has stated that "Bernardian architecture is far more than 'expurgated Romanesque'"; I would submit that cistercian architecture as a whole might be considered from that perspective. During Père Dimier's lifetime bernardine architecture received much serious attention. Various examples of it have been explained on proportional bases; as geometric patterns; on modular theory (Bucher); and much energy went into the attempt to identify (or should I say, to reconstruct) the "bernardine plan" (Esser), and to explain it as a "functional Utopia" (Braunfels). The pristine perfection of bernardine buildings needs no advertising from me, obviously. Cistercian architecture *after* the death of St Bernard, however, has generally been analyzed according to the supposed degree of decline from those ideals—continuing through the thirteenth century, the cistercian buildings of which have often been characterized as over-simplified and puritanical, if not markedly archaic.

To the degree that cistercian architects kept building Fontenays, they were archaizing: Noirlac is such a late classic, San Galgano even later. It is increasingly likely that such "fossilizations" were intentional citations of the authority of some great "source"—one of the mother houses, for example. To the degree that cistercian architects, after the bernardine period, attempted to follow the current trends, they have been given bad marks for hesitancy, conservatism or even degeneracy from their supposed "ideals". "Archaizing" or "degenerate", they can't win. I have suggested that such post-bernardine buildings should instead be analyzed according to the balance achieved between several factors: how typical they are of their time, how typical they are of their region, to what degree do we nonetheless recognize them as cistercian, and how can that quality be defined.

The quality can be given the working label of "creative functionalism", by which I mean to imply that it is appropriately cistercian but non-derivative from bernardine or burgundian forms.

More exact criteria must be sought to answer the question, "What identifies this work of art as cistercian?" One can begin most easily by listing a few elements which post-bernardine buildings seem to incorporate on a regular basis:

—they maintain a functionalism, based on "adequacy of the material".

—they employ a reduced elevation (usually two stories). This has been considered, particularly in thirteenth century buildings, a reduction from the standard three-story gothic elevation, a puritan restraint, but I wonder.... I would prefer to call the reduced elevation a consciously chosen dualism rather than a reduction from three stories, as a working hypothesis.

—they employ with great frequency *culs-de-lamps* and corbels. Usually it has been suggested that this was done because it creates a more unified appearance; it is plainer and more puritanical; it allows for the placement of choir stalls; it is easier to build that way. None of these explanations are adequate. Corbels were a cistercian preference far into the fourteenth century, at a period when contemporary architecture was largely based on a unified design from floor to vault-keystone.

—they maintain distinctive window (light) patterns, namely the oculus (now very small in some regions, like portholes) and the triplet.

The likely significance of such bernardine window patterns referred to the Unity and Trinity of the eternal Godhead. With the unequal triplet, common in the post-bernardine era, we might be said to confront the Filioque in stone and light.

But what do the other elements listed above achieve —specifically the two-part or binary elevation, and the disappearance of ribs into corbels? Actually they both work toward the same end, namely the definite division of the church elevation into two parts, higher and lower. Instead of the vault rising and growing out of the supporting piers, a unity more and more common in developed Gothic, in a cistercian church the vault system hovers above the walls, isolated and separated from them. François Bucher was the first to identify this phenomenon in bernardine building, and he described it as the maintaining of the independence

of the baldaquin. His observation can be used as a basis for analyzing later cistercian practice. While the exact ratio 1:2 of an elevation such as Fontenay, for example, disappears, the idea of two separate, distinct parts does not--presumably because it was meaningful. Such dualism underlines the separation of the world the monk must inhabit--during his period of waiting and preparation on earth--from the more usual and traditional imagery of the interior (vault) of the church as the "heavenly Jerusalem", "The City of God", the world to which he aspires and for which his life is a preparation.

If this dualism can be understood as one of the identifying elements of cistercian design, then a very great number of very handsome thirteenth--and fourteenth century--buildings can be appreciated. Not (anymore) as puritan "reductions" of the then-going fashion; but as conscious creations in the cistercian aesthetic. They can be judged on the basis of what they do, in other words, rather than of what they fail to do.

This dualism was achieved by a number of newly adopted devices. One was the use of columnar supports at such sites as Longpont, Royaumont and Altenberg (where linkage makes the dualism plain), often at a date when such supports had been dropped from the gothic repertory for at least a generation. One of the theories of architectural historians has been that such supports were dropped from regular gothic building in the late twelfth century *because* they separate the elevation, such a division and horizontal stress losing favor as Gothic developed. Cistercian gothic designers may have retained it not as an archaism but *because* of the separation of elements of the elevation which it achieves. Another such element in post-bernardine design is the lovely and appropriate "bulged triangle" clerestory pattern found at L'Epau and La Chalade, possibly fourteenth century--another Filioque.

Yet another form of cistercian "creative functionalism" may be identified in many German structures; an early example is Eberbach, of which Eydoux remarked, "The vault thus seems suspended above the church even while being perfectly supported". The German design is one of "interlocking fingers" from above and below, of "clasped hands". The supports rise and the corbels descend; the monk reaches for, and clasps hands with, God. One might cite Arnsburg; Chorin; Hude; Ebrach; and beautiful Haina--not the outer wall, where the dualism is absolute, but the monks' choir in the nave. Are these buildings--like Haina--correctly understood, in the larger view of architectural history, as examples

of "cistercian puritanism" or "cistercian conservatism"?
I think not.

I would prefer to think of such architectural
creations as successful out–croppings of Cistercianism
as an aesthetic––which I would stress as not (only)
under–decorated (although the choice not to use sculpture
was often a conscious decision to the end, not just
something they forgot to do); or simply marked by
the adequacy and functionalism of the materials. Rather,
Cistercianism as an aesthetic might be basically understood,
to extend Braunfels' observation of bernardine forms,
as the art of a utopian society. There is then a final
question to consider. Did this utopian society succeed,
where other monastic reform groups in history had
failed, *because* of the aesthetic? In other words: the
"visual" reform was not simply a denial (of the pleasures
of sculpture, color, glitter) but a positive visual substitu-
tion, the new aesthetic of Cistercianism, which we
seek to identify and comprehend in the study of cistercian
architecture. Père Dimier led the way and we follow
gratefully in his wake.

Syracuse University

SAINT BERNARD: THE AESTHETICS OF AUTHENTICITY
Emero Stiegman

It has never been doubted that St Bernard is a true spokesman for the early Cistercians. In monastic art, as[1] in everything else, his attitudes were decisive.[1] In interpreting cistercian art we rely inevitably upon his text, feeling fortunate that at least in one extended passage, in the *Apologia to William of St Thierry*, he addresses the topic directly.[2] Yet, Bernard is a difficult writer, and the *Apologia* is, historically, the most confusing of his works. I would like to comment on two unfortunately standard types of interpretation of cistercian art as they have been derived from St Bernard's *Apologia*, and to characterize, by contrast, the aesthetic that may be distilled from his spiritual writings.

In the *Apologia* the abbot severely criticized, among other things, the artistic arrangements in the churches and cloisters of the order of Cluny. The general judgment expressed there became particular legislation for all Cistercians in the *Exordium parvum* a decade later.[3] And Bernard's aesthetic vocabulary haunted monastic-constitution writers for the next two centuries.[4] In our day many commentators, responding to the abbot's language, seem to labor to the conclusion that the saint was not against art as such. Holding too long to this elementary apologetic, we stand to miss what is the true aesthetic issue and to discover altogether too little of the author's artistic rationale.[5] Yet, help is close at hand. Bernard's discussion of cistercian interiority in the much-neglected first half of the *Apologia* is a springboard to what is most wonderful in his writings and could do much, even alone, to insure a balanced explanation of cistercian art.

Too frequently what is lacking is balance. Although it is generally clear that the abbot's consideration of artistic matters revolves around concerns of monastic asceticism and contemplation, interpretations derived from the *Apologia* tend to be either ascetical in an exclusive sense or contemplative in a simplistic sense.

Ascetical interpretations are those that propose to give an adequate account of cistercian art in terms of renunciation. One observes in the *Apologia*, for example, a rejection of the lavish use of gold and gems and of overly large churches, together with the remarks that such things fostered covetousness and vanity and were purchased with resources that should have been

spent on the poor.[6] (A generation later Idung of Prüfening
shows the argument to have become a cistercian common-
place.[7]) One then tends to say that the bare walls
and rectangular contours and uncolored glass of cistercian
churches "mean" simply that attractive alternatives
were considered either morally objectionable for monks
or too expensive. As Focillon saw it, the cistercian
abbey was "an austere wall around the passionate
intensity of the faith", and Bernard's accomplishment
was to have "purged religious art" of generally undesirable
elements.[8] For Edgar De Bruyne, Bernard's "rigorist
aesthetic" fostered "the architecture •of the necessary",
one which responded to "the needs of life".[9] For Kenneth
J. Conant, the abbot was attracted to the burgundian
half-Gothic "because of its austere and practical charac-
ter".[10] The first difficulty with the concept of the
necessary in art (and the tributary language of the
superfluous, the practical, the useful, and the austere)
is its relativity. Necessary to what? We are told nothing
of the inner vision of the artist. If the functional
is determined by physical necessity, then the dimensions
in the so-called bernardine plan for an abbey church
were not functional. Meredith Lillich reminds us that
cistercian grisailles, among other examples, could be
as costly as colored glass.[11] Even appeal to simplicity
may fail to discern or communicate the early cistercian
content of that idea. Fontenay is simple for characteristic-
ally cistercian reasons.

Art historians who do not get beyond the ascetical
interpretation of cistercian art and yet speak admiringly
of it may be suspected of condescension. Some forthrightly
withhold their admiration. Arthur Kingsley Porter said
the Cistercians "accounted the art of architecture in
general a vanity, to be in consequence avoided".[12]
Emile Mâle said of Bernard: "In his Order, he forbade
art as a useless luxury....He had no feeling for the
beautiful".[13] Such history is a foreclosure of the possibility
that Bernard's ascetical language may articulate a
positive aesthetic option.

To keep that possibility open, we must learn
the language. Understanding the saint's asceticism,
we will neither become rutted in it nor imagine we
can fly over it. The latter excess seems to explain
the tendency to ignore the *Apologia*'s insistence upon
the cost of certain architectural features and upon
the necessity of considering the needs of the hungry
in planning building expenditures.[14] This reflection
does not frequently inspire the student of aesthetics,
but it is the text. Asking the *pauperes* in the monastery

to make common cause with the *pauperes* of the countryside is not, with St Bernard, a literary conceit. In his ecstatic discourse on the Song of Songs, he tells his monks, at length, that the most ravishing ointment with which the bride may anoint her breasts is *pietas*; and this is made from the needs of the poor looked upon effectively with loving kindness. In that context one cannot suspect the thought to be the moral rationalization of conpulsive asceticism. It is at the heart of Bernard's contemplative doctrine, regarding God whom we do not see and the brother whom we do see (1 John 4:20). Religious Orders remind themselves that their foundations grow old when this spirit is lost. The view that monastic frugality has no role at all to play in cistercian architecture suggests the aesthetically doctrinaire—as unhistorical, possibly, as the excess it resists. Where does one find the seam joining the artist's economy of means to the patron's limitation of resources?

For our present purpose, a more important concern of the *Apologia*'s ascetical text is that the architectural elements which Bernard wishes to eliminate will "dry up devotion".[15] Devotion, the saint explains elsewhere and at length, is the desire aroused by an intimate awareness of God's favors to us. The felt–desire (*affectus*) proper of a cultivated devotion (*devotio*) is not a state of soul found in the recently converted or in the spiritually careless—contrary, for example, to present–day usage; it is a capacity of the mature monk.[16] To art historians there may be little solace in the discovery that such religious terminology is not as transparent as a later generation and a different religious culture would wish. On the other hand, the discovery can guard historians from frustrating the founding aim of their profession through a facile, anachronistic reading of the past. In the present instance, to know precisely what Bernard fears in the art he rejects—that, among other effects, these works *impediunt affectum*—is to be rightly oriented in the attempt to ascertain the art he wishes to encourage. To understand Bernard on *affectus*, of course, requires a broader grasp of his thought patterns than a few sentences here can provde; but already we are in a position to see more than mere asceticism. When, ascetically Bernard turns away from some beautiful things, it is only that, contemplatively, he may leave open his inner space. Experience has taught him that this space is coveted and reserved by Beauty Himself. Beauty, it is important to know, is the aspect of God most lyrically celebrated in the saint's most sustained work, the *Sermons on the Song of Songs*. There is a kind

of architecture, the *Apologia* argument goes, which
contributes nothing to the advanced soul's quest for
beauty, but only distracts it from the true sources
of contemplation; we must not build this way.
 The ascetical interpretation of cistercian art,
then, so common even among fine historians, misunderstands
the asceticism to which it appeals. It fails to discern
the experience for which this art speaks.

 Many writers have offered a contemplative interpreta-
tion for cistercian art. When one attempts to explain
contemplation, one forms or enters a system of religious
thought. If we could speak of *the* ascetical interpretation,
it was only because Christian asceticism is never a
system of thought; the nature of its effort is wholly
defined by the way one perceives the approach to its
divine objective. Any merely ascetical explanation,
therefore, is as weak as any other one. Unfortunately,
critics frequently think of the contemplation which
the *Apologia* wishes to safeguard in the same univocal
way. The common notions about contemplation made
popular by the deep hellenic strains of our culture
are not always helpful for understanding the early
Cistercians. The "devotion" we have just considered
is a common Christian term. But, in Bernard's context
it becomes quite idiosyncratic, as part of a system
of contemplation—one system among others. Hence the
dire possibility of bringing St Bernard to witness to
the meaning of cistercian art while reading into his
language other contemplative systems, such as those
of Augustine or Pseudo-Dionysius.
 The complex question permits of only some brief
but hopefully suggestive remarks here. First, when
we propose a contemplative interpretation for the cistercian
renunciation of certain appealing elements of twelfth-
century art, must we not ask why Bernard's markedly
contemplative contemporaries did not find such renunciation
suitable? Think of Hugh of St Victor, a second Augustine,
as he was appropriately called: his contemplative doctrine
issued in the first full tract on the beautiful produced
in the middle ages.[17] Hugh's contemplation does not
support Bernard's aesthetics. As long ago as 1934,
Gilson expressed great surprise that his study of Bernard's
mystical theology revealed to him a very un-Augustinian
contemplative. This significant observation has been
frequently ignored (Otto von Simson, I believe, ignores
it); but I am not aware of its having been successfully
challenged.[18] William of St Thierry and Aelred of Rievaulx
do not follow Bernard in his departure from Augustine.

Think of the School of Chartres, those readers of the *Timaeus*: they were overwhelmed, as were all the High Middle Ages, by the ineradicably contemplative aesthetics of Pseudo–Dionysius. No one who shows evidence of having studied the question fails to conclude that there is a striking absence of dionysian vocabulary and spirit in Bernard's writings. The abbot seems impervious to the intellectual contemplation which character- izes Augustine and Pseudo–Dionysius. In sermon 23 of the *Super cantica* he adknowledges it, says it is the way of others, but gently counsels his monks against it.[19]

A further caution regarding citing St Bernard to explain cistercian art has to do with the warmth and affectivity of his spirituality, especially his devotion to the humanity of Christ. He considers his tender imagery, which so affected the piety of later generations, to be merely a spiritual preliminary––not an element that might suitably determine the aesthetic environment of mature monks. This facet of his spirituality would explain more plausibly the iconography of the new Gothic cathedrals rather than the particulars of cistercian abbey churches built under his direction. The *Apologia* issues a reminder to all monks: we who have left the condition of the ordinary laity no longer have the aesthetic needs of their piety (*Nos vero qui iam de populo exivimus...*).[20]

Cistercian architecture affected by St Bernard must clearly be referred, at some stage of interpretation, to contemplation. But whether we speak of the unfiltered light of the abbey church, of the columns and corbels, of the "perfect ratios" of the building plan, of the groined vaulting, the lack of ornamentation, or the ensemble effect, the correctness and clarity of interpretation will spring, not from a generalized concept of contemplation but from the specific content of Bernard's contemplative system. The interpreter hopes to tell us, in his or her appreciation of artifacts, not what the inner experience of Bernard's community *ought* to have been, but what it was.

To form a sympathetic understanding of how the appeal to the *Apologia* has produced the unhelpful interpretations I have been surveying––but more, to move positively toward the heart of St Bernard's aesthetic- –let us turn to the text. After a masterful treatment of cistercian interiority, taking up more than half the work, the author's manner changes abruptly; with harshly humorous satire he draws verbal cartoons of

the loose observance of the Cluniacs. Just innocent
fun, we are told, for those familiar with the tradition
of Horace, Perseus, and Juvenal.21 The last abuse
to be considered is the art work of cluniac churches
and cloisters.22 Here a texture of rhetorical questions
gives formal unity to the pericope. Bernard's disapproval
is strong and clear, and so we say the questions are
rhetorical. But, it is possible in the questioning to
detect how he has formed his judgment. He says,

> I shall say nothing about the soaring
> heights and extravagant lengths and
> unnecessary widths of the churches,
> nothing about their expensive decorations
> and their novel images, which catch
> the attention of those who go to pray,
> and dry up their devotion. To me
> they seem like something out of the
> Old Testament; but let them be, since
> it is all to the glory of God. However,
> as one monk to another, may I ask
> the question....'Tell me, O poor men
> —if you are really poor men—why
> is there gold in the holy place?' It
> is not the same for monks and bishops.23

There is no irony in "it is all for the glory
of God". The author admits later, on behalf of the
laity, an appeal to church as house of God.24 "Let
them be" brackets this part of the argument. This is
simply not under discussion. Bernard now opens the
conversation, on his own terms. He has a question,
he says, which he asks as a monk—to other monks.
He is not asking what justification might be given
for artistic arrangements, only what personal experience
actually underlies them. He follows the first chapter
of Benedict's rule, demanding, *monachus monachos*,
that experience be the teacher of the monk; he invites
the Cluniacs to ask *themselves* what spiritual needs
account for their aesthetic choices.25 He will not tolerate
evasions which speak of where in the celestial hierarchy
an artifact may be located, how it participates in
the divine perfection, or even how its properties manifest
the presence of a divine energy in creation, and therefore
what it means. He wants to talk psychology, and he
knows he cannot simply instruct; he must ask.
 One would have reason to resist the suggestion
that, in the pattern of rhetorical questions, there must
be perceived a bona fide question. The dashing rhetorical

character of the satire seems to argue against it. As an example of vocation pamphleteering, the work may seem to have difficulty laying claim to sobriety.26 One may notice how loudly it is echoed in the tracts of others who scarcely escape judgmental arrogance in their appeal to "conscience".27 It must be conceded that these considerations point to a damaging flaw in Bernard's work: what I have referred to as an abrupt change of manner splits the *Apologia*'s focus and mixes genres. (Perhaps some of the confusion stemming from the work may originate here.) Nevertheless, Bernard's invitation to the Cluniacs to answer a question which will be their own is genuine. At the center of all his rhetoric is a question which is not rhetorical. I look for this element within the frequently quoted and usually misunderstood part of the *Apologia* only because there are traces here of what has been reflected upon deeply and extensively in the truly penetrating first part of the work, and more deeply and more extensively in Bernard's other works. I refer to the theme of *notitia sui* (self-knowledge), and to its opposite, *curiositas* (a dissipating curiosity).

Christian socratism, the search for God in self-knowledge, is a patristic theme that is not absent in any era of Christian spirituality.28 St Bernard holds a singularly honored position in the tradition. The many early cistercian tracts on the soul are founded on the cornerstone of self-knowledge; and Bernard is the instigator of the movement.29 The centrality of *notitia sui* is, of course, a commonplace of cistercian studies. I propose it here as an aesthetic principle. Again, it may seem pretentious to claim as Cistercian a value which secular greek culture has made ubiquitous in the West. Our insistence is on the manner in which the Cistercians conceived of it. Bernard followed Origen in accepting "know thyself", not as greek wisdom, but as the dynamics of grace revealed in the Song of Songs (1:8).30 To begin to know oneself is to begin to approach God—not merely morally, in useful awareness of the sin to be removed, but in a contemplative sense; for, the beauty and love of God is nowhere so manifest as in one's own soul. In the *De gradibus humilitatis et superbiae*, Bernard developed the possibilities of humility in the theme; and in *De diligendo Deo* and the *Sermones super cantica*, he spoke of discovering one's beauty. "Even the pagan can love God for Himself alone", he said, "because although he does not know Christ, he may know himself".31 That the soul is made in the image of God is seen in the capacity and longing

it has for God.[32] This divine capacity, however, comes
to naught when the soul is lured by *curiositas* and
moves to outward things. What Bernard calls curiosity
is, not intellectual vitality, but an outward movement
that lessens concern for God's presence in the soul.[33]
It is best understood as the contrary of *notitia sui.*
Curiositas leads to *cupiditas; notitia sui* leads to *caritas.*
Such curiosity figures prominently in Bernard's questioning
the effect of cluniac art in the *Apologia.* It is the
pursuit of an inferior beauty.

On the other hand, *notitia sui,* with its special
contemplative implications, is the cistercian quest of
the beautiful. The soul itself is the cistercian criterion
of created beauty. If attainment of spiritual, or personal,
authenticity comes in the search for the true self,
then cistercian *notitia sui* may be spoken of as a principle
of authenticity. In its aesthetic dimension, the orientation
to contemplative self-knowledge may be called the aesthe-
tics of authenticity.

Was it not the very orientation of western art
which changed with the appearance of cistercian architec-
ture? Historians have at times said as much. Focillon
correctly pronounced the new art an "historical *volte
face".*[34] But we are not content to read in the *Apologia*
what Bernard turned away from, materially; we need
to understand what he turned toward, formally. When
we say the author sought the vision of God in the
true self, we speak of an orientation that will be echoed
throughout the history of western art; we define an
aesthetic principle endlessly rediscovered through the
generations .

I began by saying that it has never been doubted
that St Bernard is a true spokesman for the early Cister-
cians. If questions arise about the appropriateness
of restricting our explanations of cistercian art, all
of it, to Bernard's thought––to what Bernard preferred
and encouraged––then perhaps restricting the role of
Bernard as spokesman may be accepted as necessary
logic. Chaucer reports what seems to have been a proverb
in the fourteenth century: "Bernard the monk did not
see everything".[35] With more decorum, but to similar
effect, I would ask whether all cistercian artists saw
everything Bernard saw. Students of cistercian art
may feel the need for a cistercian orthodoxy as an
assumption, a touchstone of interpretation. They may
have to earn their confidence in such an assumption
in consultation with students of cistercian institutional
history. From students of bernardine theology they

will likely receive a few discomforting, though not discouraging, cautions.

But, at one level of discernment, they may indeed be confident. When St Bernard asked the Cluniacs to reflect upon the art of their monasteries, he did not think the special character of his contemplation rendered him incompetent to do this. As a monk he presumed upon simple spiritual authenticity in every other monk. He accepted this as an aesthetic principle so central to monasticism that, from across the divide of a newly formed congregation, he could ask their agreement on the monastic appropriateness of the art in their monasteries. What the abbot thought of as basically monastic turns out to be characteristically Cistercian. The fact that the special contemplative direction of Bernard's drive for self-knowledge was so unquestionable an assumption in his own community allows us to single out this drive as the postulate of all his thinking about art. For a work of art to be Cistercian, therefore, it should spring from and foster an uncompromising spiritual authenticity.

Saint Mary's University, Halifax

NOTES

Table of Abbreviations

CF Cistercian Fathers Series. Spencer, Massachusetts;
 Washington, D.C.; Kalamazoo, Michigan.

CS Cistercian Studies Series. Spencer, Massachusetts;
 Washington, D.C.; Kalamazoo, Michigan.

This study was delivered at the Eighteenth International
Congress on Medieval Studies held in Kalamazoo, Michigan,
May 1983, as part of the Conference on Cistercian Studies.

1. The remark is from Louis J. Lekai, OC, *The Cister-
 cians: Ideals and Reality* (Kent, Ohio: 1977) p.
 262.
2. See *Apologia ad Guillelmum abbatem; Sancti Bernardi
 opera*, eds. J. Leclercq and H. M. Rochais (Rome:
 1963) 3:62–108, esp. paragraphs 28–29.
 See Bernard of Clairvaux, *Treatises I, Apologia
 to Abbot William*, tr. Michael Casey OCSO, CF
 1 (1970) pp. 3–69, contains good notes, which
 are virtually a study guide, and a most helpful
 introduction by Jean Leclercq. The *Apologia* (1125)
 is among Bernard's early writings; it initiates
 a dispute, carried on by others in many such
 tracts, regarding observance of the Rule of St
 Benedict. All my translations are from Casey.
 The *Apologia* is cited below as Apo.
3. Lekai, p. 22, discusses the date of the *Exordium
 parvum* and of Bernard's influence in the text.
 Later official regulations of cistercian architecture
 can be found in Lekai, p. 264.
4. See Edgar DeBruyne, *Études d'esthétique médiévale*
 (Bruges:1946) 2:135.
5. Lekai, p. 263, recognizes the *Apologia* as one
 of the most "misinterpreted documents of medieval
 aesthetics". In a general cistercian history, his
 own sense of the issue is whether Bernard was
 for or against *art* and is a fair representation
 of most monastic commentary, careful to disclaim
 any antagonism against art as such. Beyond this
 there is the task of discerning the kind of art
 Bernard favors. There are serious difficulties
 in linking the saint to the metaphysical aesthetics
 claimed for gothic builders, as Lekai is inclined
 to do (pp. 263–64), following Otto von Simson.
6. Apo 28.

7. See Idung's *Dialogus duorum monachorum*, ed. R.B.C. Huygens, *Studi medievali*, 3rd series 13, 1 (1972). It is translated and introduced by Jeremiah F. O'Sullivan in *Cistercians and Cluniacs: The Case for Citeaux*, CF 33 (1977) pp. 3–141; Bernard's argument is repeated at III, 23 (p. 113). The *Dialogus* was written c. 1155.

8. See Henri Focillon, *The Art of the West in the Middle Ages* (London:1963) 2:21 and 25.

9. DeBruyne, 2:133 and 139.

10. See *Carolingian and Romanesque Architecture, 800 to 1200* (New York:1959) p. 125.

11. See Meredith Parsons Lillich, 'The Common Thread', Foreword to *Studies in Cistercian Art and Architecture I*, ed. Meredith P. Lillich, CS 66 (Kalamazoo:1982) p. xiv.

12. *Medieval Architecture: Its Origins and Development* (New Haven:1908) 2:173.

13. *Religious Art in France, the Twelfth Century: A Study of the Origins of Medieval Iconography*, ed. Harry Bober (Princeton:1978) p. 220.

14. See, for example, these remarks: "'dicite, 'inquam, 'pauperes, si tamen pauperes, in sancto quid facit aurum?'" ("Tell me, O poor men––if you are really poor men––why is there gold in the holy place?") "Fulget ecclesia parietibus, et in pauperibus eget. ...De sumptibus egenorum servitur oculis divitum". ("The walls of the church are aglow, but the poor of the church go hungry. ...The food of the poor is taken to feed the eyes of the rich".) Both from Apo 28.

15. This is Casey's precise rendering of *impediunt affectum* (Apo 28). *Affectus* here means the experiencing and expressing of what St Bernard discusses as *devotio* in the *Sermo Super cantica* (SC) 10, 7–10. Twice in the Apologia passage we are considering, the saint uses the term *devotio*; but the exact feature of devotion (as he conceives it) which a turning outward to curiosities would impede is *affectus*.

16. See SC 10, 7–10.

17. See the *Didascalicon VII*; in PL 176.

18. See Etienne Gilson, *The Mystical Theology of Saint Bernard* (London:1940) pp. 220–21, n. 24. Otto von Simson, *The Gothic Cathedral: Origins of Gothic Architecture and the Medieval Concept of Order*, (New York:1962) p. 39, says: "Bernard's

artistic views are...Augustinian". The idea is developed especially in pp. 39–50. I think it can be shown, to the contrary, that Bernard's artistic ideas are wholly tied to his contemplative system, which is not Augustinian.

19. See SC 23, *passim* but esp. 15.

20. Apo 28.

21. See Leclercq's Introduction to the *Apologia;* CF 1:16.

22. Apo 28–29.

23. "Omitto oratoriorum immensas altitudines, immoderatas longitudines, supervacuas latitudines, sumptuosas depolitiones, curiosas depictiones, quae dum in se orantium retorquent aspectum, impediunt et affectum, et mihi quodammodo repraesentant antiquum ritum Iudaeorum. Sed esto, fiant haec ad honorem Dei. Illud autem interrogo monachus monachos.. 'dicite, 'inquam, 'pauperes, si tamen pauperes, in sancto quid facit aurum? Et quidem alia causa est episcoporum, alia monachorum". (Apo 28)

24. "Nisi forte...respondeatur: Domine, dilexi decorem domus tuae....Assentio: patiamur et haec fieri in ecclesia...." ("It is, of course, possible to reply...'Lord, I have loved the beauty of your house..." Very well, we may tolerate such things in the church itself".) (Apo 28)

25. See Jean Leclercq, 'Aux sources des sermons', *Recueil d'études sur S. Bernard et ses écrits* (Rome:1962–69) 1:283. The author observes that Bernard's expression in SC 6, 9, *magistra instructus experientia* (having learned from experience, that great teacher) is from the *Regula* 1, 6.

26. Leclercq notes that Dom André Wilmart, 'Une riposte de l'ancien monachisme au manifeste de S. Bernard', *Revue bénédictine* 46 (1934) pp. 296–305, speaks of the *Apologia* as a masterpiece of pamphleteering. See the Introduction to CF 1:16.

27. See, for example, Idung of Prüfening's *Dialogus* III, 32; O'Sullivan, p. 124.

28. DeBruyne, 3:39, speaks of Origen, Gregory of Nyssa, Augustine, and other Fathers in whom the theme occurs.

29. On Bernard's role in these tracts, see Bernard McGinn, ed., *Three Treatises on Man: A Cistercian Anthropology*, CF 24 (1977) p. 29.

30. See Origen's commentary on the Song of Songs; PG 13:123. St Bernard dedicated five sermons in the *Super cantica* to reflecting upon *Si ignoras te* (Song of Songs 1.8).

31. "Meretur ergo amari propter se ipsum Deus, et ab infideli; qui etsi nesciat Christum, scit tamen seipsum". (*De diligendo Deo* II, 6; *Opera* 3:124).

32. SC 80, 2.

33. In St Bernard's *Liber de gradibus humilitatis et superbiae* (*Opera* 3), the first of twelve stages of pride, *curiositas*, occupies half the treatise. Gilson, pp. 155–57, dedicates a useful appendix to the concept.

34. Focillon, 2:20.

35. See F. N. Robinson, ed., *The Works of Geoffrey Chaucer* (Boston:1957). We read in 'The Legend of Good Women' (text F) p. 483 1. 16: "Bernard the monk ne saugh nat all, pardee!" ("Bernardus monachus non uidit omnia".) Robinson, p. 841 n. 16, discusses the sources.

THE BUILDERS OF CISTERCIAN MONASTERIES
IN TWELFTH CENTURY ENGLAND
Peter J. Fergusson

For more than a century scholars of medieval building practice have debated the question of who built the abbeys of the various monastic orders. Did the monks serve as their own designers and raise the buildings with their own hands? Or was this work done by lay craftsmen executing an overall scheme determined by a secular master mason? The notion of the monks as their own artists and builders gained currency in the mid-nineteenth century in the writings of Lenoir (1851), the Abbé Texier (1856), Springer (1861), and the Comte de Montalembert (1877).[1] Accepted until well into the twentieth century, it was only seriously challenged in the 1920s. Studies by Hamilton Thompson (1920), Coulton (1928), Swartwout (1932), and Knoop and Jones (1933, and later editions 1949, 1967), then argued the reverse position.[2] Monastic building was the work of secular craftsmen and was only rarely carried out by the monks themselves. Knoop and Jones put it typically: "Some instances could be cited of monks who were craftsmen, but they are so exceptional as to be negligible"; and, writing of the cistercian laybrothers, "Though it would be rash to assert that no masons were to be found among [them], it is in the highest degree improbable that any considerable amount of building was carried out by them".[3] This revisionist position has held firm ever since.[4]

Unfortunately, the problem cannot be solved on a right or wrong basis. It is complicated by such things as the wide variety in building conditions and practices throughout the middle ages, the differing modes of operation of the various monastic orders, and the changeable nature of factors like patronage or economics. This paper examines a part of the broader problem, the building of the Cistercians from their arrival in England in 1128 to the end of the twelfth century. No claim is made for the cistercian situation being typical; the reverse could well be argued in fact. Nevertheless, the order's expansion occurred with such unprecedented speed that its building procedures are of interest in their own right, as well as for the evidence they bring to bear on the wider debate.

The historian, Ordericus Vitalis, writing in Normandy a year or two after the first cistercian foundation was established in England at Waverley in Surrey in

1128, described a number of customs that distinguished the new order. Included among them was that "they have built monasteries with their own hands in lonely, wooded places".5 His words epitomize the Cistercians' ideal of self-sufficiency and vividly capture the pioneer spirit of the monks at a moment of decisive growth. But they also mesh so neatly with what the Cistercians wanted to believe about themselves that they need scrutiny. Did Ordericus intend his words to be taken literally? Could he be referring only to the first wooden buildings rather than to the later work in stone which required a more complex technology? Was the experience of the Cistercians different in Normandy than elsewhere?

For answers to some of these questions one need turn no further than the early documents of the order. The *Summa Cartae Caritatis* written in 1119 carefully specified the buildings needed by a new foundation:

> No abbot shall be sent to a new place without at least twelve monks and...without the prior construction of such places as an oratory, a refectory, a dormitory, a guest house, and a gate keepers cell, so that the monks may immediately serve God and live in religious discipline.6

The explicit direction about the "prior construction" of buildings contradicts the romantic notion of the monks and laybrothers setting off into the wilderness to hack out shelters for themselves as rustic land settlers. Construction of these first wooden buildings was most usually not even undertaken by an advance party of Cistercian laybrothers, but by the patron of the new foundation in close consultation with the mother house which supplied the founding community.7 And this fact would have been known to contemporaries, including Ordericus.

Shortly after settlement, however, further buildings would have been needed. To help with them outside labor was brought in. There are four references to the needs of "hired workers" in the *Exordium Parvum* (cap. xv) and the *Summa Cartae Caritatis* (cap. xiii, xx, xxiv). Confirmation of their use comes from a number of early sources. At Clairvaux for instance, the second church begun in 1135 was built with the help of outside masons, and at Fountains the monks were using lay craftsmen by 1134, two years after the settlement of

the site in fact, as may be deduced from the reference
to the greater need for food of the *operarii* and *carpentarii*
than that of the rest of the community.[8] Regulation
of these outside masons crops up in the legislation
of the General Chapter meeting at Cîteaux; in 1134
a statute permitted them to eat meat, a food otherwise
proscribed to the community, and somewhat later, in
1157, another authorized their attendance at some offices
in the church and permitted them to wear mittens.[9]

Construction was not carried out exclusively by
hired labor, however. A percentage of the monastic
community also played a prominent role. This would
make sense as a matter of economy—the survival of
the early communities was frequently marginal—and
in addition because manual labor was an essential
part of the Rule of St Benedict, which, in turn, was
basic to the cistercian reform. Manual labor not only
ensured self-sufficiency for the community, thereby
minimizing contact with the outside world, but it was
recognized for its spiritual value. To suppose that
the Cistercians excluded building as a category of
manual labor is inherently unlikely and, as will be
seen below, there is indisputable evidence that certain
monks and laybrothers worked on building projects.
When Ordericus says, therefore, that the monks "built
monasteries with their own hands", there is no reason
to doubt his words, with the obvious qualification that
they describe the situation of the order in the early
1130s.

Documents provide a fuller picture of the role
of the monks. The clearest early account comes from
the *Vita Prima*, the life of St Bernard written between
c. 1150 and 1170 by William of St Thierry, Arnold of
Bonnevaux, and Geoffrey, Abbot of Clairvaux. One passage
describes the events leading to the enlargement of the
monastery in the mid-1130s, a decision critical in the
evolution of the order's architecture from small to large
scale. While Bernard was away in Italy the Prior,
Godefroid de la Rochetaille, Bernard's cousin, worked
out plans for a new and larger set of buildings. Presented
to Bernard on his return they were met with resistance,
however. The prior in an attempt to justify the project
pointed out that "although there were no woods surrounding
the new site to make an enclosure (as was the case
with the property they occupied at present), it would
be easy to build walls down there because of the great
abundance of stone".[10] In answer Bernard argued:

A house of stone is something that

> requires a great deal of money and
> labor, and if we were to put up
> any such, men might think ill of
> us, or say that we cannot be satisfied
> in any one place. Or they might
> think we had great riches (although
> admittedly we have nothing) and
> that wealth had gone to our heads.

Eventually Bernard was won round to the idea. The
local nobility helped with gifts and these were used
to buy "abundant supplies of building material". The
text then goes on to say:

> The monks supplied the labor themselves.
> Some cut down trees, others squared
> stones, and a mill was set up on
> the river. Some worked at this and
> others at that—carpenters, tanners,
> bakers and the rest set up their
> workshops...In an unexpectedly short
> time the walls were built, encircling
> a large monastery and enclosing
> all the work places. And the newly-
> born church grew and flourished
> rapidly.

The account is not free from questions of interpreta-
tion. Taken at face value we are told only that the
monks squared the stones and constructed the encircling
wall of the monastery; other roles may be implied but
they are not specified. And as already established,
work on the "newly-born" church was done in part
by outside help. Setting these difficulties aside the
procedures at Clairvaux have a wider interest. Present
at the abbey throughout the discussions and taking
part in the subsequent enlargement at the new site
were a number of English monks, notably Henry Murdac
and Richard, who were later to play prominent roles
in building in England. Two-thirds of the order in
England had Clairvaux as their mother house and its
procedures would have served as a model for them.
It is clear from the above that both hired outsiders
and the monks worked on building projects, but what
more can be ascertained? A beginning is to list the
recorded names of masons at cistercian abbeys in the
twelfth century. Though the documentary information
is still far from complete, the list adds considerably
to the three names of cistercian builders recorded by
Harvey.[11]

ABBEY	NAME	DATE	RANK	ADDITIONAL REFERENCE
Byland[12]	Henry Bugge	1139–43	laybrother	*"custos operis abbaciae"*
	Godwyno	1170–90	secular master mason	*"magister cementario"*
Fountains[13]	Robert	1170–1200	mason	
	Ivo	1180–1200	mason	
	Jordan	late 12c.	mason	
	Gregory	late 12c.	carpenter	
	Adam	late 12c.	cementarius	
	Ucted	late 12c.	mason	
Kirkstall	Dan Alexander	1152	abbot	*"dispositis ex ordine humilibus officinis"*
Kirkstead[14]	Adam	c. 1140	monk	*"in aedificiis construendis monasteri- orum"*
Meaux[15]	Adam	1150–60	abbot	*"Adam et monachi aedifi- caverunt magnam illam domum"*
Newminster[16]	Robert	1138–40	abbot	*"edificiis inibi, de more, dis- positis"*
Quarr[17]	Johe le ffleminge	c. 1150 (?)	free mason	*"employed for building"*
Revesby[18]	Willelmo	1170–98	secular master	*"magister novi operis"*
Rufford[19]	Radulfo	1186–1204	cementarius	
	Gileberto	late 12c.	cementarius	
	Osmundo	1180–1200	cementarius	
	Roger	1180–1200	artifex	
	Hedwardo	late 12c.	cementarius	
	Roberto	late 12c.	cementarius	
	Peter of Clune	late 12c.	cementarius	
	Ralf	late 12c.	cementarius	
	Simon of Southwell with his son, Henry	late 12c.	cementarius	
Sawley[20]	Waryn	before 1189	laybrother	*"Keeper of the works of the church"*
	Hugh	1180's	carpenter	
Sibton[21]	Walter	1160–70	mason	
	Radulfus	c. 1200	cementarius	
Thame[22]	Johanne	1170–84	cementarius	
Vaudey[23]	Adam	1147–49	monk	*"in aedificiis construendis monasterio- rum"*

Warden[24]	Gaufrido	c. 1200	cementarius	
Waverley[25]	Dan William	1203	rector	*"coepit jacere fundamentum novae ecclesiae"* *"inchoavit novam ecclesiam"*
Woburn[26]	Adam	c. 1145	monk	*"aedificiis de more constructis"* *"in aedificiis construendis monasteriorum"*

This listed information can be broken down into various categories and augmented from other sources. One approach to categorization is by broad rank within the monastic hierarchy, that is, abbot, monk, and laybrother.

There are three recorded cases of abbots who engaged in the design and construction process. Two of them—Robert of Newminster, later canonized, and Adam of Meaux—had similar backgrounds. They had begun their monastic lives at the benedictine abbey of Whitby before moving south within the benedictine family to St Mary's York in the late 1120's or early 1130's. Together with Dan Alexander of Kirkstall they were monks at St Mary's in 1132 during the turmoil that led to the establishment of Fountains. Robert and Alexander are named in the *Narratio* as among the original founding monks, and Adam left St Mary's shortly afterwards to join the new community according to the *Meaux Chronicle*.[27] These details are important because they establish Robert, Alexander, and Adam at Fountains in the spring of 1133 during the visit to the new house by Geoffroi of Ainai. This monk from Clairvaux had been sent by St Bernard because the community had not been established in the traditional manner and needed instruction in the customs of the Cistercians. That these included architecture can be assumed; Geoffroi was skilled and experienced in building and the *Narratio* states that during his stay he "built houses and set out workshops".[28] Other sources establish Geoffroi's role as similar to that of a master mason and show him to have been one of the principal figures in the architecture of the order. He is named (with Archardus) as the master of the second church at Clairvaux, begun two years after he was in Yorkshire; he is credited with the building of Clairmarais in French Flanders

in 1140; and he probably worked at other sites that were founded in parallel circumstances to Fountains if the further mention in the *Narratio* that "he set in order and established many monasteries" is taken to include building.[29]

Geoffroi also most likely trained other monks in architecture, and specifically Robert, Alexander, and Adam during the time he spent at Fountains. This is not surprising given the community's ignorance of cistercian custom and the expectation of growth for the house in the years ahead. Subsequently, it is documented that all three men "set out" monasteries—Newminster in Robert's case, Kirkstall in Alexander's, and Woburn in Adam's—"after our manner", a phrase that may be taken to mean after the cistercian manner and, perhaps more explicitly, after the manner of the Clairvaux filiation to which the three houses belonged.

About Robert and Alexander nothing further is known, but about Adam the picture is much fuller. Adam built at four monasteries and seems, in fact, to have replicated Geoffroi's role as an itinerant monastic master mason. The *Meaux Chronicle* says he was occupied in constructing the buildings ("*occuparetur et esset sollicitus...*") at Kirkstead (founded 1139), Woburn (1145), and Vaudey (1147).[30] He is mentioned specifically as being at work at Vaudy in 1149 when he had his famous encounter with William, Count of Aumale and Earl of York, that led to the foundation of Meaux with Adam as first abbot.[31] During this period (1133–50) he was a monk at Fountains, but after his appointment as abbot his building activity continued for the ten years of his rule. One of his buildings is described. It was a two storey timber structure of larger size than an earlier one on which it was modelled; the lower storey served as a dormitory for the monks, the upper as their oratory. About this building the text explicitly states that both "*Adam et monachi aedificaverunt magnam illam domum*".[32] It should be noted however, that the building in question was wooden, that is, it belonged to the first family of buildings rather than to the stone and thus more constructionally complex permanent buildings.

Turning to monks who were not abbots, the names of several men are recorded who are known to have engaged in building from the Order's early years in a capacity similar to that of Robert and Adam. Within the family of monasteries affiliated to Clairvaux, besides Geoffroi of Ainai, Archardus is documented as the master in charge of the building of Himmerod in 1138 and

a Robert is mentioned as being sent from Mellifont in Ireland in 1142 to oversee work there.[33] Later, and outside England, at Walkenreid in Germany, two monks, Jordan and Berthold, laid out the plan and supervised construction of the new church begun in 1207 using twenty-one laybrothers who worked as masons, wallers, and carpenters.[34]

Monks also filled other building roles. Positions such as those of supervisor or administrator of building operations (see below) would have required some literacy and ability to control men and can be assumed to have been filled by monks. In fact St Bernard's own brother, Gérard, the first cellarer of Clairvaux, was, we are told, "skilled in directing the work of masons, smiths, farmers, gardeners, shoemakers, and weavers".[35] Additional references show the monks involvement in building in more direct terms and even, touchingly, of this activity as sometimes outrunning their skill. At Obazine (Correze), for instance, it is recorded that the monks began work under Abbot Stephen to enlarge the monastery around 1150.[36] It emerged that they were not competent for the work, however, and the abbot, who took an active role in supervising the construction, was forced to engage a number of outside masons to complete it.

Of the work of the laybrothers the texts are less revealing than might be supposed. Laybrothers outnumbered the monks in all twelfth century foundations and, bound by a lighter rule, undertook larger amounts of manual labor. One would imagine them playing a central role in the construction process. Yet few texts mention them by name. One early reference comes from Byland around 1140. This abbey's troubled early history included settlement of four sites before the eventual establishment of Byland. Among these settlements was one at Hood where the community lived four years, 1139–43. During this stay Philip, whose account of the abbey's history dates about fifty years later to c. 1197, records that Henry Bugge was "*custos operis abbaciae*". Fortunately, a little is known about Bugge. He was a knight attached to the household of the Mowbrays, a powerful family in the north of England who were the patrons of the Byland monks. It was presumably through the pious support of the Mowbrays that Bugge came in contact with the community and decided to join them. His status as a knight indicates capacity for responsibility and command. The second mention also concerns a Yorkshire house, Sawley in the West Riding. At some time before 1189 Brother Waryn is described as "Keeper of the works of the church at Sallay". Whether both men engaged

in building is debatable, however. Harvey believes
the term "*custos*" meant warden, and signified a resident
substitute for the master mason.[37] A famous example
of this occurs at Canterbury where Gervase, in his
account of the rebuilding of the Cathedral between
1178 and 1185, mentions the monk "...*qui cementarius
praefuit*".[38] Subordinate to the master mason, William
of Sens, he was "overseer of the masons", and was
clearly appointed on a temporary basis as his deputy
for giving directions during a period of major work
pressure. Gervase adds that the appointment excited
much envy and malice on the part of persons in a
position to criticize, probably the other senior masons.

On the other hand, Knoop and Jones point to
the use of the title "*custos*" in the later Middle Ages
and in non-monastic contexts to mean the sacrist, i.e.
the treasurer of the fabric fund.[39] Such a position
was largely supervisory with responsibility for making
payments for materials and labor. If the titles used
for Bugge and Waryn represent this latter function,
they furnish further proof of the presence of outside
labor which required payment for piece work and firm
on-the-spot regulation of work crews.

Despite the relative scarcity of mentions of the
laybrothers, their role in building was doubtless consider-
able. Of course, only a small percentage would have
specialized in the various building roles, perhaps 10
to 15%, and the vast majority would have been occupied
on the abbey's granges, farms, and in other tasks
within the monastery proper. Texts from the French
houses at this period throw light on the matter. At
Clairmarais (Pas-de-Calais) during a period of active
building around 1150, Abbot William is recorded as
employing laybrothers for the work, and also as "collect-
ing from the various monasteries of our order all those
who were skilled in the art of building".[40] The same
practice can be illustrated at Viktring in Carinthia.
Among the first community were five laybrothers from
Clairvaux who came from Villers in Lorraine in 1147
and are referred to as "*conversi barbati diversis artibus
periti*".[41] So widespread was the practice that the General
Chapter moved to regulate it in 1157. A statute legislated
that the monks and laybrothers could only work at
their own monasteries or in others of the order, but
not outside.[42]

For the employment of hired labor within the
community, the documents may be analyzed by the rank
of the individual in the building trade: master masons,
masons, and carpenters. The earliest instance of the

name of a master mason occurs at Quarr on the Isle of Wight, a foundation of the Congregation of Savigny established in 1132 by Baldwin de Redvers. The source records that Baldwin "employed for the building of the monastery" Johe le ffleminge who is described as a "good Free Mason". Unfortunately, it is not clear if Johe was at Quarr during its Savigniac years (1139–47) or after 1148 when the house became Cistercian. In two other cases the names of master masons occur as witnesses to monastic documents. At Revesby a charter dated between 1170 and 1198 was witnessed by Willelmo who is described as *"Magister Novi Operis"* and at Byland a deed of land was witnessed by *"Magister Godwyno cementarius"* at some time between 1170 and 1192. Both names appear in years when active construction was underway at the house, and their use as witnesses may plausibly be connected with their work within the monastery. Certainly the increasing complexity and scale of the new buildings of the Cistercians from c. 1170 forwards implies the employment of specialists; design and setting out called for high standards of what has been called "constructive geometry" and would have required a degree of professionalism of a kind, in fact, unlikely to have been found in a community. Unambiguous proof of secular masters comes from the early thirteenth century. At Waverley the first church was replaced by a vastly larger and more ambitious building beginning in 1203. The abbey's *Annales* record that the foundations were laid in that year by Dan William of Broadwater who is described as *"rector ecclesiae de Bradewatere"*. Mention of his death in 1222 and subsequent burial at the abbey indicates a period of eighteen years in which he had charge of the work at Waverley.43

More difficult to interpret are the documents that refer to the last category of men, the *cementarii*, masons, and carpenters whose names surface every now and then in the charters of individual houses. Mostly they occur as witnesses to deeds of land or other gifts to the house. Whether their association with building at the abbeys can be assumed on this basis is difficult to establish, however. At Sibton, Walter and Radulfus, both referred to as *cementarius*, were men of substance to whom the abbey granted land, the gifts suggesting their connection with work on its buildings.44 Similarly, the willingness of Sawley to oversee the legalities relating to a grant of land to Hugh the Carpenter implies his work at the Yorkshire abbey.

Elsewhere the situation is more ambiguous. At

Fountains the names of six masons and carpenters recorded in the last quarter of the twelfth century may or may not belong to men actually working at the abbey. Arguing for their association with building is the practice at Fountains going back to 1134 of employing outside labor to help with work, and the fact that the period in which their names occur was one of major activity and expansion involving the construction of large structures like the refectory and west claustral ranges. On the other hand, construction itself might have attracted increased benefactions as people seeing a successful enterprise underway were prompted by the very activity to make additional gifts; in turn, witnesses would have been needed to validate them. Thus it could be argued that the names are merely those of free men brought to the abbey as legal witnesses of the gifts. If complications arose subsequently such men easily could be found and could be appealed to in a court of law.[45] Their presence as witnesses was not, therefore, anything more than a legal matter and does not necessarily imply any professional activity. This interpretation would mean that in a case like Rufford, where the names of ten masons and carpenters are recorded from the late twelfth century, all that can be deduced is that an ample supply of such free men existed in close proximity to the abbey. A thriving town and big collegiate church at Southwell seven miles away, from where Simon with his son are mentioned as coming, would have provided livelihood for a number of masons and carpenters who might then have been summoned to the abbey to witness a gift as occasion arose.

In conclusion, what does the above material tell us about the wider debate mentioned at the start of this paper of who conducted monastic building. Clearly both monks and laybrothers took an active part in construction in the twelfth century, to a degree far greater than the mere "amateur cooperation" that Swartwout was prepared to concede to them.[46] But they also worked from the start with hired labor from outside the monastery. Apart from the documentary evidence their presence could be inferred from the large number of masons' marks still visible on the sites. However, to imagine monastic and secular craftsmen working side by side on a single building raising walling or turning vaults on the same scaffold is inherently unlikely. Such a situation would render chaotic the mundane but necessary aspects of building contracting as the calculation of task work, or the meeting of specifications, and would

lead inevitably to friction and disputes. But any monastery was a complex of buildings and when work was contracted out it is only sensible that it would be for a specific project or parts of one requiring particular skills.

That most of the names of master masons and individual craftsmen occur in the last quarter of the twelfth century may best be explained by the rise of a new professionalism. A similar trend occurs in manuscript painting and metal work. For architecture Early Gothic was marked by a sharp rise in technological complexity and by an increased sophistication in design, both features that fostered specialization. Yet to infer that building became the exclusive preserve of secular master masons and masons by the thirteenth century simplifies the situation. In England, for instance, it is likely that at Waverley the secular master who had begun the large new church, Dan William of Bradewatere, was replaced at his death by a member of the monastic community, a laybrother, John of Waverley.[47] And in Germany throughout the thirteenth century there are a number of references to both monks and laybrothers serving as masters of the works.[48]

Wellesley College

NOTES

1. A. Lenoir, *Architecture monastique* (Paris, 1852);
 L'Abbé Texier, *Dictionnarie d'orfevrerie, de gravure
 et de ciselure chrétiennes*, Vol. 27 of Migne's
 Troisième encyclopédie archéologique (Paris, 1856);
 A. H. Springer, *De Artificibus monachis et laiciis
 medii aevi*, (Bonn, 1861); Comte de Montalembert,
 Les Moines d'occident (Paris, 1877) 4.
2. A. H. Thompson, 'Medieval Building Documents',
 *Proceedings of the Somerset Archaeological and
 Natural History Society* 66 (1920) 1–25; G. G.
 Coulton, *Art and the Reformation*, (New York,
 1928); R. E. Swartwout, *The Monastic Craftsman,
 An Inquiry into the Services of Monks to Art
 in Britain and in Europe North of the Alps during
 the Middle Ages* (Cambridge, 1932); D. Knoop
 and G. P. Jones, *The Medieval Mason: An Economic
 History of English Stone Building in the Later
 Middle Ages and Early Modern Times* (Manchester,
 1933).
3. Ibid., p. 95.
4. Equally forthright is J. Harvey, *The Medieval
 Architect* (London, 1972) pp. 174–5, and the same
 view surfaces in W. Braunfels, *Monasteries of
 Western Europe* (Princeton, 1972) p. 79.
5. M. Chibnall, ed., *The Ecclesiastical History of
 Orderic Vitalis: Vol. IV, Books VII and VIII*
 (Oxford, 1973) p. 327.
6. See J. de la Croix Bouton and J-B. Van Damme,
 Les Plus anciens textes de Cîteaux (Achel, 1974)
 p. 121. The translation is by B. K. Lackner in
 J. L. Lekai, *The Cistercians: Ideals and Reality*
 (Kent, Ohio: 1977) p. 448.
7. P. Fergusson, 'The First Architecture of the Cister-
 cians in England and the Abbot Adam of Meaux',
 Journal of the British Archaeological Association
 136 (1983) pp. 32–46.
8. For Clairvaux, see M. Aubert, *L'Architecture
 cistercienne en France* (Paris, 1947) 1:64; for
 Fountains, J. R. Walbran, *Memorials of the Abbey
 of St Mary of Fountains*, The Publications of the
 Surtees Society (Leeds, 1862) 1:50.
9. J-M. . Canivez, *Statuta capitulorum generalium
 ordinis cisterciensis ab anno 1116 ad annum 1786,
 Bibliotheque de la revue d'histoire ecclésiastique*,
 1 (1933) p. 18 (1134: xxiv) and p. 67 (1157:
 56).
10. See G. Webb and A. Walker, *Saint Bernard of*

Clairvaux (London, 1960) pp. 87–89. The quotations that follow come from the same source. On the precise date of the project see E. Vacandard, *Vie de Saint Bernard* (Paris, 1927) 1:413.

11. J. Harvey, *English Medieval Architects, A Biographical Dictionary Down to 1550* (London, 1954); and also Harvey, *The Medieval Architect*, pp. 81–2.

12. For Bugge, see W. Dugdale, *Monasticon anglicanum* (London, 1817–30) 5:350; for Godwyno, W. Farrer, *Early Yorkshire Charters* (Edinburgh, 1916) 3:460–61, no. 1850.

13. For Robert, see Brit. Lib., Add. Ms. 37779 fol. 116v, and Univ. Coll., Ms. 170 fol. 43r; for Ivo, Brit. Lib., Add. Ms. 37770 fol. 12v and 13r, and Univ. Coll., Ms. 170 fol. 47r; for Jordan, Rylands Ms. 224 fol. 118v, and Oxford, Bodelian, Ms. Rawlinson B. 449 fol. 134r; for Gregory, Brit. Lib. Cotton Tib. Ms. CXII fol. 204v; for Adam, Brit. Lib., Add. Ms. 40009 fol. 289v; for Ucted, Brit. Lib., Cotton Tib. Ms. CXII fol. 286v–287r. I would like to thank Miss Joan Woodward of Oxford for drawing my attention to these mentions.

14. E. A. Bond, ed., *Chronica Monasterii de Melsa*, Rolls Series (1866) 1:76.

15. Ibid., 1:107.

16. Walbran, pp. 58–9.

17. W. H. Long, ed., *The Oglander Memoirs* (London, 1888) p. 198.

18. D. M. Owen, 'Some Revesby Charters of the Soke of Bolingbroke', *Pipe Roll Society Publications*, new series 36 (1960) p. 232.

19. C. J. Holdsworth, ed., *Rufford Charters*, Thoroton Society Record Series, 29 (1972), 30 (1974), 33 (1980): for Radulfo no. 117; for Gileberto no. 779; for Osmundo no. 997; for Hedwardo no. 826; for Roberto no. 826; for Peter of Clune no. 830; for Ralf no. 826; for Simon no. 826. For Roger, see Harvey, *English Medieval Architects*, p. 227.

20. For Waryn see R. P. Littledale, ed., *Pudsay Deeds*, Yorkshire Archaeological Society Record Series, (1916) pp. 122–3, no. 44; for Hugh, J. McNulty, ed., *The Chartulary of the Cistercian Abbey of St Mary of Salley in Craven*, Yorkshire Archaeological Society Record Series, 88 (1933) no. 123 and no. 127.

21. See R. A. Brown, 'Early Charters of Sibton Abbey, Suffolk', *Pipe Roll Society Publications*, 36 (1960) pp. 65–76, esp. 73, 75.

22. H. F. Salter, ed., *The Thame Chartulary*, Oxford

Record Society, 25–26 (1943–4) 100.

23. Bond, 1:76.
24. E. H. Fowler, ed., 'Cartulary of the Abbey of Old Warden', *Bedfordshire Historical Record Publications*, 12 (1930) n. 52.
25. H. R. Luard, ed., *Annales monastici*, Rolls Series, 2 (London, 1865) pp. 255 and 296.
26. For the first mention see Dugdale, 5:479, but compare Walbran, 1:86; for the second mention see Bond, 1:76.
27. For Robert see Walbran, 1:9; for Adam see Bond, 1:74.
28. Walbran, 1:47.
29. For Geoffroi's work at Clairvaux and Clairmarais see Aubert, *L'Architecture cistercienne*, 1:97; for Serlo's mention of his other work see Walbran, 1:47.
30. Bond, 1:76.
31. See Fergusson, 'The first Architecture', p. 40.
32. Bond, 1:107.
33. See H. Hahn, *Die frühe Kirchenbaukunst der Cisterzienser* (Berlin, 1957) pp. 80, 253; for Robert see A. Schneider, et al., *Die Cistercienser: Geschichte, Geist, Kunst*, (Cologne, 1974) p. 58.
34. R. Dohme, *Die Kirchen des Cistercienserordens in Deutschland wahrend des Mittelalters* (Leipzig, 1869) pp. 34–35.
35. M. H. D'Arbois de Jubainville, *Etudes sur l'état intérieur des abbayes cisterciennes* (Paris, 1858) p. 229.
36. Swartwout, p. 80.
37. Harvey, *English Medieval Architects*, p. xi.
38. R. Willis, *The Architectural History of Canterbury Cathedral* (London, 1845) p. 51.
39. Knoop and Jones, pp. 27–31; see also R. Branner, '*Fabrica, opus* and the Dating of Medieval Monuments', *Gesta* 15 (1976) 27–30.
40. H. de Laplane, 'Les Abbés de Clairmarais', *Mémoires de la société des antiquaires de la Morinie* 12 (1868).
41. V. Mortet and P. Deschamps, *Recueil de textes relatifs à l'histoire de l'architecture et à la condition des architects en France au moyen age XII–XIIIe siècles* (Paris, 1929) 2:21.
42. Canivez, p. 66 (1157: 47).
43. Luard, p. 113 (under 1222).
44. The suggestion is made by Brown, p. 68.
45. I am indebted to professor Christopher Holdsworth for pointing this out to me.

46. Swartwout, p. 86.
47. For John of Waverley's career in royal service
 as well as at Waverley, see Harvey, *English
 Medieval Architects,* p. 288.
48. See Aubert, 1:98–99.

Peter Fergusson spoke on Cistercian abbeys of Northern
England at the Conference on Cistercian Studies, Fifteenth
International Congress on Medieval Studies, Kalamazoo,
May 1980.

THE ORIGINAL CHEVET OF PONTIGNY'S CHURCH
Terryl N. Kinder

The twelfth century cistercian abbey church of Pontigny is located in an area of northern Burgundy where the land swells and falls more gently than in the famous grape-producing regions to the south (Fig. 1). The abbey was sited on a broad plain near the southern bank of the Serein River, on a slight rise in the terrain which allows the massive edifice to be seen from a considerable distance to the southeast and west. Today it is the splendid polygonal choir with its ambulatory, eleven chapels and flying buttresses supporting the clerestory wall which are most striking from this view. Yet this was not the appearance of the eastern end when the church was completed around 1150.

Pontigny's church had been laid out in the late 1130's[1] in an expanded version of the bernardine plan: porch, seven-bay nave, rectangular chevet, and chapels flanking not only the apse, but surrounding the transepts on three sides.[2] The original chevet and two contiguous chapels were destroyed toward the end of the twelfth century when the choir was remodeled to its present state.

Although it is clear to a modern observer that the two styles of nave and choir indicate different building campaigns, this was not noted until relatively recently. Early historians treated the church as an architecturally homogeneous entity, and most nineteenth century authors failed to observe that the choir belonged to a slightly later period.[3] Discussing the choir in his report for the Monuments historiques in 1842, Maximilien Quantin mentioned only that "cette partie de l'église est un peu plus décorée que la reste".[4] Chaillou des Barres, in his 1844 history of the abbey, stated that "cette admirable église...semble être d'un seul jet: mérite rare, presque exceptionnel". He lamented the great length of time often needed to build cathedrals, "soit que, plus tard, le goût nouveau ait prétendu corriger le goût ancien, la confusion des styles éclate dans le même edifice", something that, in his view, Pontigny had fortunately escapé.[5] Viollet-le-Duc, who visited the church in 1845 and wrote recommendations for its restoration, said the church had been built "d'un seul jet" around 1150.[6] Although it is obvious that the clean lines and pure spaces were not to his taste, he did believe that one of Pontigny's virtues

was its architectural unity:[7]

> Si l'église de Pontigny mérite que
> l'on fasse des sacrifices pour la
> préserver de la ruine, ce n'est
> pas certainement à cause de son
> style, mais bien à cause de son
> unité que rien n'est venu troubler,
> de sa simplicité excessive et des
> souvenirs qu'elle renferme.

Emile Amé, writing in 1853 on colorless glass windows in the Yonne, appears to have been the earliest author to make a distinction between Pontigny's nave and transepts—which he dated to the end of the twelfth century—and the choir with its "bundles of colonnettes and crocket capitals" which he considered early thirteenth,[8] but that is the extent of his discussion. Not until the end of the century was it said that Pontigny's chevet had probably been rebuilt, rather than simply lagging well behind construction of the transepts and nave.[9] Dehio and von Bezold stated in 1892 that the original choir must have been flat-ended,[10] although they did not propose an actual plan of it. They categorized Pontigny's first chevet as the "Cîteaux II type" and said that both mother-houses were related to the sketch of an untitled cistercian church made by Villard de Honnecourt (Fig. 2).[11] Holtmeyer took this suggestion a step further in 1906 when he published a schematized version of Villard's plan as the likely shape of Pontigny's original choir (Fig. 3).[12] In Holtmeyer's plan, the square crossing is reproduced in a square bay to the east where the high altar would have been; a right-angled ambulatory surrounds it; and four rectangular chapels were located along the east wall.

A much simpler plan was published the following year by Philippe in the *Congrès archéologique*.[13] He conjectured rather that Pontigny's original chevet consisted of one (almost) square bay with three flat-ended chapels on either side (Fig. 4), and that it had been built together with the transepts between 1150 and 1160 before the nave was begun.[14] Philippe's plan was corroborated in 1909 by Bilson, whose plan of Pontigny showed how the new choir connected to the old transept.[15] Bilson also proved that Dehio's and Holtmeyer's Villard-like chevets could not have existed at Pontigny: in the south wall of the westernmost bay of the south aisle of the present ambulatory are a double piscina and aumbry of the same shape and location

as those in the other transept chapels, demonstrating that this area must also have been a chapel and not part of a large aisle surrounding the high altar.[16]

Nevertheless, complex reconstructions of Pontigny's first chevet continued to appear, by Giesau in 1912 (Fig. 5), and Rose in 1916.[17] Both were based on Villard's sketch: deep rectangular chevet projecting three bays west of the crossing, surrounded on three sides with an aisle, and terminating with four square chapels on the far eastern end.[18] Georges Fontaine, in his monographic study of Pontigny's architecture in 1928, was also persuaded that the first chevet was of such vast dimensions. He believed that the humble solution proposed by Philippe was disproportionate to the rest of the building, and felt that a church as important as Pontigny probably would have had a more substantial eastern end.[19] He, too, put forth a design derived closely from Villard de Honnecourt's plan of a cistercian church, changing it from Giesau's and Rose's proposals only by having two bays project east of the crossing instead of three (Fig. 6). Fontaine felt that this chevet design matched the transepts at Pontigny, which have chapels on all three sides. By superimposing this plan upon the rebuilt one, he seems to be proving how large the first design was, although—to this reader at least--he creates the problem of having to explain why they then destroyed such a grand chevet to build one only slightly more grand.

An excavation, done by René Louis and directed and published by Marcel Aubert in 1942, ended speculation over the size and shape of Pontigny's original east end (Figs. 7 and 8).[20] In the first bay of the south side of the present ambulatory, remains of the foundation wall of the chapel contiguous to the choir were found. Expansion of this trench eastward revealed corner buttressing on the east and south sides of pier M6, suggesting that this had been the exterior buttress for the southeast corner of the chevet. A second trench between the first and second bays of the choir presented another segment of foundation, which would have supported the eastern wall of the chevet. Aubert concluded from these findings that the original chevet had had one bay that corresponded in depth to the first bay of the rebuilt choir. Bilson's observation of the piscina and aumbry in the south wall of the ambulatory immediately adjacent to this bay (K/L 7) was thus vindicated: part of the first bay of the ambulatory was a chapel. The condition of the wall surface above the piscina also supports this theory. The lower walls in the transepts and nave

were constructed of limed rubble, while the new choir walls are of fine ashlar construction. When the back wall of the chapel in question (L 6/7) was removed, and the south wall of the chapel extended with the new campaign (K/L 7 became K/M 7), the discrepancy in building materials had to be reconciled. Hence the limed surface of the original wall had been scratched with "coursing" marks which meet the limestone blocks of the new wall above and beyond the old one. The date of this fake coursing could not be determined, but that is less important than the effect it has of masking the transition between the old wall and the new.

The plan which Aubert drew, based on this excavation, appears conclusive.[22] In support of this hypothesis, it should be noted that all column bases east of crossing piers K5 and K6, as well as those in the ambulatory and new chapels, bear a later profile. The center and western faces of K5 and K6 have been "recycled" in the new choir; the eastern face is new because that portion was once the wall separating the chapel from the choir (Fig. 9). In other words, supports that were in line with the new plan were re-used. If Fontaine's hypothesis—that there were three bays west of the crossing which were incorporated from the old design (Fig. 6)—were correct, we could expect to find evidence in the masonry and there is none.

The masonry does yield clues in another direction, however, and that is in the elevation. Scholars have long speculated over the size and shape of the plan of the older apse, but the question of its projection into three dimensions has not been addressed. When the old choir was destroyed to make way for the new, vestiges were left, and these now allow us to reconstruct the height of Pontigny's original chevet.

Examination of the eastern crossing piers (K5 and K6) from the crossing side reveals three capitals on each (Figs. 10 and 11). The outer capital on each side supports the transverse arch of the crossing and is located just below the stringcourse which encircles the transept at abacus level. These capitals were cut from a darker, denser limestone than that used for the upper piers or arches, and the coarser texture is evident. They are decorated very simply, but not alike: on the north, incised lines suggest a leaf, while on the south three vertical lines project from an otherwise smooth surface. Both were executed in two courses and have a clear horizontal seam, although the design flows across the two blocks as though there were no

break.

Under the diagonal rib of the crossing vault is a smaller water–leaf capital set approximately one meter higher than the stringcourse. This reflects the difference in height between the groin–vaulted transepts and the rib–vaulted crossing so evident on the exterior.[23] This capital was carved to sit diagonally atop the dosseret; close examination of the block reveals the problem the mason had to resolve in shaping the stone to make this transition. The decoration also reflects its intended placement; the line coming up the center of each capital corresponds to the corner of the dosseret, and it bifurcates into two leaves which reach out to embrace the width of the rib.

The capitals under the transverse arches to the choir pose a dilemma, for their bases date from the first campaign (Fig. 9), while their crocket capitals are contemporaneous with the rebuilding. The abaci have a slightly bolder, more compact form, and the profile of the transverse arch is also later. In examining the courses of the respond, the clue is disclosed (Figs. 10 and 11). Counting down to the sixth and seventh courses below the crocket capitals on the north and south respectively, there is a single, darker, coarser stone which corresponds in height, color, texture, and level to the bottom half of the (outer) capital under the transverse arch to the transepts. It is the only stone in the respond of this density, earmarking its unique use.[24] This stone had apparently been the bottom half of a capital which supported the original transverse arch to the old chevet. Its upper half was apparently pulled from the wall when the transverse arch was dismantled, but the bottom part needed only to be chiseled back slightly to bring it flush with the respond below. Half a dozen thinner courses of stone––which are whiter than the lower part of the shaft––were then placed above the shaved–back stone to raise the elevation of the new choir. Thus the capital cluster on the eastern crossing piers originally would have displayed a rhythmic jump, as the capitals reflected the different heights of the areas they supported: transepts and choir at one level, crossing ribs above (Fig. 12).

Further evidence to support this reconstitution of the placement of capitals on the eastern crossing piers is in the "capital frieze" which is only visible once the spectator has passed into the new chevet (Figs. 13 and 14). From this point, one can see that the small crocket capital frieze is a few centimeters higher than the large crocket capital of the transverse arch, which

was raised above the shaved–back stone of the earlier campaign. This small detail shows us that the designer of the remodeling in fact wanted the choir still higher than the crossing by a small measure. Yet by placing the crocket capital for the transverse arch at precisely the height of the diagonal capital under the crossing ribs, he achieved a harmonious connection with the old part of the church (Figs. 10 and 11). And by raising the choir a bit behind the transverse arch, the impression of increased space and light in the new choir was achieved. The placement of the crocket frieze behind the transverse arch serves two purposes: to reflect the slightly increased height of the choir over the crossing, and yet to disguise an awkward juncture, in fact, to hide it from a viewer standing in the crossing (a monk sitting in the stalls).

The elevation of the original apse of Pontigny's church was therefore exactly the height of the transepts, and probably had similar fenestration: round–headed lancets at the lower level, pointed in the upper, and an octolobular rose (Fig. 15). The massing would have reflected the difference in vault heights, presenting a much less dramatic silhouette with both apse and transepts lower than the crossing. Fontaine was in fact right, although perhaps not the way he intended: the original chevet seems disproportionate to the mightiness of the rest of the church. But in this very imbalance the seeds of the remodeling may have been sown, for in less than two generations another architectural vision took its place, transforming Pontigny into the structure which we know today (Fig. 1).

State University of New York
Brockport

NOTES

Portions of this paper were given at the Seventeenth International Congress of Medieval Studies, Kalamazoo, Michigan, in May 1982.

1. Evidence for this date was presented in my Ph.D. thesis, "Architecture of the Cistercian Abbey of Pontigny. The Twelfth Century Church", (Indiana University, 1982, chapter V, especially pp. 143–44), and will be made available in a forthcoming article, "Dating the Construction of Pontigny's Church".

2. Of the hundreds of cistercian churches which conform to this "bernardine plan", only Pontigny and Preuilly (Seine–et–Marne) have chapels surrounding the crossings on three sides.

3. V.–B. Henry, who wrote the first serious monograph on Pontigny *(Histoire de l'abbaye de Pontigny,* Auxerre and Avallon, 1839) does not mention construction of the church.

4. Monuments historiques dossier no. 1576, report dated March 1, 1842.
 The *Société française pour la conservation des monuments historiques* met in Auxerre in 1850, and made an excursion to Pontigny on June 19. Quantin, secretary of the organization, published a similar report in the *Congrès archéologique* (1850) p. 86: "Le sanctuaire...est plus élégant que les nefs, tout en conservant ce cachet de simplicité qui fait le fond de l'église".

5. Etienne Chaillou des Barres, *L'abbaye de Pontigny* (Paris, 1844) p. 35.

6. Monuments historiques dossier #1576, report dated February 15, 1845.

7. Ibid.

8. Emile Amé, "Recherches sur les anciens vitraux incolorés du département de l'Yonne", *Bulletin de la société des sciences historiques et naturelles de l'Yonne,* 7 (1853) p. 245.

9. Edmund Sharpe, *The Architecture of the Cistercians* (London, 1875) p. 26, was aware of two different campaigns, although he mentions it only in passing: "...the choir of Pontigny, added to the earlier Transitional choir, is a beautiful example (of apse with radiating chapels)...."

10. Georg Dehio and G. von Bezold, *Die kirchliche Baukunst des Abendlandes,* 1 (Stuttgart, 1892) p. 530.

11. Dehio and von Bezold, p. 528.

12. Alois Holtmeyer, *Cisterzienserkirchen* *Thüringens* (Jena, 1906) pp. 47–48 and 71.

13. André Philippe, "Pontigny. Eglise abbatiale", *Congrès archéologique*, 74 (1907), opposite p. 202.

14. Philippe, p. 203.

15. John Bilson, "The architecture of the Cistercians, with special reference to some of their earlier churches in England", *The Archaeological Journal*, 66 (1909) pl. xxvi.

16. Bilson, p. 213 and note 4.

17. Hermann Giesau, *Eine deutsche Bauhütte aus dem Anfange des 13. Jahrhunderts*, (Halle, 1912) pl. XII; Hans Rose, *Die Baukunst der Cisterzienser* (Munich, 1916) p. 95.

18. The only difference appears to be that Giesau vaulted all three bays east of the crossing separately with four–part vaults (see Fig. 5), while Rose described the second and third bays as having had a six–part vault (he did not publish a plan).

19. Georges Fontaine, *Pontigny Abbaye cistercienne* (Paris, 1928) pp. 42–43. In the late 1130's when construction was begun, however, the importance which the abbey was to achieve had scarcely become apparent. For a perspicacious review of Fontaine's theory, see Jean Vallery-Radot, *Revue d'histoire de l'église de France* 15 (1929) pp. 348–352.

20. Marcel Aubert, "Les fouilles de l'église de Pontigny", *Bulletin de la Société nationale des Antiquaires de France* (1942) pp. 243–246.

21. No such piscina is visible today in the north aisle because it would have been in the wall to the right (contiguous with the chevet), which was opened up for the new design.

22. Since Aubert's trenches did not extend all the way east, the possibility remains that substructures for a larger choir could exist. Yet the appearance of a corner buttress on the east and south sides of M6 does suggest strongly that M6 marked the southeastern terminus of the old chevet, and the piscina proves that this space was a chapel and not an aisle. One must, I think, respect Aubert's conclusion until specific refuting evidence appears.

23. Crossings often receive special treatment, either by being higher than the radiating arms, or by having a different type of vault, or both. The small neighboring parish church of Ligny-le-Châtel––a wooden-roofed Romanesque structure ––had its crossing rebuilt around 1155 when it

was capped with a low ribbed vault received by Corinthian capitals on corner responds. The Cistercians, notorious for preventing upper parts from mingling with the floor, set the crossing ribs at Pontigny on simple diagonally–placed capitals; the pilaster below suggests nothing of the cross–ribbed vault above. At Silvacane (1175–1230) the triple tori of the ribbed crossing —in an otherwise pointed barrel–vaulted church —were carved to abrupt terminal points and have no responds below.

A sampling of other early cistercian churches whose crossings were vaulted differently than other parts of the church includes La Bussière, which has a highly arched groin over the crossing while the rest of the church has pointed barrel vaults, and Flaran (1180–1210) which has a rib–vaulted crossing and barrel–vaulted transepts. Numerous churches in southwestern France have domed crossings on pendentives (Cadouin, dedicated 1154; Obazine, slightly later; Grosbot, second quarter of twelfth century; Bonlieu, beginning thirteenth), while in the southeast, crossing domes were more commonly built on squinches (Sénanque, 1180–1230; Féniers, begun thirteenth century; Mazan, 1140–50; Léoncel, terminated 1188; Bonne-combe, second third twelfth century). Cf. Marcel Aubert and the Marquise de Maillé, *L'Architecture cistercienne en France* (Paris, 1947) pp. 248–49.

24. This stone is easier to see on the northeast pier (Fig. 10); the southeast pier still has much white-wash which conceals the contrast.

THE FACADE OF THE FORMER ABBEY CHURCH
OF HAUTE-SEILLE IN LORRAINE
Michelle Steger

The cistercian abbey of Haute-Seille,[1] in Latin "Alta Silva", is located in the present *département* of Meurthe-et-Moselle in Lorraine, 380 kilometers east of Paris and 130 kilometers northeast of Morimond, from which it was descended.[2] The foundation of Haute-Seille took place during a wave of fervor which led to the establishment of fourteen cistercian abbeys in Lorraine within twenty years, from 1140 to 1161 (Fig. 1).[3] It was founded c. 1140 by Agnès of Langstein, Countess of Salm, and her two sons, Henry and Herman, who brought monks from the abbey of Theuley in Burgundy.[4] Haute-Seille survived until the Revolution, at which time it was torn down, then sold, and--like many other abbeys--used as a stone quarry.[5]

The property on which the ruins of the abbey are found is now privately owned. The terrain is flat, bordered by the Herbas, a tributary of the Vezouze River, in a region of lakes and forests. None of the medieval buildings survive save the church. Its plan (Fig. 2) had the form of a Latin cross, and measured 66 meters in interior width.[6] The only surviving part includes a portion of the gutteral wall measuring approximately 20 meters in length and varying in height from 0.30 to 2.0 meters, and the partly ruined façade (Fig. 3).

Description of the Façade

The façade stands at its original width of 16.80 meters, and measures 6 to 815 meters in height in its present condition. It was constructed of beautifully shaped stones which vary from 0.28 to 0.84 meters in length and 0.28 to 0.40 meters in height. Most of the stone is whitish limestone which has, with time, become gray or yellow. The window arcades are made of alternating blocks of white stone and pink sandstone, reminding us that Haute-Seille is situated at the limits of the sandstone hills of the Vosges mountains. The joints are of yellowish cement and are narrow, typical of the careful construction of the romanesque period in Lorraine and elsewhere.

The façade of Haute-Seille is divided vertically into three sections, reflecting the interior division into three: a central vessel with a lower aisle on each

side. The tripartite façade is embraced by wall buttresses
placed against it, measuring 0.70 meters wide and
0.29 meters deep and rising to a height of 8.50 meters,
though their capstones have disappeared; and it is
divided by two wall buttresses. The buttress furthest
south has the same depth as the two inner ones but
is wider (0.90 meters) and lower (6 meters); the other,
toward the north, is a corner buttress enveloping the
angle formed by the façade wall and the north gutteral
wall. It is of the same dimensions as the first buttress,
but has a different ground plan. This can be explained
by the construction of the west wall of the conventual
building which formed the west wing of the cloister;
although nothing remains of it today, it once extended
the west façade of the church toward the south.

The four buttresses are rectilinear and, at the
present ground level, they are emphasized by an offset
chamfer on the stylobate which runs the length of the
façade and along the gutteral walls. The earth has
been banked up; ground level was once about 0.6 meters
lower, since originally one mounted three steps to enter
the church.

The elevation of the parts of the façade which
correspond to the aisles has two stories: the arcade
and the oculi. The arcade level is decorated with a
blind arch, round-headed on the north and slightly
pointed on the south. This asymmetry is caused by
the differing widths of the lateral parts of the façade
(3.15 meters on the north, 2.75 on the south); since
both the springers and the apices of the two arches
are at the same level, the arches were shaped differently
to accomodate the space. The blind arches are set into
the surface of the façade to a depth of 0.21 meters.
Their stones are squarely cut without moldings; their
beauty resides in the dressing of the voussoirs; the
springers are set with precision. The south side of
the façade was pierced with a small rectangular doorway
surmounted by a simple flat lintel. Its axis was shifted
in relation to that of the lateral façade. It has been
blocked in.

The upper level of each lateral façade is pierced
by an oculus, although that on the south has almost
totally disappeared.[7] They measure 1.40 meters in interior
diameter, and are bounded by moldings giving them
a total diameter of about 2.50 meters. They are not
infilled and never have been. The profile is simple:
an embrasure, two tori separated by a hollow molding,
and, on the outer edge, a fillet. The two oculi are
not on the axes of the aisles, but are shifted toward

the center of the façade.

The two stories are separated by a stringcourse running the full length of the façade, the profile consisting of a wide flat band, two listels and a quarter-round molding. This ornamental strip articulates the height of the transverse arches of the aisles; the blind arches on the façade are their exact reflection on the exterior.

The elevation of the central part of the façade, corresponding to the nave, today rises only two levels (Fig. 4): the lower, decorated with three arches that occupy the entire width of this portion of the façade; and the upper, pierced by three windows. On the lower level, the portal opens within the central rounded arch and is flanked by two sharply pointed blind arches. This doorway is 3.30 meters wide, and the blind arches measure respectively 2.35 meters on the north and 2.30 on the south.

The surface of the nave wall is, like that of the aisle façades, set back 0.21 meters from the arches. The three arches are decorated in "broken stick" or zig-zag patterns. Their springers are set on the abaci of two sculpted capitals common to the three arches at the center, and in the angles of the buttresses for the blind arches. The four capitals still exist, although the one on the north is badly damaged. Since the colonnettes have disappeared and no trace of them remains on the walls, I think they must have been en *délit* shafts.

The blind arches have only a single band of zig-zag decoration, whereas the portal, in addition to its archivolt similarly decorated with zig-zags, has three (Fig. 5): the lowest arch is sculpted with a twisted rope, torus, and cavetto; the middle arch with two right-angled moldings flanking a groove (which rests on a concave molding where it meets the capital below); the outer arch has a torus.

Each of these voussoirs rests on an impost block above the capital and originally extended to the ground by means of a shaft set en *délit* and a base. Today the colonnettes have disappeared. The profile of the imposts consists of a simple band, groove, listel, torus, and listel. The capital is composed of an abacus, an echinus, and an astragal; the profile of the bases is a scotia between two listels and a quarter-round molding. They have spurs at the angles (Fig. 6).

At the upper level, the façade is pierced with three round-arched windows. Their interior dimensions are 2.10 by 0.70 meters. The embrasures are widely

splayed and they are ornamented with double voussoirs resting on colonnettes. The inner voussoir of the central window is decorated with a row of concentric ovals, and the outer voussoir with a torus banded with groups of three rings (Fig. 7). In the two flanking windows, the lower voussoirs are decorated with a row of semi-circles centered in cavetti, while the upper one is ornamented with a triple row of billets. These voussoirs rest on abaci which extend into imposts that connect the three bays. The abaci have the same profile as those of the portal capitals. They rest on colonnettes set *en délit* on the interior and engaged on the exterior. Decoration of the portal and window capitals is simple and in low relief, composed of water-leaf patterns (some veined), flat leaves terminated by a small corner crocket, volutes of interlaced ribbons, crossed crockets framing a sort of fruit, interlaced fillets with curves and counter-curves, highly stylized palm fronds, and stylized leaves in scales.

The façade of the church of Haute-Seille remains most interesting in spite of the mutilations it has suffered.

Reconstruction of the Façade

Originally the façade of the church of Haute-Seille had a three-storey central section. I found two texts in the departmental archives of Meurthe-et-Moselle attesting to the presence of a rose window in the façade. One text, from 1774, mentions payment "au vitrier et au serrurier...de 15 livres de France pour avoir fait un ferement neuf et deux panneaux de vitre a la rose du portail de l'église".[8] The other text, dated 1777, describes "...payement de 46 sols pour le raccommodage des six petites fenetres du portail de l'église".[9] At present, five windows exist: the triplet windows and the two oculi. The sixth window mentioned in this text was most likely a rose which would be placed logically in the gable above the triplet windows. On the inside wall of the façade, a stringcourse marks the level of the springing of the vaults above the triplet windows. The rose must therefore have been encompassed by the lunette of the vault.

What were the dimensions of the rose and at what height was it situated? In the départmental archives of the Meurthe-et-Moselle[10] there is a sketch for the reconstruction of the façade of the church of Haute-Seille dated 1735 (Fig. 8). It shows that a classic style of façade was to have been applied to the original façade, as often happened in the eighteenth century.

From the measurements and proportions of this drawing, for which the scale is given in "toises de France", the central part of the modern façade would have covered the entire original one, yet conserving four openings: the principal portal, two oculi transformed into windows, and the rose lighting the lunette of the vault. The triplet windows would have been covered over by the pediment of the new doorway.

In transposing the scale of the eighteenth century drawing, I noticed that the openings of the central portal and the oculi were superimposed on the original ones. One can then conclude that the eighteenth century project kept the original dimensions for the modern openings. Thus the interior diameter of the principal rose would have been about 2.30 meters, and its position on the façade 13 meters above present ground level.

The façade of the abbey church of Haute-Seille was therefore divided vertically into three sections. The outer portions corresponded to the aisles on two levels: blind arcades below, pierced oculi above. The central part had three stories separated by moldings: the levels of the portal, the triplet windows, and the rose window (Fig. 9).

In drawing the façade of the church, I noticed that a certain number of important points are located at the points of intersection of several geometric figures (Fig. 10). For example, if one takes the middle of the nave façade as center, at the upper level of the chamfer, the semi-circle of ray OA (middle of portal to inner buttress) is tangent to the lower part of the stringcourse separating the ground level from the middle level; the semi-circle of ray OB (center of portal to outside buttress) is tangent to the lower part of the stringcourse separating the level of the triplet windows from that of the rose; the semi-circle of ray OC (middle of portal to exterior dimension of transept) is tangent to the upper part of the rose. The semi-circles of rays AA' and A'A cut each other at O' at the center of the upper voussoir of the central window of the triplet. The semi-circle of ray A'E cuts the circle of ray A'A or AD at b, and the distance of Ab is equal to A'A. These are two sides of a pentagon of which A', A and b are apices. If one constructs a pentagon with A'A as a side, a circumscribing circle, an inscribed square, and different figures derived from them, one obtains the principal lines of construction of the façade, and even certain dimensions of the ground plan of the church. For example, half of the square inscribed in the circle circumscribed about the pentagon of side A'A is equal

to a bay of the nave. It is known that the principles
"ad pentagonum" and "ad quadratum" always lead,
if accurately applied, to the proportions of the golden
mean.[11] It would be particularly interesting to test
them on the façade of Haute-Seille.[12]

Dating the Façade

A charter given by the bishop of Toul, Pierre
de Brixey, to the abbey of Haute-Seille, states specifically
that he consecrated the church and its altars. The
charter is dated 1176,[13] but the date of consecration
of a church does not necessarily mean that it was
completed by that date; we must examine the evidence
further. If one compares the façade of Haute-Seille,
the sculpture, and the molding profiles to those of
other buildings in the Lorraine, one notices that Haute-
Seille is similar to two churches in Saint-Dié: Notre-
Dame, and the cathedral, of which the date of construction
is known to have been 1162. The façade of Haute-Seille
can also be compared to the eastern part of the cathedral
of Verdun, which has a similar composition of triplet
windows and a buttress flanked by two colonnettes.
The portal of Haute-Seille can equally be compared
with the Lion portal of Verdum cathedral, dating about
1162,[14] which has *en délit* shafts and where the profiles
of the imposts and the abaci are similar to those of
Haute-Seille. The construction of the façade of Haute-
Seille seems therefore to be datable approximately around
1162. By 1176, the date of consecration, the entire
church was probably completed, including the façade.
The church of Haute-Seille would thus have been entirely
constructed in about thirty-six years (1140–1176), which
is about average for the abbey churches of the Lorraine.[15]

Originality of Haute-Seille

The abbey church of Haute-Seille has, in plan
(Fig. 2), the characteristic simplicity of a large number
of cistercian churches of the second half of the twelfth
century; but it is distinguished from them by the decora-
tion of the façade (Fig. 9), which is, in the words
of an archeologist of the Vosges at the beginning of
this century, "la façade romane la plus somptueusement
décorée qui subsiste sur le sol lorrain".[16] The remark
needs modification: while it is true that Haute-Seille
has the only façade in the Lorraine with five arches
occupying the entire width of the façade on its lower
level, nevertheless its capitals are less refined and
more austere than those of other churches in this region.

How do we explain this decoration which seems to conform but little to the cistercian spirit? We know that about 1150 the Chapter General promulgated laws on the subject of decoration.[17] The date of construction might explain the decoration, because we know that after Bernard's death the Cistercians often took liberties with the austerity he preached. The decoration mighty also be explained by the fact that, contrary to tradition, the church of Haute–Seille was not only an abbey church but also a parish church. In fact, at the founding of the abbey, the parish of Tanconville had been transferred to Haute–Seille,[18] and a rood–screen was built in the church. One notes its destruction in the modern period, when it was called a "muraille".[19]

Does the façade of Haute–Seille conform to models existing in the Lorraine? All the abbeys close to Haute–Seille have been destroyed, and we do not know the designs of their façades. In the Lorraine, there are only two churches whose façades are, if not comparable to Haute–Seille, at least similar to it in decoration: the premonstratensian church of Sainte–Marie–au–Bois, and the former benedictine priory of Laitre–sous–Amance. They both have blind arches framing the main portal and, at Sainte–Marie–au–Bois, a triple arcade above and an oculus. The latter is not, however, in the gable, but in the middle story. In the gable at roof level a very small oculus pierces the wall. This arrangement can be explained by the difference in structure, for Sainte–Marie–au–Bois is not vaulted, but has a wooden roof.

Blind arches of the type found at Haute–Seille may be seen on the bell towers of the churches of Sainte–Marie in Saint–Dié, Saint–Michel in Saint–Mihel, Forcelles Saint–Gorgon, on the ground floor at Varangéville, and on the façade of Sainte–Foy de Sélestat (located in Alsace, but with Lorraine influence). Triplet windows pierce the east wall of the chapel of Sainte–Catherine de Villers–Bettnach, and of the church of Bonneval.[20]

Rose windows, comparable to the rose in the gable of the façade of Haute–Seille, penetrate the gables of the façades of the churches of Mont–Saint–Martin and of Liverdun,[21] as well as of Beaupré.[22] In addition, the cistercian façades of Wörschweiller and Otterberg, built at the beginning of the thirteenth century, have only two levels, that of the portal and that of the rose.

The façade of the church of Haute–Seille is thus unique in Lorraine, and its subtle sculpted decoration reinforces the architectural design of the whole. The

decoration is more important on the central section of the façade than on the sides, undoubtedly because the central portal leads to the most sacred part of the church: the choir and the sanctuary. The division of the façade by two buttresses into three vertical zones is typical of such buildings in the twelfth century, as seen at the church of Fontenay in Burgundy. A triplet surmounted by a rose illuminates the chevet of the church of Bourbonne-les-Bains where one sees the influence of Morimond. The same pattern of wall penetration is evident in the east wall of the chevets of the cistercian churches of Noirlac and Silvacane, in the north and south walls of the transepts of Byland, Fossanova, Kopriznichka, Noirlac, Orval, and Santas Creus, and in the west façades of Fontmorigny, Noirlac, Silvacane, Villelongue, and especially Trois-Fontaines in the Marne.23 This latter façade (Fig. 11) is of much greater dimensions than that of Haute-Seille, but presents the same organization, with three stories: portal, triplet windows, and rose. Father Anselme Dimier dated Trois-Fontaines from 1160-1190;24 it is therefore contemporary with Haute-Seille. The triplet and rose window thus form a traditional cistercian schema for this period-–one that is to be found into the next century as in the façades of Hauterive in Switzerland.

The Origin of Arcaded Façades

Many façades with arcades may be found in the west of France,25 but few in the east. Certain authors think that romanesque architects sought inspiration in sarcophagi or in illuminated manuscripts, where one often finds arcaded decoration.26 This decoration may have been preferred because of its symbolic interpretation: it was the image of a "spiritual reality", of the Domus Dei with its doors, or even the Heavenly Jerusalem with its twelve gates.27 It seems to me that in the use of the triplet one can see the importance of the Trinity, and in the rose, symbol of the Virgin Mary, the particular devotion of the Cistercians to her.

The façade of the church of Haute-Seille marks a moment of equilibrium and plenitude in cistercian romanesque art in the Lorraine. In the thirteenth century the schema employed here will be developed as at Long-pont, but the spirit will never be the same, having passed from the Romanesque to the Gothic.

University of Nancy II
France

NOTES

1. This article is based on a monographic study
of the abbey church of Haute–Seille which will
form part of my doctoral thesis entitled 'L'Archi-
tecture des Cisterciens et des Prémontrés en Lorraine
au moyen–age', University of Nancy, 1983.
2. See map "Morimond et son empire" by Anselme
Dimier, in H. P. Eydoux, *L'Eglise abbatiale de
Morimond* (Rome, 1958) fold–out in back of book.
3. *Histoire de Lorraine,* published with the collabora-
tion of sixteen authors by the Société Lorraine
des Etudes Locales dans l'enseignement public
(Nancy, 1939) p. 208; M. Parisse, *La Lorraine
monastique moyen–âge* (Nancy, 1981) p. 76.
4. For the history of the abbey of Haute–Seille see:
A. Benoit, *L'Abbaye de Haute–Seille dans le comté
de Salm* (Saint–Dié, 1897); Dom A. Calmet, *Histoire
ecclésiastique et civile de Lorraine* (Nancy, 1728)
1:col. 1038; 2 col. 566, 394, 397, 349, 366, 364,
392; *Gallia christiana nova,* (1874) 13:col. 1372–
1374, Instrumenta col. 517–520; Janauschek (Vienna,
1877) 1:60; Ed. de Martinprey de Romécourt, *L'Abbaye
de Haute–Seille* (Nancy, 1887).
5. F. Claudon, "Le Sac de l'abbaye de Haute–Seille
en 1789, relation faite par F. Claudon, religieux
de cette abbaye", published and annotated by
J. Favier, *Journal de la Société d'Archéologie
Lorraine* (1894) 172–190.
6. Plan published by Abbé J. Choux, "Deux plans
d'églises cisterciennes lorraines", *Bulletin de
la Société nationale des antiquaires de France*
(1958) 118–124; reprinted by A. Dimier, *Supplément,
Recueil des plans d'églises cisterciennes* (Grignan,
1967) pl. 122; also by R. Slotta, *Romanische Architek-
tur im lotringischen Département Meurthe et Moselle*
(Bonn, 1976) pl. 43: this plan is incomplete.
Contrary to what these authors affirm in comparing
the church of Haute–Seille to that of Rein in Austria,
the church of Haute–Seille has a projecting tran-
sept, side chapels, and a rectangular chevet
(see my thesis).
7. On the south side the oculus is mostly destroyed;
one must reconstruct it by comparison with the
north oculus.
8. Departmental archives, Meurthe–et–Moselle, H 654.
9. Departmental archives, Meurthe–et–Moselle, H 655.
10. Departmental archives, Meurthe–et–Moselle, H 655.
11. F. M. Lund, *Ad Quadratum* (Paris, 1922) p. 201.

48 *Cistercian Art and Architecture*

. At the present state of my research, I cannot
affirm this positively, but it seems that the prin-
cipal points and lines of the façade construction
were not located empirically, but on geometric
designs: squares, triangles, pentagons, circles.
On harmonic design see H. Spiess, *Mass und Regel*
(Heidelberg, 1959), a study on the laying-out
of the cistercian church of Eberbach; W. Tschesch-
ner, "Die Anwendung der Quadratur und der Triangu-
latur bei des Grundrissgestaltung der Zisterzienserkir-
chen Ostlich der Elbe", *Analecta Cisterciensia*
22 (1966) 96–140; P. V. Naredi-Rainer, *Architecktur
und Harmonie* (Cologne, 1982) 100–201.

13. Departmental archives, Meurthe–et–Moselle, H 542;
Gallia christiana 13: Instrumenta cols. 517–520.

14. H. G. Marschall, *Die Kathedrale von Verdun*,
Veröffentlichungen des Institut für Landeskunde
im Saarland, 32 (Saarbrücken, 1982) 123.

15. I found the lengths of construction more or less
equal for other abbey churches in the Lorraine,
whether Cistercian, Premonstratensian, Benedictine,
or Augustinian canons.

16. G. Durand, "Les Eglises romanes des Vosges",
Supplément à la Revue de l'Art Chrétien 2 (1913)
100.

17. A. Dimier, *Les Moines batisseurs* (Paris, 1964)
p. 89.

18. Departmental archives, Meurthe–et–Moselle, H 574.

19. Departmental archives, Meurthe–et–Moselle, H 574.

20. The cistercian abbey Villers–Bettnach is located
in the département of the Moselle; Bonneval,
an abbey of regular canons, is situated in the
départment of Vosges.

21. M. Steger, "L'Eglise de Liverdun", unpublished
Master's thesis, University of Nancy II, p. 87;
the church was constructed between 1176 and
1183.

22. M. Steger, "Essai de restitution de l'église de
l'abbaye de Beaupré", *Mélanges à la mémoire
du Père Anselme Dimier* B. Chauvin, ed. (Arbois,
1982) III, 6:723, fig. 564.

23. The department of the Marne is contiguous with
that of the Meuse in Lorraine.

24. A. Dimier, "L'Abbaye de Trois–Fontaines", *Bulletin
monumental* (1965) 103–116.

25. J. Gardelles, "L'Abbaye cistercienne de Faise
(Gironde)", *Bulletin monumental* (1983) 9, shows
a drawing of the ruins of the façade of the church
in 1853, an arcaded façade. See also the façade

of Cadouin, mother abbey of Faise: F. Van der Meer, *Atlas de l'ordre cistercien* (Paris, 1965) fig. 66.

26. P. Héliot, "Observations sur les façades décorées d'arcatures aveugles", *Bulletin de la Société des Antiquaires de l'ouest* (1958) 367–399 and 419–458.

27. J. Gardelles, "Recherches sur les origines des façades a d'arcatures aveugles", *Bulletin monumental* (1978) 113–133.

Translation by A. M. Miller and Terryl Kinder.

This study was presented at the Conference on Cistercian Studies, Eighteenth International Congress on Medieval Studies, Kalamazoo, in May 1983.

ABBEY DORE: ENGLISH VERSUS FRENCH DESIGN
Carolyn Marino Malone

The transept at Abbey Dore, located a few miles
from the Welsh border, is the most extensive
early example of French gothic design that remains
in the west of England.[1] A visitor to the abbey
would assume that the bay–divided transept with its
vertical shafts is later than the nave with its horizontal
arcade of round piers, and he might, consequently,
identify the nave as Romanesque in contrast to the
transept (Figs. 2, 8, 9, 10, 12).[2] Nonetheless, if he
were to decipher the church's intricate sequence of
construction, he would conclude that the nave is actually
later than the transept. As though following the clues
in a mystery, this article attempts to unravel this
sequence of construction in order to make apparent
the original French design for the transept, the successive
changes that altered this design, and the adoption
of English forms in the crossing and nave. With this
explanation in mind, the viewer might then understand
that the English monks and masons at Abbey Dore in
the late–twelfth century had a conservative preference
for traditional English design. Moreover, reinforcements
in the crossing and transepts indicate that they had
little confidence in lightweight French gothic construction.
Structural soundness and a wish to turn back the clock
had long been cistercian values.

In 1147, monks from the French cistercian abbey
of Morimond founded Abbey Dore along an ancient Roman
road in the southern part of present day Herefordshire.[3]
Abbey Dore was its only foundation in England. In
the early 1170's, a large gift of land and the appropria-
tion of a nearby cistercian foundation increased the
abbey's resources.[4] In 1216, King John confirmed Abbey
Dore's possessions and gave the abbey more land.[5]
In 1260, the Bishop of Hereford, Pierre d'Aigueblanche,
granted an indulgence for contributions to the completion
of the abbey.[6] During the episcopate of his successor,
Thomas Cantelupe (1275–82), the church was consecrated.[7]

The twelfth–century church was 250 feet long,
a more ambitious undertaking than Fountains, Kirkstall,
or the nearby foundation of Buildwas. After the abbey
was dissolved in 1536, the church and the monastic
buildings fell into ruin, but the transept and choir
of the church were restored as the parish church in
1633. At the turn of the twentieth century, Roland Paul
excavated in the church and monastic buildings.[8] Although

the nave is almost completely destroyed, Abbey Dore remains the most complete twelfth-century cistercian church in England. Of thirty-eight twelfth-century foundations in the west of England, Abbey Dore and Buildwas are the only extensive survivors.[9]

Although Abbey Dore was founded in 1147, nothing is known of the earliest buildings on the site. The wall between the north transept chapels, and the thick wall behind the arches opening into these chapels, are found in early cistercian buildings such as Fountains, and may indicate that the present design of the transept is a refacing of older walls. But there is nothing to indicate that these chapels are significantly earlier than the 1170's (Figs. 1 and 11).[10] Several building campaigns were required to complete the present church. The beginning of the transepts can be dated to c. 1175, the beginning of the nave to c. 1180, and the extension of the choir with a rectangular ambulatory plan to c. 1190. Vaulting blocks discovered by Roland Paul suggest that the transept and nave were not vaulted until well into the thirteenth century. Only the design and construction of the transepts, nave, and the choir (before its extension) will be considered in this article.

Before the choir was extended, the plan of the church followed the early, simple cistercian cruciform plan with unaisled presbytery of rectangular termination, and square-ended chapels opening off the eastern side of each transept arm. The original plan would have had a choir of two bays, a transept with two square-ended eastern chapels extending from each arm, and an aisled nave of ten bays.[11] In the original plan the choir, as will be explained, may have opened into the chapels as they do in the present plan (Fig. 1). Moreover, the chapels of the south transept probably communicated with only an arch between them.[12] These observations have not been made before and will be explained later. This arrangement exists at Fontenay and Pontigny, and also occurs at Thennenbach and Werschweiler, which were twelfth-century German foundations of Morimond.[13]

The transept at Abbey Dore is the first design in the west of England that can be considered Gothic.[14] At the same time that Gothic was adopted at Canterbury, the transept at Abbey Dore introduced an independent version of Gothic to the west. At first glance, the transept of Abbey Dore appears to be a French design transported to English soil. The transept of Abbey Dore, like Roche in the north of England, represents the impact of French gothic vaulting and bay division

on the bayless tradition of first English cistercian
architecture. The high vaults of the transepts and
nave no longer remain at Abbey Dore, but evidence
of French vault construction still exists in the vaults
of the south transept chapels (Fig. 13). In the chapter
house at Buildwas c. 1170, the Anglo–Norman system
of rib vaulting (i.e. the shape of the vault resembles
the aisle vaults of Kirkstall) is used in conjunction
with the cistercian system of corbels. But at Abbey
Dore, French influence stands behind the use of diagonally
placed responds and the semi–circular curve of the
diagonals in the construction of the rib vaults.[15]
 In the transept of Abbey Dore, relatively thin
walls of about four feet are divided into bays with
strongly projecting groups of five shafts (Fig. 12).
These five–shaft groups are the extreme extension of
the principle of strongly projecting shafts to support
a thin wall and rib–vault which began at Saint–Etienne
at Beauvais in the 1120's. A tendency to extreme
accentuation of the bay with five–shaft groups is found
in France after 1160. Five–shaft groups are used in
two–story, French elevations similar to Abbey Dore
in the Vexin at Chars c. 1165–70 (Val d'Oise), or transport-
ed to eastern Normandy in the related building of Le
Bourg–Dun c. 1170 (Seine–Maritime).[16] Five–shaft groups
in two–story elevations are used frequently in the Aisne
and Oise in the late–twelfth and early–thirteenth centur-
ies.[17]
 Abbey Dore seems particularly close in design
to Le Bourg–Dun (Fig. 19). It is as if Le Bourg–Dun,
on the coast of France, had relayed the bay–divided
two–story elevation and five–shaft group of the French
series across the channel and to the west of England.
The system of linkage at Abbey Dore, as at Le Bourg–
Dun, is rigorously applied with functional linkage
of the three central shafts to the three vaulting ribs,
and of the outer shafts to the wall ribs. Chars is
quite different since the wall–rib is separate and support-
ed on corbels. Moreover, the five shafts support only
the three ribs of the vault. On the other hand, at
Le Bourg–Dun, the three central shafts form more of
a unit than at Chars, and the three shafts are placed
against a pilaster as at Abbey Dore, giving a similar
section to the five–shaft group in both buildings.[18]
The articulation of the two–story elevation at Abbey
Dore, as an arcade with arches in two orders separated
from deeply splayed windows by a string–course, also
recalls that of Le Bourg–Dun. This would be especially
close if the string–course at Dore were originally lower,

at the level of the crossing capitals, as we shall see may have been the case in the original design. Other similarities can also be found. The earliest profile that occurs in the bases of the crossing pier at Abbey Dore is almost identical to the Attic bases of Le Bourg-Dun (Figs. 3 and 4; see also figs 17b and 14b, which is base 2 in Fig. 3).

The use of simple, thin profiles in the arches of the south transept chapels also derives from French sources like Le Bourg-Dun. In the south transept at Abbey Dore, the flat soffit with angle-rolls used for the inner order of arch, the profile of the abacus, and the acanthus design of the capitals of this arch, are all found at Le Bourg-Dun (suggesting a similar French source if not Le Bourg-Dun itself) (Figs. 14a, 15a, 15b).[19] The quirked roll used in the orders of arch of the south transept, and the ogee keel used in the five-shaft group, are similar to details found in the southwest tower at Chartres and in other buildings connected to the St. Martin-des-Champs workshop in the Ile-de-France or Soissonnais.[20] The hood-mold used at Abbey Dore that appears in England as early as Saxon times at Deerhurst, is then adopted in Normandy c. 1100–1110 (Graville), then in northern France (Saint-Germer, Noyon choir).

The projection of the five-shaft group as a rectangular block at Abbey Dore, however, particularly resembles the strongly projecting block of vaulting shafts used in the choir at Sens. The rectangular massing of the shafts at Abbey Dore is most similar to the pilasters of shafts used in the hemicycle at Sens (Figs. 12 and 20). In both buildings this massing gives an undulating profile to the base supporting the shafts (Fig. 16b). Other features of the first design at Abbey Dore connect it with buildings other than Sens that were part of the early French Gothic architectural style. The semi-octagonal pilaster found in the crossing piers and at the entrance to the transept chapels, for example, is found in a group of buildings in the Ile-de-France which derive from the second workshop at Saint-Denis (Fig. 12).[21]

It is likely that Abbey Dore derives from a northern cistercian architectural style which, in the second half of the twelfth century, turned from Burgundy to the Ile-de-France for inspiration. This northern cistercian style has now vanished but could perhaps someday be reconstructed by a careful survey of peripheral cistercian buildings, like Abbey Dore, that it influenced. The abundant use of *congés* at Abbey Dore may derive

from lost French cistercian sources (Figs. 15a and
15b) *Congés* are prevalent in Burgundian buildings,
such as the cistercian chapter house at Fontenay of
the 50's. They are then used in related burgundian
buildings, like Montréal and the chapter house and
later choir as Vézelay. An unusual *congé* (shaped like
a base similar to that used at the entrance to the
south chapel of the south transept at Dore) is also
found in the Champenois building of Pogny, which might
suggest that such a *congé* was found in northern French
cistercian buildings (Fig. 15b).

The semi-octagonal abacus used in the five-shaft
group at Abbey Dore may also derive from a northern
French cistercian source (Fig. 16a). There was a tendency
in cistercian chapter houses, like that of Fontenay
c. 1150, to use this abacus for responds. The semi-
octagonal abacus is used for a complex respond for
the first time in England in the choir and later in
the chapter house at Buildwas c. 1165 (Fig. 21, respond
at back of photo). It is also used in the parlor at
Fountains between 1170 and 1179. Both of these examples
probably derive from a French cistercian source.[22]
The shape of the abacus at Abbey Dore, however, is
different from Buildwas and seems likely to derive
independently from a French cistercian source. The
form found at Dore is used in the 1170's in the nave
of Notre-Dame in Paris and in the nave of Cambronne,
although it projects more at Abbey Dore. Around 1175
the semi-octagonal abacus is used in the presbytery
at Roche and in the choir aisles at Ripon. It occurs
in a slightly different form in the choir at Canterbury.
All are probably based on northern French sources.

A French cistercian source may also stand behind
the use of the three-shaft group with separate abaci
for triple capitals in the choir of Abbey Dore (Fig.
22).[23] Three-shaft groups made up of separate shafts
supporting three vaulting ribs are exceedingly common
all over northern France. This type originally derives
from a reduction of the three-shaft group with dosseret
found at Saint-Etienne at Beauvais, and is used early
in the choir of St-Martin-des-Champs, and after 1150
in the nave of Cambronne and in the hemicycle of Saint-
Germer de Fly.[24] The triple shafts at Abbey Dore seem,
however, particularly close to the choir at Fécamp
(Fig. 23). The use of separate abaci for the capitals
is normal in French buildings, as at Le Bourg-Dun
(Fig. 19). Consequently, the primary features of the
choir and the south transept at Abbey Dore derive
from French early gothic buildings.

Although the design of the transepts at Abbey Dore is strikingly French, the present design in many ways may represent a modification of an original design which would have been closer to its French sources. Moreover, the following analysis of the sequence of construction at Abbey Dore indicates that, during the course of the work, French features were abandoned and west English features adopted.

There is no document that pinpoints the beginning of the work at Abbey Dore. Only the comparison of its bases and capitals with other dated buildings makes it possible to date the transept and nave. Two types of bases differentiate two phases of construction: one of c. 1175, another c. 1180 (Fig. 3; bases 1 and 6; also Fig. 14b and 17b with 16b). Although the Attic bases at Abbey Dore are closest to Le Bourg-Dun, they also resemble the Attic bases in the west bays at Worcester, which can be dated after the fall of a tower in 1175 (Fig. 4, base 1 and 3 with Fig. 3, base 3).25 The water-holding base (in which the scotia is deeply hollowed) is adopted in France slightly before 1180 and appears in the crypt of the Trinity Chapel in 1179 (Fig. 3, base 6 and base 9, which is Fig. 16b). It may have been imported directly to other English workshops, like that of Lesnes in the Thames estuary, but in most cases it seems linked to Canterbury. Canterbury could be the source at Abbey Dore for the new use of this profile in the bases of the five-shaft groups in the early 80's since the lower roll, as at Canterbury, is more bulging, less flattened, and does not expand as in other French buildings or at Lesnes.

French influences other than that of Canterbury were widespread in England in the 80's, but Canterbury often provides the only datable, as well as the most important, source for the dissemination of French forms. In the case of the crocket capital, Canterbury is the likely source, since crockets appear as early at Canterbury as in France: they appear at Canterbury in 1175 or 1176 in the aisles and triforium of the choir; they appear in the tribunes of Noyon in the late 70's, in the upper part of the choir of Notre-Dame in Paris by 1178, and also at Laon between 1175 and 1180 (Fig. 18a). At Abbey Dore the crocket style of foliage that has trefoils with marked mid-ribs (which does not become important until the Trinity Chapel at Canterbury) is introduced along with earlier forms (Fig. 18b).26 By the 80's this type of foliage had begun to spread to Oxford, right in the center of England, and to the north where it is used at Selby. Along with the trefoil

leaf, a motif not found at Canterbury appears at Abbey
Dore. This motif can be characterized as ball ornament
enclosed by leaves (Fig. 17a). In the 80's it can be
found in many areas of England (in the southeast in
the Lady Chapel at Chichester, as well as in the north
at Selby, Worksop, Oxford, and in the choir at Byland).
This capital motif can be found in France around the
same time in buildings, like Fontenay-les-Louvres
c. 1180, where it may reflect parisian influence. Canter-
bury was the largest workshop in England and very
up-to-date in its use of French designs; it may often
have transmitted modern French forms not used at Canter-
bury. Consequently, it is difficult to know whether
cistercian importation is behind forms like the ball
ornament enclosed by leaves (since it is used in many
cistercian-influenced buildings in the early 80's), or
if pattern books from Canterbury provided the motif.

At Abbey Dore the location of Attic bases (datable
to c. 1175) and water-holding bases (datable to c.
1180) provides the first clue to the sequence of construc-
tion in the transept. A comparison of the base profiles
of the transept indicate that the crossing piers were
cut first (Fig. 3, base 2 which is Fig. 14b; see also
Fig. 17b). The crossing piers have semi-octagonal chamfer-
ed pilasters on the axes, with round shafts between
them facing into the crossing, and rectangular block-
like extensions with curved corners, abutting the walls
(Figs. 12, 22, 24, 25, 26, 27, 28). These pilasters
and shafts have sloping Attic bases with long necks
and the rectangular extensions are finished with a
congé at the corner. All the bases of the crossing piers,
except the northeast pier, have spurs (Fig. 17b). The
lack of spurs on the bases of the northeast pier, and
its formal and spatial proximity to the semi-octagonal
shafts of the north transept, indicate that the northeast
crossing pier base was the last of the crossing bases
to be cut (Fig. 14b). The bases of the semi-octagonal
shafts, in the entrance to the north transept chapels,
indicate that they were cut after the northeast crossing
pier, but before the five-shaft groups of both transepts,
and before the semi-octagonal shafts in the south transept;
they still have sloping Attic bases but no spurs (Fig.
3; bases 2 and 4; also bases 4 and 7-10). On the other
hand, the five-shaft groups and the semi-octagonal
shafts of the south transept chapels are water-holding,
with a deep hollowing-out between the neck and the
lower roll (which is now rounded and no longer sloping).
This form is clearly later in date than the sloping

Attic base (Fig. 3, bases 6–10; Fig. 16b is base 9). The profiles of the five-shaft groups of the north transept are the earliest of the water-holding bases at Dore (Fig. 3, base 10). The five-shaft group on the west side of the north transept has spurs, a feature used here for the last time at Dore. The presence of the spur might indicate that this five-shaft group was cut soon after the western piers of the crossing. The five-shaft base on the west side of the south transept follows those of the north transept in the sequence of water-holding bases at Abbey Dore (Fig. 3, base 8). Comparison of profiles might indicate the following sequence: five-shaft group on the east side of the south transept (Fig. 3, base 7), semi-octagonal shafts in the entrance to the south transept chapels (Fig. 3, base 6), three-shaft groups in the choir (Fig. 3, base 11), and finally the nave piers (Fig. 3, base 12).

Hence, comparison of the bases at Abbey Dore has established the order of construction of the lower part of the walls. The bases of the north transept may have been cut before those of the south transept because they were merely part of a refacing of older walls or because here it was necessary to complete, up to a certain height, the walls that abutted the eastern range of the cloister, located to the north of the church (Fig. 1). If the eastern range was not already built, it was probably under construction. Next the south transept was laid out, then the present walls of the choir, and finally the east piers of the nave were built.

The order of the upper parts of the transept is not the same as the order of construction of the lower walls of the church that was indicated by the sequence of bases. The oldest type of foliage at Abbey Dore consists of volute and acanthus designs and is found in the following capitals: the two eastern piers of the crossing, the semi-octagonal shafts (Fig. 14a), the semi-octagonal shafts of the south transept (Fig. 15a), the diagonally placed responds of the south transept chapels, the southeast pier of the nave, and the later extension of the south choir aisle. This type of foliage is contemporaneous in design with the sloping Attic base, and the early examples at Abbey Dore can probably be dated c. 1175.[27] Because the earliest version at Abbey Dore occurs in the east crossing capitals, and in lower parts of the south wall of the transept, these structures were probably intended to be built first (Fig. 14a, 15a).

 A later date can be given to the capitals with
plantain and crockets. These crockets are often formed
of trefoil leaves with mid–ribs and are contemporaneous
with the water–holding bases; like them, they probably
date around 1180 (Fig. 18a and 18b). Close similarities
within this group of crocket capitals (Fig. 18b) at
Abbey Dore suggest the following chronology: the capitals
of the semi–octagonal shafts in the entrance to the
chapels of the north transept were carved at the same
time as the boss in the vault of the south chapel
of the north transept; the corbels in the north chapel
of the north transept were carved at the same time
as the capitals of the three–shaft groups in the choir
(Fig. 18a).
 These crocket comparisons suggest that the arches
of the north transept were built only when the south
chapels of the south transept were being vaulted. Hence,
the construction of the east wall of the south transept
preceded that of the north transept. Moreover, since
the upper part of the choir was built simultaneously
with the upper parts of the north transept, these compari-
sons confirm that the choir was built after the south
transept, as the bases indicated. Relationships within
this group of crocket capitals also reveal that the
upper part of the west crossing piers are contemporaneous
with the upper parts of the choir and the north transept,
and that the capital of the five–shaft group on the
west side of the south transept was carved at the same
time as the west crossing capitals (Fig. 17a). The
capitals of the other three five–shaft groups consist
of trumpets with scallops (Fig. 16a); consequently,
this motif must have come to Dore at about the same
time as the crocket capital.[28] At Abbey Dore the trumpet
capital, like the trefoil leaf with mid–rib, continued
to be used frequently in the piers of the nave, the
vaulting corbels of the transepts, and finally the choir
extension. The acanthus and volute patterns were also
sometimes copied in the choir extension, but are not
as prevalent.

 Molding profiles confirm, for the upper parts
of the church, the sequence suggested by the foliage
styles of the capitals. The north and south (Fig. 22)
walls of the choir are constructed about the same time
as the arches of the south transept chapels (Figs.
28 and 29), since both the plain chamfers and the
quirked roll moldings around the openings of the choir
walls (Fig. 27) are the same as those in the arches
of the south transept. In the vaults of both chapels

of the south transept, and in the north chapel of the north transept, a double roll was used for the ribs; these vaults have no central boss (Fig. 13). A triple roll was adopted for the first time at Abbey Dore in the south chapel of the north transept (Fig. 11). This profile continued to be used, with the addition of a fillet, in the later vaults of the choir extensions. A later date for the use of the triple roll than for the double roll is confirmed by the fact that the boss of the vault with the triple roll has foliage like capitals in the first bay of the later north aisle of the choir extension. The use of the triple soffit-roll, in the entrance arches to the east chapels of the north transept, also indicates that the upper parts of this chapel are later than the upper parts of the south transept chapels (Fig. 10). This later date is reinforced by the abacus profiles of the capitals of the semi-octagonal shafts of the north transept, which are a simplification of those of the south (Fig. 18b). Although the soffit molding of the south chapel of the south transept is retained for the soffit moldings of the south arcade of the nave, the foliage of the northeast pier of the nave has trefoils and the capital of the second pier of the north arcade has trumpets; consequently, the nave piers were not constructed until the arches and chapels of the north transept were begun.

In sum, both foliage and moldings date the design of the south transept as early as the choir, and probably earlier, as the bases suggested. The design of the upper part of the arches of the chapels of the south transept is earlier than that of the north transept, although the sequence of bases indicates that the lower part of the north transept was cut and probably built before that of the south transept (Figs. 10 and 12). Construction of the nave was later than the transepts.

Alterations in the design of the crossing and east wall of the south transept indicate that the original French design was different from the present structure. These additions indicate traditional English forms were adopted even before the nave was begun. These alterations may reflect concerns for stability in a thin-walled and vaulted structure with a crossing tower.

As mentioned earlier, the semi-octagonal pilasters on the axes of the crossing piers indicate French influence. The elongated shape of the western piers, however, is found only in English buildings (Fig. 1). Moreover, the block-like extensions, of about a foot in the eastern

piers (Figs. 24 and 27) but of about three feet in the western piers, (Figs. 25 and 26), create an elongation which does not harmonize with the design and proportions of the rest of the pier. Without these thickenings, the piers would be regularly planned, diagonally planted French crossing piers, and Abbey Dore would have a regular square crossing. Because of these thickenings, the crossing is elongated from east to west, forming a rectangular crossing (sometimes called an oriented crossing) (Fig. 1). Moreover, because of them, the north and south crossing arches are not aligned with the wall–ribs of the north and south walls of the transept.

There are indications in the southeast pier that it was originally planned without these block–like reinforcements, which now abut the south wall of the choir and the east wall of the south transept (Figs. 14a and 27). This is the only pier which does not have carved capitals for these reinforcements, a fact which seems to indicate that the capitals for the southeast pier were cut before the thickening of the pier was planned.[29] The thickening is not coursed with the choir or transept walls that abut it. Although the stones of the semi–octagonal pilaster and the thickening are coursed, there is a break along their joining on the north side of the pier for about two–thirds of its height (Fig. 27). These facts may indicate that the thickening was added to the pier after it was partially built with consequent weakness in the bonding.[30] These changes must have been made primarily to strengthen the support for a crossing tower.[31]

A cistercian decree in 1157 prohibited towers of extravagant height.[32] Nonetheless, during the second half of the twelfth century, low stone single–stage towers were "acceptable" and were built in England. We do not know what was intended or built at Abbey Dore. Certainly, an excessively high tower can be ruled out. It is likely a tower was planned from the beginning since crossing towers had already been added to Fountains, Kirkstall, and Buildwas. Why then were massive thickenings added during the course of construction? Perhaps a local event, in particular the documented collapse of a west tower at Worcester in 1175, stimulated the reinforcements.[33] In fact, the new design of the west bays of Worcester built after 1176 had similar thickenings between the west end of the arcade and the facade, to provide buttressing for the nave arcade since twin towers were absent. Consequently, both buildings used the same structural principle: interior buttressing in the form of projecting massive reinforcements.

At Abbey Dore, thickenings of only a foot were required to the east of the crossing, because here the thickenings were an addition to the choir walls which abutted the crossing piers. Because the choir provided a buttress on the east, it was unnecessary to make the piers project massively into the crossing on the east side. On the other hand, if thickenings had been added to the west of the crossing, they would have disrupted the regular arcading of the nave. Moreover, the massive thickenings of three feet, on the east side of the west pier which extended into the crossing, had the additional advantage of making the north and south crossing arches narrower, consequently, more steeply pointed and, hence, less likely to fail under the load of a crossing tower.

There also seem to have been changes in the design of the east wall of the south transept adjacent to this pier. The outer semi-octagonal pilasters in the openings of the chapels are coursed with the outer walls up to the imposts of the arches (i.e. the north side of the north arch is coursed, and so is the south side of the south arch) (Figs. 28 and 29). On the other hand, the semi-octagonal pilasters on the inner sides of the arches are not coursed with the wall flanking the five-shaft group (i.e. the south side of the north arch and the north side of the south arch are not coursed). This indicates that they were not cut with the wall into which the five-shaft group that supports the vault is bonded. In addition, the moldings of the two orders of the north arch of the south transept are not coursed, while those of the south arch are, indicating additional changes. Both of the arches opening into the chapels of the south transept have been built at a more acute angle than that for which they were cut. This creates awkward juxtapositions of the dog-tooth hood molding, particularly in the apex stones (Figs. 28 and 29).

Since the lower courses of the chapel arches of the north transept were laid out before the lower zone of the south transept, the relationship of the semi-octagonal pilaster and the five-shaft group in the north transept may indicate the original design for the east wall of the south transept, in which signs of rebuilding were observed. In the north transept the pilasters (and hence the arches) abut directly the five-shaft group as in similar French designs, for example at Le Bourg-Dun. Both transepts were probably planned at the outset to be similar. The only difference would have been that since earlier chapel walls already may

have existed in the north transept, merely an outer refacing was built. For this reason, the semi–octagonal shafts in the north transept chapel entrances were placed flush with the outer wall (instead of recessed within the arch as they would have been in a French design); and for this reason, only one order of arch was planned in the north transept while a double order (as is the rule in French design) had been designed for the south transept.

If the south transept had been built with the outer order of the arches directly adjacent to the five–shaft group, the width of the inner span of the arches of the south and north transept would have been the same (Figs. 10 and 12). When a wall was added on each side of the five–shaft group in the south transept, the inner spans of the south transept arches became narrower than those of the north transept.

The construction of wall on each side of the five–shaft group in the south transept, like the thickening of the crossing pier, may indicate English concern for stability in a vaulted structure (Fig. 1). This wall may have seemed important, since a communicating arch, instead of a solid wall perpendicular to the five–shaft group, was planned in the south transept, while in the north transept an earlier solid wall divided the chapels, providing a solid abutment for the five–shaft group (Figs. 11 and 13). Again, a more steeply pointed arch is less likely to be distorted by the load of the vault. Furthermore, additional wall reinforced the pier; greater bulk obviously meant greater stability.

The arch that opens the north chapel of the south transept to the choir is coursed with the responds of the north chapel, indicating that the opening was built simultaneously with the north chapel of the south transept. This regular coursing indicates that the opening was not made later, as Pevsner suggested.[34] Further evidence that the choir was originally planned to open onto this chapel, and that the opening was not pierced later (when the choir extension was added), finds support in comparison of the *congés* at the foot of the north and south arches of this chapel. These *congés* are different from those in the later eastern arch, that was pierced to open the north chapel of the south transept to the new aisle of the choir extension.[35]

It is not possible to know to what extent the original design for the south transept was altered. Certainly, major changes are indicated by the lack of coursing in the southeast pier and in the wall on

each side of the five-shaft group. Moreover, a different molding may have been planned for the outer order of the arch of the north chapel of the south transept. The chamfered impost of both arches in the south transept, like the thickening of the crossing pier, is English and would not be found in a French design.[36] In a French building the quirked roll (which frames the outer order in the south arch of the south transept) would be supported by a shaft, not a chamfer (Fig. 29). In a similar way, the crossing piers in a French building would have had two shafts between the semi-octagonal pilaster and the wall, to take the wall-rib and the diagonal rib of the vault, instead of these thickenings; the five-shaft design makes an awkward combination with the present crossing pier since the wall-rib is differentiated from the ground in the five-shaft group, but is supported on a corbel above the crossing pier and in the upper corner of the transept. In the original French design, diagonally placed shafts, like those in the chapels of the south transept, would have been placed in the corners of the transepts, as well as in the crossing pier, to support the diagonals and wall ribs as do the five-shaft group on the opposite side of the quadripartite vaults. If planned, this design would have been abandoned when the southeast crossing pier was thickened.

It cannot be known whether a change in the level of the vaulting was made when the pier was thickened or only when the upper walls were built. In either case, it is likely that the capitals of the five-shaft group and the piers were originally intended to be at the same height (Fig. 24). The level of the string course on the south wall of the choir is the same height as the crossing capitals and may reflect the intended height for the five-shaft group and string course in the transepts (Fig. 22).

Now to turn to the construction of the north transept. The capitals and soffits of the chapels of the north transept were carved after those of the south transept (Fig. 10). By now, the west English cistercian profile, of a triple roll, had replaced the rectangular format of the French rolls used in the south transept (Figs. 11, 18b). Although triple projecting moldings are also found in twelfth-century France, they were natural to the English practice of cutting the molding from chamfered instead of rectangular blocks.[37] Like the use of the chamfer in the choir openings and in the arches of the south transept, the triple roll probably

reflects English cistercian influence (Figs. 22, 28, 29). Moreover, the crocket capital with trefoils of the 80's was used not only for the capitals but also for corbels to support the vault in the chapels of the north transept (Fig. 11). Corbels might be expected for vaulting these chapels since they can be inserted easily into an earlier wall. Nonetheless, by this time corbels may also have been planned for the high vault in the transepts, and, hence, were also used in the chapels (Fig. 24). These corbels were common in English cistercian buildings. Those used in the high vault at Abbey Dore particularly resemble those in the choir at Buildwas.

Once the east wall of the north and south transepts was constructed, the upper parts of the eastern crossing piers were built. The northeast pier immediately followed the construction of the east wall of the north transept, as would be expected; it is the only pier completely constructed with the smaller size stone used in the east walls of the transept and in the lower part of the southeast crossing pier (Figs. 24, 27). Beginning about two–thirds of the way up in the southeast pier a larger stone is used, and this larger size is used for the upper two–thirds of both western piers, which were constructed simultaneously with the west walls of the transept. The larger stone is then used for the crossing arches (Figs. 24 and 26).

The upper parts of the transept at Abbey Dore were probably not built until the late 80's or early 90's, so the stilting of the wall ribs may even reflect later influences from France via western buildings, like the Lady Chapel and main church at Glastonbury. As was suggested before, the vaulting of the transept may have been planned originally at a lower level (the level of the crossing capitals and string course on the south side of the choir), instead of at the present level of the capitals of the five–shaft group. Such a heightening of the upper parts of the walls in course of construction is possible. At any rate, no corbels were cut to support the vault until the extension of the choir was begun, since they are identical in style to the foliage in the later ambulatory of the choir extension. Moreover, the vaulting ribs found beneath the floor of the transept during the sixteenth–century reconstruction were all apparently thirteenth- century.[38] Obviously, the transept rose very slowly and in several stages.

This analysis of the sequence of construction reveals that the practice of construction at Abbey Dore was: walls built to a certain height, then left waiting

while work went on somewhere else. This is similar to what occurred during construction in other west English buildings, such as St David's or wells. Moreover, the sequence established by this investigation indicates that a French design was progressively altered with English features. These alterations in part must have resulted from questions of stability. The wall on each side of the five-shaft group supported not only the vaults of the chapels but also the upper part of the wall; hence, this wall also would have reinforced the transverse arch between the quadripartite vaults of the south transept. when the thickenings were added to the crossing piers, it was possible also to increase the width of the crossing arches, providing additional support for the crossing tower (Fig. 2).[39]

Progressive changes in design were made at Abbey Dore. Each alteration departed from the original French design and derived from English traditions. When the wall was extended on each side of the five-shaft group in the south transept, chamfered arches were adopted to frame the French moldings. In the north transept the plastic triple roll was substituted for the thin lines of the French moldings, perhaps, because the triple roll derives naturally from the English way of chamfering the block of stone before it is carved. When the thickenings were added to the crossing piers at Abbey Dore, the transept acquired a traditional English oriented crossing.

Since the eleventh century, the oriented crossing with rectangular, elongated crossing piers had singled out the west from the rest of England (Fig. 5). This feature began at Tewkesbury and was soon used at Hereford, Chester, Shrewsbury, and Gloucester.[40] The pier sections at Abbey Dore are similar to those at Gloucester, Hereford, and Leominster. The later crossing of Llanthony Abbey, just across the Monmouth border from Dore, particularly resembles Abbey Dore's thickened, rectangular crossing and probably was influenced by it.[41]

The nave with its round piers in a bayless, horizontal arcade, in particular, returns to English traditions. Even in details, like the trumpet capital and the use of corbels for vaulting, its design is linked to English cistercian influences, possibly Buildwas in particular, where the trumpet capital may have been invented.[42] Certainly, a western cistercian tradition stands behind the major features of the nave design.

Since the eleventh century, the cylindrical pier had delimited a west English romanesque architectural area (Fig. 6). Lotharingian presence in the west stimulat-

ed the use of the burgundian cylindrical pier with circular imposts, instead of the compound pier which was used in orthodox Norman buildings in the east and north of England.[43] By the 1160's the cylindrical pier had spread from the west to the southeast, but all the earliest, and most impressive, of the cylindrical piers are concentrated in the west. Large cylindrical piers also characterize English cistercian architecture at Fountains and Buildwas.

Moreover, a horizontal emphasis, that can be called an anti-bay tendency, also appeared in the west at the end of the eleventh century in the choir at Gloucester and in the nave at Tewkesbury (Fig. 7). This anti-bay tendency is particularly characteristic of late eleventh and early twelfth-century buildings in the west and differentiates it from the rest of England.[44] Since the 1130's, the Cistercians reinforced this resistance to bay division, particularly in the north and west of England, where their foundations were more numerous. In the earliest phase of continental cistercian architecture, whether vaulted as at Bonmont c. 1131, or unvaulted as at Boquen or Clermont in west France, the rejection of bay division served to fulfill the wish to turn back and revive archaic forms. This early cistercian principle appeared in England in the nave at Rievaulx and continued to be used in buildings of the north such as Fountains, Kirkstall, and Furness, and also appeared in the west at Buildwas in the 50's. This cistercian anti-bay tradition merges in the west with the late eleventh-century romanesque bayless tradition in the design of the nave of Abbey Dore (Figs. 8 and 9). It is then used by the so-called "West English Gothic School of Masons" at Llanthony, St David's, and even Wells. In all these gothic buildings bay division is restricted to the upper zone of the elevation, as it was earlier during the 1120's in the nave of Gloucester.

It is possible that Abbey Dore is the source for these later gothic designs. It may have had an uninterrupted triforium that opened into the space above the aisle vault, similar to that which remains at Llanthony, although at Abbey Dore there would have been only one triforium opening, in the manner of Les Vaux-de-Cernay.[45] As at Llanthony, it may have been framed by a chamfered order that linked the triforium and clerestory (Figs. 2 and 9). If this hypothesis is correct, triple-shaft groups may have divided the upper zone of the elevation at Abbey Dore into bays. But it is also possible that the nave of Abbey Dore had instead

a simple two-story elevation, like that of Buildwas, with a clerestory and no bay division.[46]

 The nave of Buildwas was still being constructed in the 80's and must have seemed a valid alternative to the monks at Abbey Dore. Possibly, like the monks at Canterbury, they requested changes in the architect's original design for Abbey Dore since even the south transept seems a modified version of any French model. English cistercian features, like the chamfered orders of arch in the south transept, indicate that the architect may have been trained, like William the Englishman of Canterbury, in an English cistercian workshop and, like him, knew French architecture fluently.[47] He may have drawn on his English training when asked to stabilize his original design. On the other hand, there may equally well have been a change in architects, or changes in the team of masons as work progressed. The circumstances behind the alterations can never be known. At any rate, French features were eliminated and English cistercian features adopted as work progressed on the crossing piers and in the north transept. Finally, the design of the nave marked a complete return to English traditions.

 As at Roche, but even moreso in the south transept at Abbey Dore, the new gothic revelation was the division of the elevation into bays with thin lines of shafts and the articulation of arches with simple thin profiles. The nave of Abbey Dore, however, negated the message of bay division signaled in the south transept to the "Western School of Masons". If the transept at Abbey Dore stimulated the new gothic designs with bay division and five-shaft groups at Worcester and at Glastonbury, the nave at Abbey Dore indicated to west English archi-tects of Llanthony, St David's, and Wells, that compro-mises were acceptable and that bayless arcades were still a possibility in the 1180's.

University of Southern California

NOTES

The study of French sources and the order of
construction at Abbey Dore discussed in this article
are based on Chapter II of my dissertation "West English
Gothic Architecture 1175–1250", University of California,
Berkeley, 1973. The research for this portion of the
article was financed by the Samuel H. Kress Foundation.
The Courtauld Institute of Art kindly photographed
Abbey Dore for me. A Spears grant from the Department
of Art and Archaeology and a stipend from the Humanities
Committee at Princeton University provided travel funds
for me to complete my study of Abbey Dore and its
English sources. Finally, "Milton" at the University
of Southern California in Los Angeles facilitated writing
the article.

1. J. Bony, "French Influences on the Origins of
English Gothic Architecture", *Journal of the Warburg
and Courtauld Institutes* 12 (1949) 1–15. Bony
was the first to recognize the significance of
Abbey Dore. In my dissertation, pp. 44–59, I
investigated Abbey Dore as the stimulus in the
west of England for a reinterpretation of the
treatment of the wall by the "Western School of
Masons" which was defined by H. Brakspear,
"A West Country School of Masons", *Archaeologia*
81 (1931) 1–18. Brakspear failed to give an ac-
curate interpretation of the western school of
Gothic when he omitted the south transept of Abbey
Dore as a decisive influence that stimulated a
change from romanesque to gothic architecture
in the west.

2. Pevsner, p. 58 makes the eastern bay of the
nave among the earliest portions of the church.

3. Morimond is located in Champagne and is one
of the five original mother houses of the cister-
cian order. Robert Fitz Harold of Ewyas established
Abbey Dore.

4. D. H. Williams, *White Monks in Gwent and the
Border* (Pontypool, 1976) p. 9.

5. W. Dugdale, *Monasticon Anglicanum* (1817–1830,
reprinted 1970) 5: 552–554.

6. T. Blashill, "The Architectural History of Dore
Abbey", *Transactions of the Wolhope Naturalists
Field Club* 17 (1901) 184–188.

7. *Royal Commission* 1:x.

8. R. W. Paul, *Dore Abbey: Herefordshire* (Hereford,
1898); Ibid., "The Church and Monastery of Abbey

Dore" (see n. 1 above); Ibid., "Abbey Dore Church, Herefordshire", *Archaeologia Cambrensis* 82 (1927) 269–275.

9. Insignificant remains exist at Bindon, Bordesley, Cleeve, Coggeshall, Louth Park, Kirkstead, and Stoneleigh.

10. A changed roof line on the exterior of the north chapel indicates changes in the present exterior walls. Moreover, the long round–headed lancet framed with a thin continuous roll, in the east wall of this chapel, may be earlier than 1175. It is, however, close to the clerestory windows of the galilee at Durham of 1175, but long lancet-like windows occur as early as St Anselm's chapel at Canterbury or on the west side of the south transept at Romsey in the 60's, although they remain unusual until 1180. This molding seems slightly later than those in the clerestory of the north transept at Malmesbury, so a date in the early 70's seems possible, but it could be as late as 1180. The door leading from the cloister into the north transept is also round–headed and could be earlier.

11. R. Paul published nine bays in 1898 and 1904; he then excavated a tenth bay which he published in *Archaeologia Cambrensis,* p. 270.

12. Pevsner, p. 59 believed that there were walls between the choir and chapels and also walls between the chapels of the south transept, in the original plan. He believed the present openings were built when the choir extension was added.

13. See A. Dimier, *Recueil de plans d'églises cisterciennes* (Paris, 1949) 2.

14. Worcester is the only extant building which could compete with Abbey Dore as the first gothic design in the west, but Abbey Dore seems more directly related to French sources.

15. The double roll used in these vaults could also reflect French influence.

16. Bony, p. 11.

17. Examples are found at Coulonges (Aisne, c. 1180), Montigny l'Allier (Aisne, late twelfth century), Veuilly-la-Poterie (Aisne, c. 1200), Mouy (Oise, early thirteenth century), and Mareuil-sur-Ourcq (Oise, early thirteenth century).

18. In a French building, the three central shafts of a five–shaft group would be separate and not compactly grouped as a unit of three. The tendency to distinguish the three–shaft groups as a compact

unit at Abbey Dore and Worcester might suggest an influence from three-shaft groups that were currently being used in cistercian designs (for example the group in the vestibule of the chapter house at Kirkstall is quite similar to Abbey Dore). A measured drawing of this shaft group can be found in the British Library, Add. MS 36402. As at Kirkstall, the three central shafts at Abbey Dore are nearly aligned and contained within the plane, while at Worcester the three central shafts form a triangular mass. Consequently, the central shafts at Worcester depart more than those at Abbey Dore from the French five-shaft group in which the shafts are separate. A further modification has occurred at Worcester: even the wall rib shafts are no longer separate as in French designs but have merged with the pilaster-backing of the central shaft found at Abbey Dore and have been flattened in the manner of those in the nave at Gloucester. Abbey Dore is closer to the French sources of the five-shaft group; Worcester seems a further modification of the French principle of design.

19. The flat soffit is also found at Chars, Sens, and Fécamp. This type of abacus also occurs at Fécamp and Noyon.

20. The ogee keel is found in the wall rib at Chartres. J. Bony pointed out this French source. In the vestibule of the chapter house at Kirkstall of c. 1160 the three-shaft group also has a central keeled shaft with an ogee curve.

21. Examples of the semi-octagonal pilaster in this second workshop are found in the design of a pier in the choir crypt and in an exterior wall buttress of the choir of Saint-Denis. The semi-octagonal pilaster used as a wall buttress also occurs at Sens Cathedral, Saint-Germain-des-Prés choir, and c. 1170 at Domont near Paris.

22. Nonetheless, the semi-octagonal abacus at Buildwas had related English precedents in the octagonal abaci used with circular piers at Durham, Dumferm-line, and (with clustered piers throughout the nave) at Kirkstall. The semi-octagonal abacus may have been especially popular in English cistercian buildings. Cistercian influence might stand behind its use when it is used in conjunction with the three-shaft group as in the choir at Chichester.

23. The semi-octagonal abacus, in contrast to the

use of separate abaci for triple capitals, probably cannot be used as a precise tool to date parts of buildings. At Dore the more precise tool of the bases indicates that the separate abaci used in the choir are probably no earlier than the semi–octagonal abacus used in the transept. The crocket capitals of the choir also closely resemble capitals at Fontenay–en–Parisis (Val d'Oise) which date in the early 80's.

24. Three–shaft groups of a different type had been used in the choir at Saint–Cross, Winchester in 1171 as vaulting shafts. The merging type of Saint–Cross, which Bony has called trefoiled engaged columns of trefoiled shafts, can be traced back to the narthex of Saint–Denis, the east bays at Poissy, Noel–Saint–Martin, Chateau–Landon, Souppes and Vermenton; they then are used in buildings related to Saint–Cross like Easton in the southeast of England. As at Poissy, all three rolls support a single order of arch at Saint–Cross. Three–shaft groups had been used in the north and south door of the nave at Kirkstall to support an inner order of arch. This was also the case in English romanesque doors like the gate tower of Bury Saint–Edmund's. But no cistercian example of a three–shaft group that links the vault to the floor in a functional way is known to me in England which is definitely earlier than the choir of Abbey Dore. A lost contemporary or possibly earlier English cistercian source might be suggested by the three–shaft vaulting shafts which are articulated from the floor in the transept at Ripon in the later 70's. C. Wilson has recently pointed out three–shaft groups in the west of England in the Victorine houses of Keynsham and Wigmore. Although the three–shaft groups in these buildings have Attic bases and are clearly related to Worcester, they may not be relevant to Abbey Dore. The triangular projection and compactness of the massing in the shaft groups of each are close to Worcester but not to Abbey Dore. C. Wilson, "The Sources of the Late Twelfth Century Work at Worcester Cathedral", *Medieval Art and Architecture at Worcester Cathedral,* Transactions of the British Archaeological Association I (1978) pp. 83, 86.

 The massing of the three–shaft group in the choir at Abbey Dore is similar to Fécamp choir, while the three shafts of the five–shaft groups

in the transept are closer to the Kirkstall chapter house. Moreover, at Abbey Dore the central roll of the three-shaft group in the choir is still slightly larger than the side rolls, as is the case in French buildings, like Fécamp, Cambronne, and Saint-Germer. At Chichester and New Shoreham, the shafts have all become the same size, with the central shaft keeled. The same is true of the three-shaft group at Worcester. If there is not an English cistercian or Soissonais source behind the buildings of the southeast, they may also be related to French coastal buildings, like Fécamp. Fécamp was the mother house of Steyning in the southeast and also seems to have been influential at Saint-Cross, Winchester: the acanthus foliage used in the capital that is continued as an impost across the intrados of the aisle entrances at Saint-Cross is almost identical to that used in the same location at Fécamp.

25. Wilson, pp. 80–81.
26. The cutting off of the corners of the abacus, in the capitals of the north transept at Abbey Dore in which the trefoil leaf occurs, may also be a Canterbury influence.
27. The similarity of the volute capital, in the earlier capitals of the south transept at Abbey Dore, to the volutes outlined with beaded borders at Saint-Cross, Winchester, also suggests a date in the mid-70's.
28. The source of the trumpet capital is probably Buildwas where it was being used in the 70's and 80's. The trumpet capitals at Hampnett (Gloucestershire) are probably no earlier.
29. The only other possibility is that the terminations of the pier reinforcements of the southeast pier may be restorations, like the carved capital of the southwest pier. The restorer, however, would probably have carved a capital here as in the west pier, if an original had existed.
30. If this break had resulted from the sixteenth-century construction of the tower which is above the south aisle, a disruption would be expected in the upper part of the pier (this assumes that the upper part of the pier was not rebuilt). Nonetheless, it seems that the upper part of the pier has not been rebuilt. It is constructed of larger blocks than is the lower two-thirds of the pier, but this change in size seems to have occurred during the twelfth-century construction since the

upper two-thirds of the western piers are also constructed of these larger stones.

31. Fergusson lists Abbey Dore along with Buildwas as one of the buildings in which there was a change in design to build a crossing tower, but he mentions no specific alterations to the crossing. He seems to refer to the entire building campaign as the provision for a crossing tower. P. Fergusson, "Early Cistercian Churches in Yorkshire and the Problem of the Cistercian Crossing Tower", *Journal of the Society of Architectural Historians*, 3rd ser. 29 (1970) 218. Although the original plans of Fountains, Kirkstall, and Buildwas all were altered (in the 1150's, 1160's, and 1170's) to allow for towers, no unusual pier section resulted.

32. Ibid., p. 211.

33. Wilson, p. 80 supports Brakspear's observation that it was a western tower that fell in 1175.

34. Pevsner, p. 59.

35. Still another indication that the north and south arches of the north chapel are original is the fact that remnants of a string course remain on the east wall of this chapel. This proves that a solid wall once existed here. No indication of a string course remains on the north and south walls. If the north and south arches are rebuildings, any evidence of a string course has been completely destroyed since a string course normally would run around the three sides of the chapel.

36. The chamfer is much more common in England than it is in France; there is, however, slight chamfering in the crypt of Saint-Denis and in the main arcade of the choir in Noyon (Personal communication from J. Bony).

37. It is because of an English influence that the chamfer-based profile of the triple roll was first used in France c. 1130 (Caen, Montivilliers, then in the Beauvaisis, and the Saint-Denis west block). In Normandy it became a rib-profile, which it had never been in England. Consequently, when three-roll ribs appear in England they are a sign of the influence of Normandy (Birkin) or of northern France, especially when the axial roll is given a pointed section. By the second half of the century, triple rolls were common in France, and French buildings may have introduced this profile to early English cistercian buildings, like the chapter house at Forde and Buildwas, in the west of England. Nonetheless,

the change to this more projecting molding must represent at Abbey Dore a reaffirmation of the English taste for plastic, complex profiles, and the immediate source must have been the cistercian chapter house of Buildwas.

38. R. Paul, *Trans. Bristol and Gloucestershire*, p. 123.

39. The north and south crossing arches themselves, even before the reinforcements, would probably have buttressed adequately any intended nave. Vaulting shafts with thirteenth–century profiles were excavated in the nave and can still be seen lying around in this area, but it is not certain that vaulting was intended for the main span of the nave in the 1180's. The aisles were intended from the first to be vaulted with rib vaults: the southeast springer of the south aisle vault still exists in place. On the other hand, the corbel remaining on the nave side of the southeast pier of the nave arcade is not proof of a vaulted nave, since this corbel seems to be placed too low for a high vault. It may simply be a fragment from the destroyed portions of the aisle vaults which has been built into the wall later. Likewise, the corbel for a three–shaft group in the remaining wall of the nave seems a later insertion and may not represent the level of triple vaulting shafts. It might, however, have been used higher up on the nave wall in a similar way.

40. At an early date, the elongated crossing pier was also used along the south coast of England in the crossing at Chichester and soon after in the rebuilt crossing of Winchester. A more complete study of the oriented crossing can be found in F. Hearn, *"The Architectural History of Romsey Abbey"*, Ph.D. dissertation, Indiana University, 1969. I want to thank Prof. Hearn for telling me at the eleventh hour that Romsey had an oriented crossing.

41. Kathryn Horste, in a seminar I gave at the University of Michigan in 1972, suggested that this indigenous English approach to crossing–pier construction which could only be imperfectly fulfilled at Dore (where the masons were held to a partially completed design) was fully expressed at Llanthony. She suggested that the crossing at Abbey Dore may have been originally planned with piers following the usual type of Buildwas

and Kirkstall. She also suggested that the crossing at Furness (Lancashire), makes an interesting comparison with Dore. Here, it is the plan of the original church of Furness I (before 1147) which shows the Anglo–Norman type of rectangular crossing pier which is very similar to Dore's while the new church of c. 1170 shows, among other French features, the use of the diagonally placed crossing pier.

42. J. Bony believes that the trumpet capital may have begun at Buildwas and that the influence of the water leaf capital transformed the scalloped capital into a trumpet.

43. J. Bony, "La Chapelle épiscopale de Hereford et les apports lorrains en Angleterre apres la Conquete", *Actes du XIXe congrès international d'Histoire de l'art* (Paris, 1959). This Tournus type of round pier first appeared in the Bishop's Chapel at Hereford.

44. The west may be the source for the horizontal emphasis at Chichester in the southeast. But independent cases of the refusal of a bay rhythm can be found particularly in the north, at Dumfermline, at the end of the eleventh and in the twelfth century at Tynemouth.

45. This design might derive from the west bays of the nave elevation of the northern French cistercian monastery of Les Vaux-de-Cernay. If Abbey Dore had a similar elevation, it would then provide an English source for St David's Cathedral nave elevation a few years later and would suggest a context which would explain similarities and differences between Llanthony and St David's. If the triple shafts which are now placed too low in the nave wall at Abbey Dore were originally higher, they might suggest a bay-divided upper zone.

46. As at Fountains, Kirkstall, and Buildwas there would have been no triforium. This absence of a triforium was usual in French as well as English cistercian buildings.

47. The major piers with molded capitals in the crypt of the Trinity Chapel are identical to the nave piers of Furness; consequently, J. Bony believes William the Englishman had a cistercian background before he studied in France.

ARCHITECTURAL REMAINS OF KING JOHN'S ABBEY,
BEAULIEU (HAMPSHIRE)
Virginia Jansen

Cistercian architecture has been a major interest of medieval architectural history for the past thirty years. Much of the discussion has centered on the question of what is "Cistercian style", a query which now appears as inadequately posed. Instead, discussion has turned to evaluating the degree to which the Cistercians determined the aesthetic qualities in and specific features of their art, and also to investigating the interrelationships between cistercian requirements and regional traditions. Basic to such inquiry is the question of who actually fabricated to art—cistercian or local artists. As yet, the amount of destroyed work casts doubt on generalizations. Moreover, despite our fragmentary knowledge, there is every reason to assume that different factors in the fabrication of the work, such as patronage and geographical location, as well as the identity and traditions of the artists, produced different results. Consequently, to interpret each mixture of factors accurately, whenever possible, a case by case study still needs to be made. This is especially true both of largely destroyed cistercian establishments and of those the foundations of which reveal unusual circumstances. Both situations obtain for the former abbey of Beaulieu,[1] which once had the second largest church of the Cistercian Order in the British Isles[2] (Figs. 1 and 17) and must have been a major example of cistercian architecture. It was also the first in a line of thirteenth-century royal cistercian foundations, which includes Hailes, Vale Royal, Balmerino, and Sweetheart in the British Isles, and Royaumont among others on the Continent.

Beaulieu Abbey was founded in 1204 by King John (1199-1216), known more for the problems of his reign and the Interdict than for his largesse toward the Church.[3] Relations between the abbey and its royal patron often placed the convent in unusual situations. The motivation behind John's patronage and its circumstances reveals his anxiety to conform to contemporaneous standards of behavior—a motive not often attributed to this fractious monarch. According to chroniclers, John, having levied a tax on the Cistercians who claimed exemption, set out to persecute the White Monks. He changed his mind, however, after suffering a beating at their hands in a dream, and to make amends he

founded a cistercian abbey in the filiation of Citeaux.[4]

Although hostile to other cistercian houses throughout his reign, John continued his patronage of Beaulieu,[5] and ties with the royal family remained close. John visited Beaulieu at least three times, and John's son and successor, Henry III, on at least four occasions.[6] Henry continued his father's support of the abbey, perhaps from a sense of filial devotion; in any case, the abbey was one of the earliest beneficiaries, if not the first, of his munificent patronage.[7] Henry's brother, Richard of Cornwall, also made significant contributions to the abbey, and his wife Isabella was buried in the church in 1240.[8]

Although royal patronage was often advantageous, especially when it came to funding, unduly intimate relations with the world could prove detrimental to a community. The first abbot, Hugh, possibly drawn from John's retinue, was often called upon to carry out the king's will.[9] The abbot may have followed John's requests too often, however, for in about 1217 he was deposed at the General Chapter; subsequently, in 1219, he acceded to the episcopacy of Carlisle.[10] In 1246 the prior and cellarer were deposed. Contrary to cistercian practice, they had permitted Queen Eleanor to stay at the monastery for three weeks after the dedication of the church so that she could nurse the ailing Prince Edward.[11]

Thus, the monastery was both closely linked to and extensively funded by the royal house. Whether or not these connections indicate a royal context for the architecture is a question allied to the evaluation of the cistercian qualities of the architecture. Here the issues of regional traditions and the English national cistercian inheritance further affect any consideration. Particular features cannot be viewed in isolation, but must be placed in terms of the architectural context of time, location, and function in order to evaluate adequately their meaning for cistercian architecture.[12] Although too little survives of Beaulieu Abbey to provide a conclusive picture, enough masonry remains to permit at least a partial assessment of the position of this royal foundation within the English and cistercian architectural traditions.

Plan

The layout of the monastery is typically Cistercian (Fig. 2).[13] Along the east range of the cloister (a square 138 by 137 feet) were a book cupboard, vestry, chapter house, and parlor with the monks' dormitory

above, extending south from this wing. The warming house, refectory, and kitchen compose the south range. At the west the lay brothers' buildings and the cellar are separated from the monks' cloister by the usual lane, at the north of which is the lay brothers' door to the church which corresponds to the monks' entrance in the northeast corner of the cloister. The infirmary complex extends east of the cloister. As was standard in England, the day stairs were located at the eastern end of the south walk and the lavatory in the wall adjacent to the refectory entrance. The night stairs were placed in the normal location but built within, rather than alongside, the west wall of the south arm of the transept. This construction also appeared at Beaulieu's daughter house, Hailes (Glos.).

The plan of the church, too, followed a cistercian type, based on that built at Clairvaux III after the death of St Bernard (Fig. 3). It consisted of a large cruciform church with nine non-projecting radiating chapels contained within the periphery wall.[14] Other plans of this type show between five and nine radiating chapels. According to the excavations conducted at the turn of the century by William St John Hope and Harold Brakspear, Beaulieu had six chapels with four more along the straight bays of the choir. These six radiating chapels were not actually excavated, however. Because of later building in this area, only the western remains of the northern turning wall and a small piece of the sleeper wall dividing the western two chapels on this side were located. If, in fact, Beaulieu had six radiating chapels it would differ from all other cistercian plans of this type that I have found, which have an odd number. It would seem more probable, then, that Beaulieu originally had seven radiating chapels of unequal dimensions; such irregularity exists also in other churches of this plan type. If so, the number of hemicycle supports would surely have varied as well. There may have been one for each respond of the chapels. The exact arrangement, however, like so much else at Beaulieu, has disappeared.

Although the Clairvaux plan is familiar, it occurred only in a limited group of buildings—according to present knowledge, possibly twelve cistercian churches in all.[15] The increase in the number of chapels has been linked to the increase in the number of monks, particularly monk-priests who performed mass on a daily basis.[16] In fact, the clustering of this plan type in the years at the end of the twelfth and beginning of the thirteenth century suggests that the plan was

designed as a specific solution to that liturgical problem.
But other plans, such as those with a multiplication
of chapels along a rectangular outline or with projecting
radiating chapels, also suited liturgical requirements.
There, the reasons for a monastery selecting the plan
of Clairvaux III must have depended upon other factors.
Since most of the churches of this type are in the
filiation of Clairvaux, some of the church designers
surely intended, for whatever reason, to emulate the
mother church. Such, however, would not hold true
of either Bonport or Beaulieu, which are daughters
of Cîteaux.

Bruzelius places Bonport within a regional Norman
group, and Chevallier believes the church of Le Breuil-
Benoît (Fig. 4) served as the model for that of Bonport
(Fig. 5).17 The Norman group is distinguished through
the rectangular form of the radiating chapels divided
by thick wedge-shaped masonry between them instead
of straight walls which separate trapezodial chapels.
Beaulieu follows the Norman practice, a hardly surprising
fact since, until the year of Beaulieu's foundation,
Normandy and England were ruled under one king—
John. It was he who founded Beaulieu and who was
the younger brother of the founder of Bonport, Richard
the Lion-Hearted, the previous king of England and
duke of Normandy. Surely it would be natural for John
to have transferred the plan used at Bonport, even
if he installed monks from Cîteaux. Although it cannot
be proved, perhaps John may even have borrowed masons
from Bonport. The presence of the Rouen mason Durandus
is documented at Beaulieu in 1224.18 Whether the same
Durandus ever worked at Bonport, whether he was at
work at Beaulieu when the plan of the church was
established by 1207/8,19 and whether it was the same
Durandus who signed a keystone at the cathedral of
Rouen in 1233, remain unanswerable questions, given
present documentation.

In the group using the plan type of Clairvaux
III, not only are Bonport and Beaulieu royal cistercian
foundations, but also Alcobaça in Portugal and Varnhem
in Sweden. With the exception of two fourteenth-century
German churches of the Clairvaux plan, these make
up all the non-French examples in the Order. Is it
significant that royal foundations outside of France
use this plan or is it a coincidence? At Alcobaça and
Varnhem, the plan with radiating chapels was constructed
long after these abbeys had been founded, too late
for the royal founders to have influenced the design
of the rebuilding; at Bonport and Beaulieu, however,

the founders could have.[20] Possibly, the community
meant to signify its royal foundation by this plan,
but this would be an act of commemoration that currently
known documentation unfortunately does not permit us
to know. In any case, whereas the plan of Bonport
fits neatly into a regional group, Beaulieu's plan,
if not restricted solely to its east end, does not. The
links between Bonport and Beaulieu should not, therefore,
be overstated. Bonport was a modest establishment;
Beaulieu was not. In its large scale—what can only
be called royal—Beaulieu drew upon other sources.

The plan shows a very large cruciform church:
a nave of nine bays, an extended presbytery of three
bays, and a developed transept of four bays with three
eastern chapels in each arm, and a western aisle and
galilee in the terminal of the north arm. The extended
choir is not like the simple remodeling at Clairvaux
III, where only the eastern chapel was rebuilt. It
closely follows the layout of Pontigny (Fig. 6), and
at Varnhem, too, the choir is extended one bay and
chapels are placed not only in the hemicycle but also
alongside the straight bays.

The design of the transept, however, follows neither
Clairvaux nor Pontigny. Such a large expansion reflects
the plan of the third church of the mother abbey—Cîteaux
III (Fig. 7). All three features—the extended three-
bay arms, the separate galilee of the terminal wall,
and the lack of a western aisle of the arm abutting
the cloister—are present at Cîteaux. Particularly notewor-
thy is the absence of the western aisle of the south
arm because it appears in two other royal founda-
tions—cistercian Royaumont and benedictine Westminster.[21]
At Cîteaux that anomaly occurred because, during succes-
sive enlargements of the church, the pre-existing cloister
could not easily be moved. But at Beaulieu and Royaumont
the monasteries were laid out on virgin ground. The
design may therefore have acquired a particular cistercian
significance owing to its use at Cîteaux. Perhaps there
were also functional reasons, such as a wish not to
extend the nave another bay to accommodate a large
cloister, or to avoid an unnecessary expansion of the
transept, although several cistercian churches do have
western aisles in both arms.[22]

In any case, the several features of the plan
at Beaulieu suggest a conscious effort to create a cister-
cian church on the grandest scale—at the time of its
building the largest cistercian church in Great Britain
—as would befit a royal foundation. In this light the
colonization of Beaulieu directly from Cîteaux may be

significant, too. All other British cistercian abbeys in the line of Cîteaux, except for Beaulieu and its daughter houses, were founded from Waverley, the first cistercian house in Great Britain. John's brother's abbey at Bonport was also in the line of Cîteaux, but its monks did not come from Cîteaux as those at Beaulieu had. Although evidence is lacking, it seems likely that John himself had requested monks from the first house of the Order for his foundation and that this colonization was meant to reflect, perhaps even to express, his royal sponsorship.

Church Remains

Since very little of the church is now standing, most of the elevation is unknown.23 Traces of ashlar walling remain in the south aisle of the nave (Fig. 18). The plinth course of the vaulting shafts in the aisle suggests one large round respond to carry the vaulting, as seen at the daughter abbey of Netley (Hants.) (Figs. 8 and 19).24 Perhaps also comparable to Netley's, if correctly reconstructed, are the large rere-arches across the full width of each bay. The walls recede perpendicularly, as do those in the nave at Netley, rather than being splayed diagonally and dressed with coursed shafts as in its more elegant choir. Also like those seen at Netley (in the presbytery), traces of surviving ashlar indicate twin unmolded recesses at the plane of the wall (Fig. 20). The shallow double recesses at Beaulieu may have been carried up above the roof of the cloister where they probably opened up into two narrow lancet windows in each bay. In general, such a design is much like the work in the naves of Netley and Salisbury, with significant differences. At Salisbury the wall is elaborated with detached Purbeck marble shafts, whereas at Netley the jambs are treated with coursed shafts. At Beaulieu all of this appears to have been left severely plain. The wall panel, the heavy vaulting respond, the small recesses for windows, and the absence of shafting or wall-arcading emphasize the cistercian taste for austerity (at least in this western area). Although the nave may have shown a simpler architecture than the choir —also true to a degree at Netley—the work is particularly restrained when compared to such multi-shafted cistercian work as the Nine Altars at Fountains or the choirs of Byland and Rievaulx.25

Unlike the design of the walls, the pier type, based on remnants of what must be the arcade capitals, removes the architecture from a simplified cistercian

context (Fig. 21). Instead of the cistercian clustered pier (seen, for example, at daughter Hailes), the Beaulieu pier has Purbeck shafts *en délit* alternating with thinner coursed shafts around a circular core, a design used in several large English Gothic churches. Similar designs can be seen in the transept at Chichester, the presbytery at Boxgrove, and in the retrochoir at Winchester (Fig. 9). Although the contrast between the rich design of the piers and the austere treatment of the wall seems contradictory, a somewhat similar juxtaposition is also found in the chapter house. Despite the fragmentary state of the ruins, further examination of the monastic work must be considered before an interpretation can be suggested.

Early Construction: The East Range and Related Fragments

The most significant remaining fragment of the east range, the imposing, wide triple-arched entrance to the chapter house, exhibits not only breadth, but also magnificence (Fig. 22). The piers of the entrance are unusually complicated, composed of delicate shafts *en délit*, capitals, and bases of Purbeck marble. The capitals and bases are far too worn to identify any details, but the form of the piers can be reconstructed. The type seems nowhere exactly duplicated, but several piers show similar forms, particularly in their mixture of Purbeck and freestone or alternation of small recessed coursed shafts between larger, projecting shafts *en délit*. Such examples are seen at St Albans (south aisle of the presbytery, c. 1220–35), Lincoln (nave piers, c. 1230), Boxgrove (c. 1220), and the chapter house at Netley (c. 1240) (Fig. 9). In general, these piers follow the types used at Canterbury, the workshop of which provided a legacy of multiple Purbeck shafting around the core.26 With a variety of combinations possible, one should probably not expect to find the exact pier plan seen at Beaulieu. The section closest to the Beaulieu piers, but built entirely in Purbeck, is found in the retrochoir at Winchester, under construction at the same time as Beaulieu with stone from the same quarry at Binstead on the Isle of Wight.27

The moldings of the arches of the chapter house have more exact parallels. The outer chamfered order is typical of simplified cistercian tastes, while the torus and pointed rolls of the inner order also reveal cistercian ties (Fig. 10). The three-unit group of roll-pointed roll-roll is also found throughout the monastery at Kirkstall and in the monastic work and eastern windows at Fountains (c. 1220–50).28 Perhaps also in

a cistercian-related context, it was used at New Shoreham (south arcade, c. 1200). The molding seems to be a conflated or tightened version of an older cistercian molding used, for example, at Byland. The outside chamfered order emphasizes the form of the arches and creates a framing device for the inner complication.[29] This differentiation reveals a sensitivity to the effects of the different orders of the arches which seems particularly Cistercian. Unfortunately, destruction of the fabric has been so extensive that nothing more of the architecture of the chapter house remains, but a few details in other parts of the east range are still extant.

According to Brakspear, in the undercroft of the dormitory one base, with its capital turned upside down upon it, still remains in place (Fig. 23).[30] The simplified base has only a partial fillet below the scotia; simplified spurs fill the angles. The reduced spur is common, both in a cistercian and a regional context, found in England and on the Continent, for example, at Salisbury, Bosham, Byland, Pontigny, Bonport, Silvacane, Eberbach, etc. Equally typical of cistercian work is the subdorter capital with simple, flat overlapping leaves. Several examples show the type, if not the exact form: in the undercroft of the dormitory at Byland, Fontenay, and Silvacane; the library at Maubuisson; the cloister at Senanque, etc. The range in time and place does not permit localization for the Beaulieu example, but emphasizes the restrained cistercian character of the capital, found particularly in the simplified architecture of monastic undercrofts.

More elaborate is the niche which originally formed the book cupboard, north of the chapter house. A ribbed vault springs from shafts en *délit* and foliage capitals, the latter too decayed to discern the type. Both the profile of the rib, with three rolls separated by hollows (Fig. 10), and the flower boss, ringed by the central roll of the rib, are familiar to cistercian and local English work (Fig. 24). For example, the type of the boss—a central element enframed by the confluence of the roll molding of the rib—is similar to cistercian examples at Poblet, Ourscamp, the lavebo at Santes Creus, the chapter house at Le Thoronet, a chapel at Roche, etc., and in a regional context, broadly understood, to bosses in the south aisle of the Trinity Chapel at Canterbury, the retrochoir of Winchester Cathedral (Fig. 27), as well as several churches in the diocese of Soissons, etc.[31]

More puzzling are four surviving vaulting bosses now not part of any structure. Two are unfinished-

looking, roughed out bosses, whereas the other two, similar to the boss of the book cupboard, are decorated with small flowers (roses) encircled by the torus roll of the rib which is now filleted (Figs. 25 and 26). No information indicates where either boss was originally placed. The plain boss as well as the profile of its rib, a filleted roll flanked by hollow chamfers (Fig. 10), suggests a location such as an undercroft, but generally the plain chamfered ribs of such structures lacked bosses. A more likely site would be the chapter house; similar uncarved bosses have been found in the early thirteenth-century chapter house of Santa Maria de Ovila, a Spanish cistercian monastery, of which most of the remains now lie in San Francisco.32 Furthermore, the profile of the ribs compares with similar profiles in several late twelfth-century cistercian buildings and with those in the crypt of the Trinity Chapel at Canterbury (Fig. 10).

The placement of the flower bosses remains equally speculative. The chapter house cannot be entirely ruled out, but the rib profile with a beaked half-roll (Fig. 11), a sharper molding different from both the profile of the book cupboard and the moldings of the chapter house arches, argues against a location in the eastern range. Consideration of surviving evidence and the usual placement of such bosses suggests a later part of the church (perhaps a section built after 1220) as the most likely location. Although the type of boss is typical of earlier cistercian art, the profile of the rib points to later work.

The Beaked Roll and Building Campaigns at Beaulieu

The beaked half-roll, often in combination with the beaked roll, is the distinctive element in most of the extant moldings at Beaulieu (Fig. 11) except for those of the chapter house.33 The roll, usually without a fillet, is brought to a point—the beak—to underscore the change in direction before the hollow. The point at the juncture was probably easier to cut, but it also defines the change in plane between the rolls and hollows. It sharpens the edges, introducing a crisp delineation and staccato rhythm into the smoothly curving lines of the rolls and hollows. It thus emphasizes the graphic quality of the moldings.

The beaked element appeared at the end of the twelfth century, but as a frequent feature which determined the character and type of moldings, it gained popularity in the thirteenth century, especially during the twenties and thirties. Not found everywhere, the molding

has its heaviest concentration in the south and west. Elsewhere there exists a group in the region around Lincoln and sporadic occurrences elsewhere, including northern England, Normandy, and Belgium, and notably in cistercian work such as the chapter house at Furness (c. 1240).34

From the architectural context of the earliest appearances, it would seem that the beaked half-roll may have developed from the combination of the wide hollow with quirk in twelfth-century moldings, as these became increasingly elaborate and articulated, and individual elements became larger and deeper (Fig. 12).35 A line of influences may have run from northern France, particularly in the Soissonnais, to Canterbury, Furness (nave), and Abbey Dore, and thence to the beaked half-rolls of Chichester, Winchester, Wells, etc. The earliest examples I have located appear in the arcade of the retrochoir of Chichester Cathedral (after 1187) and the west porch of St Albans (perhaps c. 1195, but probably later36). Soon thereafter the beaked half-roll appears as a repetitive element in the moldings of the retrochoir of Winchester Cathedral (c. 1202), the north porch at Wells (c. 1206), the chapter house at Lincoln (c. 1215-20), the presbytery at Salisbury (c. 1225), and the presbytery at St Albans (remodeled between 1214 and 1235). Then, at both Salisbury and St Albans the beaked roll is also included in the repertory, so that these pointed elements determine the character of the moldings. This developed combination of beaked rolls and half-rolls is the form of the molding used at Beaulieu—in the monks' and lay brothers' doorways from the cloister to the church and in both a filleted and unfilleted version for vaulting ribs (Figs. 11 and 28). Other examples are found elsewhere at Clarendon Palace, Bishops Canning (Wilts.), St Albans (fragment found during recent excavations south of the transept), Furness, and Bolton. Another variant —one much more common—is the asymmetrical beaked roll, usually with a fillet. Rarely seen outside the south, it occurred in work from Canterbury (1220's or 1230's) to Glastonbury (the galilee, perhaps under construction in c. 1230 and St Albans, the latter particularly rich in specimens.37

In the elaborate form that this molding took in the doorways at Beaulieu, it seems unlikely that it could have been used before 1220.38 If we knew more about the architecture of the church, we would have a better means to gauge its appearance at Beaulieu. All we know is that the monks entered an unspecified

completed portion of the church in 1227.[39] Since these
doorways are in the nave they could postdate this
time. And since the joints in the masonry show that
at least the lay brothers' door was constructed after
the walling in which it is set, the date could well
be late in the construction of the abbey.[40] The datable
examples of the beaked roll—at Salisbury (c. 1225),
the nave and remodeled presbytery of St Albans (1214–
35), Clarendon (1230's), and Furness (c. 1240)—may
indicate the 1230's, perhaps as late as 1240. This tallies
well with the dedication of the church in 1246. It remains
to be seen whether the chronology can be set within
narrower limits.
 Documents indicate that the monastery was built
over a period of at least fifty years and the church
over forty-three.[41] Too little remains to be sure where
construction began, but with early documentation citing
gifts for construction of the church, we may presume
that it was one of the earliest structures under construc-
tion. Given that the monks entered the church in 1227,
presumably the eastern part of the church was built
fairly quickly. The south arm of the transept and the
eastern range with the chapter house and the monks'
living quarters, also essential, were probably under
construction in the same period; this assumption accords
with the stylistic evidence already examined.[42]
 The moldings with beaked rolls and half-rolls,
however, dissociate the architecture from the cistercian
character seen in the earlier construction. Most of
the architectural detail can be compared to buildings
patronized by bishops close to the Crown—the bishops
of Winchester, Chichester, Salisbury, and Wells, and
the archbishop of Canterbury. When did this group
become referential at Beaulieu? A guess is all that
we are now permitted.
 Extant documentation reveals three major hiatuses
in royal support: 1) the period 1208–13 during the
Interdict; 2) 1216–20, the period between John's death
and Henry's assumption of patronage; and 3) 1227–32,
when part of the church was sufficiently advanced
to allow the monks use of it.[43] Although the cistercian
builders probably continued work during the time when
royal funding stopped, construction must have proceeded
much more slowly; probably only the lay brothers remained
at work as a skeleton crew.[44] Before the Interdict,
not much could have been built, but the cessation of
funds at the death of the founder in 1216 must have
caused a more severe interruption of the construction
then in full swing. In 1220, when the founder's son,

the new king Henry III, resumed the substantial royal benefactions, a different team of masons seems to have been at work—a group using templates with beaked rolls and half-rolls. Possibly sent in by the patron rather than called in by the monks and designing with more freedom than the earlier masons, they may have come from one of the major workshops connected with the Crown or its advisors in southern England—from Winchester, Chichester, or Salisbury, for example.45 In any case, the rest of the work uses forms which attest to the presence of such masons, and it is primarily the beaked moldings which delineate this relationship most clearly.

Speculative material though it is, such an account is plausible given the evidence we have at present (and it is all we probably shall ever have). Based on this, the building of the abbey may have taken place in two major campaigns: 1) 1204–1216—the planning of the monastery and building of the east end of the church, perhaps including the transept, the east bay and south aisle wall of the nave, as well as the east and perhaps also the west range of the monastic buildings; and 2) 1220–1247 and later—work finished on the east and west ranges, construction begun on the refectory and south range and the rest of the nave of the church including the piers with shafts *en délit*. This chronology must be regarded as highly tentative, however, since too little remains for any firm conclusions.

The Second Campaign

Although the complicated profiles of the doorways between the cloister and the church seem best suited to a date in the 1230's, the appearance of the beaked half-roll in other, simpler contexts at Beaulieu, such as in the refectory or vaulting ribs, suggests that the molding had been used earlier (Fig. 11). The refectory may be a structure of the 1220's.

The Refectory and Its Moldings

The refectory is the best-preserved structure surviving today, but because of this it was heavily restored in the nineteenth century.46 No original bases remain and most of the capitals are either restored or recut. Nevertheless, the refectory presents us with the best chance to view the architecture of the abbey.

A long horizontal structure, the building is lit by a series of tall regular lancets on all four sides (Fig. 30).47 Like many utilitarian structures, the frater's primary aesthetic impression derives from its clearly

visible surfaces and the proportions of its uncluttered
spaces. Although an exceedingly long room, the even
cadence of the wide embrasures of the lancets sets
a tone of regularity and breadth. Other than the particu-
larly fine reader's pulpit (Fig. 38) and the enriched
south end elaborated with dog-tooth, stiff-leaf foliage,
and Purbeck shafts *en délit*, the details of the architec-
ture contribute to this modulated regularity, unlike
the multi-shafted and fenestrated opulence of the refec-
tories at Rievaulx and Fountains.

The moldings of the refectory emphasize the southern
English connections previously discussed (Fig. 11).
The arch of its doorway from the cloister (Fig. 29),
composed of a series of beaked rolls hooked in the
same direction with occasional filleted rolls, seems
not to have been duplicated elsewhere, but it shares
elements with the arcade molding of the nave at St
Albans, the choir of Boxgrove, and to a lesser degree
the triforium of the eastern transept at Salisbury (Fig.
13). The molding of the inner doorway is close to a
doorway at Lacock Abbey.[48]

The moldings of the arches of the south lancets
and the pulpit, each with a row of dog-tooth, are
simpler; varieties of their patterns can be found at
Boxgrove, Jocelyn's Palace at Wells, the thirteenth-
century galilee addition at Glastonbury, the façade
of Wells, the retrochoir at Worcester, and the wall
arcade of the retrochoir at Winchester.[49]

The present arches of the stairs to the pulpit
have a pattern which I have located nowhere else,
but its elements work slight variations on a fragment
found in the subdorter yard which has numerous relatives
(Fig. 14). The distinctive element is a kind of "chamfered
miter or bowtell", perhaps originally derived from the
miter. The profile is similar to moldings found in the
transept at Chichester, the Archbishop's Palace and
door to the north arm of the transept at Canterbury,
the west façade at Wells (all in the 1220's), and a
fragment from Beaulieu's daughter house at Hailes (after
1246).[50]

Later than any other moldings that we have looked
at, perhaps about 1270–80, the profiles of the arches
to the lavatory adjacent to the refectory nevertheless
continue the same architectural connections (Fig. 14).
Comparison can be made with moldings from Westminster
Abbey, the cloister at Salisbury, and the north nave
chapels at Chichester.

Other architectural details in the refectory reinforce
the comparisons with southern buildings.[51] The cylindrical
hood-stops over the lancets and arches of the stairway

in the refectory are seen in the transept door to the cloister at Salisbury, but so far discovered nowhere else. The one bit of tracery left at Beaulieu in the window opposite the pulpit arch—a design in plate tracery of a quatrefoil above two trefoil-headed lancets —is similar to windows popular in the architecture of this southern group patronized by Henry III and the clerics close to him. Often found in domestic work, the pattern occurred at Leadenhall in Salisbury, Winchester Castle Hall, Westminster Palace,[52] among other places.

Molded Capitals and Corbels

Although restoration has obscured many of the capitals at Beaulieu, enough remain to provide informative comparisons. A profile with a distinctive hollow cut in the lower unit (Fig. 15–Type A)[53] is found in refectory capitals of the pulpit (Fig. 31), its stairs, and the south lancets as well as in the corbels of the stairs and among the fragments in the subdorter yard. The buildings to which these details correspond are in most cases those to which the moldings may be compared. Duplicates of the pulpit capital appear in the transept at Chichester, the Garrison church at Portsmouth, and on a corbel in the castle hall at Winchester, whereas close relatives occur in the nave of St Albans and Netley, the chapter house at Furness, the transepts of York and Rievaulx, and the east walk of the cloister at Westminster.

Closely related to these capitals and corbels are two other patterns, each differing primarily in the lower unit. The one with the half-roll and fillet is found at Beaulieu in the restored capitals of the refectory door, the corbels of the lay brothers' refectory (Fig. 32), and the remains of the arcade capitals from the church (Fig. 15–Type B). The general type, illustrated as Paley's "Early English capital",[54] has many comparisons. The exact twin of the corbel and restored capital of the two refectories is seen in some capitals at Winchester (retrochoir), Boxgrove, and the north arm of the transept at Chichester; close relatives exist primarily in southern England—at the retrochoir of Winchester Cathedral, the chapel of Lambeth Palace, the presbytery of Salisbury, Jocelyn's Palace at Wells, Netley, St Nicholas at Buckenham (Norfolk), and the chapel of Clifford's Tower at York Castle. Other less precise comparisons are found at St Albans, the Temple in London, Hailes, the east end of Fountains, and the cloister at Mont-Saint-Michel, long recognized as having English connections.

A second type with a beaked half-roll in the lower unit appears in several of the fragments lying in the subdorter yard (Fig. 15–Type C). A duplicate is used in the piscina at Hythe; near duplicates are found in the castle hall at Winchester and the church at Bosham, while closely related profiles can be seen at Lambeth Palace, the retrochoir of Winchester, the crypt at Rochester, and a corbel at the east end of Fountains. Other specimens, similar except for a lower roll which replaces the beaked half-roll, exist at several southern sites: Canterbury (work of the 1220's), Lambeth Palace, Salisbury, and the abbeys of Waverley, Lacock, and Westminster.

A fourth profile exists at Beaulieu only as a partial fragment in capitals from double columns, perhaps originally in the cloister (Fig. 15–Type D). The blunted roll of its lower unit, frequent in the nave at Lincoln, is also used in many less important places, e.g., the capitals of the wall arcade and window shaft of the retrochoir at Winchester, the piscina in the south aisle at Salisbury, the undercroft at Lambeth Palace, the east end of Fountains, and at other northern sites.

In summarizing these multiple comparisons, one does not seem able to use the comparisons to support a chronology at Beaulieu for each type. The undercut lower unit, however, seems restricted to the refectory and to various corbel fragments whereas the appearance of the half-roll and fillet tyupe in both the lay brothers' refectory and nave separates the date of these structures from the monks' refectory. The capitals surveyed suggest a date in the first third of the thirteenth century with a focus on the years 1215-35 while the comparisons have shown the frequent use of the profiles in the south of England and some occurrences in the cistercian milieu of the north. One could tentatively conclude that the Beaulieu types reflect influences from southern workshops rather than cistercian ones. Evidence in the comparisons with northern cistercian buildings indicates that influences went from the south to those thirteenth-century cistercian buildings. Both regions are areas where molded rather than foliate capitals were the rule.[55] Salisbury may perhaps be the best known example of the "molded alternative". Within this austere, rather abstract kind of architecture, where decoration is provided by architectural elements such as moldings and repetitive arches, foliate capitals are occasionally used for punctuation and emphasis, for example in the eastern transept of Salisbury, and in the two doorways to the church and in the book cupboard at Beaulieu.

The presence of many corbels throughout the monastery is, of course, common to cistercian architecture, and the Beaulieu designs are fairly typical (Fig. 33). In both a practical and aesthetic sense, corbels were effective. Supporting vaulting on corbels, rather than on shafts, leaves the wall uncluttered and allows a wider room and a sense of spaciousness. Such free access was obviously necessary in a narrow passage such as the stairs in the Beaulieu frater. Likewise, merging the plainly cut arches and ribs into one stone at the springing (Fig. 32) increased the strength and ease in construction and allowed the greatest possible clearway—another utilitarian usage particularly appreciated by cistercian builders and characteristic not only in their cellars but also of their churches.[56]

Foliage Sculpture

Not surprising, the few surviving foliage capitals, foliate hood stops, and foliage decoration on the reader's pulpit, unlike the flat-leaved capital of the subdorter, place these details outside cistercian artistic preferences (Fig. 34). They use a standard type of trefoil stiff-leaf found all over England, but a few specific comments may still be made. The type with a strong mid-stem pressing into the leaf, characterized by Samuel Gardner[57] as the Lincoln variant, is nevertheless frequent in the south and west, as Gardner had also noted. Comparable foliage appears throughout the first half of the century in many locations—Winchester, Lincoln, the Temple choir in London (Fig. 35), Salisbury, Barnack, Eaton Bray, Kimpton (Herts.), York, etc.—but the capitals with a simplified stiff leaf in hard Purbeck stone from the lay brothers' door (Fig. 36) seem closest to capitals in the Winchester retrochoir (Fig. 37) and the type of curving stem in the refectory pulpit is most like the foliage plaques on the west front of Wells. The last two examples serve to emphasize the ties with the southern group, but indicate as well that this group was not isolated from Early English developments elsewhere.

Tiles

Yet remaining to be discussed are the many tiles turned up in the excavations (Fig. 16).[58] While the tiles cannot be fully treated here, a few comments will substantiate the architectural comparisons already made.

Perhaps laid near the date of the consecration

in 1246, the surviving inlaid tiles from Beaulieu belong to the Wessex group discussed by Elizabeth Eames in her catalogue of British Museum tiles.[59] The majority of the Beaulieu tiles can be compared with those from the retrochoir at Winchester, which Eames dates to c. 1235;[60] I have located twelve patterns in common. With Clarendon Palace, Beaulieu has nine common patterns; and with Salisbury, three common patterns from the cathedral (c. 1258) and three from the chapter house (1280's). Others are duplicated in tiles from Netley (three patterns) and Amesbury (four patterns),[61] and Eames added Romsey to the group.[62] Patterns include an eight-petalled rosette, a four-tile circle of rows with dots, birds, griffons, knots, diagonally cut squares, fleurs-de-lys, and several foliate patterns; many were combined into designs composed of four tiles.

Excavations have also turned up mosaic tile (illustrated in Hope and Brakspear, pl. XV) which is more typical of early thirteenth-century cistercian pavements. The mosaic pavement may have been in place by 1227, when the monks started using the church. The inlaid tiles may have been used mostly in the nave, but perhaps some were also laid down in the east end,[63] since the majority of the patterns may be compared with the earlier tiles of Winchester and Clarendon (c. 1235–50).

Arches at Beaulieu

The handling and type of the arches at Beaulieu are noteworthy and may reinforce the southern English architectural connections. The outline of the arches of the stairs to the pulpit is even (Fig. 38), unlike that of most stairways where the arches follow the graduated levels of the stairs, such as the frater pulpit at Chester or the entrance to the chapter house at Beverley. Such a profile contrasts distinctly with, say, the arches of the wall arcade of St Hugh's choir at Lincoln (Fig. 39), where syncopated arcading in two planes, irregular trefoil-headed arches, and the hood mold moving at angles different to the arches emphasize a lively and variegated movement rather than evenness and plainness. The lack of other decoration at Beaulieu permits an increased emphasis on the smooth transitions of the prevalent roll moldings which glide evenly from one arch to another. The rolls nowhere diminish in circumference but merge to maintain a constant width of the roll which adds to the regularity of effect. This is partly a matter of the girth of the moldings; in southern English building the wall is

thinner so that a simplicity replaces the rich play
on depth characteristic of Lincoln architecture. Although
both derive from Canterbury, the arches of southern
England (at Canterbury in the cloister, St Albans,
and Boxgrove, for example) maintain a French-like
regularity.

The shape of the arches may possibly be significant
as well. Instead of the variety of outlines found in
Lincoln arches, most of the arches at Beaulieu are
nearly the same—low, broad, and relatively flat (Figs.
28 and 29). They approach the form of a semi-circle
with a pointed head, i.e., the width of the chord is
almost twice the height of the arch. The least broad
arches—not surprising—are those of the entrance to
the chapter house. All of the arches surviving from
the later work, however, show this broad typology.
Their arcs are struck from centers close together, lying
near the center line dropped from the key of the arch
and usually just below the chord of the arch. The
centers of the chapter house arches, on the other hand,
lie much farther apart and close to the soffit of the
arches, more like the construction of the stilted Lincoln
arch in which the centers lie outside the arch itself.
The repetition of the obtuse arches gives a harmony
and balance to the architecture, qualities which seem
to be not only a trademark of this group of southern
buildings, but are also appropriate for cistercian expres-
sion. In northern cistercian building, many of the
arches, particularly in the twelfth century, are also
broad, while later northern cistercian arches become
more like the sharply acute lancets in the episcopal
architecture of the region.[64]

Whether a typology of arches can be formulated
and pushed to such conclusions, another type of arch
found at Beaulieu and other buildings in the south
is more specifically distinctive. Having a segmental
head, such arches appear at Beaulieu in the inner
arch of the refectory doorway, the windows of its north
wall, the lay brothers' doorway from the church to
the cloister, a fragment in the subdorter yard (perhaps
originally located in the monks' doorway from the church
to the cloister), and several doorheads (now mostly
restored) to the book cupboard, subdorter passage,
warming house, and throughout the *domus conversorum*
(Fig. 17). Whereas the segmental heads of the claustral
buildings are a practical solution for the type of entrance
needed in such domestic settings,[65] seen, for example,
in Leadenhall, Elias of Dereham's house in Salisbury,
the segmental arch on vertical springers used in the

lay brothers' (Fig. 18) and refectory doorways has
more significance. In this guise, undoubtedly derived
from domestic use, the feature was, as Colvin observed,
"particularly favored by Henry III's masons...."[66]
Its use was far more widespread than Colvin discussed,
however. In addition to the specimens at Westminster
Palace and Abbey and the hall at Winchester cited
by Colvin, the design appears at Lambeth Palace Chapel,
the transept of Rochester, the façade of Wells, the
galilee at Glastonbury, the retrochoir of St Albans,
Netley, the east end of Fountains, and the doorway
to the cloister at Lincoln, among others.[67] Although
often believed to be a particular feature of the architecture
of Westminster Abbey, the several examples of the segment-
al arch on vertical springers, occurring before the
re-building of Westminster, serve to set the abbey's
richly decorative architecture into the rather different
context of an austere English Gothic developed in the
southern areas of England during the 1220's and 1230's.[68]
The traits of segmental arches on vertical springers,
broad arches, and beaked rolls and half-rolls earmark
work of this group.

Conclusion

So little survives of King John's abbey at Beaulieu
that most statements about its architecture may always
remain tentative. Nevertheless, an abundance of piecemeal
fragments provides tantalizing evidence for speculation.
The plan of the church and the layout of the monastery
follow known cistercian types. Of course, a plan, which
is easily transmitted, would reflect the rule of the
Order most faithfully. Other details such as corbels,
which allow for convenient simplification, also respond
to cistercian needs. But the architecture in general,
built by men on the spot—whether cistercian or lay-
—could be expected to reflect local conditions. Procedures
at the quarry may have had some kind of effect, although
we may not be sure exactly what. Thus the details
of the buildings, rather than the layout, form a more
complicated aspect which need not follow international
cistercian types.

Too little remains for the historian to comment
extensively on the design of the church. There is no
longer evidence for the elevation. Yet what exists of
the walls corresponds to cistercian ideals: in specific
terms, unmolded jambs; simple, paired lancet windows;
sturdy, simplified vaulting responds; and plain walls.
The piers, however, with their Purbeck marble shafts
typical of English architecture, would seem to contradict

cistercian ideals and to set a new tone. Also found in the south and west ranges, this architecture contrasts with the austere walls of the church and the cistercian-related forms of the east range. Was there in fact a conscious effort to maintain in the church walls the cistercian ideal of restraint, a restriction not needed --or perhaps not even desired--in the monastic buildings, specifically in the chapter house and refectory? The other monastic buildings seem too utilitarian to warrant inclusion here. In the absence of extensive discussion in the literature focusing on the monastic architecture of the Cistercians in comparison to the concentration of studies on their church architecture, however, the issue cannot yet be concluded and the discrepancy in style seems, for the moment at least, more convincingly tied to a chronology of construction.

What seems to be the earliest surviving part of the monastic work in the east range (book cupboard, chapter house, and subdorter) reveals both cistercian and regional sources, but this typically cistercian mixture does not obtain for the rest of the work. Details suggest the arrival of masons from one of the great workshops of southern England, such as that from Winchester, Chichester, Wells, Salisbury, or from one of Henry III's projects. Although particularly difficult to ascertain from the few original scraps left to us, the architecture no longer reflects cistercian tenets, but uses the architectural elements of southern England (specific capital types, moldings, and arches; Purbeck shafting; stiff-leaf foliage decoration, etc.). Any congruence of the architecture of this second campaign with "cistercian ideals" may be coincidental, reflecting instead the architectural simplicity of undercrofts and the like. But rather than interpreting this work as a reflection of diminishing cistercian ideals in the thirteenth century, one should probably regard it as one result of a new patron whose funding or involvement introduced a new team of masons. Thus, what must be the second campaign of building at Beaulieu Abbey seems to the the first surviving example of the patronage and early tastes of King Henry III, who probably felt filial responsibility to support the abbey begun by his father.69 To what extent this art coincided with the tastes of the bishops of the early part of Henry's reign and to what extent these tastes may in themselves reflect the ideals of cistercian art remain subjects for future investigation.

University of California at Santa Cruz

APPENDIX I. List of Thirteenth-century Moldings with Beaked Rolls and Half-rolls in Approximately Chronological Order by Region

Several specimens illustrated in Figs. 11-14.

SITE	LOCATION	DETAIL	APPROXIMATE DATE
SOUTHERN ENGLAND AND WEST MIDLANDS			
Chichester Cathedral	retrochoir	arcade, rib	1187
Winchester Cathedral	retrochoir	wall arcade	1202 or later
	eastern chapels	arch, trefoil molding	1202-20s
St Albans Cathedral	west porch	wall arcade	1195 or 1214-35
	west bay	wall arcade	1195 or 1214-35
Wells Cathedral	north porch	arch, wall arcade	1206
St Albans Cathedral	nave	arcade	1214-35
	presbytery	window arch, wall arcade	1214-35
	fragment	rib	13th century
Chichester Cathedral	transept	arcade to choir aisle, rib	1210-20
Canterbury Cathedral	Archbishop's Palace	window arch	1220
Salisbury Cathedral	presbytery	arcade	1220-25
	eastern transept triforium	arch, hood mold	1225-30
Wells Cathedral	west facade	doorway arch, central tower arch	1220s
	Jocelyn's Palace, undercroft	doorway arch	1220
Bristol, St Augustine	Elder Lady Chapel	wall arcade	1220
Boxgrove Priory	presbytery	arcade	1220
Portsmouth, Garrison Church	chancel	rib	1220
Beaulieu Abbey	refectory	doorway arch, pulpit and stairs arch and rib lancet	1220s
	fragments	rib, arch molding	1220s
	monks' and lay brothers' doorways	arch	1220s-30s
Pershore Abbey	east end, aisle	rib	1210-30
Worcester Cathedral	retrochoir	arcade, wall arcade	1224-32
Glastonbury Abbey	galilee	arch to church, wall arcade	1230
New Shoreham, St Mary	choir	transverse rib	1230
Clarendon Palace	fragments	rib	1230s
Bishops Canning (Wilts.)	chancel	window jamb	13th century

APPENDIX I. continued

SITE	LOCATION	DETAIL	APPROXIMATE DATE
Lacock Abbey	cloister	doorway arch	1230s–40s
Croxden Abbey	fragments	rib	--
Eastbourne, St Mary	chancel	arch	--
Much Wenlock Priory	nave	arch	mid–13th cent.
Hailes Abbey	fragments	rib	1246–51
	chapter house	arch	1246–51
Westminster Abbey	choir (eastern bays of nave)	arcade	1260–69
	Chapel of St John the Baptist	tomb of Bohun children	1304–05 or 1260–70

MIDLANDS AND NORTHERN ENGLAND

Rievaulx Abbey	refectory	doorway hood mold	1200–30
Lincoln Cathedral	chapter house	transverse rib	1215–20
Beverley Minster	presbytery	arcade	1225–30
Polebrook, All Saints (Northants.)	transept	arcade	1230–50
West Walton, St Mary (Norfolk)	nave	arcade	mid–13th cent.
Kings Lynn, St Margaret (Norfolk)	chancel	arcade	mid–13th cent.
Canons Ashby, St Mary (Northants.)	north aisle	doorway	--
Buckenham, St Nicholas (Norfolk)	--	rere–arch	--
Furness Abbey	chapter house	pier, rib	1230s
	infirmary	arch of recess	late 13th cent.
York Cathedral	tomb of Walter de Gray	arcade	1255
Bolton Priory	west facade	doorway arch	mid–13th cent.

NORMANDY

Petit–Andely, St–Sauveur	choir	rib	1200
Bonport Abbey	serving hatch	molding	13th cent.
Sées Cathedral	nave	transverse rib	1230
Norrey	choir	wall arcade	1230

BELGIUM

Villers Abbey	dormitory	stringcourse	1200
	choir	rib	13th century
	chapel	respond	1220–30

(May 1983)

APPENDIX II. List of Inlaid Tile Patterns Common to Those Found at Beaulieu Abbey[70]

DESIGN	SITE	APPROXIMATE DATE	ILLUSTRATION REFERENCE
BORDER DESIGNS			
1. trefoil foliage border	Clarendon	later 13th cent.	Eames 1279–807[71]
2. zig-zag border	Bordesley	13th century	Eames 1290–91
FOLIATE DESIGNS			
3. trefoil leaf inscribed in ovoid form	Clarendon, King's Chapel	1240–44	Eames 623
4. symmetrical foliage spray with fleur-de-lys stamen	Clarendon, King's Chapel	1240–44	Eames 625
5. knot-like design with trefoil terminals	Clarendon	later 13th cent.	Eames 629
6. quarter-tile trefoil spray within hoop (not duplicate of, but similar to Beaulieu's)	Winchester, retrochoir	c. 1235	Emden, pl. VI[72]
7. quarter-tile spray inscribed and emitting fleur-de-lys (not duplicate of, but close to Beaulieu's)	Amesbury Salisbury, chapter house	13th cent. c. 1284	Stevens, p. V:5[73] Eames 2620
FLEUR-DE-LYS DESIGNS			
8. fleur-de-lys	Salisbury	13th century	Eames 2122
9. stamen-bearing fleur-de-lys	Winchester, retrochoir	c. 1235	Emden, pls. IV & VIII
10. four fleur-de-lys arranged crosswise inscribing a dot (not duplicate of, but similar to Beaulieu's)	Clarendon	later 13th cent.	Eames 2193
11. four fleurs-de-lys arranged crosswise inscribing a quatre-foil and dot (Beaulieu's adds a dot to center petal)	Winchester, retrochoir Amesbury Salisbury, chapter house Shaftesbury	c. 1235 13th century c. 1284 13th century	-- Stevens, pl. V:2 Eames 2194 Eames 2194
12. four fleurs-de-lys arranged crosswise inscribing a square and quatrefoil (Beaulieu's omits the square)	Salisbury (?)	c. 1258 (?)	Eames 2344
FLOWER AND GEOMETRIC DESIGNS			
13. eight-petal rosette or pierced octafoil (similar six-petal variant)	Winchester, retrochoir Keynsham (Clarendon)	c. 1235 13th century (1240–44)	Eames 2298, Emden, pl. VI Eames 1098 (Eames 1096)

APPENDIX II. continued

DESIGN	SITE	APPROXIMATE DATE	ILLUSTRATION REFERENCE
14. quatrefoil inscribed by scalloped form with trefoil terminals	Winchester, retrochoir	c. 1235	Emden, pl. VII:1
	Clarendon	later 13th cent.	Eames 2403
	unspecified Wessex	13th century	Eames 2403
15. six-pointed star	Winchester, retrochoir	c. 1235	Eames 2274, Emden, pls. VI & VIII
16. interlaced knot	Clarendon	later 13th cent.	Eames 637
17. four pointed loops arranged crosswise intersected by intermediate circle	Netley	13th century	--
18. quarter-tile concentric rows of dots	Winchester, retrochoir	c. 1235	Emden, pl. VIII
	Amesbury	13th century	Stevens, pl. V:9
	Netley	13th century	--
	Salisbury	c. 1258	Eames 2115
	Clarendon	later 13th cent.	Eames 2115
19. quarter-tile regularly arrayed diagonal squares	Winchester, retrochoir	c. 1235	Eames 2023, Emden, pl. VI
20. quarter-tile rose window	Winchester, retrochoir	c. 1235	Emden, pl. VIII, Knapp, fig. IV:22
	Baginton Castle	14th century	Eames 2739
BIRD DESIGNS			
21. single-headed eagle	Winchester, retrochoir	c. 1235	Emden, pls. VII:1 & VIII
	Clarendon	later 13th cent.	Eames 1944
	North Warnborough	13th century	Eames 1944
22. double addorsed bird	unspecified Wessex	13/14th cent.	Eames 1728
23. two addorsed birds with sprig between (minor variations among tiles)	Amesbury	13th century	Stevens, pl. V:21
	Netley	13th century	--
	Salisbury, chapter house	c. 1284	Eames 1969
	Halesowen	13th century	Eames 1970
	unspecified Wessex	13th century	Eames 1970
ANIMAL DESIGNS			
24. griffon, sinister with turned head, uninscribed	Winchester, retrochoir	c. 1235	Eames 1864, Knapp, fig. IV:15
25. griffon, dexter with head turned and tail merging into inscribing vine	Winchester, retrochoir	c. 1235	Knapp, fig. IV:19

NOTES

Table of Abbreviations Used

ASOC	*Analecta Sacri Ordinis Cisterciensis*, or *Analecta Cisterciensia*
Bull mon	*Bulletin monumental*
SCAA	*Studies in Cistercian Art and Architecture*
HMSO	*Her Majesty's Stationery Office*
Spec.	*Speculum*
VCH	*The Victoria History of the Counties of England*

1. As can be deduced from its former spelling, Beaulieu, pronounced "Bewley", was said in this manner at least as early as the sixteenth century. In the middle of the eighteenth century the French spelling was reinstated; see Sir James K. Fowler, *A History of Beaulieu Abbey, A.D. 1204-1539* (London: The Car Illustrated, 1911) pp. 26–29.

 At the suppression of monasteries under Henry VIII, Beaulieu was sold to Thomas Wriothesley, who later became Earl of Southampton. Much of the stone of the abbey went into building the southern coastal castles of Calshot, Hurst, and Cowes as protection against a feared French invasion (Fowler, p. 210). Thus, only a few of the abbey structures remained after the sixteenth century. Today foundation courses for many and walls for a few of the monastery buildings still exist, but very little of the church and cloister remains.

 In addition to Fowler, cited above, who reproduced drawings by Ferdinand Fissi which render the abbey as imagined before its surrender, the following are important sources for a study of the architecture of Beaulieu: W. H. St John Hope and Harold Brakspear, "The Cistercian Abbey of Beaulieu, in the County of Southampton", *Archaeological Journal* 63 (1906) 129-86, who excavated the site for several years beginning in 1900 and who cite the critical sources; and Stanley Frederick Hockey osb, *Beaulieu: King John's Abbey, A History of Beaulieu Abbey Hampshire 1204-1538* (London: Pioneer Publications, 1976). A color-illustrated pamphlet, *Beaulieu: Palace House and Abbey* (Beaulieu, 1978) usefully illustrates the site and

reproduces several of Fissi's drawings. See also
Stanley Frederick Hocky *osb*, ed., *The Beaulieu
Cartulary*, Southampton Records Series, 17 (Southamp-
ton: University Press, 1974).

 I would like to acknowledge with gratitude
the help of Lord Montagu of Beaulieu, who generously
granted me access to the abbey ruins and documents
at Beaulieu, and permission to publish my research,
and the cooperation of his friendly staff. He
and they made working at Beaulieu a pleasure.
I am also grateful to the Faculty Research Committee
and the Regents' Junior Faculty Fellowship Committee
of the University of California at Santa Cruz
for support. Portions of this article were presented
at the Seventeenth International Congress on Medieval
Studies at Kalamazoo, Michigan in 1982.

2. Writing in 1906, Hope and Brakspear, p. 148,
stated that the church "covered a greater area
than any other cistercian church in this country".
This statement has been repeated in later literature,
but what was true in 1906 was no longer true
by 1911–12 when Vale Royal, begun by Edward
I in 1277, was excavated. See Basil Pendleton,
"Notes on the Cistercian Abbey of St Mary, Vale
Royal, Cheshire", printed privately (1912); F.
H. Thompson, "Excavations at the Cistercian Abbey
of Vale Royal, Cheshire, 1958", *Antiquaries Journal*
42 (1962) 183–207; and R. A. Brown, H. M. Colvin,
and A. J. Taylor, *The History of the King's Works:
The Middle Ages*, gen. ed. H. M. Colvin (London:
HMSO, 1963) pp. 248–57, especially p. 255, fig.
28.

 The number of monks at Beaulieu, of course,
varied. Stanley Frederick Hockey *osb*, *The Account-
Book of Beaulieu Abbey*, Camden 4th series, 16
(London: Royal Historical Society, 1975), p. 17,
estimated from shoe and clothing allowances that
in c. 1270 the monks numbered about seventy-
three (including seven novices) and the *conversi*
about sixty-eight. In *Medieval Religious Houses:
England and Wales*, 2nd ed. (London: Longman,
1971) p. 1.5, David Knowles and R. Neville Hadcock,
citing the *VCH (Victoria History of the Counties
of England: Hampshire and the Isle of Wight*,
ed. H. Arthur Doubleday and William Page, 2
[Westminster: Archibald Constable, 1903]), p.
146, write that in 1329 there were thirty-six monks;
both sources note that the foundation was begun
for thirty monks (Knowles and Hadcock, p. 115;

VCH, p. 140). Knowles and Hadcock (p. 110) state that a typically large cistercian abbey in the twelfth and thirteenth centuries contained about thirty-six monks and fifty lay brothers within the first years from the date of the foundation.

3. The abbey was first founded on John's manor at Faringdon in Berkshire by 1203; by 1204 the site was changed to Beaulieu, where John had a hunting lodge which provided the monks with temporary shelter; see also n. 42. The foundation charter for Faringdon dates from 1203; for Beaulieu from 1204/5. See Hope and Brakspear for various texts, pp. 131–33, and for the foundation charter for Beaulieu, Fowler, pp. 10–13; Hockey, *Beaulieu*, pp. 14–21, and *Beaulieu Cartulary*, pp. 3–5.

4. For the story of the foundation, see the text in Hope and Brakspear, pp. 129–30, and Fowler, pp. 6–7; see also Hockey, *Beaulieu*, pp. 12–13.

5. Hockey, *Beaulieu*, p. 23, and Fowler, pp. 46–50. Hope and Brakspear (p. 134) computed that King John contributed £1463 14s.2d. to the work.

6. Fowler, pp. 109–10; visits by later kings are discussed on pp. 110–111.

7. Hope and Brakspear, pp. 135–37; Fowler, pp. 50–54; and Hockey, *Beaulieu*, pp. 28 and 31–34. At the request of the monks, probably in 1226, Henry also tried to persuade the Pope to have John's body moved from Worcester to Beaulieu, where John at first intended to be buried; Hope and Brakspear, p. 138.

8. Hockey, *Beaulieu*, pp. 29, 46, and 47; Fowler, p. 149.

9. The Close Rolls for 1205 show 107½ marks given to the abbot for attending the General Chapter as the king's messenger and fifty marks spent on the abbot and his house at Beaulieu; Hope and Brakspear, p. 133.

10. Fowler, pp. 114–16 and pp. 146–47, and Hockey, *Beaulieu*, pp. 23–25 and 217, n. 1. Hockey states that Abbot Hugh came from Cîteaux, and he may well have, but one is surprised to find such a monk as secular as Hugh was. Not only was he engaged in frequent missions for King John and later for Henry III, but he was also charged in the General Chapter of 1215 with drunkenness and possession of a dog on a silver chain. Clearly enjoying legatine and royal favor, he was elected to the see of Carlisle. The king agreed to the election on August 1, 1218, and the papal legate

approved the following day; Hugh was consecrated the following February 24.

Although the cartulary of Beaulieu's daughter abbey of Newenham twice lists the first two abbots of Beaulieu as named Hugh, both Fowler and Hockey thought that the two Hughs, since indistinguishable, were one and the same. And following the *VCH (Hampshire and the Isle of Wight*, 2, p. 146), David Knowles, C. N. L. Brooke, and Vera C. M. London, *The Heads of Religious Houses: England and Wales 940-1216* (Cambridge: University Press, 1972) p. 126, list only one Hugh. However, the problem of a monk from Cîteaux acting so much as a "protégé" of King John (Marion Gibbs and Jane Lang, *Bishops and Reform 1215-1272* [Oxford: Oxford University Press, 1934], p. 7) would be solved if Abbot Hugh were seen as two different abbots, according to the old tradition. Awkward for such a suggestion, the surviving evidence lists election for only one Hugh (1204) and the death of only one (1223).

11. Hope and Brakspear, p. 137; Fowler, p. 110; and Hockey, *Beaulieu*, pp. 29-30.

12. For example, see the studies by Caroline Astrid Bruzelius, "Cistercian High Gothic: The Abbey Church of Longpont and the Architecture of the Cistercians in the Early Thirteenth Century", ASOC 35 (1979) 3-204; and "The Twelfth-Century Church at Ourscamp", Spec. 56 (1981) 28-40, where she made a related point. Marcel Aubert had also raised the question of Cistercian architectural preferences in "Existe-t-il une architecture cistercienne?" *Cahiers de civilisation médiévale* 1 (1958) 153-58.

13. For a general discussion of monastic and Cistercian planning, see Carolyn Marino Malone and Walter Horn, "The Plan of St Gall and Its Effect on Later Monastic Planning: Tradition and Change", in Walter Horn and Ernest Born, *The Plan of St Gall: A Study of the Architecture and Economy of, and Life in a Paradigmatic Carolingian Monastery* (Berkeley and Los Angeles: University of California Press, 1979), 2:315-57, especially 2:349-55.

14. See Marc-Anselme Dimier, "Origine des déambulatoires à chapelles rayonnantes non saillantes", *Bull mon* 115 (1957) 23-34. Wolfgang Krönig (*Altenbery und die Baukunst der Zisterzienser* [Bergisch Gladbach: Heiderdruck, 1973], 65) suggested that this plan-type may have been developed during St Bernard's

lifetime.
15. Besides Clairvaux III and Beaulieu, plans of
this type are known at Alcobaça (twelfth and
thirteenth centuries), Bonport, Le Breuil–Benoît
(1190–1224), Cherlieu (c. 1200), Clairmarais (1152ff.),
Kaisheim (1352–84), Pontigny III (1185–1205/10),
Savigny (1173–1220), Varnhem (1200–50), Vauclair
[?], and Zwettel II (1343). Sometimes Mortemer
(late twelfth century), which has a somewhat
different plan, is included in this group, but
Philip F. Gallagher, "The Cistercian Church at
Mortemer: A Reassessment of Its Chronology and
Possible Sources", SCAA 1 (1982) 54, deletes Mortemer
from the group with the plan of Clairvaux III.
See Marc–Anselme Dimier, *Recueil de plans d'églises
cisterciennes* (Grignan [Drome]: Abbaye Notre–
Dame d'Aiguebelle, and Paris: Librairie d'Art
ancien et moderne, 1949). Marcel Aubert, *L'Architec-
ture cistercienne en France*, 2nd ed. (Paris: Vanoest,
1947), 1:213–20, discusses the above–cited churches
and lists other examples, less certain because
plans are not definitely known.
16. Aubert, *L'Architecture cistercienne*, 1:212 and
1:318–19. The enormous eastern extension at Foun-
tains is also attributed to the increase in the
number of monks; see W. H. St John Hope, "Fountains
Abbey", *Yorkshire Archaeological Journal* 15 (1900)
277: "Facta est congregatio monachorum numerosior
quam solebat, nam et altaria pauciora ad celebran-
dum, et chorus humilior et obscurior, et minus
capax tantae multitudinis".
17. Bruzelius, "Longpont", p. 56; Chevallier as cited
by Dr Coutan in a review of Chevallier's *Notre–
Dame de Bonport. Etude archeologique sur une
abbaye normande de l'Ordre de Citeaux* (Mesnil-
sur–l'Estrée: Firmin–Didot, 1904) in the *Bull mon*
69 (1905) 185.
18. Hope and Brakspear, p. 136, gave the text from
the Close Roll of Henry III. See also John H.
Harvey, *English Mediaeval Architects* (London:
Batsford, 1954) p. 89; and Wyatt Papworth, "Notes
on the Superintendents of English Buildings in
the Middle Ages", *Transactions of the Royal Institute
of British Architects*, ser. 2, 3 (1886–87) 231–32.
19. The first documented gift to the building of the
church was substantial—according to the Close
Rolls of 1207/8 500 marks granted by King John
to the bishop of Winchester; see Hope and Brakspear,
p. 133, and Fowler, p. 48.

20. Alcobaça was founded in 1148 or c. 1153 and Varnhem in 1150, but the plan with radiating chapels was not constructed at these sites until the late twelfth century for the former and the early thirteenth century for the latter; see Dimier, *Recueil de plans*, 1:75 and 1:173, and Frédéric van der Meer, *Atlas de l'ordre cistercien* (Paris and Brussels: Editions Sequoia, 1965), pp. 270 and 301. See also Edw. Ortved, *Cistercieordenen og dens Klostre i Norden*, 2: *Sveriges Klostre* (Copenhagen: J. H. Schultz, 1933) pp. 225–58. In his forthcoming book on English Cistercian architecture, Peter Fergusson has suggested that the use of the plan may be connected to factors of burial, patronage, and royalty—factors which seem to obtain at Beaulieu. I would like here to thank Peter Fergusson for reading a draft of this manuscript and for making several helpful suggestions.

21. For the connection between Royaumont and Westminster, see Robert Branner, "Westminster Abbey and the French Court Style", *Journal of the Society of Architectural Historians* 22 (1964) 13, but two points contradict using the plan of Royaumont as the sole source for Westminster: the group missing a western aisle in the arm of the transept on the side of the cloister includes a larger number of churches than just Royaumont and Westminster. Beaulieu surely must be considered in searching for the source for this feature at Westminster, as has been implied in some of the literature on Westminster Abbey, e.g., John G. Noppen, *Westminster Abbey and Its Ancient Art* (London: Edward J. Burrow [1926]), p. 36. In addition to Beaulieu and Cîteaux, examples lacking one aisle can be found at the second church of Altenberg, Aulne, Mellifont, San Martino(?), and Val-Dieu: see the plans in Dimier, *Recueil de plans*, 2: pls. 8, 18, 195, 264, and 297, respectively. John Bilson, "The Architecture of the Cistercians, with Special Reference to Some of Their Earlier Churches in England", *Archaeological Journal* 66 (1909) 216 n. 3, had already noted this peculiarity at Beaulieu and Royaumont "doubtless in imitation of Cîteaux [sic]". Bruzelius, "Longpont", p. 102, n. 68, also remarked that Royaumont probably was meant to imitate this feature from Cîteaux, but she did not discuss the point further. Westminster is not the only non–cistercian specimen; Hans–Joachim Kunst noted the missing aisle at the abbey

church of St–Thierry; "Der Chor von Westminster
Abbey und die Kathedrale von Reims", *Zeitschrift
für Kunstgeschichte* 31 (1968) 130. Beaulieu and
Cîteaux share a further feature––if evidence turned
up during excavation in 1933 is correct: the typical
cistercian narthex or western porch. See the Subject
Secretary's Report––Architecture, 1933, in *Papers
and Proceedings of the Hampshire Field Club
and Archaeological Society* 12:3 (1934) 312; and
Hope and Brakspear, p. 150.

22. Peter Kidson has suggested that the geometry
of laying out the ground plan should also be
taken into account. A perusal of Dimier, *Recueil
de plans,* shows the following cistercian churches
with western aisles in both arms although in
some, aisles may have been added later rather
than designed at the beginning: Alcobaça Barbeaux,
Byland, Cara Insula, Casamari, Chaalis (with
apsidal termination of transept arms), La Cour–
Dieu, Fontaine–Jean, L'Isle–en–Barrois, Longpont,
Pontigny, Preuilly, St–Bernard–sur–l'Escaut, San
Galgano, and Villard de Honnecourt's plan for
a cistercian church; undoubtedly, further examples
could be found.

23. Thus, the various cavalier reconstructions, including
the splendid model made in 1929 after the research
of St John Hope and Brakspear and now exhibited
at the abbey, present much hypothetical material.
For reproductions of these drawings see n. 1
above and for an illustration of the model, see
Edward, Third Baron Montagu of Beaulieu, *The
History and Treasures of Beaulieu: Palace House
and the Abbey* (London: Pitkin Pictorials, 1968)
p. 20. The drawing of the south aisle of the
church (Fowler, pl. VIB) is, in its general lines,
like my reconstruction.

24. The nave at Furness also shows a single, large
respond, but another of Beaulieu's daughters,
Hailes Abbey (Glos.), founded in 1246, had triple
vaulting responds. Since the remains at Hailes
do not seem to reflect any specific architectural
influences from Beaulieu, they cannot provide
information for reconstructing Beaulieu. Money
for the foundation of a cistercian abbey at Netley
was left by Peter des Roches, Bishop of Winchester,
at his death in 1238. Henry III was financially
involved in the abbey by 1244 and was called
founder. Construction seems to have proceeded
slowly. A. Hamilton Thompson, *Netley Abbey* (London:

H. M. Stationery Office, 1953); Fowler, p. 55; and Hockey, *Beaulieu*, pp. 94-95.

25. At Fountains and Rievaulx, for example, the conventual work was also elaborate. At the former site, even the infirmary passage and the exterior of the east end had shafting *en délit.*. At Rievaulx the interior of the refectory showed an abundance of arches and shafts which, as Peter Fergusson suggested in a paper presented at the Fifteenth International Congress on Medieval Studies at Kalamazoo, Michigan in 1980, provided an appropriately enriched atmosphere for the monastic ritual of communal meals. Whether or not the architecture of the naves of cistercian churches was generally simpler than that of the choirs is difficult to judge since—if surviving—so often the two parts were built at different times.

26. In referring to the piers of the Chichester retrochoir, Jean Bony, "Origines des piles gothiques anglaises à futs en délit", in *Gedenkschrift Ernst Gall*, ed. Margarete Kuhn and Louis Grodecki (Munich: Deutscher Kunstverlag, 1965), pp. 115 and 122, n. 61, noted the similarity to the entrance piers of cistercian chapter houses such as Fontfroide, and suggested the possibility of a cistercian model. If so, such a lost example could have been informative for the piers at Beaulieu, too. A Norman cistercian example which is probably later, Fontaine-Guérard, shows shafts *en délit* around a rectangular core, but it does not have the complicated outline of these English examples.

27. Hockey, *Beaulieu*, p. 19. On royal lands, Binstead also supplied stone for the building at Chichester Cathedral; the abbeys of Quarr, Netley, and Titchfield; and other work throughout southern England, including much in Southampton; Ethel M. Hewitt and C. H. Vellacott, "Quarrying", in *VCH: Hampshire and the Isle of Wight*, ed. William Page, 5 (London: Constable, 1912) p. 462.

28. See also Bilson, p. 270 and fig. 14:i. The pointed roll or bowtell is sometimes referred to as a keel molding (see Bilson, p. 262), but the term "keel" is best kept for the molding with an ogee profile that reflects the section of a boat according to Richard K. Morris in correspondence with me in 1982. For the pointed roll, Morris prefers the term "nib" or "nibbed", which seems more prevalent currently. I gratefully acknowledge the very generous help and interest of Richard Morris with moldings

and their terminology used both throughout this article and over the years in my research, and I refer the interested reader to his work housed at the University of Warwick Archive of Moulding Profiles, Coventry, England. Since some of the moldings used in this article have been sketched from the ground rather than drawn with a template or profile gauge, readers are alerted that some moldings may not be entirely correct, either in individual elements or in overall proportion and alighment. Every attempt has been made, however, to render moldings as accurately as possible.

29. Hope and Brakspear, p. 155, believed that the arches, originally probably subdivided, have now lost the innermost order. This seems unlikely, but the evidence at the site is ambiguous; they may well be right.

30. Hope and Brakspear, p. 156. The diameter of both the capital and the base measures 23".

31. Compare Bilson, p. 267.

32. See Margaret Burke, "Santa Maria de Oliva: Its History in the Twentieth Century in Spain and California", SCAA 1 (1982) 78–87. Meredith Lillich suggested that these bosses may have been meant to be painted rather than merely left unfinished. I have found another plain, carved boss on the ground near the western end of the church at Cistercian Fontaine–Guérard in Normandy.

33. For later examples of the beaked half–roll, see Richard K. Morris, "The Development of Late Gothic Mouldings in England c. 1250–1400––Part II", *Architectural History* 22 (1979) 16–17 and 19 and notes 205–207.

34. See Appendix I for a list of examples.

35. For the wide hollow and quirk, see Bilson, pp. 250: fig. 5v and 5vi, 258, 265: fig. 13x, and 266.

36. The west façade and western nave of St Albans are difficult to date, partly because of their thorough restoration in the nineteenth century. Although the architecture is clearly related to Lincoln Cathedral and the north porch of Wells, unlike these the moldings at St Albans use beaked half–rolls abundantly, so much so in fact that perhaps this molding detail indicates that the work went up later than the date at which it was originally designed. This suggestion would put the construction during the abbacy of William

of Trumpington (1214–35) rather than that of John de Cella (1195–1214).

37. Illustrated in James Neale, *The Abbey Church of St Alban, Hertfordshire* (London: privately printed, 1877).

38. Bilson, p. 267, had already noted the particular elaboration of moldings in English cistercian doorways.

39. Hope and Brakspear, p. 136, citing the Annals of Waverley from the *Annales Monastici* (Rolls Series 36) 2:304.

40. Following the joints surrounding the monks' door is inconclusive because there has been too much disturbance of the masonry. The profiles of the two doorways are so similar that they must have been designed if not put up at the same time.

41. The first known gifts of funds donated for building the abbey are dated September 12 and October 23, 1204, whereas the first money earmarked specifically for the church is recorded on January 22, 1207/8; see n. 19. For the documentation on the building see Hope and Brakspear, pp. 132–37, and Fowler, pp. 46–55 and 222–23.

42. Not entirely in agreement with what Aubert has written for the building chronology of French abbeys (*L'Architecture cistercienne,* 1:102), in England, it seems, work often began first on the sanctuary of the church and then on the two domestic ranges for the brothers. Of course, this order of construction would depend in part upon what existing structures were available for temporary shelter, a factor which seems to have been an important prerequisite for cistercian foundations. For Beaulieu the Pipe Rolls show that King John had kept his hunting lodge there in repair before the transfer of the monks to the site; see Colvin, 1:90 and 2:983, and following Colvin, Hockey, *Beaulieu,* p. 19. Next, as the two ranges at the east and west walks of the cloister were going up, the wall contiguous to the aisle of the church and the adjacent walk of the cloister were laid out and probably partially constructed. If this logical order, which is nearly that proposed by Bilson for Kirkstall in "Architecture of the Cistercians", pp. 198–99 and 235–36, was followed at Beaulieu, then it would explain why the earlier design of the south aisle differs so radically in its style from the elaborate piers, probably built much later after the sanctuary

and the crucial conventual buildings around the cloister had been finished.

The few simplified details of the west range do not provide precise enough comparisons to set this range within a conclusive chronology, but the lay brothers' buildings were probably also among the earliest structures built. At Byland and Jervaulx, in fact, it seems that the west range was the earliest section built, and at Furness the west range was probably built before the nave. At Waverley the cellarer's building was one of the earliest stone structures, and the lay brothers' infirmary was constructed before that for the monks. Clearly, since the lay brothers formed the labor force of the monastery, their needs could not be neglected. For Byland and Jervaulx, consult Nikolaus Pevsner, *Yorkshire, The North Riding, The Buildings of England* (Harmondsworth: Penguin, 1966) pp. 99–100 and 203, respectively; for Furness, W. H. St John Hope, "The Abbey of St Mary in Furness, Lancashire", *Transactions of the Cumberland and Westmorland Antiquarian and Archaeological Society*, old series, 16 (1900) 229; for Waverley, Harold Brakspear, *Waverley Abbey* (London: printed by Roworth for the Surrey Archaeological Society, Guildford, 1905) pp. 53, 58, and 72.

43. See above n. 41, where references to source material are cited.

44. The Close Roll for 15 John (1213), printed in Fowler, p. 48, gives some indication of the increased tempo when royal funds came in: "And so hasten the first payment of 400 marks lest that work ['our work at Beaulieu'] should be discontinued for want of money".

45. Salisbury is probably an unlikely source since the building of the cathedral had just begun in 1220. Of the known sites, Winchester or Chichester would seem to provide the best choice of center from which masons may have come. Beaulieu lay in the diocese of Winchester, but the details of the architecture are closer to those found in the transept at Chichester. Furthermore, the work at Boxgrove near Chichester reinforces comparisons with the latter. However, historical and architectural connections between both cathedrals and Beaulieu, including stone from the same quarry, are well established. Several of the bishops of Chichester were involved in John's and Henry's administrations,

and Peter des Roches, a bishop of Winchester,
was one of the staunchest supporters of and closest
advisors to the king. Peter administered the first
major documented royal gift of funds as well
as others for Beaulieu; the previous bishop of
Winchester, Godfrey de Lucy, also granted funds
for the work at Beaulieu, while Peter des Roches
left money for the founding of the daughter house,
Netley. Incidently, Richard le Poore, bishop of
Chichester in 1215–17, became bishop of Salisbury
in 1217 (until 1228). See Hope and Brakspear,
pp. 133–34, and Fowler, pp. 47–49 and 55–56
for the documentary material on Beaulieu and
Peter des Roches.

46. The restorations are described in H. E. R. Widnell,
The Beaulieu Record (London: Pioneer Publications,
1973), chs. 14 and 15. After the restoration of
1839–40, the refectory was illustrated by Owen
B. Carter, "Some Account of Beaulieu Abbey in
the County of Hampshire", *Weale's Quarterly Papers
on Architecture* 2 (1844).

47. The refectory measures internally thirty by nearly
130 feet, according to Hope and Brakspear, p.
160. Many of the buttresses are modern, but the
profile of their plinths can be compared with
a piece left of the plinth of the church. Although
both look modern, the form is like the plinth
of the retrochoir of Winchester.

48. This molding is much like that of the rere-arch
of the castle hall at Winchester, but that one
appears to lack beaked rolls.

49. In the restored sections of the wall arcade beaked
rolls are absent, but they are present in both
the original moldings and Willis's illustrations.
Robert Willis, "The Architectural History of Winches-
ter Cathedral", *Proceedings of the Archaeological
Institute of Great Britain and Ireland* (1845;
rpt. in *Architectural History of Some English
Cathedrals,* 1 [Chicheley: Paul P. B. Minet, 1973])
p. 76.

50. Something like the "chamfered miter" was used
as the central element of the molding in the choir
arcade at Lincoln. The specific version used at
Beaulieu appeared at Lincoln in the ribs of the
choir aisles, the nave aisles, and the Consistory
Court as well as at Boxgrove, New Shoreham,
Salisbury (clerestory), the Elder Lady Chapel
at Bristol, and as late as Hailes and the chancel
arch of St Mary's, Stone (Fig. 14).

51. The annulet rings are either too restored or simpli-
 fied to be related to other specimens. Likewise,
 the simplified base of the pulpit—two rolls separated
 by a scotia, also found on a base in the subdorter
 yard—can be compared to many examples of minor
 bases all over the country as can the bases of
 the refectory door.

52. Colvin, 1:101. Jean Bony reminded me of the
 connection with domestic building in general.

53. Richard K. Morris, p. 23, termed this a "concave
 fillet".

54. F. A. Paley, *A Manual of Gothic Moldings*, 5th
 ed. with additions by W. M. Fawcett (London:
 Gurney and Jackson, 1891) pl. X:40.

55. For molded capitals in northern cistercian architec-
 ture, see Peter Fergusson, "The Late Twelfth-Century
 Rebuilding at Dundrennan Abbey", *Antiquaries
 Journal* 53 (1973) 240 and idem, "The South Transept
 Elevation of Byland Abbey", *Journal of the British
 Archaeological Association,* 3rd ser., 38 (1975)
 166.

56. Virginia Jansen, "Dying Mouldings, Unarticulated
 Springer Blocks, and Hollow Chamfers in Thirteenth-
 Century Architecture", *Journal of the British Archaeo-
 logical Association* 135 (1982) 41–43. On the cister-
 cian use of corbels see Krönig, pp. 44 and 95–
 98. The extensive use of corbels in place of shafts
 seen in particularly rich groupings in cathedral
 churches was also more economical. The use of
 corbels reflects the cistercian view best known
 in St Bernard's letter to William, abbot of St-
 Thierry.
 Like corbels, chamfer stops are common both
 in domestic and cistercian architecture. The variety
 seen at Beaulieu is unusual, but the type with
 a simple roll at the end of the chamfer is found
 frequently in southern buildings—Winchester (castle
 hall and retrochoir), Canterbury (cloister), Chiches-
 ter, Salisbury, Wells, Netley, etc.—as well as
 elsewhere, for example, at Fountains, Lincoln,
 and Maubuisson. The most elaborate stop, found
 on the jambs to the day stairs, occurs as far
 afield as Manresa in Catalonia (Fig. 15).

57. Samuel Gardner, *English Gothic Foliage Sculpture*
 (Cambridge: University Press, 1927) pp. 23–24.

58. Illustrated in Hope and Brakspear, pls. XV–XVIII;
 also see Appendix II.

59. Elizabeth S. Eames, *Catalogue of Medieval
 Lead-glazed Earthenware Tiles in the Department*

of *Medieval and Later Antiquities, British Museum,* 2 vols. (London: British Museum Publications, 1980).

60. A convincing earlier dating by Eames, p. 190.

61. The Amesbury tiles are discussed and illustrated in Frank Stevens, "The Inlaid Paving Tiles of Wilts.", *Wiltshire Archaeological and Natural History Magazine* 47 (1936) 367-75. Since Netley and Amesbury share patterns with the Salisbury tiles, they may be considered later than the group from Winchester and Clarendon.

62. Eames, p. 192.

63. David A. Hinton, "Excavation at Beaulieu Abbey, 1977", *Proceedings of the Hampshire Field Club and Archaeological Society* 34 (1978) 51.

64. Of course, the differentiation must not be overstated, for many of the arches at Lincoln are also low and broad, and all these arches are obviously derived from Canterbury or French Early Gothic. See Francis Bond, *An Introduction to English Church Architecture from the Eleventh to the Six-teenth Century* (London: Humphrey Milford, 1913) pp. 431–42; and Eugène Viollet-le-Duc, "Arc", in *Dictionnaire raisonné de l'architecture française du XIe au XVIe siècle* (Paris: Ve A. Morel, 1858) 1:45–87.

65. Bond, p. 432.

66. Colvin, 1:125; also 1:101 and 126, fig. 20.

67. Clearly a later insert, the doorway in the eastern transept at Lincoln may indicate that elements from the south were entering the Lincoln vocabulary by the 1230s. Compare Mary A. Dean, "The Beginnings of Decorated Architecture in the Southeast Midlands and East Anglia", Ph.D. dissertation, University of California, Berkeley, 1979.

68. Compare Peter Kidson, Peter Murray, and Paul Thompson, *A History of English Architecture,* rev. ed. (Harmondsworth: Penguin, 1965), pp. 88 and 90.

69. In this regard see the letter that Henry III wrote to the pope in 1226, requesting on behalf of the monks that John's body be moved from Worcester to Beaulieu; see above, n. 7.

70. This list is largely based on Eames's catalogue of tiles in the British Museum; the complete reference is cited above, n. 59.

71. The number refers to the design number given in Eames's catalogue.

72. Some of the Winchester tiles are illustrated and discussed by A. B. Emden, "The Mediaeval Tile

Pavement in the Retro–Choir", *Winchester Cathedral Record*, No. 17 (1948) 6–12; and G. E. C. Knapp, "the Mediaeval Tiles of Winchester Cathedral", *Winchester Cathedral Record*, No. 25 (1956) 16–24.

73. For Amesbury, see above, n. 61.

APPENDIX II

Notes

1. This list is largely based on Eames's catalogue of tiles in the British Museum; the complete reference is cited above, note 59.

2. The number refers to the design number given in Eames's catalogue.

3. Some of the Winchester tiles are illustrated and discussed by A. B. Emden, "The Mediaeval Tile Pavement in the Retro–Choir", *Winchester Cathedral Record*, No. 17 (1948) 6–12; and G. E. C. Knapp, "The Mediaeval Tiles of Winchester Cathedral", *Winchester Cathedral Record*, No. 25 (1956) 16–24.

4. For Amesbury, see above, note 61.

THE CANOPY OF PARADISE
John James

As Robert Branner wrote, Longpont was the first High Gothic church built by the Cistercians.[1] It was their first to be built with cathedral-like flying buttresses, radiating chapels and three-story elevation. The reasons for breaking with tradition may have had a lot to do with the man they appointed to be their first architect.

Little is left of the abbey.[2] In the choir a few courses remain around the chapels, with most of the plinths and tori, and some of the terminal wall still stands in the south transept (Fig. 5). On the south side a passage passes through the buttresses, and enters the church alongside the wall shafts, visible in Fig. 6. Just to the west of this opening there is a vertical joint in the wall. The heights of the coursing change here, as does the color of the stone, which is grey to the east and beige to the west. Above the stringcourse the continuation of the beige stones helps to show that the grey was earlier.[3]

The terminal wall of the north transept is concealed in the undergrowth, but there is a matching joint on this side too, also with smaller blocks of stone on the west, and with the joints between them so arranged that the east-to-west order of construction is clearly displayed.

On the southern side of the south terminal wall where the beige coursing lies over the grey there are further indications of this joint: the buttresses were reduced in size, and so was the south face of the wall itself which is set back just above the dripmold. This may be seen in Figure 7.

As the photographs show, this vertical joint was only a couple of meters high, and may not necessarily have extended right through the building. Thus the eastern end of the abbey and parts of the adjoining transepts were begun first, and the western walls were laid down a little later.

The grey stonework is finely cut, with larger courses than the west,[4] and many of the stones were edged with a chisel before being finished. Within the passage there are huge corbels supporting the lintels, with large roll-molds on the underside, shown in Figures 1 and 7.

Corbels are interesting devices. They reduce the width of the opening just at head height, giving the

silhouette of wearing a tight hat while passing through the passage. There are many different shapes, but ones like these, which are massive in scale and have such large roll-molds, are not particularly common. In the second chapter of *The Contractors of Chartres*[5] I described a band of similarly well-cut stones with pre-chiselled edges, culminating in big corbels. The corbels from Longpont are like those from the Chartres triforium. The master used the same foot unit to set them out through similar geometric processes.[6]

At Chartres this master is Scarlet.[7] He worked in the triforium in 1206, but earlier in 1200 had worked on the plinths of the apsidal chapels and before that had been the first architect on the site, after the fire of 1194.[8] The initial plan for the cathedral was Scarlet's.

Chartres is one of the few buildings to have unequal chapels. This was because the new work was set over and supported by the eleventh century crypt, and the spaces between the older chapels had left too little room for equally large chapels to be inserted between them.

In Scarlet's initial scheme there was only a single ambulatory with seven deep radiating chapels and two additional chapels in the double-aisled sanctuary, shown in Figure 2. During construction, in about 1199, the pressure of pilgrims trying to get to the altars[9] seems to have persuaded the client to alter the plan and continue the double aisles of the sanctuary all round the ambulatory.[10]

But if the Chartres plan were redrawn with equal chapels, it would be almost interchangeable with the plan for the choir at Longpont, in Figure 3. The only difference between the two would be the number of bays in the sanctuary. Otherwise the walls of the chapels are curved in plan, with single shafts supporting their ribs, no provision for formerets, and with a simple splayed plinth which extends continuously around the walls.

The bay at Longpont measures twenty Roman feet, and the span forty-five.[11] Exact multiples of the same Roman foot were used to set out Chartres,[12] but where the span-to-bay ratio there was 7:3, that at Longpont was 4:9. Both are harmonic ratios using whole numbers rather than squares or circles, but where the seven and three at Chartres were part of a complex symbolism of numbers and forms, the ratios at Longpont may be no more pleasing than the sequence of $2^2:3^2$. One would need to measure the building with care to determine

the whole system. At Chartres Scarlet appears as a thinking man, concerned with philosophical issues, and seems to have incorporated many sacred ideas into the design.[13] It would be fascinating to discover if he had done the same at Longpont.

One final item of evidence which is, I think, conclusive, lies in the bases of the piers. A comparison of Figures 8 and 9 shows that the Longpont bases are identical to those under the drum piers Scarlet set up in the Chartres apse, after the ambulatory had been doubled.[14] The circular drums turn into octagonal bases under the tori. In the next course the splay follows the octagon, but under it a curved molding transforms the octagon into a square. Seen from the side this molding is not unlike Scarlet's corbel, with a crease down the centre. These moldings begin under the splay, and not above it,[15] and finish in a small chamfer rather than a sharp corner.

The same geometric system was used to determine the diameter of the drums, by making their area equal to a square which was a proportion of the span.[16] In all these things the Longpont bases are identical to those at Chartres. There are no other bases like these in the Paris Basin from this period.[17] It is hard to believe that the same master was not involved in both places.

As the first master on both buildings, Scarlet may have produced the models from which they were built.[18] This does not necessarily mean that every master who followed him would have repeated the same details, proportions, or even the same elements. The joint discussed earlier shows that, as at Chartres, more than one contractor was employed, and though each may have been instructed to follow the model, the actual sizes, heights and templates would have been determined personally by whichever master was on the job. Each master would have interpreted the model in his own way, subtly modifying the original concept as work proceeded. Looked at in this way the many differences between Chartres and Longpont are not so significant.

Also, the original design may have been altered by the client as work proceeded. A large building took many decades to construct, and as architectural ideas were changing fairly rapidly, one might expect the model to have been updated from time to time. At Chartres there is evidence for a competition in 1211,[19] resulting in changes to the design of the clerestory. After sixteen years the ideas proposed in 1194 may

have seemed out of date, and the double lancet with its large surmounting rose may have been the result.[20]

Drawings made of the choir at Longpont before it was entirely demolished show that a similar ongoing design process was at work there as the construction moved westwards.[21] The vertical proportions in the choir were modified in the nave, the structural details were altered by raising the springing of the vaults,[22] and the tall single–light clerestory was turned into a smaller version of Chartres.[23] The nave as we see it today, in the two bays which remain to us, is a greatly modified version of what had been earlier built in the choir. The two schemes are compared in Figure 4, which should be compared with Figure 16.

It is particularly interesting that nearly all these changes occurred in the upper part of the elevation, for this is where new concepts were coming in thick and fast just then.

It is usually considered that "no part of the church we now see [at Longpont] is stylistically earlier than 1205–1210".[24] For the choir this would seem to be open to doubt, especially if one compares the single windows of the choir clerestory and the low springing with other buildings from the first decade of the thirteenth century. If the raised springing in the nave, which only just clears the top of the sill, marks an updating of the scheme in accordance with what was current, then stylistically 1200 would not be an unreasonable date for the western end if only because it would have taken some years more for this not–so–tall clerestory to be elongated into the very tall schemes of Soissons and Chartres, both conceived around 1210.[25] Similarly the double lancets surmounted by a rose in the nave clerestory are quite in keeping with the years close to 1200. as may be seen in the Chartres sanctuary aisles,[26] the Chalmaison south arm and the Chapelle des Fonts in the cathedral of Laon.[27]

So, if the clerestory level of the Longpont nave can be stylistically consistent with other work around 1200, then the start of the choir should be placed about two decades earlier. That would place Longpont before Chartres, not afterwards. In which case the drum piers would have been a natural solution for the time, and not a "highly retardataire feature"[28] as they would have been in a later building. One of Scarlet's most important innovations at Chartres was the *pilier cantonné*, again suggesting that the circular drums at Longpont were an earlier work.[29]

I do not think that the retirement of Pierre le

Chantre to Longpont in 1197 can be used to date the commencement of the building works,[30] just as the translation of Bishop Jocelin's relics from Soissons cathedral in 1192 cannot be used to date the completion of the choir.[31] However, I do believe the capitals can give us some idea of dating.

Between the 1150s and the 1230s the design of the capitals in the Paris Basin was changing quite rapidly, and these changes seem to have followed a consistent evolutionary pattern. Before and after these dates the pattern is neither so clear nor as unambiguous. The reliability of using the capitals is shown by two observations: within these seventy years there is not one building where the assemblage of capitals in any upper story looks more antiquated than those in a lower level, nor is there any group of contemporary capitals in any building which are not stylistically consistent with one another. Under these circumstances it is hard not to see the capitals of the Basin evolving in an orderly and definable sequence.[32]

The capitals in some buildings can be dated with precision, and they must form the basis for any more general chronology. Those in Chartres and in the aisles of the Soissons south transept flank the work at Longpont, and are datable. In the latter, the lowest capitals can be fairly accurately placed around 1178;[33] three are illustrated in Figures 10, 11, and 12. We can also date those in the porches and aisles at Chartres to around 1200,[34] shown in Figures 13, 14, and 15. They illustrate the evolution from delicate, stylized and many-layered leaves arranged in a symmetrical manner, to a greater naturalism and inner energy.

The only capitals at Longpont which are still in place are in the western nave, three of which are shown in Figures 16, 17, and 18. They are neither as foliated nor as delicately refined as those in Soissons, nor are they as natural nor as mobile as those in Chartres.[35] They are closer to those in the clerestory level of the Soissons transept, which one could date to the later '80s.

I would therefore ascribe the aisle capitals in the nave at Longpont to just after the latter, in the 1190s. The lowest courses in the nave would have been begun five or more years earlier, say between 1185 and 1190. The start of the choir, which was begun before the nave, would therefore have to be dated to the mid '80s, if not before.[36] Thus Scarlet's scheme for Longpont was a forerunner of the great work he was to design a dozen years later on the other side

of Paris.
The nearby Premonstratensian abbey of Braine is lighter in its elements, lower and somewhat smaller (Fig. 19).37 It and Longpont would seem to have been the two most revolutionary buildings in the area. Both were well under way before the middle of the 1180s in a region which was almost totally devoid of three-story elevations.38 The four-story Soissons south transept was of course a replica of St-Rémi, and Laon cathedral probably the progenitor of both.39 But they are unique. Otherwise every building in the region built before 1190 had either one story or two, even in parish churches like Oulchy or Nouvion.40

At Braine and Longpont the continuous triforium was introduced to the Soissonais from other areas, probably from the Ile-de-France, and inserted into the relatively austere and tall unicellular structures of the area. The effect was two-fold.

As the continuous triforium wove through the slender vaulting shafts it created a horizontal movement which bound the bays together. This permitted the masters to further increase the height without seeming to be too extreme. As the vaults were raised, so the new triforium anchored the building by holding it in the air, so to speak. It raised the center of gravity above the aisles, setting it into the darkness of the triforium. All loads now appeared to flow past or through it. The impact on the whole space was momentous. The interior now appeared to float rather than being anchored to the ground.

Externally the flying buttresses seem to repeat the same idea. Their structural function is to support the thrusts from the interior cage; but the Braine and Longpont flyers, like those at Chartres, are not arranged in the most efficient way. The steep arches at Bourges used much less material than the more upstanding and horizontal ones found in the Basin.41 While the Bourges flyers look like struts bracing the building against the ground, the more horizontal arching of Chartres and elsewhere appear to suspend the interior from above. In this they perform a similar role to the triforium, in gently lifting the building off the ground, like a canopy supported from the fingers of a puppeteer.

Though the first flyers were possibly those at Voulton in the mid '60s,42 major buildings were being designed for them by 1170 at the latest, like St-Rémi.43 The flyer therefore predated the continuous triforium.

The use of both at Braine and Longpont at this time, and in the area of the Soissonais, is most signifi-

cant. The Premonstratensians were reforming their order on the Cistercian model,44 and there would probably have been considerable personal links between the two abbeys. For ideological reasons the monks at Braine may have deliberately decided to employ the triforium with the flying buttress to give the feeling of "floating a meter off the ground",45 rather than being anchored to its foundations, as in so many local buildings like Nouvion or St-Martin in Laon.

As one ponders how this idea came to their attention, few earlier sources seem pertinent. In the Paris Basin the triforium, built as an arcade set into the wall, was used at Juzières, Voulton and Monmartre for example, but was never extended across the entire bay without some walling being left between the arcade shafts and the main piers supporting the vaults. There are earlier continuous triforiums beyond the Basin, but they are more decorative than architectural, and do not have the same spacial richness as the Braine solution.

The more common type, especially in the Royal Domain, was for the arcade to be enclosed within an arched frame. This does not impart any horizontal movement, but is part of the compartmentalized vertical articulation of each bay. This traditional gallery is not unlike the elevation of a miniature church where the arcade represents the aisles and the encasing arch the main vaults. Placed between the upper windows and the aisles it is not unlike a reliquary, or a model church held in the hands of some saint.

Within the Basin, Laon may be the first example of a continuous triforium in the mid '60s, followed by the first arches of the Noyon transept triforium which were built with the adjoining piers of the choir gallery around 1170. But their size, and relative insignificance in relation to the other elements pressing hard around them, diminished their importance. They are more like a frieze, and so closer to their eleventh century prototypes than to Braine or Longpont.46

As used at Braine, and this may have been its particular contribution to the history of medieval architecture, the triforium was made into a centralizing motif in its own right. In doing so it created a new canon which, within a few years, was to influence every major architectural undertaking for the next century. Over fifty buildings with continuous triforiums were to be started in the Basin in the half century following Braine.47

In following this solution the masters at Longpont made some subtle changes—the arcade was pushed upwards to increase the spaces of the aisles so the vaults seem

to hover, and then the uppermost part was made more substantial by placing a wall against the back of the triforium arcade. This created a different balance between the lower voids and the solidity above. At least in the choir, where the vaulting capitals were set close to the triforium and the clerestory windows were small, the triforium tended to share the upper space with the vaults. It was as if the walls of a smaller single-storied church had been raised into the air, complete with windows and dado arcade, and supported on the thinnest columns. It was the Church of Paradise in the sky, or the "independence of the baldachin" as François Bucher suggested.[48]

These two distinct solutions of the triforium were, in one sense, offered to the world in much the same way as were the flying buttresses of Chartres and Bourges. The Braine solution was taken up with particular enthusiasm in the Ile–de–France where the gallery had had a long popularity, and where it was not a great step to turn it into a new form by just omitting the encasing arch. The implications are deeper than this, of course, for by leaving out the arch the arcade which remained formed an articulated hollow threading through the verticals of the bay structure, annihilating the old compartmentalized interior, and replacing it with a more unified and rhythmic arrangement.

With the invention of the double windowed clerestory and tracery, the Braine solution came into its own.[49] The alternative solution at Longpont, though taller and lighter, was in the end less acceptable. The weightier solutions of the cathedrals, like Chartres and Reims, could be seen as "mundane" interpretations of the spiritual transcendental qualities of the abbeys. While the triforium and flyers at Chartres still pull the building into the air, the solidity of the parts, especially the piers and buttresses, demonstrate what it is really made of. The function of these cathedrals is more worldly than the abbeys. It seems right that both Braine and Longpont should have experimented with ways of suspending the building on lighter posts, like a Canopy of Paradise.

Thus Longpont should be seen in context, as an abbey and not a cathedral, in which ideas were tried which were appropriate to the abbey but which led directly to the great classic churches of the next decade. It was an innovative design, and not a backward or reactionary copy. Its originality lay not only in being the first Cistercian building to be conceived in the grand manner,[50] but in the consequences of entrusting it to a master whose contracting organization was not

exclusively devoted to monastic work.51

That a commercial contractor should have been employed by the Cistercians, and that he should have designed such a church for them in that area, suggests that these monks were looking beyond the isolationist policies of their order to the world around them. As Caroline Bruzelius remarked, it led "to a new prominence and grandness of scale that ultimately left the Cistercians vulnerable to the accusation that they constructed churches inspiring not reverence but envy".52 It is one of the contradictions of history that in attempting to bring something of Paradise down to earth the Cistercians may have endangered the very spirituality which produced the new architecture.

University of Sydney
Australia

NOTES

1. R. Branner, *St Louis and the Court Style in Gothic Architecture* (London: 1965) p. 14. The research for this article has been supported by the Australian Research Grants Committee 1981/83, the Graham Foundation for Advanced Studies in the Fine Arts, and the Ministère des Relations Extérieures de France in 1982. I would like to thank Caroline Bruzelius for tempering my language, Madeline Caviness for her generosity and openness, and above all my editor Meredith Lillich for her stimulating commentaries which have broadened this article considerably. Written in Longpont, May 1983.

2. C. A. Bruzelius, "Cistercian High Gothic: The Abbey Church of Longpont and the Architecture of the Cistercians in the Early Thirteenth Century", *Analecta Cisterciensia* 35 (1979) with extensive bibliography. The abbey was pulled down between 1791 and 1830 for its stone.

3. This would be pier SE 4. The passage continues through the SE 4 and the buttresses.

4. Average coursing heights vary from 310–380 mm, compared to 220–310mm in the west.

5. J. James, *The Contractors of Chartres* (Wyong: 1979–81) especially pp. 21–23 and Pl. 20.

6. The Chartres geometry is described in James,

 Contractors, p. 28. The Longpont corbel is designed from modules of a quarter Roman foot and a similar use of the compass.

7. I gave the masters at Chartres the names of colors, discussed in James, *Contractors*, pp. 74–5.

8. The evidence for this is described in ch. VIII of James, *Contractors*, and in the references given in the isometric A on p. 181.

9. Document in E. Lepinois and L. Merlet, *Cartulaire de Notre-Dame de Chartres* (Chartres: 1862) 1:260.

10. The evidence is in James, *Contractors*, pp. 166–172.

11. 13,420mm by 5,920mm measured at the western end, and checked at the crossing. Many of the other piers were inaccurately replaced. The bays flanking the crossing are larger than the others, being $22\frac{1}{2}$ Roman feet instead of 20, making the overall distance between these flanking piers 90 feet, or twice the square of the crossing. The first Chartrain piers are also further apart than the rest.

12. The Roman foot as used by Scarlet measured 294.5mm.

13. See discussion in James, *Contractors*, pp. 148–160 and in J. James, *Chartres--the Masters Who Built a Legend* (London: 1982) pp. 83–112.

14. Bruzelius discusses these bases on pp. 63–65.

15. For the depressed griffe see C. Barnes, "The Cathedral of Chartres and the Architect of Soissons", *Journal of the Society of Architectural Historians* 22 (1963) pp. 63–74.

16. The drum of Longpont is formed by drawing a square equal to one fourteenth of the span, and transforming that into a circle of equal area through the ratio of 9:8. The same arrangement at Chartres is described in James, *Contractors*, pp. 118–119.

17. I have visited every Early Gothic church in the Paris Basin during the past four years. Similar plinths are only to be found at Villenauxe-la-Grande, though they are taller and less open in their proportions. There are slightly similar ones at Itteville and in two *spolia* bases now in the nave at Ourscamp. It is a rare concept. For these visits see J. James, "An Investigation into the Uneven Distribution of Early Gothic Churches in the Paris Basin, 1140–1240", *Art Bulletin* 66 (March 1984) pp. 15–46.

18. No models exist from the period, and few documentary references, though donors and architects are shown

holding them. It would be hard to conceive of a more practical way to explain a proposal to a client, sell an idea to a donor or form the basis for a building contract.

19. James, *Contractors*, p. 438.

20. Exactly the same templates were used for the sills, the flanking interior and exterior responds, exterior walkway and supporting corbels over the triforium in the choir of Soissons cathedral and Dourdan, both of which would be contemporary with Chartres, and I think by the same contractor, Ruby. This section of the building is drawn in James, *Contractors* GEOM:XII-D and XVIII:11.

21. Illustrated in Bruzelius, Pl. 9.

22. The vaulting capitals in the choir are below the window sills, as at Braine, unlike the "tall clerestory" in the nave. See discussion in Barnes, p. 64, n. 8 and in J. James, *Pioneers of the Gothic Movement* (Wyong: 1980) p. 7, where Grant Hildebrand and I suggested that "the springing sits under the sill from the mid '80s, at the sill from the mid '90s and above it from about 1210".

23. Bruzelius, pp. 74–76. Unlike Chartres, but like Soissons, the nave has a small rose set under a pointed arch, not a full-width rose under a round arch. The arrangement of jambs without flanking shafts is more typical of work from the Oise than from the Soissonais.

24. Bruzelius, p. 36, with discussion of other scolars' estimates in n. 154, including M. Aubert and R. Branner who agreed with this dating.

25. For Soissons see C. Barnes, "The Architecture of Soissons Cathedral: Sources and Influences in the Twelfth and Thirteenth Centuries", Ph.D. Dissertation, Columbia University, 1967, where he dates the commencement of the choir just after Chartres and the completion by 1212. In discussions in Soissons in 1977 we favorably examined the possibility that the clergy may have occupied the choir under a temporary roof set over the triforium, thus making the two cathedrals virtually contemporary. Barnes' work is important in stressing the Soissonais sources for the Chartrain elevation.

26. These windows were begun in 1201 and the rose installed in 1204. James, *Contractors*, pp. 204–208.

27. W. W. Clark, *The Architecture of Laon Cathedral* (London: 1983) where this chapel on the south side of the nave is shown to be built with the

28. nave around 1200.
28. Bruzelius, p. 65.
29. There are forty-two buildings with the *pilier cantonné* in the Paris Basin before 1240, all probably after Chartres with the possible exceptions of Angincourt, Chalmaison and the Corroy porch.
30. Bruzelius supplements her stylistic argument by suggesting that Pierre, who had written a tract against over-elaborate churches, would not have retired to Longpont if the present enormous abbey had been started. Bruzelius, pp. 29 and 41.
31. *Gallia christiana*, 10, preuves col. 114. Date given by Antonio Muldrac, *Compendiosum abbatiae Longipontis Suessionensis chronicon* (Paris: 1652) p. 36.
32. As part of the survey mentioned in n. 17, I have photographed almost every one of the capitals in the Paris Basin, and am attempting to use them to establish a dating matrix with a potential accuracy of a couple years. This was presented in open discussion at Kalamazoo in 1983, and will be published.
33. From the donation for the land by Nivelon de Cherizy in 1176, given in Paris, Bibl. Nat., *Collection Baluze*, 46 fol. 467, from a lost obituary.
34. James, *Contractors*, especially pp. 369–371 and ch. XI.
35. Capitals by the same carvers can at times appear quite different when carved in hard or soft stones, like *lucastre* or *grossière*. I have chosen capitals carved in similar stone from all three buildings.
36. In Chartres it took eight years from the start of the nave to the aisle capitals, and another ten to the clerestory sills.
37. Braine has been dated by nearly all scholars as being after Chartres and so derived from it, or just before in which case its position as one of the sources for Chartres has been ignored. In a recent article, Richard Pestell has accepted the possibility of an earlier date and discussed some of the implications, but gives no reasons. Meanwhile Madeline Caviness and myself have been independently approaching the dating of the abbey from different directions, and were recently delighted to discover that we were in agreement. In 1980, she found documents which seem to bear out a commencement date some time before 1180. Her work precedes mine, which was only begun in 1981 (as in n. 34). From the capitals

I calculated a date for those in the eastern aisles to 1180 or just after, those in the triforium to 1185 or so, the clerestory shortly afterwards and the lantern tower to just about 1195. This would suggest a commencement date of around 1177. Caviness' study of the documents and the ornamental sculpture has prompted her to the same conclusion: that the building must have been begun close to 1175, and completed in the west by 1208, and that the oft-cited dedication of 1216, which has no support in contemporary documents, has been more misleading than useful. Her study, entitled "Saint-Yved of Braine: Primary Sources for Dating the Gothic Church", will be appearing shortly in *Speculum*. My study on capitals will not be ready for a while, and the article by R. Pestell, "The Design Sources for the Cathedrals of Chartres and Soissons", *Art History* 4 (1981) 1-13 cites most of the other literature.

38. Arcy-Sainte-Restitue has an intermediate floor, but the arcade is encased. The Couvrelles west front, erected on its own before any of the adjoining work, may be the first continuous triforium in the Soissonais, being closer to 1175 than 1185 (dating from the capitals). It is interesting that this master combined the triforium with a more traditional west front with paired windows over a gabled doorway, thus "inventing" the first glazed triforium at the same time that he introduced it into the region. St-Vincent in Laon is regularly quoted as being the first three-story elevation in the region, but the documents do not clearly date it, and without the capitals there is no way of knowing. The few remaining capitals in the nave walls suggest a date closer to 1200, and I thank William Clark for showing these to me. The "Resistance to Chartres" may turn out to be a combination of stylistic evolution and regionalism, after all: see J. Bony, "The Resistance to Chartres in Early Thirteenth Century Architecture", *British Archeological Journal* 19-20 (1956-58).

39. For Soissons see the studies of Barnes; for St-Remi see A. Prache, *Saint-Remi de Reims, l'oeuvre de Pierre de Celle et sa place dans l'architecture gothique* (Geneva: 1978); and for Laon see Clark.

40. For Oulchy see E. Lefevre-Pontalis, *L'Architecture religieuse dans l'ancien diocese de Soissons au XIe et au XIIe siècle* (Paris: 1894-96); and for Nouvion see same author, "Eglise de Nouvion-le-

Vineux", *Congrès archéologique* 78 (1911) 388–98.

41. R. Mark, *Experiments in Gothic Structure* (Cambridge, Mass: 1982) pp. 34–49.

42. Salet and Prache both date the eastern end to 1180 or afterwards. From the capitals and their similarity to those at St–Quiriace in Provins I would date the choir clerestory capitals to before 1165. Externally the shaft supporting the flyer arch and the capitals under it are bonded into the wall and would therefore be contemporary with the rest of this part. Certainly the simplicity of the design suggests that Voulton may be one of the first. See F. Salet, "Voulton", *Bulletin monumental* 102 (1944) 91–115 and A. Prache "Les Arc–boutants au douzième siécle", *Gesta* 25 (1976) 31–42.

43. Prache, *St–Remi*, pp. 69–70 shows that the huge buttresses in the choir, which she dates c. 1170, were designed to support flyers, and can be seen, from the original coursing, to have been built with the adjacent chapels. The buttresses flanking the axial chapel do not project as much, and appear to have been set sideways. One contains a staircase. One might consider the possibility that a second–story chapel had been intended, set over the lower axial chapel and projecting like it. The staircase would then have joined the two, and the buttresses integrated in an appropriate way with the walls of the chapel to support flyers like their neighbors.

44. L. Lekai ocso, *The Cistercians: Ideals and Reality* (Kent, Ohio: 1977) pp. 30, 277; M. Aubert, *L'Architecture cistercienne en France* (Paris: 1947) 1: 16, 143; C. Brooke, *The Monastic World 1000–1300* (New York: 1974) pp. 181–84, 258.

45. Letter to the author from Meredith Lillich where she writes "If the Cistercians could have built their churches floating a meter off the ground, they would have done so—and in fact, at Fontfroide they actually tried to get that effect, by placing an entire, complete wall elevation, down to the plinths, bases, etc., on top of great unarticulated blocks, so the "wall" actually "begins" above the ground. The monk enters his church, he *stands in* his transitory world, and he *looks at* the habitation of God above him".

46. St Michel–en–Thierace and Braine have a lot in common; Pierre Héliot has dated the former to the 1180s, but in a recent paper Alain Gigot,

Architect for the Monuments Historiques in Laon, gave a paper suggesting an earlier date. P. Héliot "L'Abbatiale de S.-Michel-en-Thierace, modèle de S.-Yved à Braine", *Bulletin de la Commission royale des monuments et des sites* (1971) 13–43.

47. Not all new works were built with the continuous triforium. Many continued with the old encased arrangement, as Gonesse which should be dated to around 1200.

48. F. Bucher, "Cistercian Architectural Purism", *Comparative Studies in Society and History* 3 (1960–61) p. 102. I would like to thank Meredith Lillich for bringing this to my attention.

49. Tracery seems to have been invented in the east of the Basin around 1215. See my forthcoming "M1, the master of tracery", presented at Kalamazoo in 1983. The double window with surmounted oculus was an older idea, probably originating in the Oise region. It was this which was used in the aisle sanctuary windows at Chartres 1201/4 and in the clerestory of the Longpont nave.

50. Maybe not: the strict bernardine tradition in building had begun to change shortly after his death in 1153, as can be seen at Preuilly. The capitals in the ruined choir suggest a date in the mid to early '60s, so the foundations must have been begun only a few years after he died. It is a two-story elevation designed in the style of the moment—thoroughly up-to-date in fact. Above the triplet eastern windows there is a huge rose window, stretching full-width across the span, divided into sixteen segments which, from the flanking capitals which are like those in the vaults, should be dated c. 1165. We do not know enough about the history of the rose window to say whether this one at Preuilly was another cistercian innovation, but the size does seem quite unusual for this date. G. A. de Maillé, *L'Eglise cistercienne de Preuilly* (Paris: 1930).

51. This is not the place to demonstrate Scarlet's other projects, but he can be readily identified in the western upper ends of Mantes–la–Jolie and Laon cathedral, parts of Lagny and sundry other buildings which have yet to be clarified. But so far less than half of his ecclesiastic work was for abbeys.

52. Bruzelius, p. 138.

John James is a frequent contributor to medieval confer-ences at Kalamazoo.

THE CHOIR OF THE ABBEY OF ALTENBERG:
CISTERCIAN SIMPLICITY AND ARISTOCRATIC ICONOGRAPHY
Michael T. Davis

The former abbey of Altenberg, cached in a sylvan valley of the Dhunn, is one of the most princely edifices built by the Cistercians.[1] The monumentality of its structure places it among the handful of the Order's churches that embraced the aesthetics of the high gothic "cathedral architecture", yet Altenberg is thoroughly Cistercian in character. The paradoxical personality of the abbey, its severe complexity, its elegant sobriety, underscores the nature of the interchange between the Cistercians and contemporary episcopal edifices in which planning formulas and details of style were appropriated but willfully transformed in accordance with the Order's architectural policies. The elaboration of plan and structure of major houses in the thirteenth century has been viewed as symptomatic of the increasing pollution of the Order, a sign of a fatal materialism, laxity, and decay.[2] Altenberg, like its French counterpart at Royaumont, is partially the result of the conflicting pressures exerted by the internal statutes of the General Chapter that sought to maintain a degree of puritan simplicity in the face of a rapidly developing liturgy and the ambitious visions of aristocratic patrons.

Because Altenberg, along with nearby Cologne Cathedral, is one of the purest examples of the *opus francigenum* on German soil, its construction has been interpreted as a political act involving the deliberate choice of a plan and elevation on the basis of their associational values.[3] The abbey is not a reproduction of a precise model or ideal and thus suggests that gothic concept of *imitatio* was not couched in "either-or" terms based on a single source, but rather resided in generalized effects and salient features. The Rhenish abbey's existence as a cistercian foundation and as the necropolis of the noble Berg family, plus its indirect entanglement in the arena of European power politics that revolved around the Machiavellian figure of Archbishop Conrad von Hochstaden, seem to be reflected in its dual ties to France and Cologne. Its plan and elevation result from the confluence of pragmatic and iconographical factors that were unique to the abbey, were recognized by the project's patrons, and were given visual expression by Master Walter, the architect.[4]

As in so many thirteenth-century cistercian establish-

ments, the new choir at Altenberg, at its most basic level, was a practical response to the dramatic growth in the number of its brethren. Founded in 1133 and settled by the requisite cadre of twelve monks who accompanied the first abbot, Berno, from Morimond, the Altenberg community grew to 107 monks and 138 *conversi* by the end of the twelfth century.[5] This increase in a resident population equal to that of the larger houses in France would have filled the first church to overflowing.[6] The original mid-twelfth century edifice was laid out on a relatively restrained scale and display-ed an uncommon plan that reveals a major change during the course of construction (Fig. 1). The fifty-meter length of the interior was cut by a projecting transept measuring thirty meters from north to south. Four chapels opened off of the east wall of the transept and the simple semicircular apse terminated a square sanctuary bay. The southern pair of chapels comprised an outer deep, apsed unit with a small annex tucked between it and the choir. This preference for exposed apses is akin to contemporary cistercian abbeys such as Bel-laigue, Cadouin, Flaran, or Georgenthal, while the alternation of major and minor spaces produced a syncopa-tion in the exterior massing that must have resembled Fontfroíde.[7] The north arm of the transept is the clear result of a plan change, one that brought Altenberg I into a closer relationship with normative cistercian types. Two identical chapels are imbedded into a straight eastern wall in a configuration that approaches Le Thoronet and Senanque. This alteration has been viewed as a move toward a more bernardine mode of planning.[8] The nave of eight bays, fronted by a porch, rose atop square piers and was probably timber-roofed as at Marienthal (1143) or Zinna (1171).

By the mid-thirteenth century, the first abbey church, "consumed by age", had become inadequate for the thriving Altenberg community. On 3 March 1259, Count Adolf IV von Berg and his brother, Duke Walram IV von Limburg, laid the first stone of the new lavishly scaled edifice (Fig. 9).[9] Aided by a quest throughout the archdiocese of Cologne, the new fabric surged forward quickly.[10] By 1276 ten altars had been constructed, thus implying that the entire ground floor of the chevet was liturgically functional".[11] In 1281, a forty-day indulgence was issued by the Bishops of Hildesheim, Minden, and Munster to those who attended the consecra-tion or anniversary of the church and in 1287, nine altars in the choir were dedicated.[12] The shreds of documentation provide only an imprecise terminus of

c.1280/1285 for the work. Nevertheless they confirm
that the choir was realized in a compact, continuous
campaign of labor, an impression seconded by the unity
of the plan and superstructure.

The existence of the range of claustral buildings
along the south flank of the abbey church and the
necessity to enlarge the size of the choir led to a
shift in the axis of the new structure 2.70 meters to
the north (Fig. 1 and 9). The envelope of the gothic
chevet could be laid out and a substantial portion
of the ambulatory, hemicycle, and the eastern bay
of the outer aisle of the sanctuary raised prior to
the demolition of the twelfth–century fabric. The location
of the center point of the thirteenth–century plan east
of the romanesque walls insured that the process of
setting out would be as accurate as possible. At the
same time, the elder church profoundly affected its
successor: although replaced, it was not obliterated.

The new choir of Altenberg is radically different
than its predecessor and, indeed, is unique in cistercian
architecture (Fig. 2). Joined at the west to a projecting
transept, the chevet is composed of three rectangular
straight bays flanked by double aisles and a seven-
segment apse that is encircled by a single ambulatory
and seven uniform radiating chapels. The irregular
form of the transept is the most overt legacy from the
first abbey church. Its stunted south wing, hemmed
in by the east and north walks of the cloister, the
dormitory and cellar, reproduced the dimensions of
the earlier arm that, consequently, resulted in the
rectangular gothic crossing.[13] The north arm was develop-
ed fully with aisles to the east and west.

The Altenberg chevet was developed within a
square of 29.70–29.75 meters.[14] This dimension closely
approximates the interior length of the twelfth–century
transept. Because the gothic project doubtless envisioned
a complete reconstruction of the older church, there
was no pragmatic motivation behind the choice of this
measurement. The patrons of the project, the Berg family
in concert with the monks, may have asked their master
mason to "memorialize" the venerable romanesque abbey
through the incorporation of its essential dimensions
into the new plan. Although the gothic edifice appears
to be utterly ignorant of its predecessor, the absorption
of the old into the new seems to have been a decisive
factor in the generation of the thirteenth–century scheme.
As in Altenberg I, the breadth of the aisled north
transept arm is equal to the length of the presbytery,
that is, the distance from the center of the crossing

to bay division 6.15 Even the pragmatically pre-determined width of the south arm was assimilated into the choir plan. The architect, wielding his "geometrical and arithmetical instruments", apparently derived the length of the major module of the plan, a unit of approximately 4.80 meters, from the interior width of the transept or one of the sides of the crossing by means of the auron or golden section.16 Just as Suger prodded his architect to "respect the very stones" of the hallowed carolingian basilica by re-using selected dimensions in the gothic chevet design, master Walter of Altenberg's transfer of the numerical basis of the original abbey to its successor sought to assure the essential continuity of the site.17

Once the controlling square of the chevet had been laid out, the rest of the plan was developed according to simple procedures that continued long established cistercian modes of design based on a combination of square schematism and polygonal simplification (Fig. 3). The base of the hemicycle was set on a line tangent to the romanesque apse. Along this line, modules of about 4.80 meters determined the aisles and the span of the nave. One square fixed each of the aisles, while the nave breadth equaled two units. However, because the modules of the outer aisle included the exterior wall and the central vessel was marked out from the interior edges of the piers, the clear 1:2 proportions are not readily perceptible. The variety of points defined by this grid, the outer edge of the walls, all pier centers, and the span of the nave, reveals the maximum exploitation of an elementary system: one that insured a fundamental harmony between all the components of the plan.18 This method is carried out with unflinching precision east of bay division 5. The two choir bays to the west are shortened to 4.45 meters because of the fixed position of the transept. Had thoroughly uniform dimensions been the sole consideration of the architect, the chevet could have been designed easily around another controlling unit, but the decision to "re-use" a basic measurement of the old abbey outweighed total consistency in the new plan.

The keystone of the apse was located in the center of the primary square and the hemicycle polygon, seven sides of a regular dodecagon was laid out empirically around this point.19 The use of radius XW insured the continuation of the alignment of the arcade wall into the apse. The ambulatory was struck from the same center with a radius XY, then divided into seven equal segments. The alignment of elements along bay

division 6 at Altenberg corrected the awkward plan
of Marienstatt where two regular dodecagons were construct-
ed around the same geometrical center (Fig. 4).[20] At
the same time, the Altenberg solution produced western
ambulatory segments that are canted lightly and create
a subtle tension against the corresponding straight
sections of the hemicycle. The chapel mouths repeat
the 4.80 meter width of the aisles to the west and
thus are brought into a close relationship with them.
The outer wall of the chapel corona was sketched out
by the radius XZ.
 The Altenberg master's insistence upon the geometrical
purity of the apse contrasts with the designs of such
contemporary buildings as the cathedrals of Amiens,
Beauvais, and Cologne. In these edifices, the architects
tinkered with the shape of the hemicycle, lengthening
its western segments to form a mediating element between
the long straight bays of the choir and the shorter
turning sections of the apse, as they sought to integrate
visually the interior spaces.[21] In a similar fashion,
the choirs of Longpont, Royaumont, and Valmagne increased
the length of the western limbs of the polygon, but
aligned the pier pairs of the central vessel (Fig. 5).
Consequently, the line of the presbytery wall is carried
deep into the hemicycle as it is at Altenberg.[22] This
was evidently the result of a simplification of the setting
out process: the two concentric envelopes of the hemicycle
and ambulatory were struck off from a single center
with radii determined by the distances from that point
to the eastern piers of the adjoining straight bay.[23]
The final result is a hybrid between the decagonal
plan of Reims Cathedral, Mortemer, or Outscamp, with
its crisp polygonality and capacity to meld the straight
and turning bays together, and the dodecagonal scheme
of Amiens or Beauvais that lent itself to diagonality
and elegant proportions and allowed the inclusion
of a greater number of chapels. Furthermore, Altenberg
weds the Longpont and Royaumont feature of the 7/12
hemicycle configuration to Marienstatt's polygonal purity.
These modifications demonstrate that while cistercian
architecture tended to restrict itself to a limited number
of types, these solutions were not reproduced blindly.
Master Walter critiqued and tightened the models that
he adopted.
 The principles of planning at Altenberg are a
primary vehicle by which its cistercian identity was
maintained *vis à vis* the secular world. Although the
plans of the larger houses tended to grow more complex
in the later twelfth and thirteenth centuries through

the adoption of cathedral-type schemes, the methods of design remained remarkably stable, adhering to many of the same basic geometrical figures and relationships as bernardine churches.[24] The square and the regular polygon are not uniquely cistercian tools of planning, but the discipline with which they were applied at Altenberg generates an austere clarity that embodies the values of *ordo et equilibrium*.[25]

That the plan was viewed as a determinant gene in the architectural personality of Altenberg has been seen in the incorporation of significant measurements of the romanesque building. In addition, the premium placed on the clarity of the ground plan dictated the disposition of, and was sometimes achieved at the expense of, the superstructure. The buttresses between the chapels are whittled down to thin points as a means of establishing straight walls and thus maintaining the regularity of the geometrical figures that underlie the design.[26] Likewise, the insistence upon the integrity of each of the chevet polygons resulted in the disalignment of the hemicycle and ambulatory piers as well as their ribs and arches. This is revealed most clearly on the exterior by a slight wrenching of the buttress *culées* above the chapels as they launch the flyers toward the clerestory wall (Fig. 10). The overall flavor of the Altenberg choir retains traces of the cistercian tradition that conceived a building as a unified system of independent units.[27]

The elevation of Altenberg displays the same lucidity as the groundplan (Fig. 6 and 11). The main vessel rises to a height of 25 meters, but the architect calibrated the relationship of the constituent elements to the apex of the clerestory. The molding at the base of the triforium is set at 11.55 meters and, as the most pronounced horizontal member, serves as a benchmark from which the two halves of the elevation may be equated.

Despite the monumental scale of the interior and the surprising richness of the sculptural decoration of capitals and keystones, the treatment of the structure as a whole and the selection of motifs remain within the pale of the thirteenth-century cistercian vocabulary. Slim cylindrical piers, 1.01–1.02 meters in diameter, are used as the exclusive means of support with the exception of the crossing piers which are composed of a round core with eight adossed shafts.[28] The uniformity of the ground floor structure counteracts the abrupt shift in the dimensions between the straight and turning bays of the choir and promotes an unobstructed flow

of space to the very perimeter of the edifice. Perhaps reflecting a reduction of the more elaborate *pilier cantonné* and its variants or a consciously archaizing approach as a means of underscoring the monastic character of the edifice, cylindrical supports most often appeared in larger cistercian houses, such as Longpont, Royaumont, Vauclair, and presumably Vaucelles, in conjunction with a three-story elevation.[29]

With the increasingly frequent adoption in the later twelfth and thirteenth centuries of the general parti and richly membered structural systems of episcopal edifices, Cistercians flirted with the "immense heights, immoderate lengths, and superfluous widths" that had afflicted the Cluniacs. Altenberg, Longpont, and Royaumont reach heights of over 80 feet, but the willful arrest of the vault respond atop the pier abacus isolates the ground floor from those above and mitigates the verticality of the interior.[30] Of all the dimensions of a structure, height seems to have carried the greatest symbolical value and stirred the hottest anger in critics of extravagant building.[31] Thus, a deliberate step to unhook the sections of the elevation from one another may have contributed to the choice of columnar piers in these "High Gothic" abbeys. Horizontal movement and diagonal vistas were substituted in place of unimpeded ascent. Altenberg, like Longpont and Royaumont, was erected at a time when the architectural legislation of the Order was still enforced with some vigilance and all three must have been judged to have been in conformity with the letter of the ordinances. The well-known condemnation of the new work at Vaucelles in 1192, described as scandalously sumptuous and superfluous ("sumptuosum nimis est et superfluum et multis scandalizavit") could have been leveled at little more than the foundations of the nave.[32] The same year, the abbot of Longpont was chastised for a deviant dormitory, in 1217 Bohières was ordered to pull down a church tower, and in 1263 Royaumont was instructed to strip paintings and statues from the choir.[33] Moreover, the *Institutiones capituli generalis,* a compendium of the promulgations of the General Chapter, were issued in 1240 and in a revised edition of 1256, perhaps as a pointed reminder of the spartan spirit of the regulations in the face of a growing taste for elaboration luxury. Yet, the pronouncements on artistic and architectural orthodoxy dealt primarily with decoration, furnishings, and appended elements, such as towers, rather than with questions of appropriate or specific plans and elevations. There is absolutely no indication that the

ambulatory and radiating chapel choir plan or the three-story elevation were singled out and condemned because they violated cistercian tenets.

The simplification of the upper half of the structure seconds the implications of the cylindrical piers, that the master mason, while working within the idiom of the "cathedral Gothic", was completely conversant with cistercian customs. The triforium is a sham, a screened perforation opened into the zone above the aisle vaults. It shrinks to a compact belt that, at around 3.6 meters, is less than half the height of the windows above. The direct linkage of the central mullion with the clerestory, the continuity of the framing molding that rises from the base of the triforium, and the repetition of the same number of units draw the two upper levels of the elevation together (Fig. 12). The stringcourse at the upper edge of the triforium is given the same plastic value as the ascending mullion and does not compete with the molding below. Nevertheless, a clear separation of the two zones and an accentuation of the horizontal are achieved through the coloristic contrast of the shadowy recesses with the flat sheets of silvery glass, and by the thick sill blocks that weigh down upon the heads of the delicate trefled openings. As noted in the plan, the elevation is conceived in terms of the same equivocal blend of independent parts within a unified whole.

The inclusion of a middle story is fairly common in cistercian architecture from the last quarter of the twelfth century, but it was rarely treated as a continuous screen that fills the entire width of the bay. Most examples are either single openings, as at LeBreuil-Benoit, Fontainejean, and Marienstatt, or double units, seen at Aulps, Mortemer, and Royaumont, pierced through the wall. Longpont and Vauclair displayed a repeating band of arches, but in both cases it was simply a decorative appliqué to a blind wall. The open, cagelike triforium of Altenberg echoes the more florid designs found in the cathedrals of Beauvais, Cologne, and Limoges, as well as at St-Urbain in Troyes.[34] The unexpected thrust of the brittle trefled arches into the sill blocks above, which also appear to squeeze in on the ascending mullion, creates the impression that a thick mural hide has been flayed away to bare a spare skeletal trellis. Such visual twists reveal the mannered, if restrained, touch of a Rayonnant master.

The manner in which the upper half of the elevation is separated from the arcades below, but internally sectioned by an unassuming molding at the upper edge

of the triforium, the linkage of the middle zone and the clerestory, and the tracery patterns, ultimately recall the nascent Royaumont *parti* of such buildings as Agnetz near Paris.[35] However, this recessed elevation was not adopted at Altenberg where the triforium and clerestory lights fill the entire width of the bay. At Royaumont, the triforium occupied the whole wall surface between the pier responds, but, as at Longpont, the windows were pulled in and bounded by masonry strips to either side (Fig. 7). The decisively different rhythms of the openings at each level, plus the rejection of linkage, fragment the Royaumont wall into a loose confederation of horizontal zones. As in the ground plan, the Altenberg master pulled the constituent atoms of the structure into larger, more coherently organized units. The Rhenish abbey distances itself from the early thirteenth-century Parisian traditions that still cling to Royaumont by reducing the height of the triforium and elongating the clerestory. In short, Master Walter adopted an elevation that characterizes such contemporary edifices as the cathedrals of Amiens and Clermont, and St-Denis in its final form.

The tracery of the Altenberg choir was designed with a similar sensitivity to detail. As Ulrich Schröder has observed, the repetition of the twin-lancet-with-trefoil "module" throughout the upper level of the chevet serves as a key element in its unification.[36] This apse pattern, found in thirteenth-century France and Germany, is doubled in the straight bays and topped by an inscribed quatrefoil (Fig. 12).[37] Each set of forms is disposed in its own plane, from the molding that frames the bay to the mullions of the two main units, and finally, to the chamfered struts of the smaller lights. All of these interior elements co-operate to minimize the definition of the bay. The reduction of the respond to three slender colonnettes, and the lack of differentiation of transverse and diagonal rib profiles, complement the handling of the triforium and clerestory to produce an unbroken central space. The general composition of the upper levels most closely parallels Cologne Cathedral, but inspiration may have also been derived from the cistercian tradition of creating interiors within which spatial compartmentation was expressed in the aisles (Fig. 13). At Fontenay or L'Escale-Dieu, the collaterals were sectioned by barrel vaults on transverse walls, but at Pontigny, Longpont, and Ourscamp, as at Altenberg, heavier transverse arches delimited each bay (Fig. 14).[38]

The partitioning of the side aisles into well-defined

units, that underline their role as a series of discreet
chapels, may have influenced the choice of tracery
motifs. Rather than the two–or four–lancet lights of
the polygonal chapels and clerestory, the windows of
the north aisle of the choir and the east aisle of the
north arm of the transept are formed by three units
capped by a trio of trilobes (Fig. 6). This exact pattern
is rare, appearing only in the Tours hemicycle and
with slight variations in the choir of Le Mans Cathedral
and the now–destroyed College of Cluny in Paris.39
The selection of a triplet design was not imposed because
of size limitations, since the outer aisle wall offered
the same superficies as the clerestory. The slightly
taller central lancet, coupled with the pyramidal grouping
of the trilobes in the apex, effects a subtle introversion.40
The repeating units of the high windows that pull the
eye from bay to bay are replaced by a self–contained
composition. The appearance of wall strips bordering
the windows, the result of the reduction of the aisle
respond to a single shaft, reinforces the sense of separa-
tion between the aisle bays.

If the interior of Altenberg adopts the demeanor
of a cathedral of terse refinement, the exterior fully
upholds the cistercian tradition of spartan simplicity
(Fig. 10). There is no seductive sculptural embellishment,
nor such costly superfluities as pinnacles, gables,
or balustrades. Monstrously deformed gargoyles are
absent. The unadorned salients of the chapels are thinned
through two tall glacis, the lower extended across
the walls as a window sill. The upper level is braced
by a system of flying buttresses and thick pilaster
strips. The single arches in the hemicycle are surprisingly
spindly. Rising at a thirty–degree angle, they abut
the wall at the haunch of the vault in a manner akin
to Pontigny, Fontainejean, Marienstatt, or Valmagne,
and differ fundamentally from the double rank systems
of Longpont and Royaumont. Despite the height of the
abbey, the muscular salients were deemed sufficient
to assure the thin upper wall against wind load. The
low placement of the flyers is also found at Paris Cathe-
dral, the Cambrai Choir, the Strasbourg nave, and
St Sulpice–de–Favières. In addition, the water evacuation
system particular to these buttresses is copied at Alten-
berg: a long "drainpipe" slit, incised into the salient,
empties into the gutter that runs along the extrados
of the arch and traverses the buttress–upright to end
in an unadorned spout.41 The provision of a drainage
system may not be unheard of in cistercian architecture,
but its elaboration and coherence is unprecedented.

This would hint at Walter's or his successor's direct knowledge of Paris or, perhaps more plausibly, an acquaintance with the nearby Strasbourg atelier.

The straight bays are stayed by a double battery of arches with the outer flyer significantly thickened. The regularity of the Altenberg plan, in which aisle, ambulatory, and chapel depths were equalized, facilitated the smooth structural transition from the single ambulatory corridor to the double choir collaterals because all of the flyers span the same distance. This represents a notable departure from the Longpont-Royaumont shallow chapel system that was transmitted to Beauvais with unintended disastrous results.42 The deep chapel plan that was a by-product of the square schematism of Altenberg's planning process appears more frequently in major edifices constructed after 1250 and includes the cathedrals of Clermont, Evreux, Limoges, Narbonne, and Prague.

Altenberg appears, at first glance, as a symptom of the arrival of the Rayonnant style in the Rhineland or the appropriation of cathedral themes by the Cistercians. The "conversion" of elaborate episcopal exemplars into an appropriate cistercian style was perfected at the German abbey, but its flirtation with the Rayonnant style was only the final episode in the ongoing series of interchanges between the Order and the architectural mainstream. The rib vault, the ambulatory and chapel plan, and the three-story elevation were encountered successively and molded by the regulations, ordinance of worship, and aesthetic traditions of the Cistercians into a distinctive dialect. In turn, the new level of optical and spatial clarity attained at Altenberg is prophetic of major developments that pushed northern architecture in innovative directions during the late thirteenth century. The architect's quest for more stream-lined and coherent ground plans and structure, and for more unified space, may have been stimulated by cistercian models. It is noteworthy that many of the provincial regions of France and foreign lands into which the Rayonnant style spread had been colonized architecturally by the Cistercians during the early gothic period.43 Altenberg achieved a strong, stark articulation, a frank standardization of components, a comprehensibility of scale, and a structural simplifica-tion that offered a vision of the gothic style that was readily assimilable with the entrenched conservatism of local schools or the programmatic ideals of the Mendi-cant Orders.44 Altenberg stands at the end of 150 years of cistercian development, yet fully realizes the principles

of bernardine architecture in terms of the new, Rayonnant style. The abbey is a far cry from the straw–covered huts that caused St Bernard to weep over their humility, but in the complete harmony of the groundplan, the integration of the superstructure, and the lucid differentiation of the spaces according to liturgical function, it recaptured the essential qualities canonized at Bonmont, Fontenay and Himmerod in the twelfth century.

The search for the sources of Altenberg has often been confounded with a stylistic analysis of forms and profiles, thus obscuring a recognition of the difference between the pragmatic techniques of an architectural workshop and the "ideal" program of the project's patrons.45 The preceding part of this paper has sought to define the cistercian character of the building and the thinking behind its design. The stylistic connections of Altenberg, which have sparked frequent debate, have centered on two positions. Firstly, the obvious French patterns of the church have led scholars to see it as a direct derivative of the cistercian high gothic abbeys of Longpont, Ourscamp, but particularly, Royaumont.46 Royaumont is fraught with significance for it fulfilled the same twin roles as Altenberg: a cistercian monastery and an aristocratic burial place. It was the aura of the capetian house that the Berg dynasty sought to appropriate through the deliberate imitation of Royaumont in their own necropolis, Altenberg. The aping of notable or venerable buildings was widespread throughout the Middle Ages, but the novelty of the Royaumont–Altenberg relationship lay in the fact that a building *and* its style were recognized as inseparably bound to one another and to a set of meaningful values.

A second hypothesis asserts that Altenberg is a reductionist version of Cologne Cathedral as Longpont is a monastic spinoff of Soissons, and, consequently, reflects French influence second–hand.47 This view suggests that cistercian architecture is less self–contained in its development. The similarities of Longpont, Royaumont, and Altenberg stem less from an internal network that generated and dispatched building types than from a fund of design habits that were shared with mainstream models.

Such mutually exclusive positions overlook the desire of gothic patrons and the ability of their architects to infuse monuments with multiple layers of meaning. The associations of a building were not chained to an exact set of tracery patterns or arch profiles, yet

conversely, the selection of a motif may have added
further significance to a well–defined exemplum. The
writings of Richard Krautheimer concerning the iconography
of medieval architecture retain a particular cogency
in unraveling the identity of Altenberg.[48] A survey
of acknowledged "copies" in medieval architecture reveals
that imitation rarely involved replication. Rather, the
"relation between pattern and symbolical meaning could
better be described as being determined by a network
of reciprocal half–distinct connotations" that allowed
a variety of interpretations to co–exist and parallel
layers of meaning to resonate within a single structure.[49]
Although Krautheimer's investigations focused upon
the early Middle Ages, two vignettes illustrate that
the thirteenth century maintained a similarly flexible
attitude toward copying.

 Firstly, in 1268, during the preparation stages
for the construction of the Cathedral of Narbonne, Pope
Clement IV requested that his former cathedral "be
made in imitation of those noble and magnificent churches
of the kingdom of France" *("in faciendo imitare ecclesias
nobiles et magnifice operatas et opera ecclesiarum que
in regno Francie construuntur et sunt in preterito iam
constructe").*[50] Despite the specificity of this request,
motivateu in part by the archbishops' intentions to
erect an architectural affirmation of their political
and religious alliance with the king in a province
that continued to seethe with revolt and heresy, the
product of this wish was far from an exacting replica
of a "Court Style" edifice. In fact, the cathedral archi-
tects drew upon sources that were wholly outside of
the Parisian stylistic orbit. At Narbonne, the churches
of the kingdom of France were reproduced through the
towering height of the cathedral's central vessel, the
rich light effects, and elaborate tracery compositions.
The interpretation of the *opus francigenum* was not
wedded to a group of recognized acceptable models,
nor to a precise set of motifs. The architectural message
resided in general effects that could be rendered with
wide latitude without a loss of essential meaning.

 In 1224, Abbot Wigbold of Aduard, a cistercian
settlement in Frisia, sent one of the lay brothers accom-
panied by his son to Clairvaux. The man's task involved
sketching a plan of the monastery, gathering dimensions,
and studying the form and character of the buildings
for the purpose of constructing an exact replica of
St Bernard's abbey.[51] One assumes that the architect
conscientiously executed the letter of his commission,
but the Dutch abbey reveals significant deviations

from its ideal model. Seven projecting chapels ring the ambulatory in a cathedral-type schema, as opposed to Clairvaux's nine rectangular chapels that are contained by a continuous polygonal wall, and the choir appears to have been two bays deep rather than one.[52] It is clear that Wigbold's master mason duly noted such features as the ambulatory, the number of radiating chapels, the projecting transept, the short choir and long nave, but was not constrained to duplicate his prototype.

By 1259, when construction of Altenberg was inaugurated, choirs composed of ambulatory and chapels were no longer foreign to cistercian architecture, since over two score were erected during the later twelfth and thirteenth centuries.[53] The new chevet of Clairvaux, begun in 1154, as the initial example of this plan type, obviously provided a principal model for other houses of the Order. The reproduction of Clairvaux at Alcobaça in Portugal and the popularity of chapels contained within a continuous polygonal or circular wall would seem to attest to its impact.[54] Moreover, the case of Aduard (which must be considered a copy of Clairvaux, although built along different lines) does not rule out the possibility that Altenberg, along with its peers at Longpont, Ourscamp, and Royaumont, echoes the venerable burgundian monastery. The status of Clairvaux as the burial place of St Bernard may have further recommended it as a model for later cistercian necropoli.

Despite the stringency of the statutes of the General Chapter, which limited burial in their churches to kings, queens, archbishops, and bishops, a number of special bargains must have been struck with aristocratic patrons that broadened admission standards.[55] Isabella Marshal, the first wife of Richard of Cornwall, brother of Henry III, was buried at Beaulieu in 1240 and Richard himself, his second wife, Sanchia, and sons, Henry and Edmund, were interred at Hailes.[56] Royaumont received the remains of Louis IX's brothers and children, but does not appear to have been destined as the site of the king's tomb.[57]

From 1152 to 1524, the Berg counts were buried at Altenberg, but the present arrangement of tombs was contingent upon the completion of the north arm of the transept and does not seem to have been undertaken prior to the second decade of the fourteenth century. The earliest sepulchral slabs date to around 1313–1314.[58] The multiple burials under a single marker might indicate a wholesale transfer of remains, but their prior location

is unknown. Although the Bergs' desire to build a monumental dynastic necropolis was not the primary stimulus for the reconstruction, it is likely, in view of the family's foundtion and continuous support of Altenberg, that the new abbey was intended to serve as their burial site.[59]

In formulating an architectural program for the new church, a task that doubtless involved the collaboration of the Berg family and the monks, Royaumont would surely have been invoked as an appropriate model for the aristocratic monastery. The oft-mentioned gift of relics that Archbishop Conrad sent to Royaumont in 1261 demonstrates the latter's familiarity in the archdiocese of Cologne and Abbot Giseler must have enjoyed at least a passing acquaintance with his French counterpart through the annual meetings of the General Chapter.[60] However, Royaumont clearly was not replicated at Altenberg and this implies that other influences intervened. An invocation of the lapse of thirty years that separated these two cistercian works does not offer a compelling explanation of their differences. Advances in planning, refinement in tracery patterns, and the modernization of moldings are to be expected, but in the final analysis, only the general scheme of a choir with radiating chapels and the use of columnar piers were accepted from Royaumont. The quadratic mode of planning, the simplification of the upper half of the elevation, and the severity of the decoration are genetic traits of cistercian architecture as a whole, while the A:A elevation is too widespread in the Rayonnant period to supply conclusive proof of a causal relationship between the two monuments.

As Ulrich Schröder has demonstrated, Altenberg is in many respects a regional product. Its repertory of tracery, profiles, and moldings, and the form of the crossing piers, can be associated most closely with Cologne and the surrounding area.[61] Moreover, the cutting and placement techniques used at Altenberg seem to continue the Rhenish early gothic methods employed during the first campaign at Cologne Cathedral.[62] The extensive use of *en délit* shafts with binding stones roughly every third course confirms that Master Walter, like Gerhard of Cologne, lacked extensive practical experience in French ateliers. However, Altenberg is not simply a denuded version of the cathedral. The plan is set out according to a different system, the high gothic proportions of Archbishop Conrad's church are eschewed in favor of an A:A elevation, and the relationship of support to superstructure is transformed

completely.[63] While Morellian inspection of architectural details leads to an identification and localization of the workshop, it does not provide a fully satisfactory explanation of the overall character of Altenberg.

Although Cologne and Royaumont and its family of cistercian abbeys furnished important threads for the fabric of Altenberg, a series of more trenchant comparisons may be drawn with St-Denis. The three-bay choir with seven chapels and the exclusive use of columnar supports are among the most salient identifying characteristics of Altenberg, yet their combination is extremely rare in gothic architecture in general and cistercian construction in particular. Longpont and Royaumont were laid out with two bay choirs and employed multishafted piers in the ambulatory in contrast to the cylindrical members of the main vessel. The choir of Pontigny was composed of three straight bays raised on columnar supports, but it is evident that it did not have a direct impact upon the conception of Altenberg.[64] The German abbey's deep choir does not appear to have been dictated by particular topographical, architectural, or liturgical circumstances as at Ourscamp, but was selected independently of pragmatic considerations. The elongation of the sanctuary may have been motivated by the demand to erect two rings of twelve columns around the chevet in deliberate imitation of St-Denis.[65] Columns were the sole architectural elements that Abbot Suger imbued with symbolical significance, likening them to the apostles and minor prophets.[66] Within the funerary context of the royal abbey, the twelve columns may have been intended to echo such martyria or imperial mausolea as the Holy Apostles in Constantinople, the Anastasis rotunda in Jerusalem, Sta Costanza, and St Peter's in Rome.[67] Whether or not the Altenberg community was cognizant of these profound historical reverberations, the number and conscientious underscoring of the columnar piers indicate that in setting the building program for their dynastic church, the Bergs oriented the project toward the contemporary royal abbey *par excellence*, St-Denis (Figs. 2 and 8).

Similarities between the elevations of Altenberg and St-Denis further buttress the conclusions drawn from the resemblances of plan and support (Fig. 11 and 15). Altenberg exhibits the same proportional relationship of arcade to upper levels, displays an analogous band triforium that is linked with the clerestory, and shares the device of repeating double lancet patterns as a means of mediating between the hemicycle and

choir. The windows, which fill the available wall surface, create a glazed expanse that is unparalleled in cistercian architecture and mimics the effects of the dionysian lights. It hardly needs to be reiterated that the complex elegance and the finesse of the membering of the French abbey have been rescored in the severe cistercian tone and further tempered by the impact of Cologne forms. At the same time, the integrity of the significant features of St-Denis is not violated and suggests that it served as a prime model for Altenberg.

The construction of a cistercian version of St-Denis, a project that in effect telescoped two key capetian edifices, might appear as the hubristic act of a local lord, but the inauguration of Altenberg occurred at a time when the star of the Berg counts was rising. Although they did not apparently harbor imperial aspirations, Altenberg's appropriation of schemata associated with royalty became the vehicle for the expression of the dynasty's ascendant political fortunes. The Bergs figured prominently in the confused arabesque of German politics during the middle third of the thirteenth century. The bitter fight which Henry IV, Duke of Limburg and Count of Berg, had waged against Archbishop Conrad was defused in 1240 by the marriage of his son, Adolf IV, to Margareta, sister of the Cologne metropolitan, and the concession of half of Deutz to the count.[68] Adolf's subsequent support of the bellicose archbishop's aggressive territorial expansion and his anti-Hohenstaufen imperial candidates promoted the growth of his house's possessions.[69] However, as a backer of Richard of Cornwall as German emperor, he stationed himself in direct opposition to Louis IX who championed the election of Alfonso X of Castile.[70] Pacific relations with the Cologne see quickly deteriorated under Adolf V and Archbishop Siegfried von Westerburg. After a decade of acrimonious wrangling, their differences were settled in favor of the count on a battlefield near Worringen in 1288. The check delivered to the temporal power of the archdiocese further elevated the Berg county to a pre-eminent position in the area encompassed between Bonn and Dusseldorf.[71]

The tangled web of ephemeral alliances and the constant realignments of the major powers caution against tying issues of style or the selection of models too closely to a momentary political constellation. The adoption of the Rayonnant style by Conrad von Hochstaden and Adolf IV can hardly have been motivated by simple francophilia. Louis IX remained cool toward the rabid anti-Hohenstaufen policies espoused by Conrad and

seems to have viewed the English diplomacy in Germany with a healthy suspicion.[72] In a similar vein, Matthew Paris explains that the German electors turned to Richard of Cornwall in part because they "hated the pride of the French".[73] The archbishop's and his supporters' horizons were oriented much more emphatically toward London than to Paris, a position that was strengthened by an active wool commerce between the Rhineland and England.[74] Moreover, Altenberg did not reject abruptly a colonais vocabulary when relations with the pontiff soured in the 1270s. Thus, in Altenberg's case, style transcended parochial political considerations or remained impervious to radical shifts in climate.

As Hans Sedlmayr long ago pointed out, the "French manner" became the preferred language of royal architecture because it most perfectly combined the monarchical values of awesome grandeur and splendor within a profoundly religious setting.[75] This was due in no small part to the general recognizance of the French ruler as "the king of earthly kings because of his divine anointment, his power and military eminence", an aura that was captured by the kingdom's magnificent edifices.[76] Yet, Conrad von Hochstaden certainly did not envision the *matrona* of German churches as a passive copy of French *exempla*. It was that architecture's expressive cogency that freed it from exclusive national identification and made it an acceptable vehicle for the *umbilicus* of the new Holy Roman Empire masterminded by the archbishop.[77] Likewise, the Bergs turned to St-Denis not from a craving for French accouterments, but because it offered the model of the quintessential royal church, just as Royaumont set the standard for a deluxe cistercian abbey.

Altenberg illuminates one facet of the process by which buildings were charged with significance. Whereas Narbonne Cathedral achieved its imitation of the noble edifices of the kingdom of France without direct recourse to royal prototypes, Altenberg intimates that specific buildings were recognized and "copied" on the basis of a similarity of function or character. The interlarding of a variety of sources imparts to Altenberg a multivalent meaning that articulately expresses its identity through its overlapping roles as a cistercian foundation and an aristocratic church and burial site. This finely tuned definition was voiced through the process of laying out the configuration of the plan, the verticality of the interior space, the three-story elevation, the sobriety of the decoration, and key motifs, particularly the cylindrical piers. Conversely, the

content of the abbey did not dictate the master mason's templates and thus suggest that an ideal program and considerations of motival style could co-exist on independent but compatible planes.[78] Altenberg is far from a simple example of French artistic hegemony over the German Rhineland. Through the choice and careful orchestration of models, it joined an elite group of edifices whose architecture spoke the international language of aristocratic power and prestige.

Mount Holyoke College
South Hadley, Massachusetts

NOTES

This study was carried out with the assistance of a Spears Fund grant from the Department of Art and Archaeology of Princeton University during the summer of 1982. A portion of this paper was read at the Eighteenth Congress on Medieval Studies (1983), Kalamazoo, Michigan.

1. The substantial literature on Altenberg is listed by Ulrich Schröder, "Royaumont oder Köln? Zum Problem der Ableitung der Gotischen Zisterzienser Abteikirche Altenberg", *Kölner Domblatt* 42 (1977) 242. To this study should be added: Caroline Bruzelius, "Cistercian High Gothic: The Abbey Church of Longpont and the Architecture of the Cistercians in the Early Thirteenth Century", *Analecta Cisterciensa* 25 (1979) 3–204; Hans-Joachim Kunst, "Die Entstehung des Hallenumgangschores", *Marburger Jahrbuch für Kunstwissenschaft* 18 (1969) 39–42; François Bucher, composite review of Gunther Binding et al, *Das ehemalige romanische Zisterzienser-Kloster Altenberg* (Cologne: 1975), Wolfgang Krönig, *Altenberg und die Baukunst der Zisterzienser* (Bergisch–Gladbach: 1973), Gerda Panofsky–Soergel, *Die Denkmäler des Rheinlandes. Rheinisch–Bergischer Kreis II* (Düsseldorf: 1972), Gerda Panofsky–Soergel, *Altenberg* (Cologne: 1974), and Hermann J. Roth, *Die Pflanzen in der Bauplastik des Altenberger Domes* (Bergisch–Gladbach: 1976), in *Journal of the Society of Architectural Historians* 36 (1977) 208–211; see also Warren Sanderson's review of

Krönig, in *Art Bulletin* 57 (1975) 439–441.

2. Marcel Aubert, *L'Architecture cistercienne* (Paris: 1947) 1:221, states that "la rigueur se détend peu à peu"; and on p. 227, in reviewing the development of cathedral-type choir schemes, declares, "il ne reste plus rien alors du plan cistercien". See also Lester K. Little, *Religious Poverty and the Profit Economy in Medieval Europe* (Ithaca, New York: 1978) pp. 93–96, who writes that "the early cistercian ideals of simplicity, poverty, and manual labor were dissipated in an orgy of wealth in less than a century".

3. Robert Branner, *St Louis and the Court Style in Gothic Architecture* (London: 1965) pp. 132–134; Panofsky-Soergel, *Die Denkmäler*, pp. 107–109; Gerda Soergel, "Die ehemalige Zisterzienserabtei-kirche Altenberg", *Jahrbuch der Rheinischen Denkmalpflege* 26 (1966) p. 283.

4. For Walter as architect of Altenberg, see Aubert, 1:100 n. 3. The reference, "Walterus hic edificavit basilicam nostram", was taken from the abbey's necrology.

5. Panofsky-Soergel, *Die Denkmaler*, p. 90.

6. At Vaucelles in 1181, there were 107 monks and 180 *conversi*, and 130 monks and 300 *conversi* in 1252. In 1236, Louis IX donated 500 pounds to Royaumont to sustain at least sixty monks; in 1258, he increased the subsidy to provide support for a minimum of 114. Longpont seems to have sheltered a community of approximately sixty monks and fifty lay brothers. Consult Bruzelius, pp. 30, 54 n. 222, 97. Aubert, 1:54, lists population figures for Rievaulx, Pontigny, and Clairvaux.

7. The twelfth-century church was recovered in excavations published by H. A. Schäfer, "Die vorgotische Kirche von Altenberg", *Altenberger Dom-Verein, Jahresbericht für die Jahre 1908 bis 1910*, pp. 35–41; Henri-Paul Eydoux, *L'Architecture des églises cisterciennes d'Allemagne* (Paris: 1952) p. 36; Hanno Hahn, *Die Frühe Kirchenbaukunst der Zisterzienser* (Berlin: 1957) pp. 236–238, 338; Kronig, pp. 22–30. The five-apse plan of Altenberg I has been placed within the general orbit of the Cluny II apse échelon family. Schäfer hypothesized that the strengthening of the exterior wall on the south side of the apse occurred c.1180–1190 and was necessitated by the erection of vaults.

8. Hahn, p. 237; Krönig, p. 17.

9. "Sub isto domino reverendo abbate (XIII. abbas dictus Giselerus) V anno ordinacionis sue presidente cathedre pontificali in Colonia domino Conrado illustris vir dominus Adolphus comes de Monte, sororius eiusdem domini archiepiscopo, et frater eius dux de Lymburg, dominus Walramus de Heynsberch, primum lapidem locaverunt in fundamentum novi monasterii de Bergis, V nonas Marcii presentibus conventu et multis aliis secularibus". Quoted from Binding, p. 8. Panofsky–Soergel, *Die Denkmäler*, pp. 90–91, demonstrated that the ceremony took place in 1259, not 1255, as previously assumed. The Archbishop of Cologne, Conrad von Hochstaden, did not take part in the ceremony as Branner, p. 132, stated.

10. The authorization for the quest, issued by Archbishop Engelbert II, was published by Hans Mosler, *Urkundenbuch der Abtei Altenberg* (Bonn: 1912) pp. 191–192.

11. Panofsky–Soergel, *Die Denkmäler*, p. 91, citing a 1517 abbey chronicle: "Constructe sunt X altare cum lavatorio in ecclesia nostra ab Adolpho milite de Stamheym...Sub eodem (Abbot Dietrich I[1264–1276]) constructa sunt decem sacella cum suis altaribus in circuitu ecclesiae et fons in introitu, suppeditante expensas nobilissimo viro D. Adolpho milite in Stamheim". Jongelinus, *Notitia abbatiarum ordinis Cisterciensis per orbem universum libros X complerea* (Cologne: 1640) quoted by Panofsky–Soergel, apparently based his chronology of the choir construction, which he states was brought to completion in ten years, on the same source. Nine of the altars were dedicated in 1287. It is not necessary to presume, as does Panofsky–Soergel, that the entire choir and transept were finished by around 1276. At Cologne, the liturgical offices were celebrated after the completion of only the ground floor. Consult, Arnold Wolff, "Chronologie der ersten Bauzeit des Kölner Domes, 1248–1277", *Kölner Domblatt* 28–29 (1968) p. 226.

12. Mosler, pp. 266–267.

13. A detailed discussion of the cloister, based upon extensive excavations, is contained in Binding; also Panofsky–Soergel, *Die Denkmäler*, pp. 93–96, 101, 132–136. The gothic crossing measures 10.65 x 8.70 meters between pier axes.

14. The measurement of the width of the choir was taken across bay division 5. This square includes the outer walls.

15. For Altenberg I, see Hahn, p. 338. The breadth
of the transept, approximately 18.30 meters, is
nearly equal to the length of the north arm,
measured from the middle of the crossing to the
wall (18 meters).

16. The old transept breadth equaled about 7.8 meters.
Consult the plan in Krönig, pp. 18–19. The use
of the interior measurements of the twelfth–century
structure was surely an operation of convenience.

17. The importance of measurements as a means to
underscore the connections between edifices is
emphasized by Richard Krautheimer, "Introduction
to an 'Iconography of Mediaeval Architecture'"
Journal of the Warburg and Courtauld Institutes
5 (1942) pp. 12–13. For the dimensional relationships
between Suger's work and carolingian St–Denis,
see Sumner Crosby, "Abbot Suger's St–Denis, The
New Gothic", *Acts of the Twentieth International
Congress of the History of Art* (Princeton: 1963)
1:85–91; Sumner Crosby, "Crypt and Choir Plans
of St–Denis", *Gesta* 5 (1966) p. 4.

18. For a summary of the use of the square in medieval
planning, see François Bucher, "Medieval Architectur-
al Design Methods, 800–1560", *Gesta* 11 (1972)
pp. 37–44. The manipulation of the module at
Altenberg results in a subtle differentiation of
each aisle and a progressive widening of space
toward the central vessel.

19. Each side of the hemicycle measures 3.0–3.02
meters. The relation of this dimension to the
4.80 module closely approximates the golden section.

20. For Marienstatt, consult Kunst, p. 36 and Fig.
23. My conclusions on Altenberg vary from the
views of Kunst, p. 42, who stated that the ambula-
tory was struck from a different center than the
apse. It is true that the *geometrical* centers of
the two polygons are different, but the same
center was used in the process of laying out.
Compare the Altenberg design with that of Beauvais
where two different radii were used in order
to keep the western segments of the ambulatory
and hemicycle parallel with one another. Stephen
Murray, "The Choir of the Church of St–Pierre,
Cathedral of Beauvais, A Study of Gothic Architectur-
al Planning and Constructional Chronology in
Its Historical Context", *Art Bulletin* 62 (1980)
p. 539.

21. Consult, Nils L. Prak, "Measurements of Amiens
Cathedral", *Journal of the Society of Architectural*

Historians 25 (1966) pp. 209–212; Franz Graf Wolff Metternich, "Zum Problem der Grundriss–und Raumgestaltung des Kölner Domes", *Der Kölner Dom* (Cologne: 1948) pp. 51–77; Murray, pp. 539–540; Kunst, pp. 39–42.

22. At Royaumont, this assumption is based on plans published in Philippe Lauer, "L'Abbaye de Royaumont", *Bulletin monumental* 62 (1908) p. 232; and Henri Gouin, *L'Abbaye de Royaumont* (Paris: 1932) pp. 2–3. Because of the fragmentary state of the choir and in the absence of exacting excavations, precise determination of the choir scheme is impossible.

23. Murray, p. 539, n. 41, step 4.

24. The "laws" which governed cistercian planning are set forth by Hahn, pp. 314–338; also Otto von Simson, *The Gothic Cathedral*, 2nd ed. (New York: 1962) pp. 39–50; Peter Fergusson, "Notes on Two Cistercian Engraved Designs", *Speculum* 54 (1979) pp. 1–17.

25. François Bucher, "Cistercian Architectural Purism", *Comparative Studies in Society and History* 3 (1960) pp. 89–105, especially pp. 98–104. Villard de Honnecourt's famous design of a "church made of squares for the Cistercian Order", graphically illustrates the longevity of square schematism in the Order's achitecture.

26. At Beauvais and Royaumont, the space of the chapels opens more widely toward their depth.

27. Bucher, "Cistercian Purism", p. 100, applied this phrase to twelfth–century buildings of the Order.

28. The diameter of the piers is nearly identical to those of Longpont, Royaumont, and Vauclair, which measure 1.06–1.07 meters. See Bruzelius, p. 145. This raises the tantalizing specter that general design formulae may have existed within the Order. Consult Fergusson, p. 1.

29. Bruzelius, pp. 65–68, views the use of cylindrical piers at Longpont as the result of a "deliberate esthetic choice" defined by a conscious search for simplicity among monastic builders. Cylindrical piers formed a strong local tradition in the Aisne Valley and persisted in Burgundy well into the thirteenth century at Notre–Dame, Dijon, for example. At the same time, Aubert, 1:273, describes their use as "habitual" in England. Eugene Viollet-le–Duc, *Dictionnaire raisonné de l'architecture française du XIe au XVIe siècle* (Paris: 1854–1868)

3:495, notes the continuation of the use of columns in the Parisis in such churches as St-Severin in Paris, Champeaux, Chapelle-sous-Crécy, and Bagneux, to which may be added Brie-Comte-Robert, Nogent-sur-Oise, and the "weak" piers of Gonesse. In the final analysis, the persistence of columnar piers defies regional classification and may be symptomatic of a more modest mode of design applied to parish churches and priories. See Branner, p. 36, for the opinion that the Royaumont master may have been versed in the design of such buildings.

30. An uninterrupted respond is found at Ourscamp, the shortest of the "High Gothic" cistercian abbeys at 19.90 meters.

31. The criticisms of Alexander Neckham and Pierre le Chantre are well known and can be found in Teresa G. Frisch, *Gothic Art, 1140–c.1450* (Englewood Cliffs, New Jersey: 1971) pp. 30–33. Matthew Paris, *Chronica Majora*, ed. Henry R. Luard (London: 1880) 4:279–280, assails the luxury of the friars who, during the thirteenth century, erected buildings of regal height: "jam vix transactis viginti quatuor annis, primas in Anglia construxere mansiones, quarum aedificia jam in regales surgunt altitudines".

32. Aubert, 1:225–227; Bruzelius, pp. 58–59.

33. For the Longpont infraction, see Bruzelius, p. 43; the Bohières incident is reported by Peter Fergusson, "Early Cistercian Churches in Yorkshire and the Problem of the Cistercian Crossing Tower", *Journal of the Society of Architectural Historians* 29 (1970) p. 219. The reprimand to Royaumont is discussed by Aubert, 1:145; and Bruzelius, p. 97. As the latter points out, the criticism was directed at the accretion of paintings and sculptural decoration, not at the architecture.

34. Schröder, pp. 225–226. Branner, pp. 75–76, traces the screen triforium with pierced spandrels to the work of the St-Denis Master at St Germain-en-Laye.

35. Consult Branner, pp. 21, 98, 120, for a discussion of the "recessed parti"; also Peter Kurmann and Dethard von Winterfeld, "Gautier de Varinfroy, ein 'Denkmalpfleger' im 13. Jahrhundert", *Festschrift für Otto von Simson zum 65. Geburtstag* (Berlin: 1977) p. 124.

36. Schröder, pp. 230–231.

37. This pattern can be found at Agnetz, the Royaumont triforium, the now-destroyed treasury of the Ste-

Chapelle, the nave clerestory of Sens Cathedral, the Cologne Cathedral triforium, and the Servatius-kirche in Siegburg.

38. The extant vault springers in the south aisle of the Royaumont nave indicate that the transverse and diagonal ribs were given the same profiles.

39. Schröder, pp. 232–233, connects the Altenberg pattern to the doublet-with-three-trilobe composition found in the Cologne Cathedral chapels, as well as at the Ste-Chapelle and Amiens Cathedral. In the context of Cologne and Altenberg, he opines that this three trilobe group may have been an indication or symbol of an anti-Hohenstaufen stance and a political orientation toward the West. In light of the ambivalent relations between the Rhineland and France, discussed below, this hypothesis seems untenable. Dieter Kimpel, "Le Développement de la taille en série dans l'architecture médiévale et son rôle dans l'histoire économique", *Bulletin monumental* 135 (1977) p. 201, has noted prudently that with the rationalization of the production of tracery pieces, the number of possible patterns was reduced. This standardization of tracery would caution against drawing sweeping conclusions based on motival similarity alone.

40. The trilobe motif introduced into these aisle windows was repeated in the clerestory above. It is possible that this slight enrichment of decorative vocabulary, in comparison to the simple oculi of the radiating chapels, betrays a second phase of construction.

41. Louis Grodecki, "Les Arcs-boutants de la cathédrale de Strasbourg et leur origine", *Gesta* 15 (1976) 43–51. It should be remarked that the Paris and Strasbourg flyers rise at a sharper, forty-five degree angle. A similar system appears at Marienstatt, although provisions for water drainage are lacking. The clerestory walls at Longpont and Royaumont are stayed by double ranks of flyers.

42. Murray, pp. 539, 541, 547–549.

43. For the new concerns that animated architecture in the later thirteenth century, see the classic studies of Lisa Schürenberg, *Die kirchliche Baukunst in Frankreich zwischen 1270 und 1380* (Berlin: 1934); and Werner Gross, *Die abendländische Architektur um 1300* (Stuttgart: 1948). Kunst (cited n. 1 above) contains many pertinent remarks concerning the interaction of cistercian and secular church planning. In southern France, for example, Emile

Mâle, "L'Architecture gothique du Midi de la France", *Revue des deux mondes*, series 9, 31 (1926) pp. 826–829, attributes the introduction of vaulting techniques in the region to the Cistercians. Branner, pp. 99–100, characterized Clermont Cathedral as having stressed the restrained side of the Court style that descended from Royaumont.

44. Wolfgang Braunfels, *Monasteries of Western Europe* (Princeton: 1972) pp. 125–140, 246, contains a concise evaluation of the Cistercians' influence and the adoption of many of their basic architectural precepts by the mendicant orders.

45. Schröder, pp. 239–241, recognized that Altenberg reflected a more "dappled" pattern of connections than had previously been posited. An example of the symbiotic relationship between monastic patrons and their architects is furnished by Lon R. Shelby, "Monastic Patrons and their Architects", *Gesta* 15 (1956) pp. 91–96.

46. Schröder, pp. 209–228, offers a critique of the positions taken in regard to Altenberg's sources. The most recent proponents of the Royaumont derivation include Panofsky–Soergel, *Die Denkmäler*, pp. 107–109; Branner, pp. 132–134; Bruzelius, p. 136; Krönig, pp. 83–84; and Sanderson, review of Krönig, p. 40.

47. Paul Clemen, *Die Kunstdenkmäler des Kreises Mulheim am Rhein*, Die Kunstdenkmäler der Rheinprovinz, 5/II (Düsseldorf: 1901) p. 30; Eydoux, pp. 76, 125; C. Halbach, *Der Dom zu Altenberg* (Altenberg: 1953) who attributed the design of the abbey to an architect from Cologne Cathedral.

48. Krautheimer, pp. 1–33.

49. Ibid., p. 9.

50. This quotation is taken from Raymond Rey, "La Cathédrale de Narbonne", *Congrès archéologique* 112 (1954) p. 456; also Marcel Durliat, "La Signification de la cathédrale de Narbonne et sa place dans l'architecture gothique", *XLVe Congrès organisé par la Fédération historique du Languedoc méditerranéen et du Rousillon*, Narbonne archéologie et histoire, 2: Narbonne au moyen âge (Montpellier: 1973). pp. 209–210.

51. The voyage of the Aduard master is recorded by Aubert, 1:97–98. See also J. Nanninga Uitterdijk, "Etude sur l'abbaye d'Aduard", *Bulletin monumental* 38 (1874) pp. 216–224.

52. The number of chapels in both abbeys appears to have been nine. At Aduard, the semi–circular

or polygonal chapels were supplemented by two
rectangular chapels that corresponded to the straight
bay of the choir, whereas at Clairvaux III, all
of the chapels were related to one of the sides
of the hemicycle polygon.

53. Aubert, 1:212-227; Pere Anselme Dimier, *Receuil
de plans d'églises cisterciennes*, 2 vols. (Paris:
1949); Idem, "Origine des déambulatoires à chapelles
rayonnantes non saillantes", *Bulletin monumental*
115 (1957) pp. 23-34; Bruzelius, pp. 48-60.

54. For Alcobaça, see Pere Anselme Dimier, *L'Art
cistercien hors de France* (La Pierre-qui-Vire:
1971) pp. 256-298; Krönig, pp. 59, 61. It is possible
that northern French sources, such as Thérouanne,
Dommartin, or Archbishop Samson's choir at Reims
influenced the genesis of the Clairvaux III scheme.
Wilhelm Sclink, *Zwischen Cluny und Clairvaux.
Die Kathedrale von Langres und die burgundische
Architektur des 12. Jahrhunderts* (Berlin: 1970)
p. 112. Thérouanne and Dommartin seem to have
been the immediate sources for the cistercian
abbey of Heisterbach. Pierre Héliot, "Le chevet
de la Cathédrale de Thérouanne", *Bulletin monumental*
108 (1950) pp. 103-116; Kunst, p. 34. Schröder,
p. 241, finds Heisterbach influence at Altenberg
in the wall spurs that buttress the nave walls,
thus suggesting that this earlier family of edifices
would have been well known to architects of the
thirteenth and fourteenth centuries.

55. In 1152, the first ordinance was passed by the
General Chapter that allowed tombs within their
churches. Dom Joseph Marie Canivez, *Statuta capitu-
lorum generalium ordinis Cisterciensis ab anno
1116 ad anno 1786* (Louvain: 1933-1941) 1:1152.
This legislation was reiterated in 1180 and in
1240-1256. See Bruzelius, pp. 39, 93-94, for the
strict enforcement of the regulations and Aubert,
1:329-349, for examples of inhumation and tomb
monuments.

56. Noel Denholm-Young, *Richard of Cornwall* (Oxford:
1947) pp. 19, 76.

57. Branner, p. 33, and Georgia S. Wright, "Royal
Tombs at St. Denis in the Reign of St. Louis",
Art Bulletin 56 (1974) pp. 224-243, have forwarded
the hypothesis that Royaumont might have been
intended to replace St-Denis as the royal necropolis.
This seems unlikely as has been countered by
Alain Erlande-Brandenburg, *Le roi est mort* (Paris:
1975) pp. 78, 93. Bruzelius, p. 94, suggests that

the non-monarchical burials at Royaumont required special negotiations between Blanche of Castile and the abbot of Citeaux or the General Chapter.

58. The extant tomb slabs and monuments are listed by Panofsky-Soergel, *Die Denkmäler*, pp. 117–123. The majority are clustered in the so-called "ducal choir" (Herzogenchor). The arrangement of tombs in the north arm may provide an approximate *terminus ante quem* for the completion of the transept. While numerous differences in details demonstrate that the terminal and west walls of the transept were erected subsequent to the choir, another set of changes in the tracery patterns occurs west of the eastern nave bay (Fig. 6). The window compositions of the west wall continue those of the choir, with minor alterations, as does the clerestory of the first nave bay. The north transept wall window, which draws together motifs found in the clerestory lights and exterior gables of Cologne Cathedral, appears consonant with a date of around 1300–1310.

59. Jongelinus in 1640, reported that the chapel of St Mark, which lies to the west of the abbey church, served as the original burial spot for the counts of Berg and that their remains were transferred into the Gothic edifice at a later date. However, he placed the dedication of the chapel during the abbacy of Berno (1133–1151), but Panofsky-Soergel, *Die Denkmäler*, pp. 138–140, justifiably dates the present structure to 1220–1230. The final resting place of the Bergs during the twelfth and thirteenth centuries remains an open question. Nevertheless, the steady stream of donations, listed in Mosler, shows that the Berg family remained loyal and generous benefactors of Altenberg throughout the gothic era.

60. Soergel, "Die ehemalige Zisterzienserabteikirche", p. 283; Branner, p. 133. Schröder, pp. 222–223, minimizes the importance of the General Chapter meetings as a conduit through which architectural ideas were transmitted. However, as the two consecrations at St-Denis illustrate, such conclaves of ecclesiastical heads could stimulate the spread of artistic concepts and motifs.

61. Schröder, pp. 229–242, where Haina, Marburg, and Heisterbach are tied to Altenberg.

62. Dieter Kimpel, "Die Versatztechniken des Kölner Domchores", *Kölner Domblatt* 44/45 (1979/1980) pp. 277–292. The thick coat of paint and the

extensive restoration which the Altenberg fabric has undergone make a precise determination of masonry techniques difficult. However, in the sections of the edifice that survived the collapses of 1821 and 1830, Colonais methods of cutting and placement may still be confirmed.

63. The apse of the cathedral was laid out according to a system of triangulation, while the straight bays of the choir and transept were based on the use of quadrature. See Willy Weyres, "Das System des Kölner Chorgrundrisses", *Kölner Domblatt* 16/17 (1959) pp. 97–104. For the high gothic character of Cologne, consult Peter Kurmann, "Köln und Orleans", *Kölner Domblatt* 44/45 (1979/1980) pp. 255–276.

64. The abbey of Vaucelles also had a deep choir plan with three straight bays and, according to the sketch of Villard de Honnecourt, was raised atop cylindrical piers.

65. The thirteenth–century reconstruction of St–Denis obviously altered the supports of Suger's choir. Compound piers replaced the columns of the early gothic chevet and one pair of twelfth–century supports was eliminated from the aisles. Thus Altenberg seems to combine the thirteenth–century groundplan of St–Denis with its twelfth–century type of supports. While it is not likely that Suger's *De consecratione* was read by the Altenberg monks, a visitor to the abbey might well have been apprised of the number, meaning, and context of the columns.

66. *Abbot Suger, On the Abbey Church of St Denis and Its Art Treasures*, ed. Erwin Panofsky and Gerda Panofsky–Soergel (Princeton: 1979) p. 104. "Medium quippe duodecim columnae duodenorum Apostolorum exponente numerum, secundario vero totidem alarum columnae Prophetarum numerum significantes..." For further symbolic meanings attached to columns, see Joseph Sauer, *Die Symbolik des Kirchengebäudes*, 2nd ed. (Freiburg: 1924) p. 134.

67. This funerary link is strengthened by Clovis I's foundation of the Saints–Apôtres in Paris as his sepulchral church in imitation of Constantine's Holy Apostles in Constantinople. Moreover, the twelfth–century chevet of St–Germain–des–Prés, which replaced the original church dedicated to Sainte–Croix and Saint–Vincent and sheltered numerous Merovingian tombs, was constructed along the lines of St–Denis with a ring of twelve

columnar piers encircling the central vessel. See May Vieillard–Troiekouroff, "Sainte–Genevieve et ses dépendances", in "Les Eglises suburbaines de Paris (IXe–Xi siecles)", *Memoires de la fédération des sociétés historiques et archéologiques de Paris et de l'Ile de France* II (1960) pp. 165–188; Idem, "Saint–Germain–des–Prés", in Les Anciennes églises", pp. 89–114; Erlande–Brandenburg, pp. 49–52. Also consult, Krautheimer, "Mediaeval Architecture", pp. 8–12; Idem, *Early Christian and Byzantine Architecture*, 3rd ed. (Harmondsworth: 1979) pp. 39–70; André Grabar, *Martyrium: recherches sur le culte des reliques et l'art chrétien antique* (Paris: 1946) vol. 1, for the relevant Constantinian monuments. I owe thanks to John Onians of East Anglia University for his provocative and stimulating thoughts on these matters.

68. Helmut Kahm, "Adolf IV (VI), Graf von Berg", *Neue Deutsche Biographie* (Berlin: 1953) 1:76; Heinrich Neu, "Heinrich IV, Herzog von Limburg, Graf von Berg", *Neue Deutsche Biographie* (Berlin: 1969) 8:367–368; Marianne Kettering, "Erzbischof Konrad von Hochstaden" *Der Kölner Dom* (Cologne: 1948) pp. 13–24; Charles Bayley, *The Formation of the German College of Electors in the Mid–Thirteenth Century* (Toronto: 1949) p. 14.

69. Bayley, pp. 24–25.

70. Ibid., pp. 55–201, details the intricate political maneuvering of the various factions and claimants to the imperial crown. After the Treaty of Paris was signed in April 1259, Alfonso lost French support for his candidacy. See Denholm–Young, p. 95.

71. Adolf Gauert, "Adolf V (VII), Graf von Berg", *Neue Deutsche Biographie* (Berlin: 1953) 1:76.

72. Consult Ernst Kantorowicz, *Frederick the Second, 1194–1250*, trs. E.O. Lorimer (London: 1931) pp. 568–570, for Louis IX's neutrality in the struggle between pope and emperor.

73. Matthew Paris, 5:603.

74. Matthew Paris, 5:624–625; Denholm–Young, pp. 67–68, 87. Conrad von Hochstaden visited London in March 1257 to urge Richard to take possession of his German kingdom in person.

75. Hans Sedlmayr, "Die gotische Kathedrale Frankreichs als europaische Konigskirche", *Oesterreichische Akademie der Wissenschaften Philosophisch–historische Klass. Anzeiger, 1949* (Vienna: 1950) pp. 390–409.

76. Ibid., pp. 407–408. The quotation is drawn from

Matthew Paris, 5:480.

77. Although Branner, p. 132, considered Conrad von Hochstaden a francophile, this does not reflect accurately the archbishop's political stance. Moreover, Cologne Cathedral cannot be viewed as an architectural opponent of Aachen and "the old imperial ideals", as Branner stated. Both William of Holland and Richard of Cornwall were crowned at Aachen. Like the progress of Charles VII and Joan of Arc to Reims nearly two centuries later, coronation at Aachen seems to have been a *sine qua non* for any claimant to the imperial throne.

78. Kimpel, "Die Versatztechniken", pp. 290–291.

CISTERCIAN INFLUENCES ON PREMONSTRATENSIAN
CHURCH PLANNING: SAINT-MARTIN AT LAON
William W. Clark

Writing in 1923, Sir Alfred Clapham described the church at Prémontré, motherhouse of the reform order bearing that name, as having been prior to its destruction, "a normal cistercian type".[1] Thereby, he set the tone that has governed the study of the church architecture of the premonstratensian canons. While Sir Alfred was neither the first nor certainly the last writer to remark on the similarities between cistercian and premonstratensian churches, his is the most often cited opinion doubtless because his article discussed the most examples.[2] Indeed, there is a considerable literature devoted to the study of the many relationships between the Cistercians and Premonstratensians. Historians, liturgists and other specialists have made detailed comparisons, for example, between the statutes of the two orders and rightly concluded that Prémontré adopted many cistercian customs and practices, but Clapham's superficial observations have sufficed for architectural historians.[3] Admittedly, there are great difficulties involved in making comparisons between examples widely separated by time, geography and local building practices and traditions. Thanks to the researches of the late Father Anselme Dimier, however, it is now possible to compare at least the plans of two important early churches, one cistercian, the other premonstratensian, built at the same moment, in the same region and, therefore, sharing the same local traditions.[4] No less important, both communities owe their origins to the same influential patron, Bartholomew de Jur, bishop of Laon (1113–1150). Separated by no more than forty-five kilometers and by less than ten years, the plans of the cistercian church at Foigny and the premonstratensian church of Saint-Martin at Laon present a test case in which to investigate some cistercian influences on premonstratensian planning.

Saint-Martin, at Laon: The First Church Reconstructed

Of the churches at the four major abbeys in the administrative and organizational hierarchy of the Order of Prémontré, founded by Norbert of Gennep in 1120, only the *prima filia*, Saint-Martin at Laon, survives with sufficient of the original structure to permit architectural analysis.[5] The first attempt to reform the unruly community of regular canons at Saint-Martin, which

had been founded by Bartholomew de Jur in 1117, was
led by Norbert himself, in 1119, acting at the instigation
of the bishop and the pope. Defeated as much by his
own lack of administrative leadership experience as
by the intractability of the canons, Norbert abandoned
Saint–Martin and with fourteen followers settled at
Prémontré in 1120. By Christmas Day, 1121, when the
group took formal possession of the site from the monks
of Saint–Vincent at Laon, the community numbered forty
clerics with additional laymen.

Answering the call of Bishop Bartholomew de Jur
to attempt once again the reform of the canons at Saint–
Martin, Norbert sent Gauthier de Saint–Maurice, one
of his most trusted followers, and other Premonstratensians
to the abbey in 1124.[6] This time their efforts were
successful owing, historians tell us, to the presence
and personality of Gauthier. After Norbert, the founder,
and Hugues de Fosses, first abbot of Prémontré, Gauthier
de Saint–Maurice was one of the most influential of
the early Premonstratensians. He served as abbot of
Saint–Martin until elected Bishop of Laon in 1150. In
fact, it is due to Gauthier, historians explain, that
Saint–Martin was chosen to be the *prima filia*, second
in importance only to Prémontré itself, because both
the second and third daughter abbeys, Floreffe in
Belgium and Cuissy, in the Aisne, were founded prior
to the successful reform of Saint–Martin.[7]

The chronicles indicate that after several early
years of sometimes dire poverty the community at Saint–
Martin began to prosper. Abbot Gauthier seems to have
been an able administrator. By 1149, according to Hermann
of Laon, the canons of Saint–Martin were so rich that
they surpassed in possessions and income all other
religious communities in the diocese.[8]

Nothing is known about the church built by the
regular canons, which was described as the "new church"
in 1122 and again in 1132, other than the fact that
it was taken over and used by the premonstratensian
reformers.[9] While we have no documents giving precise
dates for the erection of the present church (Fig.
1), analysis indicates that the first period of construction
dates from the third quarter of the twelfth century,
the abbacy of Garin (1150–1174). The uniformity and
homogeneity of the fabric suggest that this phase completed
the building, which might be anticipated from the prosper-
ity described by Hermann of Laon. A second building
phase, which included raising the height of the transept
in order to vault it and the nave at the same level,
occurred late in the twelfth century. This later building

period included the addition of rib vaults in the nave and transept and flying buttresses to sustain them.[10] From this beginning, barely a generation after the completion of the first structure, the sequence of modification, rebuilding, alteration and restoration has continued to the present day.[11] In spite of the many changes, the plan and *parti* of the mid-twelfth-century church can be recovered, except for the first facade design. In the absence of archeological excavations and other documentation, we can say little except that there is no evidence of a porch or narthex structure—nothing, in short, to suggest that the present facade does not reflect the original in its general lines.[12]

The plan of the first premontratensian church (Fig. 2) consists of a nine-bay nave flanked by side-aisles, two prominently projecting transept arms at a height lower than that of the nave, and a two-bay sanctuary.[13] Three contiguous rectangular chapels open to the east from each transept arm. The two-bay sanctuary is as wide as the nave, but less tall, and terminates in a flat wall. Light and altar space in this area of the church were increased by opening rectangular niches in the three exposed walls of the eastern apse bay.

The nave elevation (Figs. 3 and 4) consists of two stories: pointed main arcades carried on rectangular piers having a rear projection, and clerestory windows set well above the arches. Architectonic emphasis throughout the nave was and is minimal. The piers have simple impost moldings instead of capitals, and the arch soffits are devoid of moldings. The inner voussoirs are slightly recessed from the front surface, but the profiles are square. The clerestory windows centered above each arch are also handled austerely. Their large round-headed openings have a steep bottom splay, but no framing moldings or architectonic decoration. On the exterior (Fig. 5 and 6) a continuous horizontal molding marks the bottom of the splay and the top of the aisle roof. A second molding runs between the wall buttresses at the level of the window opening imposts and, at a slight distance from the window opening, arches above and around it. The actual window opening has no exterior emphasis other than the recession provided by the splay.

The side-aisle windows are smaller versions of the clerestory lights, equally devoid of interior ornament and likewise framed by two horizontal moldings. The lower continuous band crosses the aisle wall buttresses, while the upper runs between them and arches over

164 *Cistercian Art and Architecture*

the window opening. The original disposition is intact
on the south side, but is preserved on the north only
in the westernmost bay. Owing to the presence of the
cloister, the other north aisle windows have been heavily
reworked. They lack not only the hood molding, but
all semblance of the consistency seen on the south
side.

 The minor articulations of the outside wall surface
(vertical buttresses at both aisle and clerestory level),
articulations conspicuous by their absence inside the
main vessel, are carried into the aisles. The support
structure of the aisle roof rested on transverse arches
spanning the aisle bays. Against the outside wall these
arches rested on simple pilaster strips, the juncture
being marked by an impost molding. The aisle face
of the main piers was similarly articulated by a pilaster
strip topped by an impost instead of a capital. The
aisle arches have the same flat, undecorated surfaces
as the main arcades. Thus, the aisles appeared to
be sequences of units, as opposed to the flat, continuous
mural surfaces of the nave itself.

 The nave scheme was completed by a pair of
square towers erected over the easternmost aisle bays.
To regularize the bay size, the second bay west of
the crossing was extended, compensating for the shorter
size of the bay between the towers, itself the result
of the square plan of the towers. It should be noted,
however, that the lack of interior articulation would
have made the dimensional change all but invisible.
Far more noticeable is the fact that, owing to the towers,
the first nave bay has no clerestory windows.

 To strengthen the tower structure, the lower bays
were rib-vaulted at aisle level, and again at the third
level, the top of which rises just above the nave clere-
story. The original towers might have been provided
with spires at this point. Their two top levels at present
are later additions: the fourth level at the time of
the nave and transept vaulting; the fifth with the
reconstruction of the facade in the late thirteenth century
(Figs. 5 and 6).

 The lack of correspondence between the levels
of the nave, transept and south tower, which is still
substantially intact, raises the possibility that the
parti was revised during construction. The horizontal
molding that marks the top of the first tower level
is a continuation of the original transept cornice.
The top of the second level, which has a single round-
headed window, framed by the ever present drip molding,
in the south face, might be read as the sole remaining

indication of the original intended height of the nave clerestory.14

The archeology, however, indicates that the nave was built to its present height in the first campaign. On the east wall of the transept, the line of the original wall buttress against the nave gable wall is still visible on both sides, even though the original gable cornice has been replaced by a simpler drip molding. In fact, the molding that marks the top of the second level of the tower does not precisely correspond to any other level in the structure. It serves simply as the base for the third story. This level of the tower, which has double arcades opening to the west and south, also does not correspond to other levels in the church since it projects above the nave clerestory cornice.

The third story of the tower, the top level of the original design still in place, introduces a richness of surface design and articulation that contrasts sharply with the bare expanses of wall in the nave and aisles punctuated only by exterior window moldings and wall buttresses.15 The tower corners are stabilized by heavy pier buttresses treated as pilaster strips with re-entrant angles cut into the corners. To minimize the impact of buttresses, whose mass is unrelieved by the corner treatment in the two lower stories, colonnettes were cut into the pilaster-strip corners at the third story. The visual play between the re-entrant angles and the corner shafts softens the corner mass. The pilaster strip flanked by colonnettes, repeated as the support between the arches on each tower face, becomes a rhythmic element in the design across all the faces as well as the corners. Linked by the continuous impost molding it ties the whole design together. The colonnettes not only articulate the frames around the openings but the corners as well. The actual openings into the tower chambers are narrow, round-headed lights, set deep in the layered, articulated surface, now rich with torus moldings, imposts and foliage capitals.16

The richness of ornament and articulation of wall surface in the towers is anticipated in the transept terminal wall on the south side. That the original arms, which are not exactly aligned with each other in plan, were considerably lower than the present cross volume is demonstrated by the horizontal moldings and by the presence of original windows in both east walls and in the south transept terminal wall. The north transept terminal wall had no windows because the abbey buildings adjoined it, and probably neither west wall originally had windows (although a later

window was inserted on the south side). The original design in the transept arms (Figs. 9 and 10) called for three windows on the east wall, centered above the molded arches opening into the three rectangular chapels.

Each chapel is covered by a four-part rib-vault which, while it has no formerets, is provided with *en délit* respond shafts set in the corners. The respond capitals, most of which are concealed behind the eighteenth-century woodwork, are of the same style and type as the foliage capitals in the sanctuary niches. Like all of the vault capitals in Saint-Martin, the chapel respond capitals are set with the wall plane rather than on the diagonal. The profile of the vault ribs consists of three tori, the center of which has a shallow cavetto sunk in it. The vault keystones were decorated with small wreaths of foliage. Each chapel is lighted by a single round-headed window. Although the interior side had no framing moldings, the original size and form of the chapel windows can be reconstructed from the pattern of exterior moldings.

The outermost chapel on the south side (Fig. 11) preserves the top of the original window opening, including the drip molding, while the horizontal molding marking the bottom of the original splay is preserved in sections of the wall and across the wall buttresses. Sections of the molding are also still in place flanking the enlarged window opening in the outermost chapel on the north arm. The pattern of the two moldings is precisely that of the nave aisles and clerestory; the upper molding arches over the window openings but does not cross the pier buttresses, while the lower molding is continuous across all surfaces.

Precisely the same molding pattern can still be discerned on the east walls of both arms at clerestory level. Two of the three original clerestory windows are still intact on the south arm, but only one on the north side. All of them have the same format and decoration. The filled-in opening of the center window on the south side, closed as a result of altering the internal divisions from three to two at the time of the vaulting, is still visible behind the curious buttresses added at the end of the twelfth century. Directly above the top of the window molding is the original cornice, a continuous band that runs around all three walls.

The design of the transept terminal consisted of four round-headed lancet windows disposed in pairs and separated by the central pier buttress. The upper windows still reflect the original design, their top

frames formed by the cornice molding of the lateral walls. They were surmounted by a triangular gable probably containing two or three arcade units around ventilation openings.[17] That the lower windows are later insertions that altered the earlier designs can be seen from the fact that they are not integrated into the pattern of wall moldings. Their splays end above the lower string course and their imposts have been imperfectly linked to the upper molding. Not only is this the reverse of the usual relationship established between the window and the moldings, in which the lower molding is continuous and the upper molding discontinuous, but the evidence also suggests that the present size relationship reverses the original. The lower windows with their triple-stepped frames are enlarged and elaborated versions of the originals. In the first scheme the upper lights descended further, so that their bottom splays rested on the horizontal molding now met by the imposts of the lower windows. Using the pattern of decoration found on the upper lights as a guide, the original lower windows would have been almost the same size as their upper counterparts and would have had their lower splays resting directly on the lower horizontal molding. Examination of the interior splays on both sets of windows confirms these changes. The curious treatment of the upper splay is clearly a method designed to conceal the changes, particularly the shortening of the window opening. Unlike the situation of the terminal, where evidence of the original disposition was preserved, it is not possible to determine if the first scheme included a window in the west wall of the south arm.[18] Given the concentration of light on the east side and the increasing number of windows directing attention to the central liturgical space, it is doubtful that the original plan included windows on the west side of the transept arms.

If the question of the window in the west wall of the south transept arm is, for lack of evidence, unresolvable, this is hardly the case with the apse terminal wall (Figs. 8 and 10). The late thirteenth-century window, composed of four lancets and an oculus, occupies most of the flat wall area, but the original wall fabric to either side and on the exterior provides clear evidence of the first design.[19] Exterior wall fill below the east window indicates the width of the original rectangular niche, which was centered on the terminal wall and flanked by a pair of windows. Window size is indicated by the preserved sections of exterior molding

and by the outer voussoirs of the interior splays. A
second pair of windows flanked the niche at clerestory
level, but they were set closer together between the
curve of the vault formeret and the gable over the
niche. The bottom edge of the upper window splays
rested on the interior horizontal molding, while their
tops are indicated by sections of the hood moldings
on the outside. The strong horizontal molding above
the windows is the continuation of the cornice on the
lateral walls. The gable above was rebuilt when the
nave vaults were added, suggesting that the apse was
re–roofed at the same time. The two arcade units in
the gable are framed and molded in the late twelfth-
century pattern, whereas the originals might have been
unmolded circulation holes, as on the eastern nave
gable.

On the interior, the terminal wall altar niche
was, like the niches preserved in the lateral walls,
covered by a short section of pointed barrel vaulting.
The pointed arch opening into the niche, and the formeret
against the outer wall, were profiled by a simple torus
molding carried on colonnettes masking the corners.
Their imposts were connected by a horizontal string-
course in the niche and across the wall face as far
as the window splays. All of the apse windows lack
architectonic frames on the interior, in contrast to
the strong visual emphasis given the niches and the
responds for the two quadripartite vaults over the
apse. A careful visual hierarchy is established in
the responds and vault ribs, including the distinction
in the type of capital foliage from that used for the
niche and window capitals and that on the respond
capitals. The *doubleaux* rest on larger engaged shafts
fronting pilaster strips. The angles between pilasters
and walls house the smaller ogive responds; yet the
shafts are intentionally bound together by continuous
capitals. On the crossing face of the entrance arch,
an additional pair of colonnettes has been added to
the responds, with the result that the arch itself has
two more ranks of torus molding than the succeeding
arch. The whole system of arches and shafts creates
a pattern of decreasing numbers of arch moldings and
supporting colonnettes and a diminishing perspective:
four ranks on the entrance arch, two ranks on the
intermediate *doubleau*, a single torus for the formeret
against the terminal wall.[20] The shafts in the corners
against the terminal wall are, in fact, the responds
for the vault ribs rather than for the formeret. The
rib profiles have a comparable distinction according

to use, beginning with the single torus for the formeret. *Doubleaux* and ogives have a profile of three grouped tori, the center being larger. The grouping is tight and admits only a thin line of shadow in the vault ribs, whereas the tori on the transverse ribs are separated by obvious cavetti and the center torus has a shallow cavetto cut into it. Formerets are used throughout the apse, but have no respond shafts. Instead of introducing shafts, the builder introduced a set-back in the clerestory wall surface, a set-back masked by the continuous horizontal molding that connects the imposts of the responds and marks the vault springing. The depth of the set-back corresponds exactly to the diameter of the torus-molded formeret. The bottom edges of the unmolded clerestory-window splays rest on the horizontal molding and further conceal the set-back in the wall surface. The design of the lateral walls follows that of the terminal: a rectangular niche flanked by windows. The wall space is less, however, with the result that the eastern bay contains one window and the niche. The second window is opened in the western bay, the symmetry of the pattern being interrupted by the wall responds separating the bays. The different sizes of the window and the niche mean that neither is centered on the lateral wall—nor is the western window centered in that bay because the transept chapels would block it. The result is a disjunction between the clerestory windows, which are centered in each bay, and the lower elements, which are related to the niches.

The exterior faces of the lateral walls (Fig. 13) reflect the interior arrangement since a strong pier buttress, between the niche and the ,western window, creates a disalignment that is not found in the clerestory. The pattern of moldings, one marking the bottom of the window splay and the other arched over the round-headed opening, is seen again—but with the difference that the lower windows are flanked by colonnettes carrying torus-molded arches around the windows. Additional colonnettes punctuate the outer corners of the niches and, as on the windows, rest on bases set well above the lower stringcourse. It is noteworthy that this lower stringcourse is continued without interruption across the window walls, around the niches (before their windows were enlarged downward), and across the eastern strip buttress; but they do not cross the intermediate buttresses. In a reversal of the usual pattern, including that of the clerestory windows, it is the molding (used at impost level in the lower windows) that crosses all of the surfaces, even the intermediate

buttresses. The clerestory had a continuous lower molding, now removed, and still has a discontinuous upper molding.

The richness of the moldings and decorative patterns on the exterior of the sanctuary is a parallel to the interior ornamental and spatial complexity. The contrast is striking between the flat, unarticulated wall surfaces in the nave (Fig. 4), and the spatial ambiguity of projections, recessions and multiple linear patterns on the walls and vaults of the apse (Fig. 10). Corners, angles and changes of direction are masked by responds, colonnettes, formerets and vault ribs; yet the windows have no architectural frames. The lack of vertical correspondence between the two levels is not disguised, nor is an attempt made to impose regularity between the lower wall and the clerestory and vaults. Two visual patterns co-exist. The builder used architectural elements to create a unifying visual pattern that links the two, yet simultaneously establishes a spatial ambiguity between undifferentiated openings and precisely edged surfaces. No other part of Saint-Martin approaches the apse in the richness of ornament, complexity of decorative patterns and changing wall surfaces. The simplicity and directness of the nave is followed by the lower transept arms with their multiple openings. These in turn give way to the increased ornamental richness and spatial ambiguity of the apse, the liturgical focus and visual climax of the church.[21]

Notre-Dame at Foigny: Reconstruction of the Plan

The abbey of Notre-Dame at Foigny, the earliest and most important cistercian foundation in the diocese of Laon, was founded by Bernard of Clairvaux himself, in 1121, at the express request of Bartholomew de Jur.[22] Cistercian tradition has it that the site of Foigny was among those considered and rejected by Norbert in 1118/1119 (just prior to his attempt to reform the canons of Saint-Martin at Laon), but that Bernard had no hesitation in accepting it. The abbey of St Michel-en-Thiérache ceded the land to Bernard and on 11 July 1121 monks from Clairvaux, under the leadership of Abbot Rainaud, arrived and began to establish themselves. Work advanced rapidly on the first church, which was constructed on an island between two branches of the Thon, and consecrated in the presence of Bernard on 11 November 1124.[23] Of this structure we know nothing (though it is said to have survived until after the Revolution), because the frequent floods of the Thon caused the monks to abandon the island and move to the right bank where they built the monastery.

Foigny prospered and grew, attracting large numbers of recruits to the austere regimen championed by Bernard. By 1141, the monks at Foigny were able to found a daughter house at Boheries, close to Guise, with the help of Bartholomew de Jur. In turn, he retired from the episcopal see to become a monk at Foigny in 1150 and died there in 1157.

The vast new church (Fig. 11) built at Foigny in the third quarter of the twelfth century, in spite of the usual damage, repairs and rebuildings from the destructions of the Hundred Years War, the Wars of Religion and other calamities, survived until after the Revolution. The last major repairs of record took place in the eighteenth century, indicating the buildings were in good condition at the time a hospital was briefly installed at Foigny following the Revolution. In 1793 the buildings were sold and, following an unsuccessful attempt to preserve them, systematic destruction began in 1796. When Father Anselme Dimier excavated in 1959 the site of the church could be identified only by a fragment of the north transept buried in a mound of rubble.

Through his investigation of three areas of the site, Dimier recovered the church plan (Fig. 12), a great many architectural fragments and a quantity of floor tiles, many of which were still *in situ*. The plan consists of a nave of eleven bays preceeded by a narthex and flanked by side-aisles. The projecting transept is unusually developed for a cistercian church, with side-aisles to the west and three contiguous, rectangular chapels to the east side of each arm. The rectangular sanctuary terminates in a flat wall and was originally covered by two bays of rib vaults. From the quantity of architectural fragments found during the excavations, consisting chiefly of vault ribs and clusters of wall shafts, Dimier concluded that the entire church was rib vaulted. The fragment of the northwest arm that was unearthed confirms this hypothesis by the presence of the base and a section of the shaft of an angled wall-respond in a corner.[24]

Dimier identified the plan of Foigny as an early example of the "bernardine" plan and recognized several direct correspondences to the plan of the founding abbey, Clairvaux, where the second church was built c.1135–1145.[25] The similarities are so striking, indeed, that it is well to note the few minor differences: the apse at Foigny was 4 m. deeper and the nave between 2 and 3 m. longer than at Clairvaux. Most striking are the close correspondences in the dimensions of the

two transepts, although one peculiarity should be noted. The plan of Clairvaux, based as it is on old documents rather than systematic excavations, shows the west aisles of the old transept arms to have been walled off from the main space and internally partitioned to create two more chapels on each arm, the outer of which was only reached by passing through the inner. That the spaces were so divided originally, at least on the south side, may be inferred from the position of the night stairs, parallel to and against the west side of the main vessel of the transept at Clairvaux. The claustral buildings were also on the south side at Foigny, but the position of the night stairs and other means of access to the cloister cannot be determined from the evidence that remains. Finally, the documents found by Dimier suggest that the west spaces at Foigny were, indeed, aisles flanking the transept volume and were without internal partitions.[26]

Foigny and Laon Compared

Reconstruction of the first state of the plan of Saint-Martin at Laon (Fig. 2) and recovery of the plan of Notre-Dame at Foigny (Fig. 12) make possible the comparison of these two important, contemporary monastic foundations resulting from the initiatives of the same influential patron, Bartholomew de Jur. In fact, they constitute an interesting and revealing test case for the commonly stated proposition, following Clapham and others, that premonstratensian churches were copied from cistercian foundations. In a general way, it is true, the plan of Saint-Martin does resemble that of Foigny, given the obvious differences in scale. But only one specific feature of this plan is identifiably cistercian: the contiguous, rectangular chapels opening from the east side of the transept arms. The fact that both have three chapels per arm is less important than the presence in the premonstratensian church of one of the most identifiable architectural features of cistercian churches.

It is also true that both plans feature two-bay, flat-walled apses.[27] But when the three altar niches and their flanking windows are taken into account, the differences are more striking than the superficial similarities. The plan of the apse of Saint-Martin at Laon has a richness of projections and recessions and a multiplicity of openings that translate into an ambiguity of space at the very point where the Cistercians demanded clarity and definition. The planar limits so visible in a cistercian plan like that at Foigny translate,

in an apse like that at Fontenay (and probably also that of Foigny if the surviving views have even the most general accuracy), into a space defined with great clarity by pierced planes.[28] The rigorous order of such a design is diametrically opposed to the ambiguity of surfaces and planes characteristic of Saint-Martin (Fig. 12). The changing directions and different sizes and locations of windows create a space that seems larger than it actually is, a space that can be said to be illusionistically enlarged. The cistercian apse puts the emphasis on the planes and the holes in them that admit the rich light to the liturgical space. Illusionism is avoided in favor of clarity and order.

Fontenay demonstrates another cistercian characteristic that must have existed at Foigny, which was also the product of a single, extensive building period; namely, the unity of the design throughout the building. This can be inferred at Foigny from the presence of the same vault rib profile and the same clustered shafts found throughout the area of the excavations. In contrast, the first scheme at Saint-Martin presents a series of rather striking contrasts, as for example between the flat, unarticulated nave walls with timber roof and the richly decorated, highly articulated, rib-vaulted apse. Another series of contrasts is presented by the three different heights in the building, although it must be admitted that in themselves height differences are hardly an unusual feature in medieval buildings. It is, in this context, a matter of contrasts in the premonstratensian structure, as opposed to the relatively greater uniformity in the cistercian. Saint-Martin at Laon showed a more obvious and elaborate progression in the increase and richness of ornament toward the liturgical center of the building. The vaulted apse is the visual climax of a sequence of increasing decorative complexity that contrasts markedly with the planar quality of the nave walls. In the apse every angle, every change of direction, is masked by wall shafts; windows appear in different sizes and locations. The wall actively projects and recedes creating an ambiguity of surface definition. The most striking feature, however, is the progressive enrichment with ornament, inside and out, and the obvious changes in the role of decoration in different parts of the building, all of them products of the same builder. In short, Saint-Martin at Laon exhibits an aesthetic preference for changes and contrasts and for the sequential disposition of architectural ornament.

The aesthetic of early cistercian churches, judging from the surviving examples and from the documentation

of others, was far more uniform.[29] At Fontenay, Trois-
Fontaines, Ourscamp and, by extension, Foigny, the
altar area was no more richly decorated than the rest
of the structure.[30] The special emphasis that it received
was the result of the dramatic increase in light owing
to the multiple windows, as well as to the clarity of
the organization and disposition of the window openings.
The cistercian preference for definition by light and
wall planes is markedly different from the pronounced
linearity of Saint-Martin at Laon, especially in the
apse. Laon has an analogous, but different, order
to the *parti*—a visual order that stresses line not plane,
as well as progressive enrichment, and therefore, delights
in contrasts, ambiguities and disjunctions.

The most complex patterns of linear ornamentation
are reserved for the visual climax of the church, the
apse, where the patterns are as rich on the interior
as on the exterior. In addition to the pronounced horizon-
tal moldings above and below the windows, colonnette
shafts are introduced in inside and outside corners
to link the bands. On the exterior, the shafts link
the moldings of the lower windows and are also set
in the window openings themselves. On the interior,
the shafts run the full height of the main wall to,
that is, either the springing of the vaults or of the
arched entrance to the niches. The uniform size, but
different heights, contribute to the spatial complexity.

Burgundian Influences at Laon

The use of shafts in this manner, like most of
the elements and details of the decoration at Laon,
follows local practice. There is, however, one feature
at Saint-Martin, appearing in the region for the first
time, that can be definitely identified as Burgundian
in origin and probably Cistercian by transmission.
This is the set-back of the clerestory wall plane and
the accompanying introduction of formerets under the
vaults (Fig. 10). The depth of the set-back, which
is the diameter of the formerets, is thus concealed
by them and by the horizontal string-course that connects
the respond imposts.

The clerestory set-back is first introduced in
conjunction with a set-back of the second story wall
plane in the elevation of the buildings based on the
scheme of the great abbey church at Cluny.[31] A set-
back beginning at the base of the second story is visible
in the barrel-vaulted naves at Autun, Beaune, and
Paray-le-Monial, as well as in the surviving transept
fragment of Cluny itself.[32] Restriction of the set-back

to the clerestory level, together with the stringcourse and the formerets, occurs for the first time in the naves of Avallon, Vézelay and related buildings.33 From this usage in groin-vaulted buildings, the whole scheme was incorporated into rib-vaulted buildings, such as Montréal, the Cathedral of Sens (chevet straight bays), Saint-Martin at Chablis, Saint-Eusèbe at Auxeree, Langres and countless others.34 It is probably impossible to identify the first appearance of the scheme in a cistercian building, owing not only to the loss of so many important early examples, but also to the fact that the treatment appears in conjunction with groin-vaults as frequently as with rib-vaults at this time in Burgundy. The earliest surviving cistercian example appears to be the nave of Pontigny where, however, the molding between wall and vault is so insignificant that it led Branner to say there were no formerets at Pontigny.35 Defining the formeret as an obvious and pronounced molding, Branner is, strictly speaking, correct. Nonetheless there is a narrow strip that separates the two planes. I wonder if we are not in the presence of yet another indication of a *parti* altered during the building by the introduction of rib-vaults at Pontigny.36 Thereafter the set-back of the clerestory wall plane becomes a common treatment in rib-vaulted cistercian structures in Burgundy and north France, judging from such twelfth and thirteenth-century examples as Trois-Fontaines, Jouy, Chaalis and the choir at Pontigny.37 The device has an inconsistent history in the early gothic buildings of north France, appearing sporadically and subject to variations in such examples as the tower bays at Noyon, the nave of Saint-Etienne at Beauvais and Saint-Germer-de-Fly.38 One such variation, probably derived from the choir of Durham rather than from Burgundy, becomes part of the standard gothic vocabulary in Normandy, beginning with the upper chambers of the Tour Saint-Romain of Rouen Cathedral, the nave of Saint-Pierre at Lisieux and the choir of La Trinité at Fécamp.

Before the middle of the twelfth century, however, the clerestory set-back and associated features are found only in Burgundy. It must have been from a burgundian source, probably cistercian, perhaps the nave of Pontigny, that it was adapted by the builder of Saint-Martin at Laon. In the final analysis it is, in fact, the only design feature at Saint-Martin for which there are no local precedents. Together with the concept and plan of the rectangular chapels opening east from the transept arms, this detail in the handling of the wall is the only identifiable cistercian, or at

least burgundian, element found in Saint–Martin at
Laon.

Regional Influences at Laon

 In contrast, regional features abound in the building
and firmly place it in the mainstream of architectural
and sculptural developments in the Aisne Valley during
the third quarter of the twelfth century.[39] While certain
elements are so ubiquitous as to defy more than general
localization (flat ended apses and the extensive use
of wall moldings to lend linear emphasis to the surface,
to name but two examples), others are unquestionably
distinctive to the region. For the sake of the present
discussion the list has been reduced to: a single element
of plan and structure, the projecting altar niche; and
three specific details in the sculptural decoration:
the highly unusual "palm–tree" capitals and two forms
of keystone ornamentation (medallion heads wreathed
in foliage and angels).
 In his monumental study of the 1890s covering
religious architecture in the old diocese of Soissons,
Lefèvre–Pontalis singled out the projecting, gabled
altar niche as one of the more distinctive regional
features.[40] In another article for the *Congrès archéolo-
gique* of 1911, he listed some fifty examples of altar
niches dating from the third quarter of the twelfth
century and discussed the variations in location and
constructional techniques. Concluding that they can
only have been intended for altars, he added that
they were nonetheless important for the sense of plasticity
they contributed to unrelieved wall surfaces.[41] With
few exceptions his examples in both studies were limited
to the diocese of Soissons.[42] However, when one investi-
gates the diocese of Laon, the western parts of the
dioceses of Senlis and Noyon and the eastern sections
of the Aisne valley, then the list of examples multiplies.
In short, while projecting altar niches are characteristic
of the entire region, the greatest concentration of surviv-
ing examples does lie to the east and south of Soissons
and can be found in a variety of buildings, from parish
and collegial churches to monasteries and even Laon
Cathedral.[43] They are found in the churches of Benedic-
tines, regular canons and, in this instance, Premonstraten-
sians; but in no instance are (or were) they found
in a cistercian foundation.
 Saint–Martin at Laon is also the only known example
to have niches opened in the lateral walls of a rectangu-
lar apse. Standard placement called for niches to be
oriented, usually one from the main apse (as at Nouvion-

le-Vineux, Fig. 14), and, space permitting, one from each transept arm, in buildings without transept chapels. Although it is the sole surviving premonstratensian church to have them, the presence of projecting, gabled altar niches places Saint-Martin at Laon firmly in the mainstream of Aisne Valley architecture in the third quarter of the twelfth century.

If the altar niches are a common and widespread regional feature, the same is not the case with the distinctive "palm-tree" capitals on the triumphal arch of the apse at Saint-Martin (Fig. 15).[44] The "palm-tree" motif consists of twin acanthus leaves sprouting from a central stalk carved in a spiral pattern. The flat, spiky leaves branch across the capital to touch at the tips or to indicate the corners, the only spot where they curl. This distinctive capital design is found in a limited number of locations, which can be roughly divided into two groups. There is an early group with less distinctly carved foliage, often not even acanthus, which culminates with the three examples at Saint-Denis. The second group is characterized by very pronounced acanthus leaves, the sharp points of which are emphasized by drilling. "Palm-tree" capitals with this kind of foliage are, with the exception of the example on the reverse of the west facade at Chartres, concentrated in the region north and east of Paris: the south ambulatory at Noyon, the crossing at Vailly, the east aisle of the north transept at Laon Cathedral (Fig. 16) and the two sets at Saint-Martin, Laon. There is a trio of slightly later examples in the apses of Oulchy-le-Château, Val-Chrétien and Nanteuil-Notre-Dame.[45] It should be noted that while Val-Chrétien was also a premonstratensian abbey, founded from Saint-Martin at Laon in 1134, the capitals and other architectural details suggest that the design was derived from nearby Oulchy-le-Château rather than from the founding house. The close geographic proximity of this trio of later examples, plus the sharing of other, less distinctive foliage types and details, suggests the continued activity if not of a single sculptor, then at least of a small workshop active in all three churches, perhaps as much as a decade after the rest of the series.

The designs of the two vault keystones in the apse of Saint-Martin at Laon (Figs. 17 and 19), different as they are from each other, provide additional evidence of regional links.[46] The types exemplify two common approaches evident in early gothic keystone decoration. Ornament in the first is confined to the bottom face of the keystone, usually circular in form; while the

more exuberant ornamentation of the other spills over the sides of the keystone into the space between the ribs. The first type is represented by the eastern vault keystone (Fig. 17), which has an unusual design variation on the usual foliage patterns. In the center of the keystone is a small head surrounded by a separate, compact wreath of foliage. The western keystone (Fig. 19) falls into the second category: a much less contained bunch of foliage is all but obscured by four flying angels. Angels on keystones are an obvious and rather common device; but usually they are single figures confined to the bottom face of the key, and less often there are two or more flying, displaying the lamb of God, or engaged in a similar activity. The usual place-ment for keystones bearing angels is in the vaults directly over altars, as for example in the transept chapels at Laon Cathedral and the apses of Nouvion-le-Vineux and Vailly (Fig. 20); or in an adjacent bay, for example, in the crossing of Nanteuil-Notre-Dame, where the apse bay itself is barrel vaulted, and at Bruyères in the bay before the apse. During the last third of the twelfth century keystones decorated with angels proliferate all across north France.[47] The flying angels of Saint-Martin at Laon, however, belong to an earlier phase of the development, when the majority of the examples are still located in the Aisne valley.

If the angel keystones become widespread in the later twelfth century, the little medallion heads (Fig. 17), whether full face or in profile and always wreathed in foliage, remain, with but rare exceptions, localized in the Aisne valley.[48] The earliest examples appear to be in the chapels at Noyon (Fig. 18), and the transept at Vailly, which are probably the sources for the one at Saint-Martin. The other examples all post-date Noyon and Saint-Martin. The medallion-head keystones at Laon Cathedral, for example, belong to the third building phase and are contemporary with the examples in the south transept arm at Soissons Cathedral, at Bazoches and Bussiares.

Like the altar niches, these three details of ornament are largely unknown outside of the Aisne valley and do not occur in any surviving cistercian buildings, whether regional or Burgundian. The list of such features could be extended to other details in the design of Saint-Martin at Laon. In fact, another set of strictly local features common to the late twelfth century work at Saint-Martin confirms that we are not dealing with an unusual or isolated phenomenon.[49]

When the analysis is extended to other premonstraten-

sian churches, whether in the Aisne valley or not, the situation remains analogous to that of Saint–Martin at Laon. For example, the church of Saint–Yved at Braine could hardly be less cistercian in plan, structure and aesthetic.[50] If anything, owing to its later date, it displays an even greater affinity with Aisne valley architectural techniques and conceptions than does Saint–Martin at Laon. Studying Braine, one becomes more and more convinced that it could have been created nowhere else than in the Aisne valley architectural milieu of the last quarter of the twelfth century.

A comparable situation exists with regard to Picardy and the ruins of the premonstratensian church at Dommartin.[51] Recent archeological excavations and still unpublished finds have produced an accurate plan that makes it possible to analyze the direction and sequence of construction. At the same time this sequence finds confirmation in the numerous, high quality, foliage capitals found during the excavations. Together with the few examples previousy known, these capitals will fill an important gap in our knowledge of early gothic architectural sculpture in Picardy over the second half of the twelfth century. They will make it possible to continue and deepen the investigation of Picard influences in England begun by Bony and continued by Fergusson.[52]

One other point that emerges from the excavations at Dommartin is that, once again, the evidence provides a convincing demonstration that the superficial resemblances between the plan of Dommartin and cistercian churches is misleading. Leaving aside the problem of the impact of the choir plan of Dommartin on such cistercian examples as Clairvaux III and Pontigny III, the most identifiable cistercian feature remains the transept chapels, a feature immediately visible on the plans. As soon as the investigation moves to the actual structure, however, the similarities vanish before a wealth of local features and constructional characteristics that individualize Dommartin or, for that matter, any premonstratensian example.

Conclusion

Because they are an easily recognizable element in plan, the presence of contiguous rectangular chapels on the east sides of transepts in premonstratensian churches has, as an indication of cistercian influences, been given too much prominence. Certainly the early chapels were derived from cistercian sources, probably as single elements and then incorporated into otherwise local systems. Beyond such superficials in planning,

the architectural evidence does not sustain the idea of significant influences from cistercian churches that in any way could be considered a parallel to the degree or type of premonstratensian debt to cistercian statutes, institutions and administrative organization. Likewise, the notion of an identifiable premonstratensian architecture utterly fails to convince, as even a hasty comparison of such buildings as Saint-Martin at Laon, Saint-Yved at Braine and Dommartin reveal. On the other hand, much has been written about the essential unity of twelfth-century cistercian architecture.[53] While cistercian builders were always responsive to local techniques and building practices, they nonetheless achieved and preserved a sense of aesthetic unity that transcends local differences to create a recognizable cistercian spirit in twelfth-century architecture.

Queens College, C.U.N.Y.

NOTES

1. A. W. Clapham, "The Architecture of the Premonstratensians, with Special Reference to Their Buildings in England", *Archaeologia* 73 (1922–1923) 117–146, esp. 121.

2. For example see: L. Régnier, "Notes sur l'abbaye de la Lucerne et sur l'architecture de l'ordre de Prémontré", *Annuaire des cinq départements de la Normandie* 78 (1911) 262–290; and E. Hardick, "Pramonstratenserbauten des 12. Jahrhunderts im Rheinland, ihr Verhältnis zu den französischen und belgischen Vorstufen", *Analecta Praemonstratensia* 11 (1935) sep. pag. (cited below as AP).

3. Some of the more important sources on the order and its history include: "Norberti archiepiscopi Magdeburgensis, vita", *MGH Scriptores* 12:663–706 ("Vita A"); D. Papebrochio, "Sanctus Norbertus Praemonstratensis ordinis fundator, archiepiscopus Magdeburgensis; ad vitam Sancti Norberti commentarius praevius", PL 170:1235–1254; "Vita S Norberti", PL 170:1253–1344 ("Vita B"); J. Lepaige, *Bibliotheca Praemonstratensis Ordinis* (Paris: 1633); and C.

L. Hugo, *Sacri et canonici Ordinis Praemonstratensis annales* (Nancy; 1734–1736). More recent studies focusing on the twelfth century are: F. Petit, "Les Vêtements des Prémontrés au XIIe siècle", AP 15 (1939) 17–24; G. Schreiber, "Prämonstratenserkultur des 12. Jahrhundert", AP 16 (1940) 41–104; 17 (1941) 5–33; P. Lefèvre, *L'Ordinaire de Prémontré*, Bibliothèque de la revue d'histoire ecclésiastique, 22 (Louvain: 1941); C. Dereine, "Les Origines de Prémontré", *Revue d'histoire ecclésiastique* 42 (1947) 352–378; Lefevre, *Les Statutes de Prémontré*, Bibliotheque de la revue d'histoire ecclésiastique, 23 (Louvain: 1947); Petit, *La Spiritualité des Prémontré aux XIIe et XIIIe siècles*, Etudes de théologie et d'histoire de la spiritualité, 10 (Paris: 1947); N. Backmund, *Monasticon Praemonstratense* (Straubing: 1949–1956); H. M. Colvin, *The White Canons in England.* (Oxford: 1951), the best introduction in English; Petit, "Le Puritanisme des premiers Prémontrés", AP 27 (1951) 137–148; Idem, "Comment nous connaissons saint Norbert", AP 36 (1960) 236–246; Idem, "Pourquoi saint Norbert a choisi Prémontré", AP 40 (1964) 193–205; J. B. Valvekens, ed., *Acta et Decreta Capitulorum Generalium Ordinis Praemonstratensis*, 3 vols., AP 42–51 (1966–1975) sep. pag. On the contacts between the Cistercians and the Premonstratensians, see: G. Madelaine, *Etude sur l'amitié religieuse de saint Bernard et de saint Norbert* (Caen: 1878); H. Heijman, "Untersuchungen über die Prämonstratenser-Gewohnheiten", AP 2 (1926) 5–31; 3 (1927) 5–27; 4 (1928) 5–29, 113–131, 225–241, 351–373; J. B. Valvekens, "Relations ordinis nostri cum ordine Cisterciense", AP 19 (1943) 63–69; P. Lefèvre, "Prémontré, ses origines, sa premiere liturgie, les relations de son code legislatif avec Cîteaux et les chanoines du Saint Sepulcre de Jeruslaem", AP 25 (1949) 96–103; F. Petit, "Bernard et l'ordre de Prémontré", *Bernard de Clairvaux* (Paris: 1953) 289–307; and T. J. Gerits, "Les Actes de confraternité de 1142 et de 1153 entre Cîteaux et Prémontré", AP 40 (1964) 193–205 with bibliography.

4. See the articles cited in n. 22. It has also been announced that the work journals of the excavations at Foigny will be published in the *Mélanges Anselme Dimier*, v. 1.

5. The first historical study devoted to Saint-Martin was that by C. Gomart, "Notice sur l'abbaye de Saint-Martintin de Laon (de l'ordre de Prémontré)", *Bulletin de la Société académique de Laon* 18 (1966–1868) 121–166; also published in *Etudes Saint-Quentinoises*

4 (1870–1873) 3–48. Gomart made extensive use of the older works by Lepaige and Hugo (see n. 3) and the summary in *Gallia christiana* (Paris: 1751) 9: 662–668 and *Instrumenta* 10:191–192. Baron Béthune de Villers, "Laon, église Saint–Martin", *Bulletin des séances de la Gilde de Saint–Thomas et de Saint–Luc* 6 (1884–1886) 280–290; the thesis by A. Biver, "Essai historique sur l'abbaye royale de Saint–Martin de Laon des origines à l'union à l'évêché", *Ecole nationale des Chartes, Positions des theses* (1911) 17–26; Idem, "L'abbaye royale de Saint–Martin de Laon des origines a l'union à l'évêché", *Ecole nationale des Chartes, Positions des theses* (1912) 9–15, was never published. On the architecture see: L. Broche, "Laon, église Saint–Martin", *Congrès archéologique* 78/1 (1911) 225–239; Hardick, pp. 43–52; M. Berry, "La Restauration de l'ancienne Abbaye et de l'Eglise Saint–Martin de Laon apres la guerre 1939–1945", *Annales des amis belges du vieux Laon* 3 (1954–1955) 4–7; Idem, "Trois carrelages récemment découvertes dans l'Aisne", *Bulletin de la Société nationale des Antiquaires de France* (1961) 67–74; R. Brichet, "Restauration de l'abbaye de Saint–Martin, à Laon", *La Construction moderne* 77 no. 3 (1961) 65–82; J. Fritsch, "Quelques remarques sur l'architecture de l'église Saint–Martin a Laon", *Mémoires de la Fédération des sociétés d'histoire et d'archéologie de l'Aisne* 25 (1980) 67–81; and B. Ducouret, "Le Palais abbatial de Saint–Martin de Laon", *Bulletin monumental* 140 (1982) 183–195.

6. See Petit, 1947.
7. See the works cited in n. 5. For Floreffe and Cuissy, see Backmund.
8. Hermann of Laon, "De miraculis s mariae Laudunensis, Libro III", ed. R. Wilmans, *MGH Scriptores* 12: 653–660.
9. Studies concerning the architecture of Saint–Martin are given in n. 5. So far as the early church is concerned the present analysis supersedes that given by the author in his unpublished master's thesis, "Saint–Martin at Laon. *Prima Filia Praemonstratensia"*, Columbia University, 1964.
10. The later building campaign is studied in greater detail in the author's master's thesis, cited in n. 9, and will be published in another study devoted to regional architecture around Laon.
11. The most recent restorations were to the eighteenth–century woodwork in the transept and choir, which were finished in 1982.

12. On the present facade, the best analysis is that by Fritsch. My guess is that the twelfth–century facade had three portals, the center of which might have been framed by a gable, as at Berzy–le–Sec and Cour-melles. The centerpiece of the facade might have been a small rose window, patterned "before" the present rose in the south transept, but "after" the two newly finished rose windows in the transepts of the cathedral. See W. Clark and R. King, *Laon Cathedral* I (London: 1983).

13. The most accurate plan and the one that is correct in its details is that by E. Brunet published by Fritsch, p. 70, that is the basis of Figs. 1 and 2.

14. In line with this possibility, it should be noted that the difference between the moldings marking tower levels one and two is similar to the height difference between the transept as first built and the apse bays.

15. The north tower was rebuilt in the eighteenth cen-tury. The design of the south tower has many region-al affinities that will be discussed in another study.

16. The design should be compared with the treatment of the walls of the apse.

17. The ventilation openings might have been plain and unmolded, as on the eastern nave gable; but arcad-ing in the pattern found on the apse terminal wall is more likely.

18. The fact that the present window in the west wall of the south transept has the same ornament as the low-er windows in the terminal wall suggests that it too dates from the end of the twelfth century.

19. E. Lefèvre–Pontalis, "Les Niches d'autel du XIIe dans le Soissonnais; *Congrès archéologique* 78/2 (1911) 138–145, observed the traces of the niche and restored the plan, but not the wall design.

20. This is visually analogous to the actual diminishing of the size of the apse observed at Fontenay and dis-cussed by C. Bruzelius, "The Twelfth–Century Church at Ourscamp", *Speculum* 56 (1980) 28–40.

21. The liturgical choir of the church actually extended two bays into the nave. The eighteenth–century choir closing was still in place when Tavernier de Jun-quieres made his watercolor view, which was subse-quently engraved by Née for B. de la Borde, E. Bé-guillet and J.-E. Guettard, *Voyage pittoresque de la France* 10 (Paris: 1792).

22. A. Dimier, "L'Eglise de l'abbaye de Foigny", *Bulle-tin monumental* 118 (1960) 191–205; *Idem*, "L'Eglise de Foigny", *La Thiérache 1873-1973*, Société archéolo-

gique de Vervins et de la Thiérache (1973) 71–
77. The work journals of the excavations are to be
published in the *Mélanges Anselme Dimier.*

23. Dimier, "Le Miracle des mouches de Foigny", *Cîteaux
in de Nederlanden* 8 (1957) 57–62.

24. Dimier, 1960.

25. On the excavations at Clairvaux, which did not inves-
tigate the area of the church, see: P. Jeulin, "Quel-
ques découvertes et constatations faites à Clairvaux
depuis une vingtaine d'années", *Bulletin de la Soci-
été nationale des antiquaires de France* (1960) 94–
118; and W. Schlink, *Zwischen Cluny und Clairvaux*
(Berlin: 1970). On the "bernardine" plan see: A. Di-
mier, *Recueil de plans d'églises cisterciennes* (Paris:
1949); K. H. Esser, "Uber die Bedeutung der Zister-
zienserkirchen", *L'Architecture monastique,* Bulletin
des relations artistiques France–Allemagne (Mainz:
1951); H. P. Eydoux, *L'Architecture des églises cister-
ciennes d'Allemagne* (Paris: 1952); Esser, "Uber den
Kirchenbau des Hl. Bernhard von Clairvaux", *Archiv
für mittelrheinische Kirchengeschichte* 5 (1953) 195–
202; Idem, "Les Fouilles de l'église romane de l'ab-
baye de Himmerod", *Mémorial du voyage in Rhénanie
de la Société nationale des Antiquaires de France*
(Paris: 1953) 171–174; Eydoux, "Les Fouilles de
l'abbatiale d'Himmerod et le notion d'un 'plan ber-
nardin'", *Bulletin monumental* 111 (1953) 29–36; Es-
ser, "Les Fouilles à Himmerod et le plan bernardin",
*Mélanges saint Bernard; VIIIe centenaire de la mort
de saint Bernard* (Dijon: 1954) 311–315; Dimier,
"Le Monde claravallien a la mort de saint Bernard",
Mélanges saint Bernard, 248–253; C. W. Clasen,
*Die Zisterzienserabtei Maulbronn in 12. Jahrhundert
und der bernhardische Klosterplan* (Kiel: 1956); H.
V. Beuer, "Evolution du plan des églises cister-
ciennes en France, dans les pays germaniques et en
Grande-Bretagne", *Cîteaux en de Nederlanden* 7 (1957)
269–289; F. Bucher, *Notre-Dame de Bonmont and the
Earliest Cistercian Abbeys of Switzerland* (Bern:
1957); H. Hahn, *Die frühe Kirchenbaukunst der Zister-
zienser* (Berlin: 1957); Eydoux, *L'Eglise abbatiale de
Morimond* (Rome: 1958); Bucher, "A Failure of Archi-
tectural Purism", *Perspecta* 6 (1960) 5–15; Idem, "Cis-
tercian Architectural Purism", *Comparative Studies in
Society and History* 3 (1960–1961) 89–105; Dimier, "Eg-
lises cisterciennes sur plan bernardin et sur plan bé-
nédictin", *Mélanges René Crozet* (Poitiers: 1966)
697–704; Idem, *Recueil de plans d'églises cistercien-
nes, Supplement* (Paris: 1967); D. A. Walsh, "An Ar-

chitectural Study of the Church", *Bordesley Abbey*, BAR (1983) 2:207–287.

26. Dimier, 1960.

27. This feature is far too common in the medium-sized and small churches of north France to be considered as an indication of "contact". For example, see E. Lefèvre-Pontalis, *L'architecture religieuse dans l'ancien diocèse de Soissons au XIe et au XIIe siècle* (Paris: 1894–1896).

28. On Fontenay see: L. Bégule, *L'Abbaye de Fontenay*, 4th ed. (Paris: 1966).
The observations of R. Branner, *Burgundian Gothic Architecture* (London: 1960) on the aesthetic sensitivity of the Cistercians are also appropriate. See also Bruzelius.

29. Bruzelius; and the studies of Bucher, cited in n. 25.

30. Dimier, "Le Plan de l'église cistercienne de Trois-Fontaines", *Bulletin monumental* 123 (1965) 103–116; Idem, "Trois-Fontaines, abbaye cistercienne", *Mémoires de la Société d'agriculture, commerce, sciences et arts du département de la Marne* 53 (1965) 38–51; Bruzelius; Dimier, "Deux campagnes de fouilles a l'abbaye d'Igny", *Mémoires de la Société d'agriculture, commerce, sciences et arts du département de la Marne* 78 (1963) 18–27; and R. Courtois, "Le Premiere église cistercienne (XIIe siecle) de l'abbaye de Vauclair (Aisne)", *Archéologie médiévale* 2 (1972) 103–131.

31. This aspect of Cluny has so far escaped notice, see C. Edson Armi's forthcoming book. This discussion is only an outline of the problem and does not pretend to completeness.

32. Branner, 1960, passim; and Schlink, passim.

33. Branner, 1960.

34. Branner, 1960, passim; and Schlink, passim. This is yet another point missed by J. Henriet, "La Cathédrale Saint-Etienne de Sens: le parti du premier maître et les campagnes du XIIe siecle", *Bulletin monumental* 140 (1982) 81–174.

35. Branner, 1980.

36. Terryl Kinder has recently completed a Ph.D. dissertation on Pontigny: "Architecture of the Cistercian Abbey of Pontigny: The Twelfth Century Church", Indiana University, Bloomington, 1982.

37. See the illustrations in M. Aubert, *L'Architecture cistercienne en France* (Paris: 1947). The absence of such a setback in the nave at Ourscamp thus becomes another argument in favor of Bruzelius'

hypothesis that the nave was planned initially for groin vaults.

38. These and other examples are discussed in W. Clark, "The Nave of Saint-Pierre at Lisieux, Romanesque Structure in a Gothic Guise", *Gesta* 16/1 (1977) 29–38. The reader is cautioned, however, that I made several errors in the list of buildings not having set-backs, which are here corrected.

39. The main studies dealing with regional architecture in the Aisne and adjacent departments are: E. Fleury, *Antiquités et monuments du département de l'Aisne* (Paris: 1877–1882); Lefèvre-Pontalis, 1894–1896; A. Mäkelt, *Mittelalterliche Landkirchen aus dem Entstehungsgebiet der Gotik*, Beiträge zur Bauwissenschaft, 7 (Berlin: 1906); Lefèvre-Pontalis, 1911; E. Moreau-Nélaton, *Les Eglises de chez nous; arrondissement de Château-Thierry*, (Paris: 1913); Idem, *Les Eglises de chez nous; arrondissement de Soissons* (Paris: 1914); E. Brunet, "Les Edifices classés de l'Aisne", *La Construction moderne* 44 (March 1929) 297–307; M. Blancpain and J. Roubier, *L'Aisne*, Charme de la France (Paris: 1956); M. Hollande, *Sur les routes de Champagne* (Reims: 1959); and various articles in the *Dictionnaire des églises de France* 4 (Paris: 1968). I am preparing a more detailed study of the impact of Laon and Noyon cathedrals on regional architecture.

40. Lefèvre-Pontalis, 1894–1896.

41. Lefèvre-Pontalis, 1911.

42. Some of the examples in the 1911 article can be removed from the list on the basis of the fact that they are non-projecting. When one adds examples from other sources, however, the list numbers over seventy-five and is still growing.

43. At Laon Cathedral the niches are non-projecting owing to the thickness of the eastern terminal wall. See Clark and King, 1983.

44. The list includes twelve buildings at this point. The three examples at Saint-Denis are counted as one, even though they are found in parts of the church constructed in different campaigns by different builders. John James and I are preparing a joint study of the "palm-tree" sculptor and his workshop.

45. For these buildings, consult the works cited in n. 39.

46. R. Branner, "Keystones and Kings", *Gazette des Beaux-Arts*, 6th series 57 (1961) 65–82, defined

the two types.
47. Among other buildings containing keystones with
 angels are: Aizy (destroyed), Braine, Bruyères,
 Croutes, Guignicourt, Laon Cathedral, Laon, Saint-
 Martin, Larchant, Marigny-en-Orxois, Nanteuil-
 Notre-Dame, Nouvion-le-Vineux, Noyon, Oulchy-
 le-Château, Saint-Michel en Thiérache, Seringes,
 Soissons, Vailly and Veuilly-la-Poterie. There
 are many others to be found in other regions.
48. They are found at Bazoches, Bussiares, Laon
 Cathedral, Laon, Saint-Martin, Noyon, Soissons
 and Vailly. One of the rare exceptions is Montierend-
 er. See L. Schreiner, *Die frühgotische Skulptur
 Sudwestfrankreichs* (Cologne/Graz: 1963) 124-127,
 pls. LXIX-LXXII.
49. Among them are: *en délit* shafts held in place
 by corbel rings, distinctive vault profiles, and
 the form of the south transept rose window.
50. On Braine see: the studies cited by Backmund;
 J. Bony, "The Resistance to Chartres in Early
 Thirteenth-Century Architecture", *Journal of the
 British Archaeological Association*, 3rd series,
 20-21 (1957-1958) 35-52. In addition, there is
 the unpublished dissertation by J. McClain, "A
 Reconstruction of the Sculpted Portals of the West
 Facade of Saint-Yved de Braine", Ohio State,
 Columbus, 1974; and another in progress by N.
 Bianchina, *Saint-Yved de Braine; étude architectur-
 ale*, University of Paris. The stained glass is
 currently being studied by Madeline Caviness.
51. On Dommartin see C. Enlart, *Monuments religieux
 de l'architecture romane et de transition dans
 la région picarde* (Amiens: 1895); R. Rodière,
 "Dommartin (Canton d'Hesdin)", *Le
 Pays de Montreuil, La Picardie historique et
 monumentale*, 7 (Amiens: 1933) 194-215; P. Héliot,
 Les Eglises du moyen âge dans le Pas-de-Calais,
 (Arras: 1951-1953). The first results of the new
 excavations have invalidated most of what is
 said about the plan and construction of the church
 in these earlier studies, see: P. Pontroué, "Quatre
 ans de recherches archéologiques à l'abbaye de
 Dommartin", *Bulletin de la Commission départementale
 des monuments historiques du Pas-de-Calais* 9
 (1973) 266-280.
52. J. Bony, "French Influences on the Origins of
 English Gothic Architecture", *Journal of the Warburg
 and Courtauld Institutes* 12 (1949) 1-5; and P.
 Fergusson, "The South Transept Elevation of Byland

Abbey", *Journal of the British Archaeological Association*, 3rd series, 38 (1975) 155–176.
53. The most recent and in many ways the best assess-
ment is that by Bruzelius, passim. See also A.
Dimier, "En marge du centenaire bernardin, l'église
de Clairvaux", *Cîteaux* 25 (1974) 309–314.

THE CHEVET OF HAMBYE, 1200–1250:
CISTERCIAN ARCHITECTURE IN A BENEDICTINE CONTEXT
Joel Herschman

The abbey church of Hambye, in the diocese of Coutances (Manche), occupies a curious position in the annals of cistercian architecture. The monastery was founded in 1145 by monks from the reformist benedictine monastery of Tiron, and although not actually belonging to the Cistercian Order, the monks of Hambye showed their sympathy with the austerity of the Cistercians in their architectural style.[1] The original form of the abbey church, begun shortly after 1200, was based on a cistercian plan (Fig. 1).[2]

However, as the work on the church progressed through the first half of the thirteenth century, it reflected a pattern well-known among the Cistercians, the gradual invasion of the bernardine principles by the new architectural ideas developed in secular churches, especially the great high gothic cathedrals.[3] For Hambye, the nearby cathedral of Coutances, which was under construction during the same period, had the greatest impact. We will see that, from the 1220's through the 1240's, the essential shape of the chevet of the church (Fig. 2) was established by masons coming directly from Coutances, from ateliers actually in progress there. After a strongly cistercian beginning, with a first choir plan drawn from the great cistercian abbey of Clairvaux, the subsequent work on the church drew further and further away from, although never forgetting, its cistercianizing origins and closer and closer to the orbit of the cathedral workshops.

The key problem is the tall, lighted ambulatory (Figs. 3, 4, 5). This form, which first appears in a gothic vocabulary at Bourges, early in the thirteenth century, is also seen in the 1220's at the cathedrals of Le Mans and Coutances, and probably was present at the now-destroyed church of the monastery of Saint-Martin at Tours.[4] The usual tendency has been to assume that Hambye, as an independent design, was another member of this "family".[5] However, in an important but too-often-ignored note, Robert Branner remarked that the configuration of the Hambye chevet most likely reflected the direct influence of the cathedral workshop at Coutances.[6] Thus, rather than being an independent member of the Bourges family, it was essentially a version of Coutances' chevet.

The purpose of this paper is to reaffirm and

document Branner's contention, in the light of the
archeological evidence, to show how the unusual form
of the Hambye chevet came about and, at the same
time to provide an example of the impact of cathedral
architecture on an essentially cistercian architectural
milieu.

Campaigns of Construction

 The chevet of the abbey church of Hambye was
built in three basic campaigns (Fig. 1). The first
probably occupied the first decade of the thirteenth
century. The second, although basically a "repair job",
made an important change in the overall form of the
chevet. It probably occupied a few years to either
side of 1228, the one clearly documented date we have.
The third campaign, during which the central vessel
of the choir was constructed and the choir was extended
westward, was most likely in the late thirties or early
forties, and was completed by 1248.
 The first campaign was responsible for the construc-
tion of the radiating chapels, part of the wall of the
choir aisles, and a thin strip of wall in the ambulatory
above the openings of the choir chapels (Figs. 1, 4,
5, 6). It is characterized by rough granite bases with
non-water-holding cavets similar in type to the bases
of the north nave aisle at Coutances, which date from
the first decade of the thirteenth century.[7] The walls
are built of roughly shaped slabs of granite, quarried
from the adjacent hillside, following the cistercian
pattern of using locally-available materials.[8]
 The original choir was to have been one half
bay shorter on the west than the present one (Fig.
1). That is, the crossing piers would have stood further
east, by one-half the length of the present choir bays.
Thus, they would have lined up with the east wall
of th earliest monastic buildings of the east range,
and the projected east wall of the south transept could
have been continuous with this wall. The evidence
for this is found in the choir aisle walls (Figs. 4,
5). The granite bases characterizing this campaign
are found only in three responds on each wall, reading
westward from the last chapel opening. The responds
to the west are later. The original construction was
decorated with two string courses. One, on the outside,
runs at the base of the chapel windows and continues
into the first of the tall lancets of the straight bays,
where it stops. Its counterpart on the interior is discern-
ible only in the straight bays, at the level of the
sills of the chapel windows. On the interior, this course

stops just west of the third respond of the choir aisle on each side; on the north, about one foot west of the respond and on the south, about eighteen inches to the west. This marks the westward terminus of the achieved construction of these walls. The original scheme was to bring them further westward to complete the bay, yielding four narrow bays per aisle. The short distance between responds suggests double bays of vaulting, perhaps five-part vaults with the fifth rib running to the outer walls but this is not clear. The fifth rib of the easternmost bay on each side would have fallen over a window, and it is not certain how it would have been accommodated. The fourth respond of this series would have marked the corner of the transept, or more likely a transept chapel of the present type. Again, this respond would have lined up with the eastern wall of the monastic buildings.

The choir chapels are rectangular in plan and are enclosed in a smooth perimeter wall (Fig. 1). This is a cistercian scheme and goes back to the choir of Clairvaux, constructed between 1166 and 1174. The type appeared in Normandy toward the end of the twelfth century and was found at the cistercian monastery of Savigny, near Hambye, built between 1173 and 1220.9

As proposed by Marc Thibout, the construction of these chapels and the adjacent walls of the choir aisles probably dates from the first decade of the thirteenth century. This is confirmed by the surviving bases of the chapels and choir aisles (Fig. 6), which, as already mentioned, resemble those of the north aisle of Coutances' nave, which dates from the first decade of the century. Few of the original capitals of this campaign survive (Fig. 7). Most are replacements installed during the second campaign, as will be discussed below. The surviving first campaign capitals are found on the wall that separates the second and third radiating chapels on the north side. They are very crude, and like the bases are carved from a coarse-grained granite which obviates any fine detail. The foliage, such as it is, is held close to tall, slender drums and there are rudimentary crockets. The general configuration fits with the 1200-1210 date as it is similar to that of the nave aisle capitals at Coutances.

The chapels retain their original form, despite extensive replacements of capitals, responds and moldings. Even the vaults, which to judge from the rib profiles are no doubt replacements, preserve the semicircular formerets against the window walls and chapel openings that the original ones probably had.10 However, the

ambulatory has been modified significantly, and here
the most problematic aspect of the discussion arises.

Prior discussion of the sources and *parti* of the
ambulatory has tended to center around its form as
it exists at present, with a clerestory atop a tall blank
wall (Figs. 4, 5), yielding a spatial configuration
resembling that of the ambulatories of Coutances and
Le Mans, with which it has often been tied. The assump-
tion has been made that this is the original scheme.[11]

The archeological evidence, however, shows that
the present form of the ambulatory was not part of
the first campaign of c. 1200–1210, but was the product
of a partial rebuilding undertaken during the 1220's
by a workshop which came from the cathedral of Coutances.

Unquestionably, the ambulatory was designed
from the beginning to have a vault somewhat higher
than the vaults of the chapels (Figs. 4, 5). There
is a uniform horizontal break running above the arches
of the chapel openings at a height of about five to
seven courses. (It can be seen just below the lowest
scaffold holes.) Further, the highest of the surviving
granite blocks of the original granite responds of the
ambulatory, those that were not replaced later by lime-
stone, sit about half-way between the break and the
molding of the chapel piers that mark the springing
of the chapel vaults. The ambulatory vault must have
sprung above these blocks, since there is no reason
to assume they are reused, and thus would have been
higher to some degree than the chapel vaults.

The difficulty is to determine the height of these
springers, and that of the vault they held, and the
treatment of the wall above the chapel openings. Given
the date, and the cistercian connection, two possibilities
come to mind. One is a wall with windows above the
chapel arches, in the manner of Clairvaux. The other
is a lower wall without windows and vaults only slightly
higher than the chapel vaults, in the manner of Pon-
tigny.[12] The possibility of a five–part vault suggested
by the close placement of the aisle responds would
lend support to this latter hypothesis, but there is
no sign of a Pontigny–type corbel over the chapel openings
to take the fifth rib.

The problem is insoluble. If the present break
marked the original top of the wall, given the limit
imposed by the surviving respond block, there would
have been no room for a vault, even one with a fifth
rib and semicircular formerets like the chapel vaults.
The present height of this original wall would have
been adequate only to support a temporary roof over

the chapel vaults, and it was, obviously, to this height that it was built. The completion of the ambulatory would have, regardless of the option chosen, necessitated raising this wall further. The evenness of the break indicates that the wall stopped at this point rather than having been built higher and then levelled because of damage.

While the state of the evidence prevents us from deciding between a Clairvaux or Pontigny type of raised ambulatory, there can be no doubt that the present height of the wall, with its zone of windows, was achieved in the campaigns of the 1220's and later. The archeological evidence will be discussed shortly, but if the original scheme envisaged a lighted ambulatory of the Clairvaux type, it would have been a low, cistercian version of the form, rather than the lofty space we see today. If the first campaign dates to the period 1200–1210, then a tall, Bourges–type structure (as exists today) would have been improbably precocious in this austere, provincial, cistercianizing context at a time when the shape of Bourges, radical in the height of its ambulatory, was barely emerging.13 The present height is much more believable in the 1220's, when the similar ambulatories of Coutances, Le Mans and Saint–Martin at Tours were under construction.

Above the masonry break we have spoken of, the stones of the wall are smaller and more regular, the wall slightly thinner and the responds composed entirely of inserted blocks of limestone. The capitals which support the ambulatory vaults (Figs. 8, 9) can be precisely located in the series of capitals from the north radiating chapels and north transept of the cathedral of Coutances. This work was done by the workshop that established the raised ambulatory at Coutances and the moment represented by the Hambye capitals is at a point when that work was approaching its conclusion. The low proportions of the Coutances chapels indicate that the raised ambulatory there was envisaged from the beginning of the campaign. Clearly, then, the present lofty height of the ambulatory at Hambye was established by masons coming from Coutances at a time when the tall ambulatory there was already well–established.

The situation can best be understood in the overall context of the second campaign at Hambye. The masonry of the radiating chapels there is curiously inconsistent, especially in the decorative features (Fig. 6). The lower parts are of rough local granite, including the aforementioned granite bases with exposed cavets. In

the upper parts, however, the decorative panoply of responds, capitals, imposts and articulating moldings are carved from fine-grained limestone, except for the few surviving granite capitals we have already mentioned. Most of the moldings are elegantly carved, with the undercutting typical of Normandy, but a few on the wall between north chapels II and III are simple: chamfers with fat rolls. The limestone capitals are of a true crocket type, although under square imposts, with the crockets projecting crisply from the drums, and are very different from the granite types in their sharp cutting and finely-veined leaves. We have here an incoherent mixture of two styles and periods, with the more elegant, later work tending to be higher up than the earlier, cruder work, but with no clear pattern of separation. The capitals and moldings of the newer work can, like the ambulatory capitals, be traced directly to the workshop of the north chapels and transept at Coutances, which was active there in the later 1220's.

The only likely explanation for this garbled situation is that in the 1220's a fire took hold in the temporary roof protecting the chapel vaults and brought these vaults down. This collapse damaged the upper parts of the chapel decorations in most places. This would account for the randomness of the replacements and their concentration in the upper parts, and for the fact that only the uppermost strip of the ambulatory wall shows replacements (since only the edge of our hypothetical roof would have projected there).

The evidence of capitals and moldings suggests that masons at work on the north chapels at Coutances were despatched to Hambye to repair the damage, probably at the behest of Bishop Hugues de Morville of Coutances. The repairs to the chapels modernized them and made them more elegant. They were probably completed by 1228 when Bishop Hugues arranged a donation to provide for liturgical illumination,[14] which undoubtedly marks the availability of these chapels for services. This episode is strongly suggestive of the Bishop's personal involvement in the affairs of Hambye. As the repairs were nominal and the materials readily available either at Hambye or at Coutances where limestone could have been borrowed from the cathedral *chantier,* the work need not have occupied more than three or four years. No changes in style can be discerned.

The same masons then turned to the ambulatory (Figs. 4, 5), probably in preparation for beginning the work on the choir. They raised the wall to its present level, following the proportions which were

taking shape at Coutances. By raising the vault of
the ambulatory, they were also imposing a rather tall
choir on the modest abbey church they had found original-
ly. They avoided decorating this raised wall, perhaps
out of respect to the cistercian austerity of the original
construction, perhaps because of the small scale of
the ambulatory, or perhaps only as a measure of economy
and to save time. The actual amount of work involved
in this second campaign is so minimal that it suggests
a very economical approach on the part of the masons.

As the masonry changes slightly above the string
course at the base of the windows, and looks closer
to that of the ambulatory vaults, it may be that these
windows were only constructed at the time the vaults
were being built, following the sequence used at Cou-
tances.[15] The raising of the ambulatory wall would
have followed the date of 1228 when the chapels were
opened for use, and, again need not have taken more
than three or four years, at the outside. The chapels
and middle zone of the ambulatory wall at Coutances
were completed by 1235, so the two campaigns ran more
or less concurrently,' with that at Coutances beginning
much earlier, however.[16]

Therefore, although Hambye was originally designed
c. 1200–1210, with a somewhat elevated ambulatory
vault, whether in the manner of Clairvaux or Pontigny,
it owes its present tall proportions to the intervention
of the masons from the cathedral where such a design
was being constructed, and, a comparison of capitals
and moldings indicate, was already well under way.
To return to our original question, it appears that
Branner was essentially right. The "Bourges" section
here reflects the influence of the cathedral nearby.
If Hambye was a member of the "Le Mans, Coutances,
Saint-Martin de Tours family", it was an adopted child
—adopted by the bishop and masons of Coutances.

Scholars agree that the choir of Hambye (Figs.
2, 3) was probably completed by 1248 when a Synod
was held there, and probably earlier.[17] It bears a
superficial resemblance to the central vessel at Coutances,
begun after 1239,[18] but really only in the tall, cylindri-
cal piers that accommodate the raised ambulatory. While
the Coutances design is in two levels, arcade and
clerestory, with a passage at clerestory level, the
Hambye design is thin-walled and has three levels,
with a low clerestory and a zone of simple, arched
openings between the arcade and clerestory. This thin-
walled, three-level elevation seems to have more affinities
with the choir of Rouen than with any *Basse-Normande*

structures. An examination, however, of the bases, capitals and chamfer moldings of the arcade arches, among other features, indicates that, as with the raising of the ambulatory, this work was done by masons from the choir of Coutances.

The first major change of this campaign was the displacement of the crossing one-half bay to the west (Fig. 1). As there was no prior central vessel construction, this was easily accomplished. Our proposed earlier scheme for five-part vaults in the aisles was easily modified to four-part vaulting, with one short bay retained at the east, followed by two twice as broad, which coincided with the bays of the central vessel as now established. This yielded a longer, more "cathedral" type of choir and left room for the large transept chapels we see today.

The tall ambulatory of the second campaign necessitated a tall choir arcade (Figs. 2, 3). Above this was a zone of blank wall, pierced by arched openings which let light into the ambulatory roof. Above this was a short clerestory, further shortened at the base by the steepness of the roof over the ambulatory vaults. The increased height of the choir necessitated extending the culées of the flying buttresses outward to resist the greater stresses. In the chapels this yielded very deep but thin culées with single flyers which are also found on the Coutances choir. The deep buttresses added to the straight bay stair towers probably also date from this campaign (Fig. 1).

The final design is not as curious as it first might seem. The thin-wall construction is rare enough in western Normandy at this time, but it continues the pattern of the first two campaigns in running the passage behind the walls at the vault abutments, rather than in front of them in a "thick-walled" design. This may reflect a carry-over of the simplicity of cistercian ideas from the first design, or simply a response to the relatively small size of the building. The present ambulatory is rather narrow. If the usual *Basse-Normande* treatment of the double wall were followed (that is, doubling the piers as at Coutances, Bayeux, and Saint-Etienne at Caen, among others), the choice would have been either to narrow the already restricted ambulatory, or to narrow the choir, which as is, has unusually vertical spatial proportions for this part of the world. The choir space is severely restricted by the chapels, which were designed to surround a lower ambulatory and choir. Accommodating a lofty, thick-walled scheme would have severely restricted the circulation space.

A thin-walled structure was the only way to achieve height without bulk.

While the source of the choir design at Hambye cannot be determined with certainty, there is sufficient evidence to permit a tentative hypothesis. As well as the treatment of the flying buttresses, many details point to an origin in the Coutances workshop. The capitals of the hemicycle piers at Hambye (Fig. 10) are very close to those of the upper part of the crossing at Coutances (Fig. 11). This observation, incidentally, would confirm a date in the 1240's for this work. The wall structure of the middle zone (Fig. 3), segmental arches *en viaduc* in granite slabs, hidden behind the wall, is related to the wall structure of the middle level of the ambulatory wall at Coutances. While the triplets under an arch of the straight bay clerestory windows resemble, perhaps only coincidentally, the ambulatory windows at Le Mans, the two-lancet and inverted trefoil pattern, in a sort of plate tracery, of the turning bays, is identical to the ambulatory and choir windows at Coutances. These features cannot simply be explained as "local practice". Their cumulative effect suggests that the workshop here came from Coutances. If so, how may we account for the great difference in design?

The two-level elevation with passage of the Coutances choir was a new design, established after 1239 by a new master mason under the influence of similar constructions in Burgundy.[19] It replaced an earlier design which most likely had three levels, in some way related to the ambulatory design, although not identical to it.[20] Some idea of the general form of this earlier scheme may be provided in the bays of the east walls of the transepts which mediate between the three levels of the transepts and the two levels of the choir. These bays were built after 1239 by the choir workshop, but their mediating function may fortuitously have preserved an original three-level design with some sort of intermediate zone decoration of the type of Hambye. The clerestory passage here was pushed up to the base of the high windows, thus reducing the height of the clerestory zone, although not changing the height of the windows themselves. These proportions, reduced to a thin-walled structure, would result in the design of the Hambye choir. This must remain a speculation, but the filiation of the details makes it somewhat suggestive.

Conclusion

Returning to our first premises, we see a design for a monastic church beginning, around 1200, as a version of current cistercian practice, imitating either Clairvaux or Pontigny, then as the work progressed being modified by the intervention of the local cathedral workshops in the direction of greater height and greater elegance alien to the original principles of Saint Bernard, but tempting to his successors.[21] By the time the church was completed, c. 1248–50, it had become, in its proportions if not in its decoration, a rustic mini–cathedral. This lends weight to the remarks of Robert Branner on this building. Although the original design of 1200 may have envisaged a lighted ambulatory, it would have been a low, cistercian version of the form. The present proportions that place Hambye in the family, if such it is, of Le Mans, Coutances, and Saint–Martin at Tours, the perhaps collateral descendants of Bourges,[22] are not the result of independent developments at Hambye but of the direct influence of the cathedral workshops at Coutances. If Hambye is a member of this family, then it is by adoption.

Fordham University

NOTES

1. The bibliography on Hambye is not extensive. See: Bernard Beck, "Historique de l'abbaye et déscription archéologique", *Art de Basse–Normandie* no. 44 (1968) 12 ff.; Marc Thibout, "L'Abbaye de Hambye", *Congrès archeologique* (1966) 337–357; Pierre Héliot, "Le Chevet de l'abbatiale de Hambye", *Annales de Normandie* 25 (1975) 3–12. For a general guide see Mme. E. Beck, *L'Abbaye de Hambye* (Coutances: 1967). I would like to thank Mme. Beck and Bernard Beck for their help over the years and for useful conversations, and Professor William Clark for help with the archeological puzzle.
2. Héliot, p. 6.
3. One of the most useful of the many discussions of this question is found in Robert Branner, *Saint Louis and the Court Style in Gothic Architecture* (London: 1965) pp. 36–39. See also Marcel Aubert

and la Marquise de Maillé, *L'Architecture cistércienne en France* (Paris: 1947) 1:212–216.

4. For bibliography on this question, see my article, "The Norman Ambulatory of Le Mans Cathedral and the Chevet of the Cathedral of Coutances", *Gesta* 20/2 (1981) pp. 323–332.

5. Most recently see J. Thiébaut, "Les Choeurs des cathédrales de Coutances et le Mans, Chronique", *Bulletin monumental* 140 (1982) p. 233.

6. Robert Branner, "Encore Bourges", *Journal of the Society of Architectural Historians* 25 (1966) p. 301.

7. This agrees with the dates proposed by Thibout, pp. 337–338. For the nave aisles at Coutances see my dissertation, "The Thirteenth Century Chevet of the Cathedral of Coutances", New York University, 1978.

8. See Phillip P. Gallagher, "The Cistercian Church at Mortemer: A Reassessment of the Chronology and Possible Sources", *Studies in Cistercian Art and Architecture*, vol. 1, CS 66 (1982) pp. 54, 64, n. 6.

9. Thibout, pp. 340–341 saw Savigny as the model for the plan of Hambye. However, Héliot, pp. 7–9, felt Savigny must have had a low ambulatory and that the Hambye scheme must go back directly to Clairvaux.

10. Round formerets are still found at Hambye in the chapter house of the first third of the thirteenth century. See Bernard Beck, "Recherches sur les salles capitulaires en Normandie", *Bulletin de la Société des antiquaires de Normandie* (1965–1966) pp. 36–37.

11. See especially Thibout, p. 344, Héliot, pp. 7–9.

12. For Clairvaux, see most recently Wilhelm Schlink, *Zwischen Cluny und Clairvaux, Die Kathedral von Langres und die Burgundische Architektur des 12. Jahrhunderts* (Berlin: 1970) pp. 100–119, esp. 112, figs. 96, 97. Also Branner, "Encore Bourges", p. 301. For Pontigny, André Phillipe, "Eglise abbatiale de Pontigny", *Congrès archéologique* (1907) pp. 200–202.

13. Robert Branner, *La Cathédrale de Bourges et sa place dans l'architecture gothique* (Paris: 1962) pp. 4–6.

14. Héliot, pp. 7–9.

15. Dissertation, ch. 4.

16. For the date of 1235, see my "Norman Ambulatory",

pp. 324–325.

17. Thibout, pp. 337–338. Héliot, p. 4, saw the chevet
 and transept completed well before 1250.
18. Dissertation, pp. 131–139.
19. Ibid, pp. 124–131.
20. See my "Norman Ambulatory", pp. 324–325.
21. See n. 3 above.
22. For bibliography on this "family" see my "Norman
 Ambulatory", notes 1, 3.

This study was presented at the Conference on Cistercian
Studies, Eighteenth International Congress on Medieval
Studies, Kalamazoo, May 1983.

CISTERCIAN FOUNTAIN HOUSES IN CENTRAL EUROPE
Heinrich Grüger

Following up the study prepared by H. J. Arens, of the *Wasserwirtschaftsamt* of North-Rhine Westphalia, in April 1981 for the international congress "Wasser Berlin '77",[1] we searched for scientifically useful data concerning the plumbing systems of medieval monasteries. The search, however, yielded nothing, since the sole information concerning hydraulic construction in cistercian houses was to be found in fragmentary reports on the excavations of drainage canals, water lines, fountains, walled cisterns and fish ponds. No archeologically trustworthy studies exist of the sewage system in even a single cistercian abbey.[2]

In view of this dismal state of research, it is most welcome that Meredith P. Lillich undertook a survey of the basic attitude of monasticism from the late Antique to the middle ages towards the problem of personal grooming and hygiene.[3] The title of the study itself points to the often neglected fact that water supply systems were not simply a question of technical know-how for the medieval monk. In the light of Christian faith, the object of all creation was its fulfillment in the world of the spirit; thus, concealed behind the basic needs of daily life was a higher purpose than mere material benefit.

The following paper is concerned with a part of the medieval cistercian plumbing systems—with only a small segment of the water supply construction and this only in a very limited part of the western world: namely, with fountain houses in central Europe. This area comprises the territory of the Holy Roman Empire and the kingdom of Poland as of 1618,[4] an area in which fully 175 monastic houses of Cîteaux were founded in medieval times.[5]

In the running water of the fountain house, which normally was located opposite the entrance to the refectory, the monks washed their faces and hands in the morning and before and after mealtimes, washed their clothes, and quenched their thirst. Here, hair and beards were cut; hence, the room was often also dubbed "tonsure". Here the bloodletting was done, in order to remove "harmful bodily fluids" and to preserve the health of the community. The fountain also provided water for the ritual *mandatum* in the cloister. Always, the fountain served both human needs and liturgical purposes, so that care was taken that it always provided

fresh water.[6] To meet that goal, the Cistercians shied
neither from effort nor from cost nor from technical
difficulties in order to bring in water of unadulterated
purity, even from a great distance. Although in central
Europe far fewer medieval monastic structures survive
than in England,[7] the few examples of the provision
of water for drinking and other uses reveal the desire
to draw this precious gift of God from unspoiled springs
in nature.

For that purpose at Walkenried in the Harz moun-
tains,[8] a walled and vaulted reservoir was built with
a massive layer of gravel and sand, several hundred
meters from the monastery into the slope of a wooded
mountain, in order to collect and purify the spring
water of the mountain and send it on into the monastic
enclosure by means of pipes and a walled, subterranean
canal. There, in the sixteenth century, the water fed
a fountain with stone collecting basins, drip pans
and dispersing pipes in front of the headmaster's house
and the student's bathroom and then ran off under
the cloister into the *Bornheuslein* or fountain house,
or directly into the kitchen where it was caught in
a stone trough with a drain. The water that overflowed
the basin in the fountain house flowed through a vaulted
drainpipe under the reading room into a sewer.[9]

At Orval in the walloon section of the diocese
of Trier,[10] carefully planned conduits had already
been laid out in the twelfth century. They directed
the necessary drinking water into the fountain house
and the kitchen from the northern side of the valley,
underneath the nave of the church, and into the center
of the cloister.[11] Other conduits and ground water
today still feed the stone-set fountain of Margravine
Mathilda of Tuscany, which, with its crystal-clear
cool water stands in front of the west facade of the
north aisle of the church.

The monks of Pelplin in Pommerellen[12] built a
"waterworks" outside the cloister, a bucket wheel which
mechanically raised the water of the stream Ferse to
the desired level. From there, it ran in subterranean
conduits to the cloister and to the fountain house where
it poured into a copper basin by four taps before flowing
through pipes into the kitchen and meat locker and
finally, underneath the buildings back into the Ferse.[13]

The old water supply and drainage system of
the abbey Ebrach in Upper Franconia[14] is partially
known from the colored map which Johann Leonhard
Dientzenhofer drew for the Baroque reconstruction of
the monastery in 1687.[15] According to that map, the

Ebrach flowed partially exposed, partially covered through the monastic lands. A channel branched off, running under the library that protruded eastward from the south wing of the dormitory.16 The channel continued under the latrines and under the southern part of the west wing of the cloister and rejoined the Ebrach west of the *quadrum*. Dientzenhofer unfortunately neglected to include the remaining conduits that served the kitchen and the fountain house and carried run-off from the roofs.

In Heinrichau in Silesia,17 the Cistercians dammed the pure water of the Renkelbach several hundred meters southwest of the monastery and diverted it into a conduit that ran through the gardens to the kitchen and cloister, open outside the abbey walls and covered inside the grounds.18 The water of the dammed pond was insufficient to supply the weaving shop with its mechanical looms, the shoemaker's shop, the brewery, the tannery, the mills and other industrial and agricultural operations within the walls. It was decided to use the more abundant flow of the Ohle which passed by in a swampy lowland about 400 meters east of the monastery. That necessitated costly land purchases, complicated transactions, and the acquisition of water rights in the swampy, alder-forested Ohle valley and several kilometers further upstream. Since the level of the monastery was almost five meters above the water level of the stream, it was necessary to begin the diversion at a considerable distance. Soon after 1266, the Cistercians built the canal along the west slope of the valley and, for the last 600 meters before the outlet into the Zinkwitzbach, cut it four and six meters, and in places seven to eight meters, into the rising land to the west. The resulting ditch measured four to five meters at the bottom and twelve to twenty meters across at the top of the banks. The thousand cubic meters of excavated earth was heaped up into a two–kilometer–long dam that prevented the water in the upper course of the ditch from draining off into the lowland five meters deeper. With this artificial course more than two and a half kilometers long, the monks diverted almost all of the water of the stream that, even today, flows into this bed. Where the Renkelbach joins this canal, a weir was built, and part of the water was directed through a subsidiary canal into the monastic complex to supply the gardens and the commercial enterprises. With that, the energy problem of the monastery was permanently solved, and at the same time, the monks had buffered themselves against the vicissitudes of

a hostile environment: the stream, cut deep into the earth between steep embankments at the foot of the monastery wall, offered efective protection against sudden attacks from marauding gangs.[19]

The structures for water supply and distribution at Walkenried, Orval, Pelplin, Ebrach and Heinrichau represent only a fragment of the hydraulic construction of any one of these monasteries. They are only the beginning of the total water-supply system. The much more comprehensive and complicated complex of technical construction in the area of the *quadrum,* the gardens, the workshops, the infirmary, and the monastery grange, and the lay-out of drains for the latrines, the kitchen, the hospital and the hostel, the drainpipes for rain and melt water from the roofs—this many-faceted system is unknown because it ran underground and was so solidly constructed that it survives unscathed the weight of modern trucks and agricultural machines. Since methodical surface excavations are almost never possible, these conduits are discovered only by chance. Thus, every attempt to reconstruct monastic plumbing systems, which over the centuries have been disturbed and altered, is doomed to failure. Just as with the mechanisms that caught and redirected water outside the monastery, little remains of the end of the plumbing system where the water emerged at the taps in the kitchen, in the fountain house, in the infirmary, in the gardens, in the workshops. Moreover, the supplying of water for profitable large-scale enterprises has changed so frequently over the course of time that the present conditions of the technical structures do not allow conclusions about their original disposition.

The only visible part of the old water-supply system, which here and there survived the changes of time, is the fountain house. Even so, no more than twelve still exist in central Europe—a number too small to form the basis of a study.[20]

In eighteen other examples, the lay-out is superficially known through excavations or old maps and engravings, so that one has a total of thirty examples. In the remaining 150 monasteries, nothing can be said about the placement, form, or technical fittings of the fountain houses because the medieval structures were replaced by Baroque buildings.[21] The cistercian houses in the Protestant territories of Germany that had already been secularized in the sixteenth century retained the old cloister buildings only when they were transformed into princely schools or Protestant seminaries.[22] The majority of the dissolved monasteries fell into ruin,

were razed or heedlessly used as stone quarries, so that practically nothing remains of many cistercian houses.[23]

An inventory of the preserved cistercian fountain houses and those known by excavation or illustration yields the following, arranged by type of ground-plan:

A. *Fountain houses with square plan, located in the middle of a wing of the cloister.*

 1. Bonmont (Switzerland), twelfth century, covered with a pyramidal roof, no longer extant and known only from a reconstructed illustration.[24]
 2. Schönau (near Heidelberg), early thirteenth century; known only through excavations; internal measurements 8 x 8.30 meters; a round-arched entrance to the cloister measuring 3.65 meters across. In the northeast corner, a spiral staircase within the wall leads to the upper floor, where a room that possibly served as a library stretches over the fountain house and the adjacent part of the cloister (Fig. 1).[25]
 3. Marienthal (near Helmstedt), beginning of the thirteenth century; no longer extant and known only through superficial excavations.[26]
 4. Stams (Tyrol), c. 1300, covered with a pyramidal roof; no longer extant and known only through an engraving and a seventeenth century description; the fountain had three basins, graduated in size.[27]
 5. Wörschweiler (Saarland), c. 1300 (?); small oblong (!) structure because the monastery, which was built fifty-five meters above the surrounding valleys on a narrow ridge, had limited building space (the church on the north side and the refectory on the south side of the *quadrum* rise above the steep slopes of the mountain); no longer extant and known only through the excavated foundations.[28]

B. *Fountain houses with square plan, located in a corner of the cloister garth.*

 6a. Orval (Belgium), first structure originated in the twelfth century, located in the southeast corner of the cloister garth; known only through, in part, badly destroyed

foundations that lie under the foundation of the second structure.[29]

7. Pforte (Thuringia), twelfth century, in the northwest corner of the cloister; no longer extant and known only through cursory exploration (Fig. 1).[30]

C. *Fountain houses with hexagonal plan.*

8. Zwettl (Lower Austria), early thirteenth century, completely preserved; sexpartite, domical rib vault, early Gothic windows. A two-stepped, round granite base supports a large, round, conch-shaped granite basin, dome-shaped, above which rises a small Baroque fountain dated 1706 (Fig. 1).[31]

9. Altzella (Saxony), early thirteenth century; no longer extant and known only through excavations.[32]

10. Lilienfeld (Lower Austria), early thirteenth century, completely preserved since it was rebuilt after the 1810 fire; a light and uncommonly restive hall, richly decorated with early gothic marble columns in the corners and in pairs on either side of the fifteen round-headed windows, which are grouped in sets of three. The six ribs of the domed vault, the blind arches and the framing moldings of the windows rest on these columns. The marble, neo-Gothic fountain setting stems from 1807, since the earlier lead fountain, erected in 1461 with three shell basins fed by thirty-eight pipes, was dismantled in the dissolution of the monastery in 1789 and sold as scrap metal.[33]

11. Neuberg (Steiermark), c. 1300, completely preserved; with three tripartite tracery windows, ribbed vault and a small fountain, whose water is drunk with iron ladles because legend credits it with healing properties.[34]

12. Pelpin (Pommerellen, Poland) perhaps fourteenth century; in 1646, a "pinnaculum turriculae, quae est super lavatorium ambitus: was mentioned (according to this, the fountain house was like a tower, topped with a pyramidal roof and weathervane); no longer extant. In 1884, the foundations were uncovered, and in 1889, the modern six-sided

fountain house was built on them.35

D. *Fountain houses with octagonal plan.*

13. Georgenthal (Thuringia), thirteenth century, only fragments of the sidewalls preserved. It had Gothic tracery windows, was built with two sides of the octagon opening into the cloister with splendid portals, and had a domical cross–ribbed vault.36

14. Loccum (Lower Saxony), thirteenth century, no longer extant. Only the springing of the cross–ribbed vault is visible on the wall of the cloister. In the center of the room stood a brass fountain.37

15. Eldena (Pomerania), c. 1300, no longer extant, and known only through excavations; the room lay two steps lower than the adjacent cloister.38

16. Neuzelle (Lower Lausitz), c. 1300, completely preserved; with three Gothic, tracery windows and a domical star–vault whose ribs are constructed of shaped bricks.39

17. Chorin (Brandenburg), before 1320; only the sockels remain (Fig. 1).40

18. Doberan (Mecklenburg), fourteenth century, no longer extant and only known through archeological probes.41

E. *Fountain houses with nine–sides.*

19. Maulbronn (Württemberg), c. 1250, completely preserved, two sides built into the cloister, with a domical star–vault, slender windows with delicate tracery, and two portals open to the cloister; an extraordinarily decorative, airy hall flooded with natural light. The second story is half–timbered, above it a polygonal tower–like roof (Fig. 2).42

20. Heiligenkreuz (Lower Austria), end of the thirteenth century, completely preserved; one side open to the cloister, the other sides pierced by Gothic tracery windows with stained glass of the thirteenth and fourteenth centuries; a medieval lead fountain stands in the center of the light and elegant cross–rib vaulted hall.43

F. *Fountain houses with a chapel–like plan with polygonal terminations.*

21. Walkenried (Lower Saxony), c. 1300, complete-
 ly preserved except for the original ribbed
 vault; a large room composed of oblong
 bays and a five-sided termination (5/8);
 five tracery windows and two portals opening
 into the cloister (Fig. 2).[44]

22. Arnsburg (Upper Hesse), c. 1300, no longer
 extant and, together with the foundations
 of the round fountain, known only by excava-
 tions; a room consisting of a transverse
 oblong bay and a polygonal three-sided
 termination (3/6), probably with three
 tracery windows.[45]

23. Haina (Hesse), c. 1300, completely preserved;
 a room with a transverse oblong bay,
 five-sided (5/8) termination, five bipartite,
 Gothic tracery windows, two portals open
 to the cloister, and with a sexpartite ribbed
 vault over the polygonal apse.[46]

24. Ter Duinen (Belgium), probably c. 1300,
 five-sided (5/8) polygon without an anteroom;
 no longer extant and only known from
 the "Kaart van de Duinenabdij in 1580
 door Pourbus geschilderd, Brugge, Groeninge-
 museum".[47]

25. Oliva (now Oliwa near Gdansk, Poland),
 c. 1400, completely preserved; a room with
 one transverse oblong bay, polygonal five-
 sided (5/8) termination, lit by six windows
 and opening with a wide arch into the
 cloister, of which the adjacent bay between
 the refectory and the fountain house is,
 like the fountain house, covered with a
 star vault. The exterior of the chapel-
 like structure is now undecorated. Until
 c. 1800, the emblem of Oliva stood in the
 center of the room: a large brass fountain
 in the form of an olive tree.[48]

26. Bebenhausen (Württemberg), c. 1400, complete-
 preserved; a room with an elongated five-
 sided (5/8) termination, five Gothic tracery
 windows, three portals opening into the
 cloister and a homogeneous, domical net
 vault. The upper floor of the tower-like
 structure is half-timbered construction.[49]

27. Marienwalde (Neumark; now Bierzwnik,
 Poland), c. 1400; razed and known only
 through excavations; a room with a square
 bay, five-sided (5/8) termination and three

windows.[50]

28. Bronnbach (Baden), fifteenth century, built in 1411 by a lay brother to replace an older structure of the thirteenth century and completely preserved; an elongated room with three-sided (3/8) termination, three Gothic tracery windows and a homogeneous star vault. The polygonal, massive upper story, covered with a tower-like roof, houses the library.[51]

6b. Orval (Belgium), third fountain house, seventeenth century, no longer extant above the level of the sockel; a room with an oblong bay and polygonal five-sided (5/8) termination.[52]

G. *Fountain houses with unique plans.*

29. Eberbach (Rheingau), thirteenth century, no longer extant and known only through old maps and superficial probes; a chapel-like room with a wide, transverse oblong bay and enclosed, semi-circular apse and five windows; the round fountain stood half in the anteroom and half in the apse.[53]

30. Wettingen (Switzerland), thirteenth century, completely preserved; a flat rectangular niche across from the entrance to the refectory, which protrudes only slightly from the line of the outer wall of the cloister; the fountain basin is recessed into the wall. East of the dormitory in the middle of the earlier abbey courtyard stood a second fountain for bathing.[54]

6c. Orval (Belgium), second fountain house, late twelfth century; in the southeast corner of the cloister garth in the same location as the earlier fountain house (cf no. 6a), only with a polygonal, three-sided (3/8) termination replacing the two exposed sides—probably to better illuminate the interior space; no longer extant, however known through excavations.[55]

Square plan fountain houses are also found at the cistercian nunnery of Marienstern (Lausitz),[56] at the premonstratensian abbey Steinfeld (Eifel),[57] and in the cloister of Merseburg cathedral (Saxony).[58] Chapel-like fountain houses with polygonal terminations are also found at the former benedictine abbeys of Sts Peter and Paul in Hirsau (Black Forest)[59] and Blaubeuren

near Ulm[60] and in the cloister of the cathedral at
Magdeburg.[61] To the unique types belong the beautiful
round fountain house of the premonstratensian abbey
Unserer Lieben Frau in Magdeburg, which protrudes
like a tower into the cloister garth and whose massive
upper story, housing the library, is covered with a
high and pointed conical roof.[62]

Of the thirteen monasteries in Bohemia and Moravia
and the six in Silesia, not a single fountain house
survives, although written sources leave no doubt that
they generally did exist.[63] The Hussite wars, the lapse
of discipline at the time of the Reformation (when the
Cistercians of the kingdom of Bohemia and its neighboring
lands Silesia and Lausitz almost died out), and the
Thirty Years War destroyed the medieval buildings.
The monasteries that survived the vicissitudes of this
period or that could be refounded during the Counter-
reformation replaced the ruined old *quadrums* with
expensive new buildings in the seventeenth century.[64]
As a result, the cistercian houses in Bohemia, Moravia
and Silesia now display a marked Baroque character,
even where the medieval substance of the church and
of individual rooms in the cloister was retained.[65]

The sixteen monastic houses of the order in the
former kingdom of Poland, where only the fountain
house of Oliva is preserved and that at Pelplin known
through excavation, fared otherwise. Jedrzejów, Koprzywnica,
Sulejów, and Wachock, Polish daughters of the primary
abbey, Morimond, were small and insignificant monasteries
with small conventual populations. Their Romanesque
and early Gothic churches were not longer than 37–
41 meters, and the cloisters enclosed garths with 15–
18 meter internal spans. It was sufficient to provide
a water basin in a simple niche in the cloister instead
of a fountain house.[66] Other Polish monasteries such
as Wongrowitz (Wagrowiec), Lond (Lad), Obra, Blesen
(Bledzew), Krone (Koronowo) and Priment (Przemet)
vegetated during the Reformation and, during the Swedish–
Polish Wars, were on the brink of complete disintegration.
This was the result of the crown's policy, since the
sixteenth century, of regarding all abbeys as royal
commendations. The commendatory abbots appointed
by the monarch often had nothing more to do with the
Cistercian Order beyond enjoying the income from its
properties. As a result, the buildings deteriorated,
the conventual population waned, and, deserted by
their abbots, the discipline of the convent degenerated.[67]

With the exception of the examples listed above
under G, the basic forms of the cistercian fountain

houses of central Europe conform easily to vocabulary of Romanesque or Gothic architecture. The dodecagon, from which the sexagonal and the nonagonal monastic fountain houses developed, derives from the Constantinian funerary church erected in Jerusalem in the first half of the fourth century. The emperor spared no expense in this structure, and the best artists of that period contributed to it. The splendid, broad Anastasis–rotunda of this gradiose church complex rested on twelve immense, richly decorated marble columns and was often imitated in later central plan structures.[68] The architects of the eleventh and twelfth centuries did not make slavish copies; for them, it was of no concern whether the model was round, dodecagonal or octagonal, since at that time each of these geometric ground–plans were permissible in sacred buildings. For that reason, Bishop Meinwerk of Paderborn, in building his copy of the Anastasis–rotunda at his episcopal seat in 1036, could make it an octagon, even though he had sent an abbot to Jerusalem expressly to measure and record the holy places.[69] Since the erection of Charlemagne's imperial chapel at Aachen, which adopted the late antique tradition of imperial sacred architecture found in San Vitale in Ravenna, the octagon had become a permanent basic form in western architecture.[70] As a result, the base of ten and twenty–five that was still the obligatory system of proportions in Carolingian sacred architecture gradually was replaced by the numbers 3, 6, 9, 12, 18, 27, as well as 2, 4, 8 and the larger numbers of these sequences.[71] The building of six–sided,[72] nine–sided or polygonally terminated chapel–like fountain houses was therefore not contrary to the tradition and proportions of medieval architecture.[73]

In conclusion, a word concerning monastic fountains. The cistercian fountains whose life–giving, living water held religious symbolism for the monk, who had been reborn to a new life in a baptism by water, always stood in the middle of the room, whose architecture, sculpture and stained glass always were imbued with a sacred character. The fountain was either carved from a hard stone (often marble or granite), formed from lead, copper, or brass, or poured of bronze––in any case made of a permanent material to avoid costly repairs.

The design combined a jet and basins: three graduated basins or conch–shaped shells caught the water that gushed up from the central jet and let it stream from the rim of the uppermost basin into the middle basin like a transparent veil in whose "folds"

the rays of sun streaming through the windows of the fountain house created thousands of sparkling light effects. The water flowed through many copper tubes into the main basin, at which the monks drank, bathed or washed their eating utensils.[74] Ever since Nicola Pisano and his son Giovanni took this type of basin fountain, enlarged, as the basis for the construction of the Fontana Maggiore in the piazza in Perugia,[75] the form rapidly became predominant in Italy and the bordering countries, as is proved by the Fontana dei Fiumi of Giovanni Lorenzo Bernini in the Piazza Navona and his fountain in part of the Palazzo Barberini in Rome, as well as the Residenz fountain in Salzburg created by an Italian master in 1651–1661.[76]

Cistercian basin fountains that stood in fountain houses of only eight meters in diameter were much smaller and simpler than the imposing municipal fountains of Perugia, Rome and Salzburg. But even in such a small area, medieval artisans understood how to create elegant, harmonious designs. Such a fountain is shown on the coat of arms of Heilsbronn *(Fons salutis)* near Ansbach (secularized in 1525) as the expressive emblem of this family monastery of the Franconian Hohenzollern.[77]

Medieval cistercian fountains in central Europe are, to be sure, known through some old descriptions —but today there are few actually preserved. The single construction preserved from the medieval period is the fountain made of lead at Heiligenkreuz near Vienna.[78] The lead fountain at Lilienfeld was auctioned off as scrap in 1789 and replaced with a neo–Gothic marble fountain in 1887. In Zwettl and Neuberg, the main basins stem from the middle ages, but the superstructures are modern additions. Preserved at Maulbronn is the lowest basin whose diameter—just as at Heiligenkreuz —fills half the eight–meter wide fountain house. The middle basin with the eight pairs of lions dates only from 1878, and the bronze top with the modern tin spire previously belonged to the abbot's fountain in front of the hunting lodge at Maulbronn.

An exception to this superstructure design was the brass fountain at Oliva (Pommerellen) destroyed c. 1800. Its form imitated the olive tree, the heraldic emblem of the monastery. All else that can be said about the cistercian fountains and fountain houses of central Europe is hypothetical. Here is a field ripe for archeological research, and hopefully, the many open questions will one day be successfully answered.

Trier (West Germany)

List of Fountain Houses According to Date of Origin[79]

Bonmont	12th cent.	A	1131	Switzerland	
Orval I	12th cent.	B	1132	Belgium	
Pforte	12th cent.	B	1132	GDR	
Orval II	late 12th cent.	G	1132	Belgium	
Schönau	early 13th cent.	A	1145	GFR	
Marienthal	early 13th cent.	A	1143	GFR	
Zwettl	early 13th cent.	C	1142	Austria	Preserved
Altzella	early 13th cent.	C	1175	GDR	
Lilienfeld	early 13th cent.	C	1206	Austria	Preserved
Georgenthal	13th cent.	D	1142	GDR	
Loccum	13th cent.	D	1163	GFR	
Eberbach	13th cent.	G	1135	GFR	
Wettingen	after 1227	G	1227	Switzerland	Preserved
Maulbronn	c. 1250	E	1138	GFR	Preserved
Heiligenkreuz	late 13th cent.	E	1133	Austria	Preserved
Stams	c. 1300	A	1273	Austria	
Wörschweiler	c. 1300	A	1171	GFR	
Eldena	c. 1300	D	1199	GDR	
Neuzelle	c. 1300	D	1268	GDR	Preserved
Walkenried	c. 1300	F	1129	GFR	Preserved
Arnsburg	c. 1300	F	1174	GFR	
Haina	c. 1300	F	1188	GFR	Preserved
Ter Duinen	c. 1300	F	1138	Belgium	
Chorin	before 1320	D	1258	GDR	
Neuberg	after 1327	C	1327	Austria	Preserved
Pelplin	14th cent.	C	1258	Poland	
Doberan	14th cent.	D	1171	GDR	
Oliva	c. 1400	F	1178	Poland	Preserved

Bebenhausen	c. 1400	F	1190	GFR	Preserved
Marienwalde	c. 1400	F	1294	Poland	
Bronnbach	15th cent.	F	1151	GFR	Preserved
Orval III	17th cent.	F	1132	Belgium	

NOTES

1. H. J. Arens, "Wasserwirtschaftliche Massnahmen der Zisterzienser", *Symposium über die historische Entwicklung der Wasserwirtschaft und der Wasserversorgung Berlin 1981*, Schriftenriehe der Frontinus-Gesellschaft, 5 (Berlin: 1981) pp. 83–96.
2. In excavations, the placement of walls and foundations is often of more interest than the sanitation systems of the monastery.
3. Meredith P. Lillich, "Cleanliness and Goliness: A Discussion of Medieval Monastic Plumbing", *Mélanges à la mémoire du père Anselme Dimier*, ed. Benoît Chauvin (Arbois: 1982) III, 5:123–149.
4. The western part of the former Holy Roman Empire includes the monasteries of Belgium, Luxembourg, Lorraine, and Switzerland; but not the Cistercians in Holland, practically a sovereign state since 1609, or the Cistercians in the Artois and Franche-Comté, ceded to France in 1678.
5. H. P. Eydoux, *L'Architecture des églises cisterciennes d'Allemagne*, Travaux et memoires des Instituts français en Allemagne (Paris: 1951) p. 15 f. lists only ninety-six cistercian monasteries in the German Empire, although he included Ruhekloster in Denmark, Wongrowitz, Lond, Blesen and Mogila in Poland, and Dünamünde in Latvia (which never belonged to the Holy Roman Empire), yet on the other hand omitted many houses in Belgium, Austria, Bohemia, and Moravia.
6. At Kloster Neuberg (Steiermark), the water was purported to have healing properties.
7. There is little in the much larger central European area to compare with the large number of medieval cistercian houses in England, such as Bindon

(Dorset), Buildwas (Shropshire), Byland, Fountains, Jervaulx, Kirkstall, Rievaulx, and Roche (Yorkshire), Coggeshall (Essex), Croxden (Staffordshire), Dore (Herefordshire), Furness (Lancashire), Tintern (Monmouthshire), and Waverly (Surrey), even when one considers that these all lie in ruins. Maulbronn and Bebenhausen, the ruins of Chorin, Arnsburg, Villers, Orval, and Aulne and the medieval remains at Heiligenkreuz, Zwettl, Lilienfeld, Sittich (Sticna) and Sulejów offer no comparison with the remarkable state of so many of the English cistercian houses.

8. Founded in 1129 as a daughter of Altencamp, secularized in 1556, made a school in 1557; the church is now a ruin. Today, a settlement of a Protestant monastic community resides there.

9. *Die Bau- und Kunstdenkmäler des Landes Braunschweig, VI. Kreis Blankenburg*, ed. K. Steinacker (Wolfenbüttel: 1922) pp. 308–314.

10. Founded in 1070 by Benedictines from Calabria, in 1110 became a monastery of Augustinian canons, taken over in 1132 by Cistercians from Trois-Fontaines; destroyed in 1793; since 1926, a trappist abbey.

11. "Orval: L'ancien cloître, historique de son évolution", extract from *Pays gaumais* (1963–64) pp. 24–25.

12. Founded in 1267 as a daughter of Doberan, secularized in 1923, since then the residence of the bishop and cathedral chapter of Kulm (Chelmno, Poland).

13. R. Frydrychowycz, *Geschichte der Cistercienserabtei Pelplin und ihrer Bau- und Kunstdenkmäler* (Düsseldorf: 1905).

14. Founded 1127 as a daughter of Morimond, secularized in 1803; the extensive Baroque buildings today serve as a prison.

15. Illustrated in J. Hotz, *Zisterzienserklöster in Oberfranken* (Munich–Zurich: 1982) p. 21; see also G. Zimmerman, ed., *Festschrift Ebrach 1127–1977* (Volkach: 1977) pp. 247 ff. and 307–309.

16. It was destroyed three times by fire; hence, in the sixteenth century it was rebuilt, for protection, over flowing water.

17. Founded 1227 as a daughter of Leubus, secularized in 1810; until 1945, the residence of the grand duke of Saxony-Weimar; since 1945 Polish and called Henryków; in the Baroque buildings is presently a state agricultural technical school with boarding and a priory of the cistercian

abbey of Szczyrzyc.

18. The intensification of agriculture after the Thirty
 Years War obviously affected the taste of the
 water, so that, two kilometers west of the monastery,
 Abbot Ackermann (1702–22) dammed the Zinkwitzbach
 whose clear cold water was fed by countless sources
 in the 1000–hectare beech forest. This water was
 brought by an open canal to the south side of
 the brook valley, and, from the edge of the village
 of Heinrichau, it was carried through oak pipes
 under the road and over the Ohle canal into
 the confines of the monastery.

19. H. Grüger, *Heinrichau, Geschichte eines schlesischen
 Zisterzienserklosters 1227–1977*, Forschungen und
 Quellen zur Kirchen– und Kulturgeschichte Ostdeutsch-
 lands, 16 (Cologne–Vienna: 1978) pp. 125–129.

20. There are completely preserved fountain houses
 at Heiligenkreuz, Zwettl, Lilienfeld and Neuberg
 in Austria, Wettingen in Switzerland, Maulbronn
 and Bebenhausen in Württemberg, Bronnbach in
 Baden, Arnsburg and Haina in Hesse, Walkenried
 in the Harz and Oliva near Gdansk.

21. Only the four Austrian monasteries of Heiligenkreuz,
 Zwettl, Lilienfeld and Neuberg, which were spared
 the Thirty Years War, have continued up to today
 to painstakingly care for the core of the medieval
 quadrum.

22. This happy fate was enjoyed by the secularized
 foundations of Maulbronn and Bebenhausen, Heils-
 bronn near Ansbach, Loccum in Lower Saxony,
 Walkenried and Michaelstein in the Harz, Riddags-
 hausen near Braunschweig, Marienthal near Helmstedt
 and Pforte in Thuringia. Other abbeys, such
 as Scharnebeck near Luneburg, Doberan and Dargun
 in Mecklenburg, Kolbatz (now Kolbacz) in Pomerania,
 Lehnin in Brandenburg, and Doberlug in the
 Lausitz, became princes' palaces and were so
 radically altered that it is no longer possible
 to reconstruct the medieval disposition of the
 rooms.

23. Completely disappeared, or reduced to remains
 hardly worth speaking of, are thirty–seven of
 these roughly 135 monasteries: namely Baudeloo,
 Boneffe, Grandpré, Ter Doest, Ter Duinen and
 Waerschoot in Belgium; in Lorraine, Châtillon,
 La Chalade, Chéry, Clairlieu, Escurey, Freistorf,
 Isle–en–Barrois, the primary abbey Morimond (whose
 buildings lay partly on French, partly on Lorraine
 territory), Pontifroid, Saint–Benoît–en–Voivre,

Stürzelbronn and Villers-Betnach (Weiler Bettnach); in Switzerland, Haucrêt; Grevenbroich in the Rhineland; Schönau and Tennenbach in Baden; Königsbronn in Württemberg, Ihlo in East Friesia; Reinfeld in Holstein; Grunhain and Sittichenbach in Saxony; Himmelpfort in Brandenburg; in Pomerania, Buckow (now Buków), Hiddensee and Stolpe; in Bohemia, Heiligenfeld (Svaty Polé), Münchengrätz (Mnichovo Hradiste), and Nepomuk; and in Moravia, Wisowitz. (Visovice).

24. F. Bucher, *Bonmont und die ersten Zisterzienserabteien der Schweiz*, Berner Schriften zur Kunst, 7 (Bern: 1957); A Schneider, ed., *Die Cistercienser, Geschichte, Geist, Kunst* (Cologne: 1974) p. 70.

25. *Die Kunstdenkmäler des Grossherzogtums Baden, 8: Amtsbezirk Heidelberg*, ed. A. von Oechelhaeuser (Tübingen: 1913) pp. 606 ff.; R. Edelmaier, *Das Kloster Schönau bei Heidelberg. Ein Beitrag zur Baugeschichte der Cistercienser*, Karlsruher Dissertation, Heidelberg, 1915.

26. *Die Bau- und Kunstdenkmäler des Herzogthums Braunschweig, 11: Kreis Helmstedt*, ed. P. J. Meier (Wolfenbüttel: 1896) pp. 127–143.

27. M. Zadnikar, *Sticna in zgodnja arhitektura cistercijanov* (Ljubljana: 1977) p. 172.

28. J. Λ. Schmoll gen. Eisenwerth, "Die Mittelalterlichen Bauten der ehemaligen Zisterzienserabtei auf dem Wörschweiler Klosterberg. 3. Vorbericht über die Bauuntersuchungen und Grabungen", *Beiträge zur saarländischen Archäologie und Kunstgeschichte*, 9. Bericht der staatlichen Denkmalpflege (Saarbrücken: 1962) pp. 57–68.

29. See n. 11.

30. W. Hirschfeld, *Zisterzienserkloster Pforte. Geschichte seiner romanischen Bauten und ein älteres Westwerk*, Beiträge zur Kunstgeschichte, 2 (Burg bei Magdeburg: 1933), publication of a dissertation, (Dresden: 1933).

31. *Die Kunstdenkmäler des Zisterzienserklosters Zwettl*, ed. P. Buberl, Ostmärkische Kunsttopographie, 4 (Vienna: 1940) p. 168.

32. E. Badstübner, *Kirchen der Mönche (East Berlin: 1980)* p. 211; *Beschreibende Darstellung der älteren Bau- und Kunstdenkmäler in Sachsen, 41*, ed. C. Gurlitt, Ergänzungsheft (Dresden: 1922) pp. 5–82.

33. N. Mussbacher, *Das Stift Lilienfeld* (Vienna: 1976) pp. 22 f.; K. Oettinger, *Stift Lilienfeld 1202-1952* (Vienna: 1952).

218 Cistercian Art and Architecture

34. F. S. Pichler, *Die Habsburger Stiftung Cistercienser Abtei Neuberg in Steiermark. Ihre Geschichte und ihre Denkmale* (Vienna: 1884) p. 43 f.
35. See n. 13.
36. A. Holtmeyer, *Cisterzienserkirchen Thüringens. Ein Beitrag zur Kenntnis der Ordensbauweise*, Beiträge zur Kunstgeschichte Thüringens, 1 (Jena: 1906) pp. 226–250.
37. U. Hölscher, *Kloster Loccum. Bau– und Kunstgeschichte eines Cisterzienserstiftes* (Hannover–Leipzig: 1913).
38. H. Kloer, *Das Zisterzienserkloster Eldena in Pommern nach den im Jahre 1926/7 vorgenommenen Ausgrabungen*, Dissertation der Technischen Hochschule Hannover, Leipzig 1928.
39. J. Fait, J. Fritz, *Neuzelle. Festschrift zum Jubiläum der Klostergründung vor 700 Jahren 1268–1968* (Munich–Zurich: 1968).
40. *Chorin. Gestalt und Geschichte eines ehemaligen Zisterzienserklosters*, St Benno–Verlag (Leipzig: 1980).
41. A. F. Lorenz, *Doberan. Ein Denkmal norddeutscher Backsteinbaukunst*, Deutsche Bauakademie, Institut für Theorie und Geschichte der Baukunst, Studien zur Architektur und Kunstwissenschaft, 2 (East Berlin: 1958).
42. E. Paulus, *Die Cisterzienser–Abtei Maulbronn* (Stuttgart: 1882); J Dörrenberg, *Das Zisterzienser–Kloster Maulbronn* (Würzburg: 1938).
43. F. Gaumannmüller, "Die mittelalterliche Klosteranlage der Cistercienser–Abtei Heiligenkreuz", *Festschrift zum 800–Jahrgedächtnis des Todes Bernhards von Clairvaux*, Austrian Cistercian Congregation of the *Heiligsten Herzen Jesu* (Vienna–Munich: 1953) pp. 167–210, especially 196 f.
44. *Die Bau– und Kunstdenkmäler des Landes Braunschweig. Bd. 6: Kreis Blankenburg*, ed. K. Steinacker (Wolfenbüttel: 1922) pp. 263–367.
45. W. Zschietzschmann, "Ausgrabungen im Kloster Arnsburg 1958", *Kunst–Chronik* 12 (1959) 67–78.
46. O. Schürer, "Die Baugeschichte der Klosterkirche zu Haina". *Marburger Jahrbuch für Kunstwissenschaft*, ed. R. Hamann, H. Weigert (Marburg: 1926) 2:91–170.
47. L. Develiegher, "De Duinenabdij te Koksijde", *Archaeologia Belgica, 30* (Brussels: 1960).
48. *Die Bau– und Kunstdenkmäler der Provinz Westpreussen, 1: Pommerellen*, ed. J. Heise (Danzig: 1884) p. 98 ff.

49. E. Paulus, *Die Cisterzienser-Abtei Bebenhausen* (Stuttgart: 1886).

50. P. Hoffmann, *Nordische Cisterzienserkirchen unter Berücksichtigung der Backsteinbaukunst,* dissertation of the Technische Hochschule Dresden, Essen 1912, pp. 67–77.

51. *Die Kunstdenkmäler des Grossherzogthums Baden, IV: 1. Abtheilung: Amtsbezirk Wertheim,* ed. A. von Oechelhaeuser (Freiburg im Breisgau: 1896) pp. 6–88.

52. See n. 11.

53. H. Hahn, *Die frühe Kirchenbaukunst der Zisterzienser. Untersuchungen zur Baugeschichte von Kloster Eberbach und ihre europäischen Analogien im 12. Jahrhundert,* Frankfurter Forschungen zur Architekturgeschichte, 1 (Berlin: 1957) p. 21.

54. D. Wili, "Baugeschichtliches über das Kloster Wettingen", *Cistercienser-Chronik* 6 (1894) 209 f.

55. See n. 11.

56. It stems from the second half of the thirteenth century and serves now as the cloister anteroom; see *Beschreibende Darstellung der älteren Bau- und Kunstdenkmäler des Königreichs Sachsen, Amtshauptmannschaft Kamenz-Land,* 35, ed. C. Gurlitt (Dresden: 1912) p. 164.

57. G. Dehio, *Handbuch der deutschen Kunstdenkmäler, Rheinland,* ed. R. Schmitz-Ehmke (Munich-Berlin: 1977) pp. 611–616.

58. Built in the twelfth century; see G. Dehio, *Handbuch der deutschen Kunstdenkmäler, Der Bezirk Halle,* 2nd ed. (East Berlin: 1978) p. 274 ff.

59. Now torn down; see W. Irtenkauf, *Hirsau. Geschichte und Kultur* (Sigmaringen: 1978).

60. E. Lehmann, *Die Bibliotheksräume der deutschen Klöster im Mittelalter,* Schriften zur Kunstgeschichte, 2, ed. R. Hamann, E. Lehmann (East Berlin: 1957) pl. VI, no. 20.

61. Nine-sided (9|14) polygon without anteroom, with eight windows and vaulted with nine cross-ribs, built 1363; see H. J. Mrusek, *Drei Deutsche Dome* (Dresden: 1963) p. 37.

62. See n. 60, fig. 13; it was built c. 1150.

63. Only Himmelwitz in Upper Silesia, which was founded as a convent of only twenty monks, was probably content with a fountain basin in the cloister.

64. The rebuilding of the monasteries Königsaal near Prague (Zbraslav), Plass (Plasy), Saar (Zd´ár) and Ossegg (Osek) in Bohemia, Welehrad (Velehrad)

in Moravia, Leubus (Lubiaź), Heinrichau (Henryków), Kamenz (Kamieniec), Rauden (Rudy), Grüssau (Krzeszów) and Himmelwitz (Jemielnice) in Silesia was necessary after the utter devastation of the Thirty Years War, since monks of the late seventeenth century could not be expected to spend their lives within cold and bleak walls. Whether it was also necessary to erect monastic palaces with sumptuous facades 223 meters in length and with projecting towers (as happened in the Silesian foundation Leubus, whose convent never exceeded 40–50 members) is quite a different matter.

65. A. Prokop, *Die Markgrafschaft Mähren in kunstgeschichtlicher Beziehung*, 4 vol. (Vienna: 1904) passim; J. Neuwirth, *Geschichte der christlichen Kunst in Böhmen bis zum Aussterben der Premysliden* (Prague: 1888); Zd. Wirth, *Umeleck památky Cech* (Prague: 1957); F. Machilek, "Die Zisterzienser in Böhmen und Mähren", *Archiv für Kirchengeschichte von Böhmen–Mähren–Schlesien* 3 (1973) pp. 185–220; H. Weczerka, ed., *Handbuch der Historischen Stätten: Schlesien* (Stuttgart: 1977); *Verzeichnis der Kunstdenkmäler der Provinz Schlesien*, pp. 1–5, ed. H. Lutsch (Breslau: 1886–1903); H. Tintelnot, *Die mittelalterliche Baukunst Schlesiens*, Quellen und Darstellungen zur schlesischen Geschichte, 1 (Kitzingen: 1951); H. Grüger, "Schlesisches Klosterbuch", *Jahrbuch der Schlesischen Friedrich-Wilhelms-Universität zu Breslau* 21 (1980) pp. 84–109 (Kamenz); 22 (1981) 1–32 (Leubus), 33–49 (Rauden), 50–61 (Himmelwitz); 23 (1982) 27–54 (Heinrichau), 55–83 (Trebnitz), 84–145 ("Der Orden der Zisterzienser in Schlesien 1175–1810. Ein Überblick"); M. Kutzner, *Cysterska Architektura na Slasku w latach 1200–1330*, Prace habilitacyjne (Thorn: 1969).

66. Z. Swiechowski, *Budownictwo romańskie w Polsce. Katalog zabytków*, Zródla do Historii Kultury Materialnej (Wroclaw–Warsaw–Cracow: 1963); Z. Swiechowski, *Opactwo cysterskie na Sulejowie. Poznánski Towarzystwo Przyjaciól Nauk*, Prace Historii Sztuki, IV, 2 (Poznan: 1954).

67. N. Pajzderski, "Les Abbayes cisterciennes en Pologne", *Bulletin monumental* 86 (1912) pp. 59–69; J. Kloczowski, "Les Cisterciens en Pologne", *Cîteaux, commentarii Cistercienses* 21 (1970) pp. 11–134.

68. Also the Memoria, built c. 350 in the late antique episcopal church in Trier, which housed a much

visited relic (the *tunica domini*), was a monumental dodecagon of c. 12 meters in diameter; the architect of the east choir, which Archbishop Hillin of Falmagne added on to the east wall of Gratian's square hall after 1150, continued the tradition of the dodecagon by making the Romanesque choir seven sides of a dodecagon. See H. Cüppers, F. Ronig, *Führer zu vor- und frühgeschichtlichen Denkmälern*, Trier, Römisch–Germanisches Zentralmuseum, 32, (Mainz: 1977) Pt I: Text, pp. 104–118.

69. What was built in Paderborn as a very free imitation was an octagon with four almost square wings on the cardinal points, i.e. an octagon penetrated by a cross. See A. Fuchs, *Paderborn* (Berlin: 1965) p. 38 f.

70. It was used as the basis also of St Lambert in Muizen near Mecheln (Belgium) near the end of the tenth century, also in Ottmarsheim (Alsace) c. 1000, in the double chapel of St Ulrich in the imperial palace at Goslar c. 1140, in the All Saints' chapel in the cathedral precincts at Regensburg, as well as in many crossing towers of Romanesque cathedrals like Mainz, Speyer, Worms, Maria Laach, Neuss, Königslutter, St Aposteln in Cologne and St Godehard in Hildesheim.

71. A. Kottmann, *Das Geheimnis romanischer Bauten. Massverhältnisse in vorromanischen und romanischen Bauwerken* (Stuttgart: 1971); H. Spiess, *Mass und Regel. Eine mittelalterliche Massanordnung an romanischen Bauten,* dissertation of the Technische Hochschule, Aachen 1959; O. Schubert, *Gesetz der Baukunst* (Dresden: 1954); J. Csemegi, "Die Konstruktionsmethoden der mittelalterlichen Baukunst", *Acta Historiae Artium Scientiarum Hungaricae,* 2 (Budapest: 1955) pp. 15–50; F. V. Arens, *Das Werkmass in der Baukunst des Mittelalters. 8. bis 11. Jahrhundert,* dissertation, Würzburg, 1938.

72. In Germany, we also find hexagonal central plan spaces in the twelfth century funerary chapel of the benedictine monastery Grosscomburg in Württemberg and in the St Matthew chapel in front of the castle Kobern on the Moselle river, built by Duke Heinrich II for the relic of the head of St Matthew which he brought back from the crusade in Damietta in 1221.

73. For the polygonally terminated fountain houses with chapel-like form also derive from the hexagon but more often from the octagon.

74. The lowest basin was often of considerable size so that many monks could use it at once. At Heiligenkreuz, it had a circumference of 12.5 meters; at Lilienfeld, the water streamed from thirty-eight pipes to serve that many monks.

75. This largest and most elegant of the medieval Italian fountains was built 1275–1278. See O. Gurrieri, *Perugia, arte e storia* (Terni: 1972) p. 24.

76. G. Dogo, *Guida artistica d'Italia*, 3rd ed., (Milan: 1979); H. Keller, W. Hege, *Salzburg* (Munich–Berlin: 1956) p. 42.

77. A. Schneider, ed., *Die Cistercienser. Geschichte, Geist, Kunst*, (Cologne: 1974) p. 574.

78. The top basin was destroyed in 1683, then reconstructed, topped with a copper basin and the whole crowned with a cross. See n. 43.

79. Column 1: Name of monastery
 Column 2: Date of construction of the fountain house
 Column 3: Type of fountain house
 Column 4: Date of foundation of monastery
 Column 5: Current political allegiance
 Column 6: Present condition of the fountain house
 (only indicated where preserved)

 The abbreviations mean: GFR=German Federal Republic, GDR=German Democratic Republic, c=circa.

Translation by Dr. Susan McChesney Dupont

THE ABBEY OF REALVALLE IN CAMPANIA
Joselita Raspi Serra and Massimo Bignardi

A suggested reconstruction of the design of the Abbey of Realvalle, which today is in ruin, is here presented, to be followed by a detailed analysis by Massimo Bignardi, presenting the history of the abbey and the methodology used in the reconstruction of its plan. We developed our plan (Fig. 1) starting with the right side wall, where traces of the vault ribs still remain (Figs. 2, 3). An opening was discovered in the end wall of the right transept, and the area around the cloister was investigated (Figs. 4, 5), where a later structure had been annexed to the outer wall of the church. At the site we also found construction to the south and west of the cloister, including part of the wing for the *conversi* (Fig. 6). Our survey of Realvalle traces for the first time its structural development in detail.

Our work has been based on a thorough examination of the architectural remains at the site. Too often such important analysis has been carelessly conducted in the study of southern Italian monuments. This shortcoming has kept our understanding of these monuments rather vague, and has left unstudied the relations between different categories of architecture as well as its relationship to the growth of historical centers. A comprehensive survey is needed of the sites of the religious orders of Campania and the other regions of southern Italy to facilitate a thorough study of their relationship, as well as to save the buildings, often now in a ruinous state. Such a study would provide a new outline for the region's architectural tradition and for connections between ecclesiastical architecture and contemporary politics, particularly in churches in Naples.

The monastic architecture of the region shows a free selection of motifs, often directly drawn from the Order's chief centers. In the case of Realvalle the monument was to become a model for its territorial area. The source of its design seems clear if our hypothetical reconstruction of Realvalle is compared with the plan of the Abbey of Fontenay.[1] While it would not be too surprising if the important French monastery, the early prototype repeated in numerous cistercian projects, might also be reflected in the Abbey of Realvalle founded ca. 1275, our hypothesis would gain further interest if the latter was indeed a "pure" cistercian design--not compromised, as in Naples, by the influence

from the cathedral churches of France.

Our hypothesis of a plan with flat-ended apses for Realvalle is supported by the presence of this feature in later church plans of the region. More precisely, the church of San Francesco in the nearby Nocera Inferiore[2] exhibits a similar form—flat-ended apses, here connected to a single unaisled nave—which would seem to confirm, by imitation, the previous existence of the motif in the region. The evolved decorative detail of the Franciscan church also seems to be drawn from the stylistic forms of the cistercian building. Motifs were not only repeated but entered the architectural vocabulary in use in Campania; the development of stylistic elements, as well as their essential continuity, is evident.

The historical investigation of a single monument gains validity when it provides the basis for understanding the origins, and continuity, of architectural thought among related monuments. Thus we present our suggested reconstruction of Realvalle—a cistercian architectural form transmitted to and diffused by the Franciscan Order in southern Italy.

The Plan of the Cistercian Abbey of Realvalle:
A Hypothetical Reconstruction

Between 1274 and 1280, the cistercian abbey of Santa Maria di Realvalle was built by Charles I of Anjou in the San Pietro section on the outskirts of Scafati, to commemorate the victory of his forces over Manfred in the Battle of Benevento. The archival sources, while rich and numerous, are limited to the reigns of Charles I and Charles II of Anjou. Documentation from the fourteenth century reveals nothing except data relating to bequests, donations, and privileges granted the monastery. The abbey survived the Innocentine suppression, but not that of the French at the beginning of the nineteenth century; in 1805 the complex was definitively closed.

The bibliography for historical vicissitudes is large: from Ughelli, to Francabandiera,[3] to the latest research by Arcangelo R. Amarotta.[4] Few of these works are true architectural analyses; there we have only the studies by Janauschek, then Wagner Rieger, and finally the summary by Venditti.[5]

Of the monastic complex, little remains today. The original building scheme was constructed for Charles I by the Frenchman Pierre de Chaul:[6] the east-west axis of the church, with apse facing east; the right aisle (Figs. 2, 3), which forms one side of the square

cloister (Figs. 4, 5); and, radiating from the cloister, the sacristy, chapterhouse (actually a continuation of the arm of the transept), the refectory placed opposite the church and not far from the stream, and the hall for the conversi (Fig. 6) placed on the west with axis perpendicular to that of the church (Fig. 1). The monks' quarters were situated between the refectory and the stream where today a neglected garden adjoins the apse of the church reconstructed in the late Baroque era. The general ground plan is generated from a quadrangular module and sets forth a scheme adopted from France, for example Fontenay, Clairvaux II, Clermont and others, and used in Italy at Casamari and Fossanova.

Of the church there remains a part of the right aisle wall, on which are the moldings of three pointed arches resting on half columns (Fig. 2), enclosing ogival, single-light windows with trilobed intrados (Fig. 3). The latter provide evidence of early Angevin architectural style, which is strongly characterized by French forms. The Angevin style was formulated with sophistication in the franciscan mother church in Naples, San Lorenzo, but it had already been anticipated in the spatial design (of cistercian type) in the chapterhouse of the convent of Sant'Agostino alla Zecca in Naples.

In essence, Charles I looked to France for the construction of the Abbey of Realvalle, as he did with the coeval church of Santa Maria della Vittoria in Marsica, a daughterhouse of the French abbey of Le Loraux. In the case of Realvalle, Charles looked to Royaumont, which his brother, King Louis IX, had constructed between 1229 and 1235 in the diocese of Beauvais. The choice of site and project design was entrusted to Pierre de Chaul, an intimate of the King. Likewise, the construction as well as sculptural decoration were entrusted to Gauthier d'Asson,[7] then to Baudelin de Linais, and finally to Thibaud de Seaumur. Even the flat roof tiles were *ad modum Franciae*.[8] Moreover, the Abbey was a daughter of the French motherhouse of Royaumont, in the filation of Cîteaux; in 1279, thirty-seven monks arrived at Realvalle from Royaumont.[9] In sum, one may say that the monastery had a distinctly French air.

The meager remains of the church today allow a very intriguing hypothesis for reconstructing the plan, by attempting to apply strictly the module of construction proposed by Hahn in *Die frühe Kirchenbaukunst der Zisterzienser* (Berlin, 1957). Our graphic reconstruction (Fig. 1) was, in fact, developed by

following that modular type, the *bernardischer Grundtypus,* proposed by Hahn for buildings influenced by Clairvaux II and "the personal wishes of S Bernard" (Romanini). The existence of a modular scheme in cistercian construction was pointed aout as early as the "thirties by Le Corbusier at certain churches', for example, that of Chaalis. Following Hahn's directives we have tried to verify, in a possible diagrammatic plan of the church, the lucid rationality and compositional harmony possessed by the complex as a whole. The basic module is certainly the square, found in the cloister, the bays of its galleries (eight bays on the long sides, seven on the short sides), and also in the side aisles of the church, seven bays long. From the proportional scheme of 4:3—which is the relationship between the width of the nave with aisles and the width of the transept including chapels —one calculates that the length of a side aisle of the nave would be two-thirds the total length of the church, apse included. The single measurement at our disposal is the length of the right side aisle which we know was divided into seven bays, of which only three, outlined by pointed arch moldings, are visible at present (Figs. 2, 3); two bays are engulfed by a construction built by local farmers in the area where the facade once existed. The two remaining bays, toward the transept, are easily reconstructed as lining up perpendicularly with the east wall of the cloister.

Once we have the measurement of the length of the right aisle, which turns out to be about 44.5 meters, we can work back to the others: the total length of the church would be about 68 meters, the width of the nave plus aisles about 22 meters. Given the proportional relationship of 4:3 we can also derive the width of the transept arm which corresponds to the sum of the widths of the central nave plus one lateral aisle; one can also obtain the depth of the choir from half the length of the transept. Having made these arithmetric calculations, we find that each side aisle would measure about 6 meters, from the side wall to the center of the corresponding pier, which is equal to the distance between the engaged columns (Fig. 2). We thus have demonstrated the use of a square module which determines the bays of the side aisles; this is also repeated to establish the elevation. Indeed, the original ogival arches remaining on the side wall are also inscribed in a square bounded at the bottom by a molded string-course of semi-circular section, that ran along the outer walls of the church as for example at Fossanova, Casamari and also in the earliest of the franciscan

churches—with the difference that at Realvalle it is interrupted by columns.[10] One derives the length of the transept by doubling the sum of the widths of the nave plus aisles; it thus ends up being approximately 44 meters, corresponding to the traces of masonry discovered on the outer part of the east side of the cloister with the deviation of a few tenths of a centimeter.

The details of this hypothetical plan—which resembles the plans of Fontenay, Clairvaux II, Clermont, and in Italy the plan of Santa Maria del Corte in Sardinia—must be verified by the existing documents and possible excavations. The only data provided by the historical documentation is that the church had three aisles divided by pilasters.[11] Excavation would be necessary to determine the actual form of the apse, which we have suggested to be flat-ended and of the bernardine type. The plan suggested previously by Wagner Rieger and repeated by Venditti, on the other hand, called for an ambulatory similar to the choir design found at Royaumont and repeated in San Lorenzo in Naples, built at about the same time as Realvalle. Our proposed hypothesis for the plan offers, to those who may undertake the investigations necessary to recover the design of Realvalle, a possible direction for their work.

The University of Salerno

NOTES

1. Marcel Aubert, *L'Architecture cistercienne en France* (Paris: 1947) 1: Fig. 28.
2. Joselita Raspi Serra, "L'Architettura degli Ordini mendicanti nel Principato Salernitano", *Mélanges de l'Ecole française de Rome* 93 (1981) 2, pp. 605–81, note 4.
3. *L'Abbazia di S Maria di Realvalle presso Scafati* (Bari: 1922).
4. "Real Valle, badia gotica sul Sarno", *Atti dell' Accademia Pontaniana* (Naples, n.s. 22, 1973).
5. R. Wagner-Rieger, *Die italienische Baukunst zu Beginn der Gotik* (Graz and Cologne: 1956–57); A. Venditti, "Urbanistica e architettura angioina", *Storia di Napoli* (Naples: 1969) v. 3.

6. The extant documents infer that De Chaul was guided by suggestions communicated to the king by four French monks, two from Royaumont and two from Le Loraux. They were sent by the General Chapter which met at Cîteaux in 1273. For sources see Amarotta, "Real Valle".

7. The French form "Gauthier d'Asson" used by Amarotta is preferable to "d'Assonne" given by Venditti, "Urbanistica e architettura".

8. *Reg. Ang.* 1276 B, n. 26, f. 236, in *Archivio storico italiano*, 4th series, 2, p. 358; Venditti, p. 855, note 17.

9. *Reg. Ang.* 1267, f. 207, t (year 1278), in C. Minieri Riccio, *Della dominazione angioina nel reame di Sicilia* (Naples: 1876) p. 20; quoted by Amarotta, p. 7, note 17 of the abstract.

10. The decoration of the church shows typically French types: capitals with inverted crockets but also with acanthus leaves very similar to those of the Abbey of San Galgano near Siena; also the design of the dado, the pointed arches of torus moldings, and the rib profiles of the vaults, a series which is repeated later in the entrance portal of San Francesco of Nocera Inferiore. The horizontal cornice was subsequently used in Naples in the side aisles of the angevin church of San Elizio in Piazza Mercato. I have compared these decorative motifs with the repertory given in Aubert, *L'Architecture* I, p. 284.

11. Refer to the documents indicated in H. W. Schulz, *Denkmäler der Kunst des Mittelalters in Unteritalien* (Dresden: 1860) 4, p. 85, also cited by Amarotta, "Real Valle", p. 7, notes 18 and 19 of the abstract. Both authors mention the document taken from *Reg. Ang.* 28, f. 148 B.

Translation with the assistance of Renée George and David Lipfert.

THE TOMB CANOPIES AND THE CLOISTER AT SANTES CREUS
Barry Rosenman

Santes Creus is one of the most significant cistercian foundations in Catalonia. In 1151, the Catalan count, Ramon Berenguer IV, invited monks from the abbey of Grand Selve in Languedoc to establish a monastery in the "frontier" wilderness of his expanding county.[1] Santes Creus became the recipient of royal patronage once again during the reigns of Peter III of Aragon (1276–1285) and his son James II (1291–1327). As benefactors they provided funds for the construction of the royal residence at the monastery, the cloister and the refectory.[2] In addition Peter, James and his queen Blanche of Anjou, made Santes Creus a royal mausoleum by selecting it as their burial place. The buildings undertaken through the initiative of James in particular, which include the monarchs' tombs and the cloister, are related by the designs of the tomb canopies and of the north arcade of the cloister. This paper will investigate the stylistic relationship of these structures and clarify the roles played by the various artists mentioned in documents preserved today in the Archivo de la Corona de Aragón.

In accordance with the strict reformist tendencies of the Cistercian Order, Santes Creus was situated in a remote region, about fifty–five miles southwest of Barcelona, in the valley of the Rio Gayá on land donated by the Moncada family.[3] Twenty-three years after the invitation extended by Ramon Berenguer IV the monks started to erect their church.[4] The plan and interior of the edifice reflect the austere, ascetic rules associated with the early buildings of the Cistercian Order. The church has a Latin–cross plan; the vaulted nave is separated from the side aisles by an arcade of robust, cruciform piers made of plain, thick stones. The transept arms, the apse and the side chapels are simple rectangles. Consecration took place in 1211, but construction continued until 1225.[5] Along the south side of the church a cloister was built; all that remains from that period is the fountain, whose design probably reflects the original appearance of the galleries of the cloister.

After a long hiatus when few or no improvements were made, Peter III gave the impetus to finish the church facade and to build the royal quarters.[6] In 1258 Peter chose Santes Creus as his burial place, a pledge he reaffirmed in 1282.[7] (James I, Peter's

father, was buried at Poblet, another important cistercian
foundation in Catalonia.) As the Infante and later
as King of Aragon, Peter led a vigorous life, first
assisting his father in suppressing a rebellion in Valencia
and then in a two-front war against Charles of Anjou
and Philip III of France. At one point the chivalrous
Peter agreed to settle the struggle through a personal
duel with Charles.[8] All three protagonists died in 1285;
Peter passed away on 10 November in the town of Villa-
franca de Penadés. From there his body was carried
to Santes Creus by the nobles, who surrendered it to
the monks for burial. The corpse was washed, clothed
in a cistercian robe, and put into a coffin which was
placed next to the high altar.[9] The monument, however,
which we see today in the crossing of the stark, monastic
church was commissioned only in 1292, when James
II ordered Mestre Bartomeu, the head of the workshop
at the cathedral of Tarragona, to proceed to Santes
Creus and build a tomb to honor his father.[10] James
sent further instructions to Bartomeu during the construc-
tion of the tomb. He told the artist to confer with
the abbot of Santes Creus on the making of the tomb;
to use the stones James had acquired from Sicily; and
finally, to place the tomb next to the pillar in the
choir in front of the altar of Saint Andrew (Fig. 1).[11]

Over the course of three years Bartomeu conceived
and executed the bizarre agglomeration consisting of
a Late Antique porphyry tub (which serves as the king's
coffin), resting on the backs of two crouching lions
and covered by a "miniature Gothic cathedral", whose
niches contain the figures of Christ, the Virgin and
Child, the Apostles and two cistercian saints.[12] The
whole ensemble is surmounted and surrounded by a
groin-vaulted canopy supported by ten columns made
of jasper. The inner vault of the canopy presents a
celestial vision of gold stars on a blue background,
a presentation of the analogy between architectural
structures and the symbolic concept of the Heavenly
Jerusalem.[13] The essential design of the canopy is
an enframing arch enclosing a tracery pattern consisting
of cusped trefoil arches crowned by three oculi.

The canopy is the major similarity between Peter's
tomb and the double-tomb built for James and Blanche.
James pledged to be buried at Santes Creus and Blanche
made a similar oath in her will of 1308. Blanche promised
funds for the construction of the cloister, refectory
and other claustral buildings. For her tomb, James
tried to find porphyry stone so that her coffin should
match the porphyry receptacle containing Peter's

remains.14 James' search was fruitless, however, and
in lieu of porphyry he obtained stone from the Gerona
quarries.15 In 1312 James sent Bertran Riquer and
Pere de Pennafracta to Santes Creus to study and inspect
the funerary monument built by Mestre Bartomeu.16
In 1313, James wrote Riquer that he and Pere de Penna-
fracta should return to Santes Creus to make a tabernacle
in the manner, form and measure of the one standing
above his father's sepulcher.17 Riquer and Pennafracta
obeyed James' commands and built a canopy that is
nearly identical to the earlier canopy in Santes Creus.
The major variations are the substitution of a quatrefoil
for a hexafoil in the oculus and the addition of a
foliate decoration along the edges of the main arches
(Fig. 2).

Beneath the canopy sits the double-tomb, a large
rectangular sepulcher decorated with the coats of arms
of James and Blanche on their respective sides, and
a blind arcade filled in with an opaque dark blue
glass. The lid of the sarcophagus is gabled and on
each declining plane reclines an effigy. Both effigies
are dressed in cistercian robes and wear crowns; their
heads rest on pillars supported by angels, while Blanche's
feet are placed against a dog and James' feet against
a lion.

James' attempt to obtain porphyry and his orders
to Riquer and Pennafracta to construct a canopy similar
to the baldachin built in the 1290s for Peter's tomb
show his desire to create a familial chain through
the sepulchral monuments in Santes Creus. Another
indication of James' patronage at the monastery, then,
is the repetition of the canopy design in the cloister.
The decoration of the north gallery, buttressing the
south side of the monastic church, resembles the tracery
design of the tomb canopies. The arcades have three
lancets, but only one pentafoil roundel (Fig. 3). The
two lower oculi of the canopies' tracery are reduced,
in the cloister, to trefoils inscribed within the lateral
lancets, resulting in a change of proportions as well,
for now the side lancets are higher than the central
one whereas in the tomb tracery the central lancet
exceeds the sides in height. Nevertheless the similarities
between the baldachins of the royal sepulchers and
the arcade motifs indicate the dependence of one construc-
tion on the other. It is possible to ascertain the nature
of this relationship by examining the documents and
other examples of works devised by the two artists
mentioned, Mestre Bartomeu and Bertran Riquer.

Part of the confusion regarding the artists' role

is a result of early published documents which established
Riquer as the architect of the cloister program. Based
on that information Emile Bertaux attributed to Riquer
the cloister design and the tomb canopies.[18] Bertaux
was partially right; Riquer is the master of the cloister
and one of the tomb canopies, the second one that
was built in 1312 for Blanche's and James' tomb. Both
canopies preceded the construction of the cloister, which
was only started in 1313.[19] There is some debate over
when the cloister was begun. Although a colophon from
a manuscript written in 1367 stated that the first stones
for the cloister were set in 1313, Teodoro Creus, an
historian of the monastery, argued that the scribe
made an error, copying 1313 instead of 1303.[20] The
earlier date can be suported by donations made by
James and Blanche in 1301 and again in 1310 when
Blanche's will left a sum to Santes Creus for that purpose.
Neither donation is conclusive proof that work had
begun. In any case, the cloister was not started before
the baldachin over Peter's sarcophagus.

It is extremely unlikely that Riquer devised the
original design for the canopy, since he was sent by
James to study the canopy over Peter's tomb before
building one for the double-tomb. This would not be
necessary if he had built both tomb canopies. On the
other hand, if we turn to works by Mestre Bartomeu
we can show that he generated the design for the balda-
cins. His work on the cathedral of Tarragona demonstrates
his familiarity with the elements that compose the tracery
design, for he uses this pattern to decorate a face
of the buttress on the right side of the central portal.[21]
The buttress is subdivided by decorative stonework,
its rectangular field outlined by a series of receding
edges. The artist applied an arch to this field and
then divided it further with twin pointed arches surmount-
ed by a quatrefoil in a roundel (Fig. 4). Bartomeu
obviously had acquired knowledge of the Rayonnant
style, a style closely associated with the capetian
court in France.

The type of window tracery found in Rayonnant
architecture, that is, French architecture of the mid-
thirteenth century and later, was not established in
the Iberian peninsula much earlier than the construction
of the baldachin for Peter's tomb. Lampérez y Romea
characterizes the thirteenth century tracery in Spain
as the most simple, with one colonnette dividing the
bay to make the two small pointed arches upon which
the lobulated rose sits, as in the apse of León cathedral,
begun in 1255 under the direction of Master Henrique

of Burgos.[22] Master Henrique did design a triplet beneath three trilobes along the north side of the nave, but the plainness of the triplet (without a trefoil) and the flattened trilobe at the top indicate that his models were French buildings of the 1240s.[23] In another nave window, three colonnettes subdivide the space into four smaller arches, two hexafoil oculi and a larger one at the top. The different sizes of the oculi, the absence of cusping on the smaller arches, and the enclosing of the two smaller oculi by two larger arches —the oculi are not independent—show a dissimilar concept from the tracery design of the tomb canopies in Santes Creus.

The absence of models in Spain has directed scholars' attention to other countries, mainly Italy and France, for models. Duran i Canyameras believed that the antecedents for the Santes Creus tombs lay in the works of Arnolfo di Cambio.[24] Duran saw a major change in the emancipation of the aedicula from the wall. In Arnolfo's tomb canopies the cover is attached to the wall, e.g. the tomb of Cardinal de Braye. Arnolfo did popularize the use of the baldachin over the sarcophagus, but the formal language he employed, both in the tombs and altar canopies, is quite different from the canopies of the royal tombs in Santes Creus.

The groin-vaulted canopy for altars, a canopy with two intersecting barrel vaults, appears for the first time in the last quarter of the thirteenth century. Four columns are always joined by arches; no architraves are used. Arnolfo, and later Cosmati designers such as Giovanni da Cosma, were the masters of this type. Their altar canopies in S Paolo fuori le mura, and S Maria in Cosmedin in Rome, for example, never have a tracery design that fills the space between the columns. In S Paolo the arch is partially a trefoil arch, but the moldings of the trefoil are not independent of the main arch. The cusps are connected to it by stone. The spandrels are solid and support relief figures. These elements and the arch are bordered by a heavy cornice that projects above the niche and recedes over the arch. In each corner is a finial in the shape of an open tower, and between the finials is a triangular pediment lined by crockets and pierced by a trefoil above a small rose window supported by flying angels, which bring to mind Early Christian works of the *apotheosis* motif. The peak of the vault serves as a base for a miniature canopy.

Helen s'Jacob compared the Santes Creus baldachins to the canopies of the tombs in Royaumont and Longpont,

which are only preserved in drawings from the Gaignières
collection.25 Based on these drawings we can eliminate
the canopy of the tomb of St Louis' son, Louis of France
(d. 1260), as a model. The round arch is set within
a rectangular frame. The solid spandrels are pierced
by trilobes in a roundel, and the top is bordered by
a balustrade perforated by a frieze of quatrefoils.
The tomb of Jean de Montmirail (d. 1217) stood in the
abbey of Longpont, separated by a pillar from that
of his daughter Marie, the wife of Enguerrand III
de Coucy. In 1253 the monks received permission to
erect a tomb for Jean in the choir of the church, commemo-
rating his great virtues and the miracles that had
occurred by his grave.26 Aubert believed that the monumen-
tal tomb was made soon after 1253, but since it uses
a design closer in style to contemporary architecture
than that of Louis of France's tomb canopy in Royaumont—
a work of the royal court which promoted that style—
—it may be much later in date, or at least after the
construction of Prince Louis' tomb.27 Montmirail's tomb
has an added compound pier that divides the main
arch into two smaller cusped arches. A quatrefoil sur-
mounts the small arches, while a gable caps the main
arch. The gable is lined by crockets and ends in a
cross-shaped flower. The tympanum of the gable is
pierced by a trilobe, but in the drawing there is a
Crucifixion scene in this trilobe. This tracery design
is set into the four buttresses. The corners of the buttress-
es are topped by pinnacles and the roof is rimmed
by a balustrade with a series of quatrefoils.

A third tomb must be mentioned because it shows
the artistry of a Parisian master of the 1270s. During
the sad journey home to Paris, when Philip III returned
with the body of his father, Saint Louis, Philip's wife
Isabella of Aragon suffered a fatal accident near Cosenza
in Calabria when her horse threw her to the ground.
To prevent her body from putrefying the flesh, organs
and entrails were removed and entombed in the cathedral
of Cosenza.28 The bones were brought back to St-Denis
for burial in the royal monastery, but Philip also
arranged for a monument to be erected in Cosenza.
This monument consists of a wall relief depicting the
Virgin and Child worshipped by the kneeling figures
of Philip and Isabella. Each figure is framed by an
arch, but the architectural ensemble is more complex.
A niche frames a large arch that is subdivided by
two colonnettes. Each colonnette is made of three shafts.
The central shaft rises to make two large arches enclosing
a trilobe surmounting a trefoil arch. The trefoil rests

on one of the inner shafts. The other shaft, the one on the central side of the main colonnette, forms the arch enframing the statue of the Virgin and Child. This arch does not ascend as high as the flanking arches because a large roundel inscribing a quatrefoil rests upon it. Since this central motif does not have the intermediate double-roundels as in Peter's canopy, the central arch must be smaller than the other two, whereas the reverse occurs in Peter's baldachin.

The monument to Isabella, the canopy over the tomb of Jean de Montmirail, and the baldachins over the sarcophagi in Santes Creus all reflect the mastery of linear effects that concerned architects of the Rayonnant period. Branner clalims that "there are some elements, particularly window tracery, that suffice to distinguish Parisian origins..."[29] He credits the franciscan and dominican friars with carrying the Rayonnant patterns abroad, just as cistercian monks had spread the use of the ribbed vault.[30]

Neither the franciscan nor the dominican church in Barcelona still exists. A nineteenth century drawing of the dominican house, Santa Catalina (begun 1243), if accurate, captures the appearance of two types of window tracery.[31] The lower windows of the apse display a triplet surmounted by three oculi. The central lancet of the triplet is taller than the others, and each has a trefoil inscribed within its frame. The oculi are independently drawn, that is, no arch molding ascends to surround the oculus. But the interior patterns of eight lobes are tightly held to the outer circle and do not meet at the central point. This type of oculus resembles the relief from the north transept of Notre-Dame in Paris; it differs from the patterns of the canopies at Santes Creus.

A closer example of the pattern seen at Santes Creus is the church of St-Urbain in Troyes, founded in 1262.[32] Branner says that almost all of the motifs of the clerestory are Parisian in origin.[33] A triplet, three trefoil arches with the central lancet slightly taller, is surmounted by three oculi, each containing a quatrefoil. A gable extends from the clerestory and peaks in a cross-shaped floral motif. St-Urbain presents an arrangement that is closest to the design executed by Mestre Bartomeu for the canopy over Peter's tomb.

This northern French impact is evident even in the forms of the capitals of the canopy (Figs. 5, 6). The capitals conceived in the late thirteenth century in the churches of northern France present a unique type, distinct from the capitals of the earlier part

of the century.[34] As early as Reims some capitals exhibit the new variety whereby the bell of the capital is hidden behind a flat screen of foliage.[35] Earlier the bell was dominated by a thick, wide and flat stem from which a few leaves emerge, especially at the corners of the capital where one small leaf replaces the large acanthus type and serves to mask the transition from the bell to the wider abacus. At Reims, the broad stalk disappears and thin running branches grow across the face of the capital. From these branches sprout numerous leaves that encircle the bell.

A variation of this type is used for Peter's canopy. The capital has an abacus made of a thick convex molding above a concave molding and a pair of rings at the bottom framing the bell. At the corners the shape of the capital is nearly rectangular, while the intermediate capitals are closer to an oval form. The corner capitals also differ from the intermediate ones because each has animals, birds or hybrids as additional decoration to the foliage. This mixture of flora and fauna is unusual in the thirteenth century. Gothic artists had refrained from making historiated capitals to the extent that their Romanesque predecessors had, but some appear at Reims, and in the collection of the Musée de Cluny there are capitals from St-Urbain at Troyes dated to the last third of the thirteenth century where animals, birds and humans peek out through the foliage.[36]

Yet the artists involved in the Santes Creus tomb projects do not have a personal link to that area. In the documents Bartomeu is addressed "civi Tarrachonen-si"; Riquer, "magistro operis Barchinone"; and Pere de Pennafracta, "lapicide Ilerdensi".[37] Are there models, then, closer to Santes Creus than Troyes? Most of the major building campaigns for cathedrals and churches in southern France are almost contemporary in date with Bartomeu's work at Tarragona: Albi begins in 1276; Limoges, 1273; Narbonne, 1286.[38] St-Nazaire, Carcassonne is started in 1269, but its windows have trefoils at the top of the lancets instead of oculi;[39] therefore, St-Urbain appears to be the closest design. Even in Catalonia, the major cathedrals are undertaken at a later date, with Barcelona in 1298 and Gerona in 1312.[40]

The elegant canopies that tower over the sarcophagi of Peter III, James II and Blanche of Anjou were erected by Catalan artists deeply influenced by the Rayonnant style then closely associated with the court of the late capetian rulers in France. Bartomeu's design for the canopy over Peter's sepulcher became the model

for the later constructions at Santes Creus. Riquer was ordered to copy and imitate Bartomeu's solution when James decided to build the second monument, and Riquer simply converted the free-standing canopy form into the arcade of the north gallery of the cloister when presented with that project. The patronage of James II at Santes Creus exhibits a vocabulary of its own.

Minneapolis, Minnesota

NOTES

This article is based on a section of my dissertation. Funding for my research was provided by a Kress Fellowship and Putnam Dana McMillan Travel Grant from the Graduate School, University of Minnesota.

1. On the history of Santes Creus and its patrons see Eufemià Fort i Cogul, *El Monasterio de Santes Creus* (Santes Creus: Amics de Santes Creus, 1976).
2. The building of the royal residence was started during Peter's reign and continued by James; the cloister and refectory are specifically named by Blanche in her will of 1308, which was published by J. Ernesto Martínez Ferrando, *Jaime II de Aragón, su vida familia* (Barcelona: Consejo superior de investigaciones científicas, Escuela de estudios medievales, 1948) 2: 34–39.
3. For the role played by the Moncada family in establishing Santes Creus see Jose Fernandez Arenas, *Los Monasterios de Santes Creus y Poblet* (León: Editorial Everest, 1979) p. 4.
4. Leopoldo Torres Balbás, *Arquitectura gótica* (Madrid: Editorial Plus-Ultra, 1952) p. 231, discusses the history of the church.
5. Fernandez Arenas, p. 5.
6. Fernandez Arenas, p. 5.
7. Peter's decision to be buried at Santes Creus is discussed by Eufemià Fort i Cogul, *La Mort i l'enterrament de Pere el Gran* (Barcelona: R. Dalmau, 1966) pp. 34–38.
8. This story is related by Ernst H. Kantorowicz, *The King's Two Bodies: A Study in Medieval Political Theology* (Princeton: Princeton University Press,

1957) p. 260.

9. A contemporary chronicler, Bernat Desclot, recounts the events of Peter's death and burial. Desclot, *Crònica*, ed. M. Coll i Alentorn (Barcelona: Editorial Barcino, 1951) 5: 163.

10. E. Morera, *Tarragona cristiana* (Tarragona: F. Aris, 1898) 2: 634–635, attributes the decision to build a funerary monument to Alphonse III (1285–1291), Peter's eldest son, who directly succeeded him to the throne. Morera cites a document in which Alphonse provided the monastery with income from royal lands. It is more likely that Alphonse was paying the expenses for the funeral, which the monks had to bear.

 James' first letter to Bartomeu was published by Heinrich Finke, *Acta Aragonensis* (Berlin–Leipzig: W. Rothschild, 1908–1922) 1–2: 905–906.

11. These letters can be found in Antoní Rubió y Lluch, *Documents per l'història de la cultura catalana mig-eval* (Barcelona: Institut d'estudis catalans, 1918–1921) 2: 6–7.

12. By their attributes only a few of the apostles can be identified, e.g., Peter and Paul by the sword and keys. The cistercian figures are shown in robes and hold a book and a staff, but neither can be identified.

133. On the concept of the vault or dome as a symbol of the Heavenly Jersualem see Karl Lehmann, "The Dome of Heaven", *Art Bulletin* 27 (1948) pp. 1–27.

14. James wrote to Walter of Brienne, Duke of Athens, asking him to send James porphyry stone from Greece. The letter was published by Martínez Ferrando, 2: 62. It is the first indication that James intended to imitate Peter's tomb.

15. The letter is in the Archivo de la Corona de Aragon, reg. 238 fol. 231.

16. In a letter of September 1312, published by Finke, 1–2: 906: "Construatur quoddam sepulcrum seu tumba similis illi in quo sepultum est corpus illustrissimi domini regis Petri...inspecto dicto sepulcro recipiatis mensuras et formas eiusdem..."

17. Finke, 1–2: 906–907: "...fiant unum tabernaculum et quod ipsum tabernaculum fiat ad modum et formam et de eisdem mensuris quibus tabernaculum sepulture dicti regis Petri patris nostri factum est et constructum..."

18. Bertaux, "La Sculpture du XIVe siècle en Italie et en Espagne", in *Histoire de l'art*, ed. André

Michel (Paris: A. Colin, 1923) 2, pt. 2: 669.

19. The 1303 date is supported by Pierre Lavedan, *L'Architecture gothique religieuse en Catalogne, Valence, et Baleares* (Paris: H. Laurens, 1935) p. 34. Torres Balbás, p. 232, refers to the colophon to argue for the 1313 start of construction.

20. Teodoro Creus, *Santas Creus* (Villanueva y Geltrú: J. A. Milá, 1884) pp. 55–66. The colophone is in *Summa confessorum compilata a Fr Joanne*, Tarragona, Biblioteca Provincial MS 125.

21. Bartomeu is called by James "constructori operis ecclesie Tarrachonensis", Finke, 1–2: 905. In addition Mossén Sanç Capdevila, "La Seu de Tarragona: Notes històriques sobre la construcció, el tresor, els artistes, els capitulars", *Analecta Sacra Tarraconensia* 12 (1935) 34–35 cites payments to Mestre Bartomeu in 1277 and 1282.

22. Vicente Lampérez y Romea, *Historia de la arquitectura cristiana española en la Edad Media* (Madrid: Espasa-Calpe, 1930) 2: 535.

23. Robert Branner, *St Louis and the Court Style in Gothic Architecture* (London: A. Zwemmer, Ltd., 1965) p. 114.

24. Feliu Duran i Canyameras, "Las Influencias italianas en los sepulcros reales de Santes Crues", *Santes Creus* 2 (1962) pp. 187–188.

25. Helen s'Jacob, *Idealism and Realism: A Study of Sepulchral Symbolism* (Leiden: E. J. Brill, 1954) p. 99.

26. A brief history, description and illustration of Montmirail's tomb appear in Marcel Aubert, *L'Architecture cistercienne en France* (Paris: Les Editions d'art et d'histoire, 1943) 1: 340.

27. Aubert, 1: 340.

28. On the Cosenza monument, see Emile Bertaux, "La Tombeau d'une reine de France à Cosenza en Calabre", *Gazette des beaux-arts* 19 (1898) pp. 265–276, 369–378; and more recently, Stefano Bottari, "Il Monumento alla regina Isabella nella cattedrale di Cosenza", *Arte antichita e moderna* 1 (1958) pp. 339–344.

29. Branner, p. 114.

30. Branner, p. 114.

31. Branner, pp. 115–116 and pl. 137.

32. Louis Grodecki, *Gothic Architecture* (New York: Harry N. Abrams, 1976) p. 187.

33. Branner, pp. 106–108.

34. Denise Jalabert, "La Flore gothique, ses origins, son évolution du XIIe au XIVe siècle", *Bulletin*

monumental 91 (1932) pp. 181–246.

35. See Jalabert, figs. 36 and 38.
36. Illustrated and catalogued by Marcel Aubert and Michele Beaulieu, *Description raisonné des sculptures de moyen âge, de la renaissance et des temps modernes 1, Moyen âge* (Paris: Editions des musées nationaux, 1950) p. 109. The capital was given to the Louvre by Selmersheim during the restoration of the church.
37. Bartomeu, in a letter from James published by Finke, 1–2: 905; Riquer, in a letter from James published by Rubió y Lluch, 2: 23; and Pere de Pennafracta, in a letter from James published by Finke, 1–2: 906–907.
38. Grodecki, pp. 179–188.
39. Grodecki, p. 187.
40. Nikolaus Pevsner, *An Outline of European Architecture* (London: Penguin Books, 1968) pp. 143 and 148.

This study was presented at the Conference on Cistercian Studies, Eighteenth International Congress on Medieval Studies, Kalamazoo, May 1983.

RECONSTRUCTING THE CHAPTER HOUSE
OF SANTA MARIA DE OVILA: THE FIRST STEPS
Margaret Burke

For over twenty years—from 1959 to 1980—masonry remnants of the monastery of Santa Maria de Ovila lay in disordered piles near the de Young Museum in Golden Gate Park, covered with weeds, brambles, and even with trees, whose roots grew down through the mounds of stones.

These battered and decaying stones were all that remained of the carved elements of the buildings of this medieval cistercian monastery, which William Randolph Hearst had purchased and dismantled in Spain in 1931. The stones had been shipped to California, where Hearst wanted to use the monastery buildings as part of a magnificent private castle he planned to build.[1] But his plans for the castle changed, and several years later, in 1941, he presented the monastery stones to the city of San Francisco, with the intention that the entire complex of monastery buildings would be reconstructed as the Museum of Medieval Arts, to be a part of the de Young Museum.

City officials and the museum's director were delighted to receive the monastery's stones. Architect Julia Morgan and her staff drew plans for the monastery as a museum, and a site for the museum was chosen; but the city never raised funds for the construction. The stones, which were beautifully packed—first in excelsior, then in wooden crates—were stored outdoors in the park, near the de Young Museum. There they became the prey of arsonists, who set fire to the crates five times. The last two fires, in 1959, brought virtual destruction to the stones. Nevertheless Walter Steilberg, an architect who had long been associated with the project, estimated that perhaps half of the carved pieces of two of the buildings—the refectory and the chapter house—were salvable and that it would be feasible to reconstruct these two parts of the monastery.

Again nothing was done; other projects took precedence. The Museum Society re-erected the portal of the monastery's church within the de Young Museum in 1964-65;[2] but the museum's director in the 1960s considered the rest of the monastery stones worthless and permitted the park department to use them for building retaining walls, foundations for fountains, and the like. Other pieces were simply carried away, and some were vandalized.

By the 1970s the stones appeared to have been forgotten, many of them lying in piles, sometimes shoved about by park department bulldozers, others almost hidden by overgrowth. At the fourteenth International Congress on Medieval Studies (1979) I expressed the wish that a study might be made, in the hope that some part of the monastery could still be rebuilt in spite of years of neglect and pilferage. Just at that time there was a return of interest in the monastery stones, led especially by art historian Walter Horn[3] and by Ian McKibbin White, director of the Fine Arts Museums of San Francisco. They wanted to know whether any reconstruction could still be done, particularly reconstruction of the chapter house, a purely Gothic structure built in the early thirteenth century and probably the most beautiful of the buildings. In 1980 they obtained a grant from the Hearst Foundation, to examine the remaining monastery stones and to determine whether any reconstruction might still be feasible.

This study was made under my supervision in the spring of 1980. The special purpose of our project was to segregate the carved pieces of the chapter house.[4] When our work began we did not know whether we would find even 15% of the chapter house stones. For our field work, at the stone site in the park, we had a crew of four men. Our major piece of equipment was an "articulated loader" with a big scoop; but most of the crew's work was accomplished by digging and prying and by heaving on the stones (they are very heavy—some of them weighing over half a ton).

Our grant money, which was intended merely for an initial investigation, lasted only a short time; yet in those few weeks we had recovered most of the chapter house stones that still exist. Museum director Ian White was tremendously encouraged, and I felt gratified that we now had found more than the 50% to 60% of carved pieces that were thought to exist twenty years earlier. In fact, of the three arches of the entrance portal we had found about 75% of the stones. The directors of the Hearst Foundation were also pleased with our progress, and in the following year (1981) we received from them a much larger grant, with which we proposed to bring our project to the point where we would be ready to obtain cost estimates for actual construction of the building.

The second phase of the project, under the new grant, began with the recovery of even more chapter-house pieces from the site. Numerous stones were also recovered from other locations, including some that

were being used to shore up Stow Lake (a man-made lake in the park); and we were specially happy to have returned to us about twenty large key pieces that had been inadvertently given away.

We have now, in all, 511 carved pieces of the chapter house—well over half of the original complement.5 These include all of the thirty stones of the springers above the wall columns on the interior of the building; 66% of the stones of the wall arches (interior); and over 75% of the segments of the arches of the portal. We also possess a large quantity of plain limestone blocks from the chapter house, which can be used for wall facing. A permanent enclosure of chain-link fencing has now been constructed at our site and the carved stones of the chapter house (plus over one hundred of the plain limestone blocks) have been placed within it.

After the field work had been completed, our big concern was the preparation of architectural drawings that would reproduce the design and dimensions of the original building of the chapter house as closely as possible. We had expected that these new drawings might depend heavily on the drawings made by Julia Morgan's staff for the monastery as a Museum of Medieval Arts, the unfinished project of the 1940s. However, study of these documents revealed that the monastery stones had clearly not been unpacked when the drawings were made. The drawings were very handsome but were simply presentation drawings which would doubtless have been changed when precise information became available. In any case, in the initial stages of work on that early monastery-museum project, details of the construction of the chapter house represented only a small part of a large and complex undertaking. The architects and draftsmen who made those drawings had been guided largely by the stone-setting diagrams (the diagrams made in Spain in 1931, to show how the stones were to be re-assembled) and on a few photographs taken at the time of the dismantling. These were the same materials on which our research had depended; but now we had other valuable aids at hand—the chapter house stones themselves, which could provide a greater amount of accuracy for the new drawings.

Our work had to be approached tentatively since, in the beginning, it was based largely on suppositions. We started with a major feature of the chapter house —the triple-arched entrance portal—and assumed that the Spanish mason who had made the stone-setting diagrams in 1931 could easily have measured the height and

width of the arches and would probably have indicated them accurately andin agreement with his stated scale. Accordingly, my crew and I enlarged the stone–setting diagram of the entrance portal (Fig. 1) to actual size on a group of 4-foot by 8-foot plywood panels, laid out the curved pieces of the arches on that pattern —and found that the diagram for the arches was indeed accurate. However, there was a discrepancy in an adjacent part of the structure: the piers that had supported the arches of the portal. Our measurements of the actual stones of the piers showed that the diagram was not entirely reliable in that area, as it indicated a measure- ment somewhat narrower than the stones themselves. Moreover, within the group of stone–setting diagrams, the ground plan of the building was drawn mainly to show the sequence of foundation stones at the perimeter of the building, and it did not match the diagrams of the elevations.[6] It therefore became apparent that the stone–setting diagrams could best serve as guides, and that detailed information had to be derived from the stones themselves.

The chapter house stones did provide information not only about details of design but also about the building's dimensions and wall thickness. For example, on many of the carved stones of the portal arches there were traces of mortar or a termination of smooth–finished surface at the place where another stone had once abutted. By the use of such indications it was possible to fit together the stones that had rested directly upon the impost molding above one of the piers. This layout of stones produced the plan of the piers at impost level (Fig. 2), from which we derived the thickness of the portal arches, which was also the thickness of the west wall.

At the beginning of the study the interior of the chapter house appeared to present problems; but such an impression may not be unusual when the task is to reconstruct a plan and elevations from masonry remnants and a few old photographs and diagrams.

The interior of the chapter house was a rectangular room with a rib–vaulted ceiling that was supported by ten wall columns and by two free-standing columns on the longitudinal axis of the room (Fig. 3). The vault ribs divided the space into six bays or compart- ments. From the stone–setting diagram showing the plan of the foundation stones, it appeared that the bays were not of identical dimensions. The matter to be solved was the determination of dimensions, for the six bays seemed to be almost equal, but not quite, in size.

Also, the form of each group of springers above
the wall columns, which comprised the beginnings of
the vault ribs and wall arches, was different from
the others. (For description of the springers see n.
7 and Figs. 4, 5, and 6.) In some instances the group
of shafts or rolls of the lowest springer stone (the
part that would rest on the impost) was tightly packed
and narrow and ascended almost vertically, whereas
in other cases the shafts of the lowest block were given
more space (cf. *a* and *b* of Fig. 4) and others began
to splay and curve directly above the base. Moreover,
differences could exist within each group of blocks:
in the case of the beginnings of the wall arches (the
rolls furthermost to the sides of the springer stones),
the amount of splay and curve of the shaft at one side
of the block might be different from its counterpart
on the other side of the block.

Nevertheless, the finesse of the carving gave
assurance that variations in the form of the springers
were knowingly and deliberately planned and were not
irregularities arising from incompetence or indifference
of the medieval craftsmen. In fact, it quickly became
evident that variations in the form and curve of springers
were dictated by variations in bay dimensions; for
example, a greater (or lesser) splay at the beginning
of a wall arch (part of springer) indicated that the
distance spanned by that arch would be greater (or
lesser).

From study of the curves of the shafts of the
springers together with study of the stone-setting diagrams
and photographs, the following observations were made:
Of the six bays of the plan (Fig. 3), the outer
bays (bays 1 and 5, 2 and 6) were wider than the
central bays (bays 3 and 4). The reason was that the
three-bay division of the length of the room corresponded
only approximately to the width of the three arches
of the portal; the central bay (bay 3) corresponded
in width to the central arch, but at the ends of the
wall, on the interior, more space was added beyond
the arches to accommodate corner wall columns. So bays
1 and 5 were eleven inches wider than bay 3; and
the same minor adjustments were mirrored in bays 2,
4, and 6.

Furthermore, it was observed that the three bays
at the west, near the entrance (bays 1, 3, and 5),
appeared to be deeper than the three bays at the east
(bays 2, 4, and 6), where the bishop's throne and
altars had been located. Perhaps this variation was
intended to allow more space for guests and for members

of the community, whose assigned places would have been in the western bays; but more likely, in this chapter house, the variation was intended to provide a more pleasing visual effect to the room.[8]

Such changes in dimensions are slight and may be scarcely worth mentioning here. Yet only by detecting such small variations and finding the reason for their existence did it become very clear that these were not irregularities and inconsistencies but were deliberate. They also provided necessary clues for recreating the master mason's plan and design of the chapter house. What would be less obvious to a casual observer are the numerous fine adjustments that the master mason made to the curves of adjacent stones--small variations which show his concern for making the work as pleasing to the eye as possible. He compressed and stilted (or splayed and spread) the springer stones to allow for the desired differences in the size of the bays. Also, the springers above the two large piers of the portal were made compact and very narrow, in order to avoid crowding or obscuring the curves of the portal's arches (Fig. 7). In spite of numerous adjustments that were made, he was able to create a graceful, easy flow of forms while at the same time giving an impression of simplicity, regularity, and uniformity to the whole. Working with the stones as guides gives one tremendous respect for the master mason who built the chapter house. At every turn I have marveled at the skill, the knowledge and the sensitivity that his work shows. The building was indeed a work of perfection.

At this time (May 1983) the plans, elevations, and section drawings of the chapter house have been completed. Also completed is a detailed inventory of each of the 511 carved stones that we have uncovered, with a sketch of each, showing any restoration needed. The last major work of this part of the project was the construction of a scale model of the chapter house. The model gives a better idea of the building than one can derive from diagrams, elevations, or old photographs. It will, I hope, also be an aid for future construction.

And now all this information has been given to the museum's architects, the structural engineer, and the stone-masonry contractor, who are preparing cost estimates for the actual construction of the building. The matter of financial means for undertaking the construction is beyond the scope of this article. Yet--perhaps because the project has been a great success so far --we all are very confident that the chapter house

of Santa Maria de Ovila can be and will be reconstructed at the de Young Museum.

M. H. de Young Memorial Museum
San Francisco, California

NOTES

1. For details of the dismantling of the monastery buildings and plans for their reconstruction in California, see my article "Santa Maria de Ovila: Its History in the Twentieth Century in Spain and California", in M. Lillich, ed., *Studies in Cistercian Art and Architecture* 1, CS 66 (Kalamazoo: 1982) pp. 78–85.
2. The stones of the portal of the church had been stored in a warehouse and were untouched by the fires.
3. Dr Walter Horn, professor emeritus of medieval art history at the University of California at Berkeley, is a trustee of the Fine Arts Museums of San Francisco as well as being co-author of the monumental work *The Plan of St Gall* (Berkeley: 1979).
4. At the same time it was tempting to look for stones from the refectory, a large and handsome building begun in the late twelfth century; but very few remnants of that building could be found.
5. When the buildings were dismantled in Spain in 1931 it was reported that the masonry was then only about 80% complete, since the monastery had long been used as a quarry by nearby villagers.
6. The diagrams had been made as practical guides, of course, and were not intended to be regarded as construction drawings.
7. Each wall springer consists of three blocks of stone (Figs. 4 and 5) that had originally been arranged one above the other and seated on the impost above a wall column. These blocks, which comprise groups of shafts, made up the beginning of the vault ribs and wall arches—that is, they were the bundles of shafts from which the separate arches of the vaulting would spring. The wall

springers rose to heights of from 42 inches to
54 inches and constituted about one third of the
length of each arch or rib.
 We were very lucky to have found all thirty
blocks of the ten wall springers; and it was our
special good fortune that several of the stones
still bore the dismantlers' code numbers, by which
their exact location in the building could be identi-
fied. By the use of paper patterns of the upper
and lower surfaces of the other springer stones
it was possible to match up and correctly place
all the unidentified pieces (see Fig. 6). This
complete group of springer stones has been a
valuable tool for preparing reconstruction drawings
of the chapter room.

8. Enlargement of the bays near the entrance can
 be seen in other medieval chapter houses as well.
 Here the difference in dimensions between east
 and west bays is only about nine inches.

This article is based on a paper presented at the Eight-
eenth International Congress on Medieval Studies, Kala-
mazoo, 1983.

A RIB FROM SACRAMENIA
AT FLORIDA STATE UNIVERSITY
François Bucher

The cistercian abbey of Sacramenia in the province of Segovia was settled in 1142 by monks from L'Escale–Dieu and was the first foundation of the Order in Castile. L. Torres–Balbas dealt with the building with some difficulty since the church is atypical in plan, and finally also because all the other buildings had been shipped to the United States to be eventually resurrected as "The Old Spanish Monastery" on 163rd Street North and Dixie Highway in Miami Beach.1 In 1925 William Randolph Hearst had bought the cloister, refectory, the exceptionally important chapter house and other structures through his agent Arthur Byne for one and a half million dollars. He hoped to reconstruct the buildings at St Simeon, perhaps for a similar use as that planned for Santa Maria de Ovila whose church was proposed to be transformed into a swimming pool with the apsides serving as dressing rooms. The shipload of boxes containing 35,874 numbered stones packed in straw duly arrived in New York and was quarantined by customs as a result of an outbreak of hoof and mouth disease in Spain. The straw had to be removed and the pieces repacked at a cost of $75,000. In 1930, when the Hearst empire suffered financial setbacks the monastery was sold to Gimbels Department Store, and finally in 1953 to Messrs. E. Raymond Moss and William S. Edgemon, contractors in Miami (Fig. 4).

The 10,751 wooden crates were accompanied by exemplary plans and elevations which were to be used for the reconstruction (Fig. 5). The Miami developers engaged fifteen workmen and eight experienced masons, among them Allen Carswell who had been employed by J. D. Rockefeller at The Cloisters. The crew was initially confronted with the monumental task of organizing the innumerable stone elements in sequence (Fig. 6). Only then could they begin to rebuild the refectory and the cloister on a new foundation, using wooden formwork (Fig. 7). In spite of readjustments and the use of some newly quarried slabs for the webbing, they eventually produced the most authentically flavored late Romanesque and Gothic ensemble in North America, last but not least because the former abbey is a functioning sanctuary bathed in strong light, not dissimilar to that of Spain (Fig. 8).

Eventually the funds ran out and parts of the

monastic building, including the kitchen of c. 1380, were bulldozed behind the reconstructed abbey where I found some moss-covered pieces incongruously protruding from the humid ground. Thus the only recorded excavation of a medieval structure undertaken in the United States eventually took place with the permission of the Episcopalian Diocese of Miami and the gracious support of Rev. Bruce E. Bailey in December 1980 (Fig. 9). The soft soil released numerous fragments, among them two complete semicircular ribs and parts of a heavy transverse arch which were laid out on the ground (Fig. 10). The extremely brittle elements and the crew were finally placed in a rental truck which was duly stopped by the Florida State Police. The troopers demanded a no-nonsense explanation of the provenance of our goods, and to their credit believed our improbable tale.

The diameter of the rib closely fits the diagonal of a bay of the former kitchen of Sacramenia, which consisted of two vaulted bays. The problems of reconstructing the rib in the Fine Arts Gallery of Florida State University in Tallahassee were highly instructive and frequently duplicated the difficulties faced by a medieval crew, even if we had the advantage of using finished pieces which had originally been integrated in a vault.

Our procedures included the following steps:

1) The porous limestone voussoirs soaked since 1953 were akin to newly quarried, malleable, but also fragile stone. A drying period of a full year in an airconditioned environment restored most of the elements to their original hardness, and they began to ring true. We found that pieces which still rang slightly "dull" were still wet at the center. While drilling into one of the segments steam developed and it exploded. The voussoirs were then cleaned, leaving a slight patina.

2) Masons' and especially the placement marks helped us to establish the top and bottom position and a possible sequence of some of the voussoirs (Fig. 1).

3) We had to face the most basic decision of restoring. Should we, as nearly everyone hoped, reconstruct the element to conform to the gothic "pointed arch syndrome" by using the first voussoirs which rested on the horizontal *tas de charge* as the key at the top, or should we reconstruct the rib in its rational, more cerebral (and original) semi-circular form (Fig. 2). Should we reintroduce a missing keystone as a newly carved boss or leave an open space at the top? We opted for the simplest solution using original material and replaced the keystone with two short voussoirs.

In addition we added one clearly identifiable missing piece in the *tas de charge* (Fig. 13).

4) We had to establish the original radius of the rib by laying out the pieces on a paper tracing floor (Fig. 11). The radius of the intrados turned out to be 261 cm. and the arch was laid out tightly. Upon construction we found that even with the greatest care it would have been impossible to predict the actual length of the constructed arch precisely. This meant that we had to shorten one voussoir before placement of the two top pieces. To my delight I found that the same last minute corrections were often necessary in medieval construction, such as in Cologne cathedral where the top voussoirs meeting the keystone had to be cut back in situ. These minor adjustments could be performed rapidly, in the case of Cologne requiring perhaps a little over an hour per piece, in our case seventeen minutes. We also found that the students using an electrical stone saw took longer to produce a clean face than the author who used a mallet and a wide, toothed chisel.

5) With the intrados span of the arch established at a considerable 17'22" (522 cm) and an extrados of 18'8" (570 cm), we procceded to weigh the elements. The two *tas de charge* combined weigh 1,074 pounds, and all the voussoirs together only 907 pounds, or a total of 1,981 pounds, a full half ton less than our initial estimate. Consequently the combined ribs and *tas de charge* used for the original bay weighed about two tons, taking into account the heavier keystone. At this point we realized that the intellectual, we could say, "aristocratic" work which concerns art historians had ended. We were entering a completely different phase of experience, namely actual construction.

6) In spite of the heavy *tas de charge*, permanently anchored in the brick wall on top of two semicircular concrete piers, it became immediately obvious that even a relatively light, free-standing, semi-circular arch, consisting of voussoir cross-sections of 24 cm. length and 18 cm. width and joined by thin beds of mortar, would instantly buckle upon removal of the form. An elegant solution suggested by Arnold Wolff, cathedral architect of Cologne, could have been achieved by drilling grooves into the back of the voussoirs and anchoring each piece to the other, thus stabilizing the arch from behind. Since these clamps would of course not have corresponded to the line of stress, I could have recommended this possibility only for denser, less breakable stone,

such as possibly the heavier but stronger Indiana lime-
stone. Because tension wires, (used, for instance for
ultralight airplane wings) would have looked ungainly,
and above all because the safety of colleagues and
visitors of the Art Gallery was an absolutely primary
concern, we decided to fix each rib individually to
the wall with reinforcing bars ranging from 1/2" to
3/4" diameter, depending on the weight of the rib segment
(Fig. 3). To give the arch a "breathing" quality we
moved it 5" (13 cm) away from the wall.

7) The most important, pitilessly precise guiding
element consisted of a chalk line drawn on the wall
by means of a string. Surely the same method was
used to repeatedly check out the curve of the formwork
on which the ribs of medieval structures were to be
placed (Fig. 12).

8) Even for a small project requiring precision
an intelligent, smoothly working crew was and is essential
both for the success of the work and above all for
safety. One of the recurring problems of medieval archi-
tects and our crew were absentees who were replaced
by journey men, in our case hired off the Gallery corridor.
Their performance could be dangerously poor.

9) We designed several possible forms, including
a strong, movable centering which could have been
bolted into the wall. We forgot that it would interfere
with our shaky aluminum scaffold, then discarded formwork
altogether, and visually lined up the segments with
the chalk line. For several reasons, above all because
it was extremely difficult to line up the re-rods in
absolute parallels, the results displayed picturesque
Ruskinian shifts, and we had to undertake difficult
corrections (Fig. 13).

10) We at first used a three-legged hoist and pulley
system to raise the pieces to the appropriate level,
then shifted to an electric forklift which could also
be used as a ramrod to push recalcitrant segments
into the wall. All the upper pieces were weight-tested
by two seated students, usually holding beer cans,
which resulted in a weight of c. 320 pounds depending
on their consumption of liquids, another problem of
medieval architects dealing with ever thirsty masons.

11) I kept reminding the crew of Villard de Honne-
court's warning, "Be cautious with your work, and
you will stand out as a wise and distinguished man".
It was a blessing in disguise to have a 275 pound
block of the *tas de charge* slam against my hand which

required eighteen stiches. We realized that medieval arches resting on formwork were in continuous movement until the forms were removed, and the structure was allowed to settle.

12) It also became clear that day-to-day financial records had to be kept current, and had to be available to the patron, in this case Albert Stewart, director of the Gallery. As we know these still barely exploited financial accounts of medieval construction give us the only fully "three-dimensional" insight into facets of structural and esthetic decisions often ignored by historians.

13) After completion of the work we realized how many imperfections had to be corrected, and conversely began to search for adjustments in medieval buildings in which imperfect joints were smoothed out before painting could be started, which in itself would hide minor mistakes. We had to readjust pieces, fill the joints with mortar, camouflage the rods with brick red paint and perform a last safety check (Fig. 13). We still must date the rib based on a template. Similar cross sections of voussoirs found in the cloister of Santiago (1321 ff) St Célestin (1393–96), St Didier (1359) in Avignon and other examples confirm a late fourteenth century date.

In conclusion we must stress that the lessons learned in our modest project are somewhat sobering. The very first and most rigid consideration—now and in the Middle Ages—was and is structural stability. Safety factors determined aesthetic considerations much more fundamentally than art historians tend to assume. The crew is of great importance, and the wish of all the students to sign an especially well-placed segment gave the masons' marks an added meaning of personal achievement and responsibility. Even in our simple, pre-programmed pieces one could observe work of better and lesser quality. We also found that the consistency of stone, its response to humidity and ice, must have been a primary factor not only in the survival of the structure but also in its aesthetic impact. The choice of very stable, usually denser stone would have prevented sophisticated design refinements. The compromise between a malleable stone which would easily rot, and a tougher material which could not be shaped quickly and would require more time to carve, must have brought on one of the most soul-searching moments in the architect's decision process. Thus, for instance, the selection of

the easily frayed, beautiful red sandstone for the north tower of Strasbourg cathedral was a consciously irresponsible decision. In a small way our limited experiment brought us face-to-face with questions which deeply affect construction in stone, such as refinement versus stability; speed and therefore lower cost (using shoddy material) versus construction procedures and stone which will stand the test of time; heavy; less easily moved centering, versus lighter and less rigid formwork; incentive pay for good work etc., etc.; in short decisions which preoccupied architects more constantly than problems of design.

Most importantly our experiment proved that hundreds of architectural fragments stored in museum basements can and should be used as "abstract" *sculpture* (Fig. 13). After all the problems faced in the reconstruction of a minor building element, it was good to hear a visitor exclaim, "My, this looks like a large Brancusi!" Just as Mies, Le Corbusier and Wright perceived architectural elements as sculpture, and conversely furniture as ornamental architecture, we must learn to judge construction details as highly sophisticated, abstract sculpture.

Florida State University
Tallahassee

ONLY WITH THE
HELP OF ANGELS

THANKS TO AN
INTERESTING CREW Love to y'all
frances.

NOTES

1. For more information see:

Elie Lambert, *L'Art gothique en Espagne aux XIIe et XIIIe siècles* (Paris: 1931) p. 92.

"Sold: One Monastery", *Art Digest* (December 1942).

Leopoldo Torres Balbas, "El Monasterio Bernardo de Sacramenia (Segovia)", *Archivo español de arte* 17 (1944) pp. 197–225.

Idem, *Monasterios cistercienses en Galicia* (Santiago: 1954).

Eleesbaan Serrano Mesa, "El Monasterio trasladado", *ABC* (Madrid), 23 January 1958, pp. 4–6.

"Transplanted Monastery: Monastery of St Bernard of Sacramenia", *Travel* 102 (August 1954) pp. 25–26.

Juan Antonio Gaya-Nuño, *La Arquitectura española en sus monumentos desparecidos* (Madrid: 1961) pp. 162–168.

M. Anselme Dimier, *Les Moines batisseurs* (Paris: 1964) p. 9.

Trevor Wyatt Moore, "Miami's Medieval Treasure", *The Episcopalian* (March 1968) pp. 26–28.

Walter Cahn, "Romanesque Sculpture in American Collections: XIV. The South", *Gesta* 14 (1975) pp. 75–77.

William S. Edgemon, "I Bought A Monastery From Hearst", *North Dade Journal* (20 July 1977).

Joanne E. Sowell, "Sacramenia in Spain and Florida: A Preliminary Assessment", *Studies in Cistercian Art and Architecture* 1, ed. Lillich, CS 66 (Kalamazoo: 1982) pp. 71–77.

This report was presented at the Seventeenth International Congress on Medieval Studies, Kalamazoo, 1982.

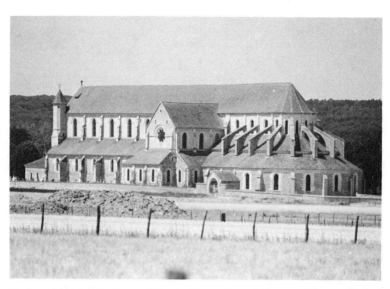

Kinder, Fig. 1 Pontigny Abbey. From the southeast (Photo: Kinder)

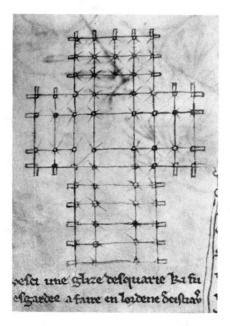

Kinder, Fig. 2 Villard de Honecourt. Plan of a cistercian church
(Paris, Bibl. nat. MS fr. 19092, fol 14v). (Photo:
Bibliothèque nationale. Used with permission)

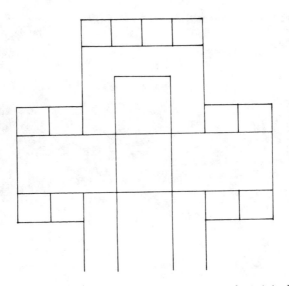

Kinder, Fig. 3 Pontigny. Plan of transepts and original chevet
according to Holtmeyer (Drawing: Kinder, after
Holtmeyer)

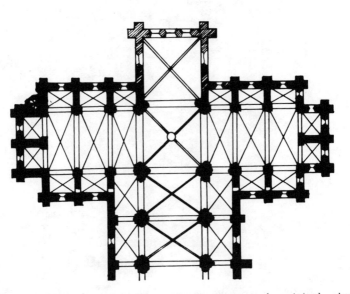

Kinder, Fig. 4 Pontigny. Plan of transepts and original chevet
according to Philippe (Drawing: Kinder, after
Philippe)

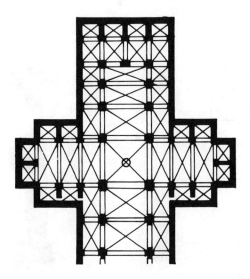

Kinder, Fig. 5 Pontigny. Plan of transepts and original chevet
according to Giesau (Drawing: Kinder, after Giesau)

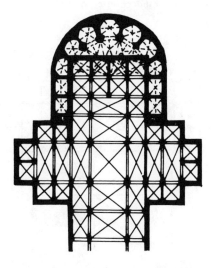

Kinder, Fig. 6 Pontigny. Plan of transepts and original chevet
superimposed upon rebuilt chevet, according to
Fontaine (Drawing: Kinder, after Fontaine)

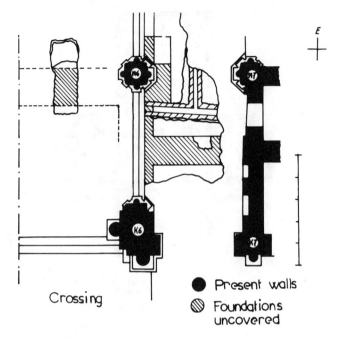

Kinder, Fig. 7 Pontigny. Foundations of original chevet and flanking
chapel of south transept as found on excavation
(Drawing: Kinder, after Aubert)

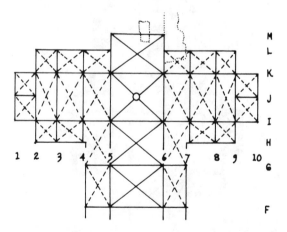

Kinder, Fig. 8 Pontigny. Reconstructed plan of original chevet
according to Aubert. Dotted lines show excavated
areas. Numbering by Kinder. (Drawing: Kinder,
after Aubert)

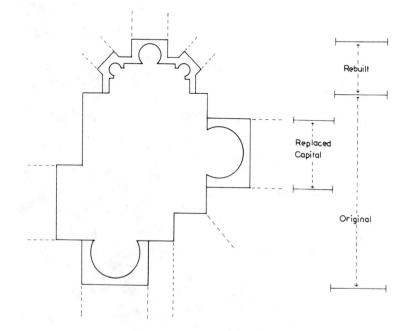

Kinder, Fig. 9 Pontigny. Northeastern crossing pier, showing
original and rebuilt portions (Drawing: Kinder)

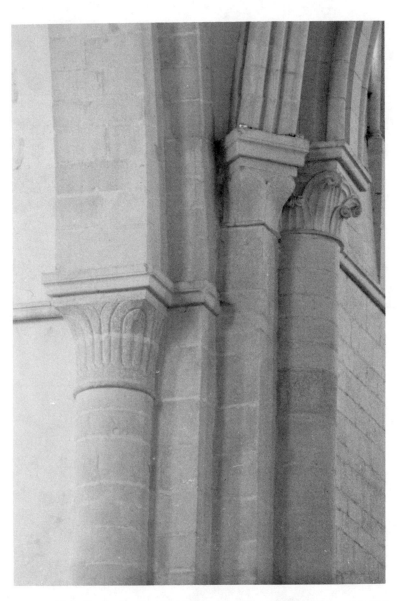

Kinder, Fig. 10 Pontigny. Capitals of the northeastern crossing
pier, as seen from the crossing (Photo: Kinder)

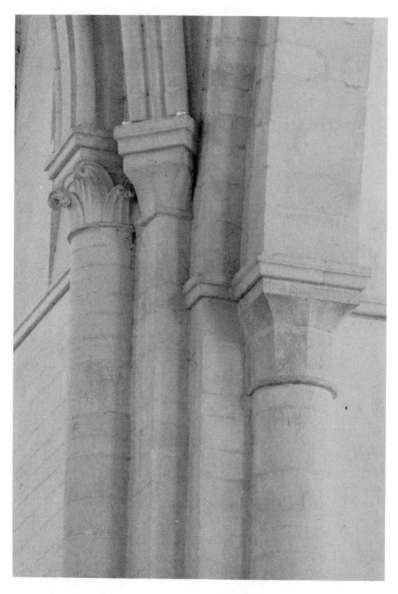

Kinder, Fig. 11 Pontigny. Capitals of the southeastern crossing pier, as seen from the crossing (Photo: Kinder)

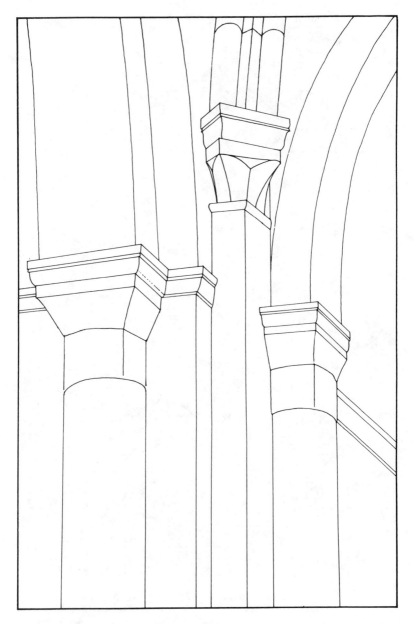

Kinder, Fig. 12 Pontigny. Original disposition of capitals on north-
eastern crossing pier (Drawing: N. Frisch)

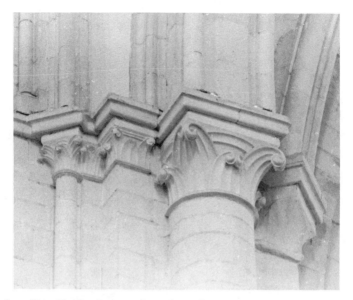

Kinder, Fig. 13 Pontigny. Capitals of the southeastern crossing pier, as seen from the new chevet (Photo: Kinder)

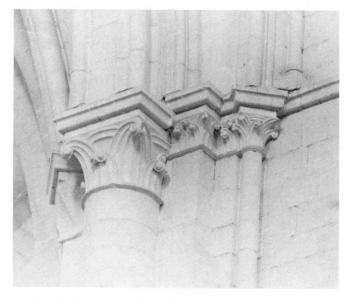

Kinder, Fig. 14 Pontigny. Capitals of the northeastern crossing pier, as seen from the new chevet (Photo: Kinder)

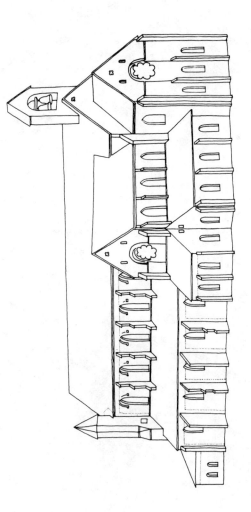

Kinder, Fig. 15 Pontigny. Exterior from the southeast with reconstruc-
tion of original chevet; bell tower is hypothetical
(Drawing: N. Frisch)

Steger, Fig. 1 Map of the cistercian
foundations in Loraine in
the Middle Ages
(Drawing: Steger)

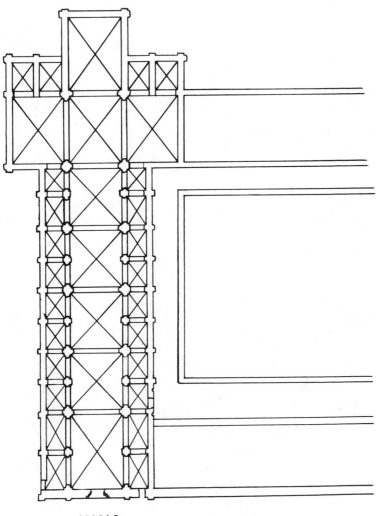

Steger, Fig. 2 Haute-Seille, plan of the church (Drawing: Steger)

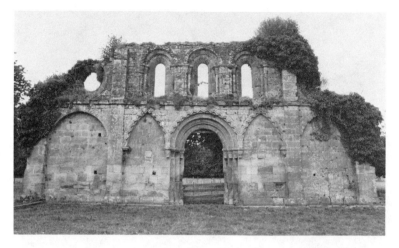

Steger, Fig. 3 Haute-Seille, façade (Photo: Steger)

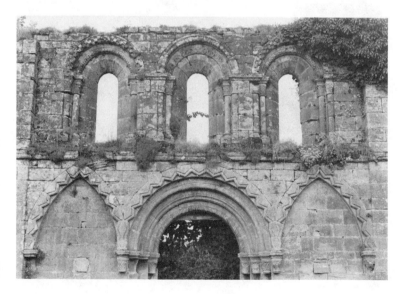

Steger, Fig. 4 Haute-Seille, façade, detail of the central section
(Photo: Steger)

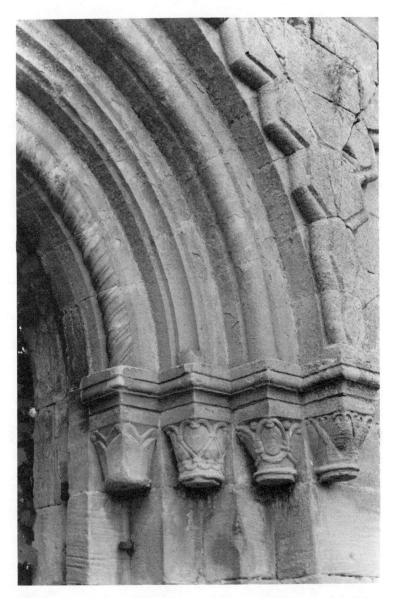

Steger, Fig. 5 Haute–Seille, central portal, voussoirs and capitals
(Photo: Steger)

Steger, Fig. 6 Haute–Seille, central portal, bases of the colonnettes
(Photo: Steger)

Steger, Fig. 7 Haute–Seille, central bay of the triplet, detail
(Photo: Steger)

Steger, Fig. 8 Haute-Seille, façade in 1735, after a drawing in
the Archives departementales de Meurthe-et-Moselle,
H 655 (Drawing: Steger)

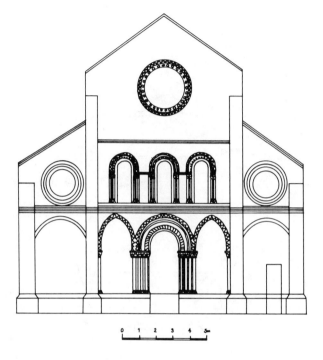

Steger, Fig. 9 Haute-Seille, restored view of the façade (Drawing:
Steger)

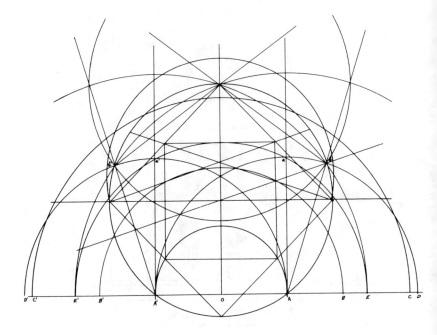

Steger, Fig. 10 Haute-Seille, façade, projected layout of the design
(Drawing: Steger)

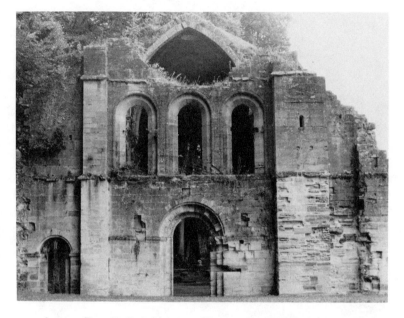

Steger, Fig. 11 Troisfontaines (Marne, façade (Photo: Steger)

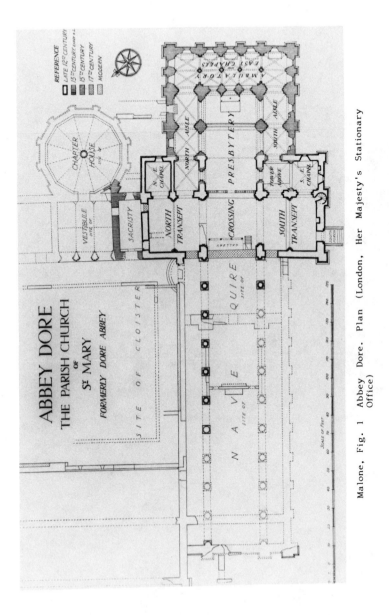

Malone, Fig. 1 Abbey Dore. Plan (London, Her Majesty's Stationary Office)

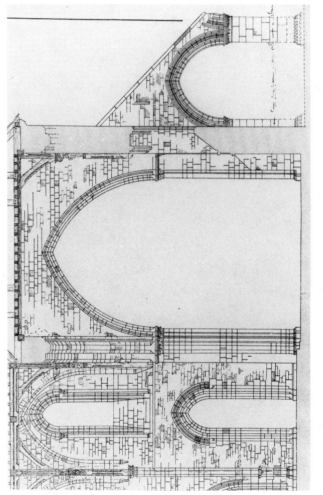

Malone, Fig. 2 Abbey Dore. East-west section of south wall of the choir and nave (Architectural Association _Sketchbook_, First series (1873) no. 2).

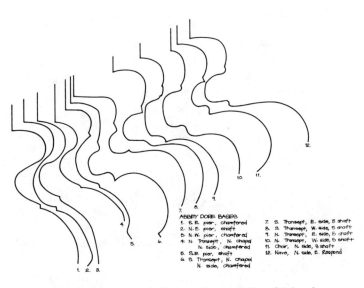

ABBEY DORE BASES
1. S.E. pier, chamfered
2. N.E. pier, shaft
3. N.W. pier, chamfered
4. N. Transept, N. chapel
 N. side, chamfered
5. S.E. pier, shaft
6. S. Transept, N. chapel
 N. side, chamfered

7. S. Transept, E. side, 5 shaft
8. S. Transept, W. side, shaft
9. N. Transept, E. side, 5 shaft
10. N. Transept, W. side, 5 shaft
11. Choir, N. side, 3 shaft
12. Nave, N. side, E. Respond

Malone, Fig. 3 Abbey Dore. Base profiles (Malone)

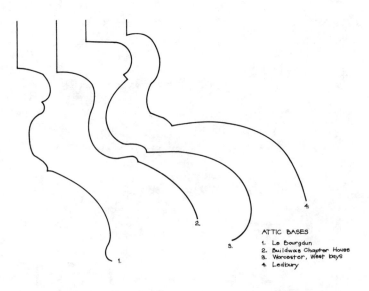

ATTIC BASES
1. Le Bourgdun
2. Buildwas Chapter House
3. Worcester, West bays
4. Ledbury

Malone, Fig. 4 Attic bases (Malone)

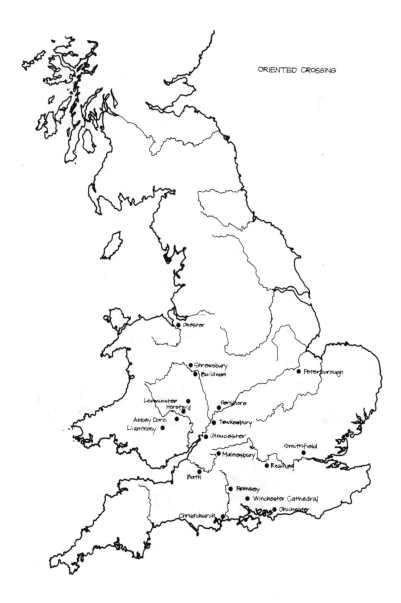

ORIENTED CROSSING

- Chester
- Shrewsbury
- Buildwas
- Peterborough
- Leominster
- Hereford
- Pershore
- Abbey Dore
- Tewkesbury
- Llanthony
- Gloucester
- Smithfield
- Malmesbury
- Reading
- Bath
- Romsey
- Winchester Cathedral
- Christchurch
- Chichester

Malone, Fig. 5 Map. Oriented crossing (Malone)

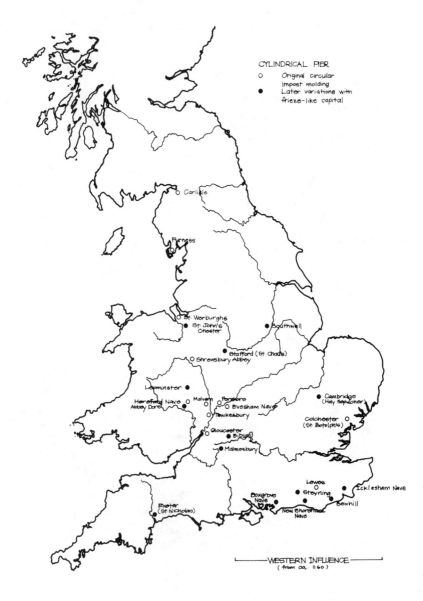

CYLINDRICAL PIER

○ Original circular
 impost molding
● Later variations with
 frieze-like capital

○ Carlisle

Furness

○ St. Werburghs
● St. John's
 Chester

● Southwell

● Stafford (St. Chads)

○ Shrewsbury Abbey

● Leominster

Hereford Nave ○ Malvern ○ Pershore
Abbey Dore ● ○ Evesham Nave
 ● Tewkesbury

○ Gloucester
 ● Bishops

● Malmesbury

● Cambridge
 (Holy Sepulcher)

Colchester ○
(St. Botolph's)

● Lewes
○ Steyning

Boxgrove ● New Shoreham
Nave Nave

● Icklesham Nave

● Boxhill

Exeter
(St. Nicholas)

⌐——— WESTERN INFLUENCE ———⌐
 (from ca. 1160)

Malone, Fig. 6 Map. Cylindrical pier (Malone)

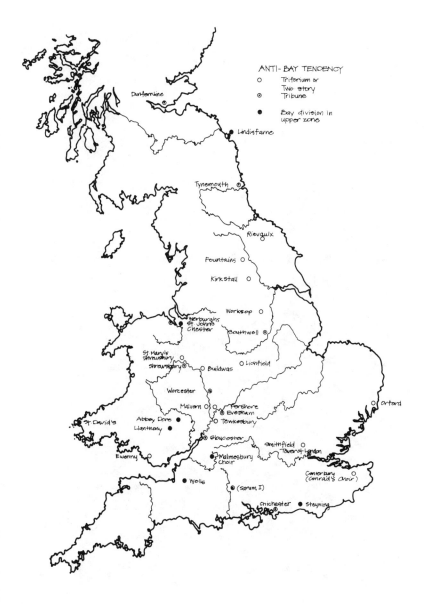

ANTI-BAY TENDENCY

○ Triforium or Two story
◉ Tribune
● Bay division in upper zone

Dunfermline

Lindisfarne

Tynemouth

Rievaulx

Fountains

Kirkstall

Worksop

Werburghs
St John's
Chester

Southwell

St Mary's
Shrewsbury
Shrewsbury Buildwas

Lichfield

Worcester

Malvern Pershore
Evesham

Orford

St David's Tewkesbury

Abbey Dore
Llanthony

Gloucester

Smithfield
Tower of London

Ewenny

Malmesbury
Choir

Canterbury
(Conrad's Choir)

Wells

(Sarum I)

Chichester Steyning

Malone, Fig. 7 Map. Anti-bay tendency (Malone)

Malone, Fig. 8 Abbey Dore. Nave, north arcade (Malone)

Malone, Fig. 9 Abbey Dore. Nave, south arcade (Malone)

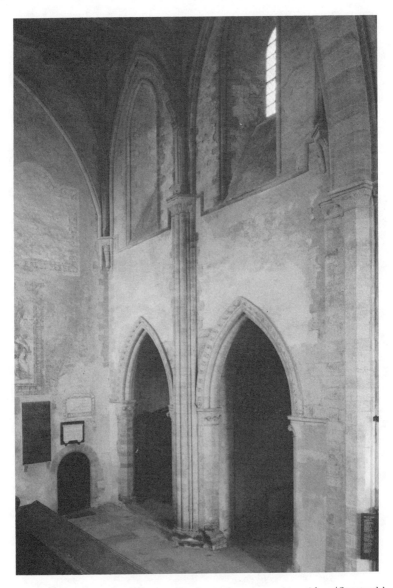

Malone, Fig. 10 Abbey Dore. North transept, east side (Courtauld
Institute)

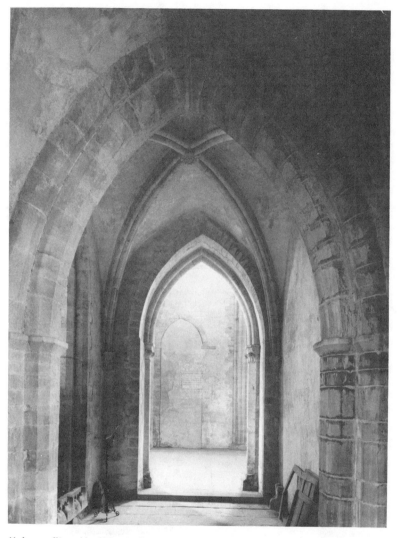

Malone, Fig. 11 Abbey Dore. North transept, south chapel from east (Courtauld Institute)

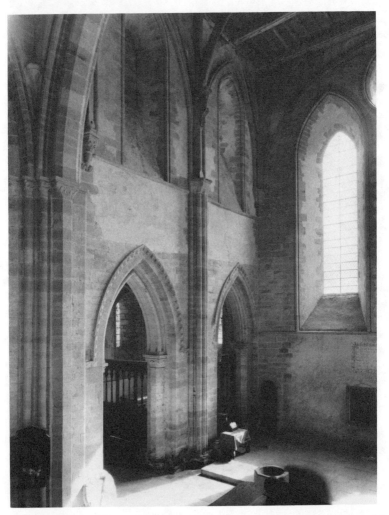

Malone, Fig. 12 Abbey Dore. South transept, east side (Courtauld Institute)

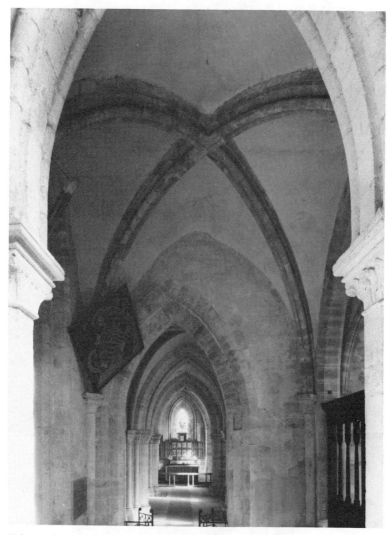

Malone, Fig. 13 Abbey Dore. South transept, north chapel from west (Courtauld Institute)

Malone, Fig. 14a Abbey Dore. Northeast crossing pier, west side,
capitals (Malone)

Malone, Fig. 14b Abbey Dore. Northeast crossing pier, north side,
bases (Malone)

Malone, Fig. 15a Abbey Dore. South transept, north chapel, south
side, capital (Malone)

Malone, Fig. 15b Abbey Dore. South transept, south chapel, south
side, capital (Malone)

Malone, Fig. 16a Abbey Dore. North transept, east wall, five-
shaft capital (Malone)

Malone, Fig. 16b Abbey Dore. North transept, east wall, five-
shaft base (Malone)

Malone, Fig. 17a Abbey Dore. Northwest crossing pier, east side, capitals (Malone)

Malone, Fig. 17b Abbey Dore. Northwest crossing pier, east side, bases (Malone)

Malone, Fig. 18a Abbey Dore. Choir, north wall, three-shaft capitals
 (Malone)

Malone, Fig. 18b Abbey Dore. North transept, south chapel, north
 side, capital (Malone)

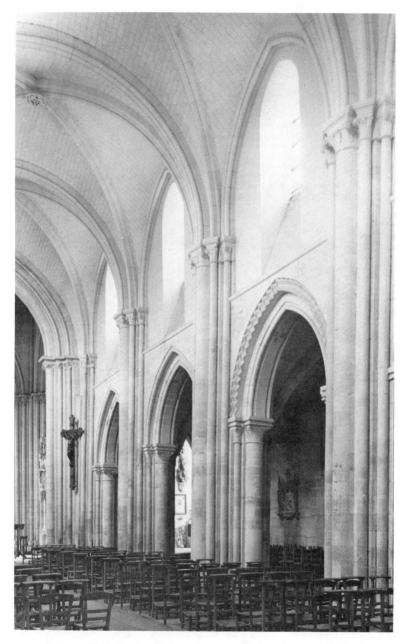

Malone, Fig. 19 Le Bourg-Dun. Nave, south arcade (Malone)

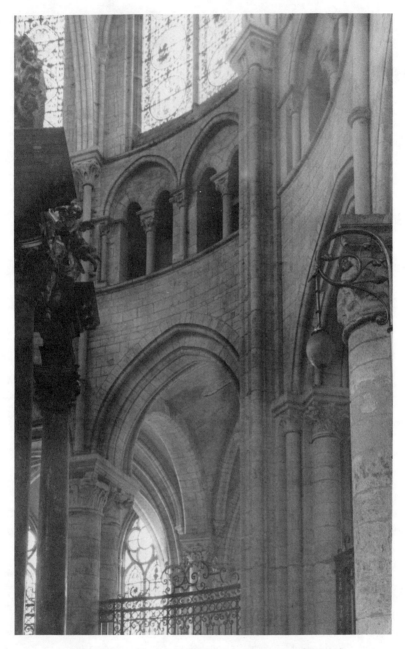

Malone, Fig. 20 Sens. Hemicycle, south side (Malone)

Malone, Fig. 21 Buildwas. Chapter house, west wall (Malone)

Malone, Fig. 22 Abbey Dore. Choir, south wall from east (Malone)

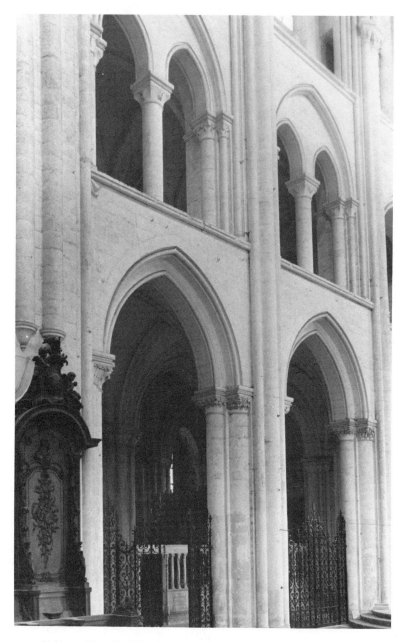

Malone, Fig. 23 Fécamp. Choir, north side from west (Malone)

Malone, Fig. 24 Abbey Dore. Crossing from southwest (Courtauld Institute)

Malone, Fig. 25 Abbey Dore. South transept, west wall from east
(Courtauld Institute)

Malone, Fig. 26 Abbey Dore. South transept, west wall from southeast
(Malone)

Malone, Fig. 27 Abbey Dore. Northeast crossing pier, north side
(Malone)

Malone, Fig. 28 Abbey Dore. South transept, north chapel (Malone)

Malone, Fig. 29 Abbey Dore. South transept, south chapel (Malone)

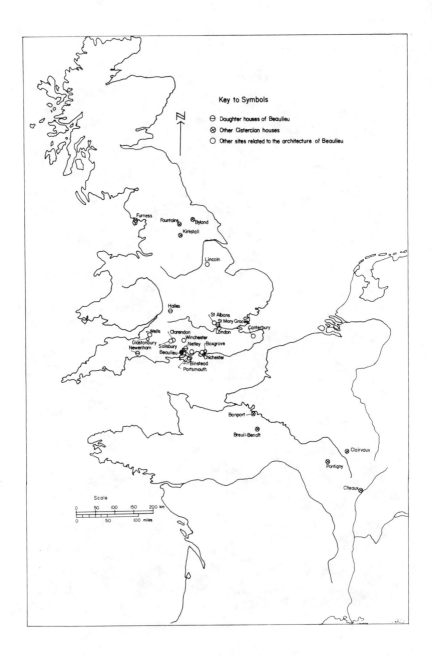

Jansen, Fig. 1 Sites related to the architecture of Beaulieu (Drawing: George Jansen)

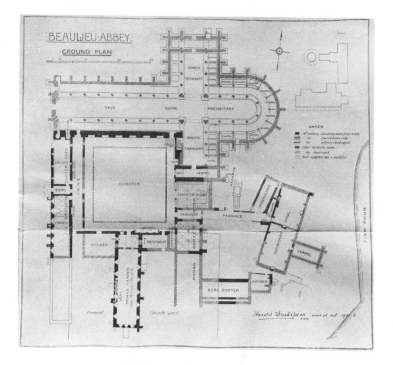

Jansen, Fig. 2 Beaulieu. Plan (<u>Archaeological Journal</u> 59, 1902)

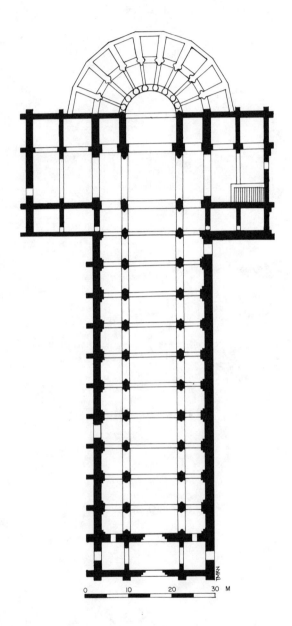

Jansen, Fig. 3 Clairvaux III. Plan (Taina Rikala de Noriega after Krönig)

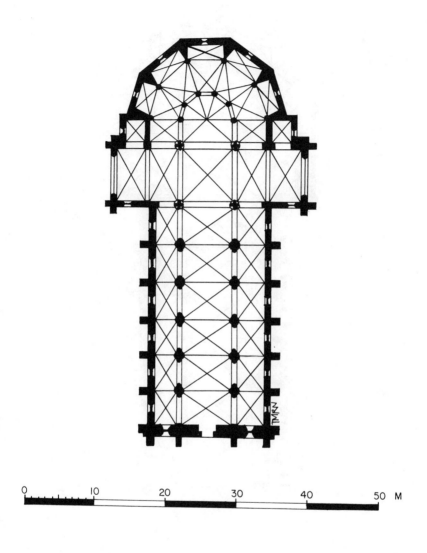

0 10 20 30 40 50 M

Jansen, Fig. 4 Le Breuil-Benoît. Plan (Taina Rikala de Noriega
after Dimier)

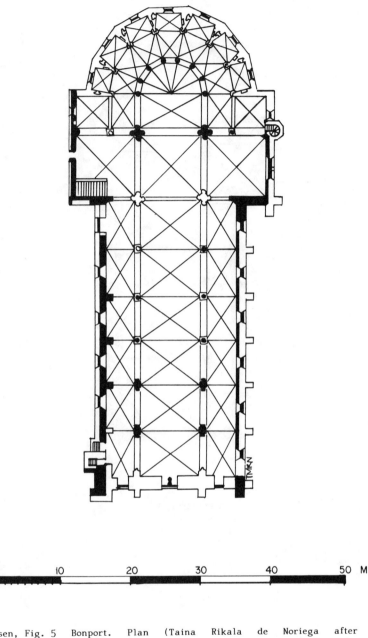

0 10 20 30 40 50 M

Jansen, Fig. 5 Bonport. Plan (Taina Rikala de Noriega after
 Dimier)

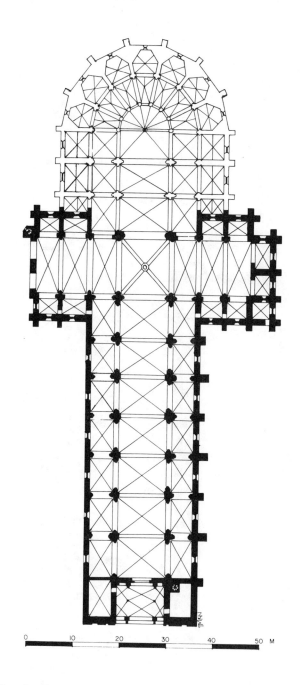

0 10 20 30 40 50 M

Jansen, Fig. 6 Pontigny III. Plan (Taina Rikala de Noriega after
Dimier)

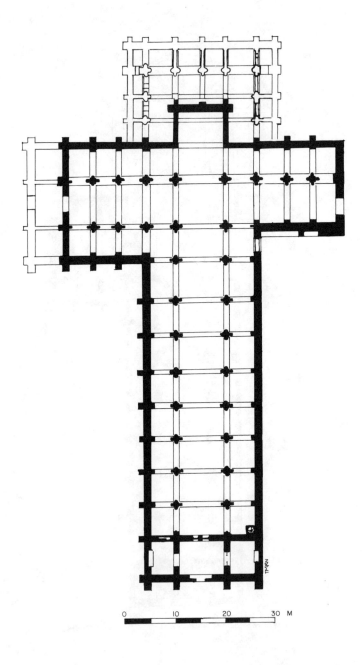

Jansen, Fig. 7 Cîteaux III. Plan (Taina Rikala de Noriega after Krönig)

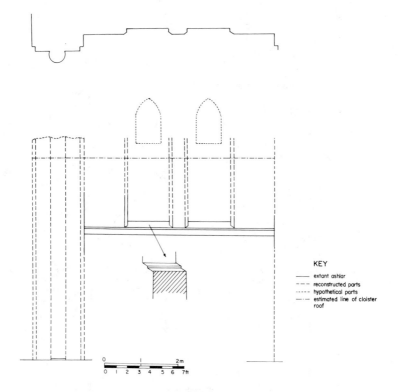

KEY

——— extant ashlar
– – – reconstructed parts
······ hypothetical parts
—·— estimated line of cloister roof

Jansen, Fig. 8 Beaulieu. Reconstruction of nave south aisle wall
(Taina Rikala de Noriega and George Jansen)

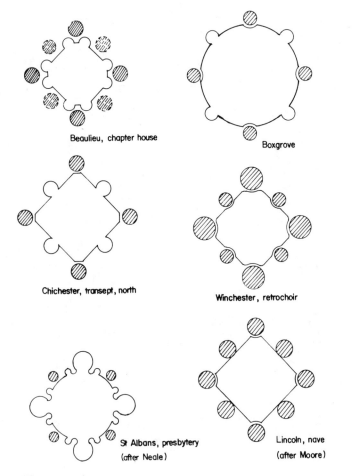

Beaulieu, chapter house

Boxgrove

Chichester, transept, north

Winchester, retrochoir

St Albans, presbytery
(after Neale)

Lincoln, nave
(after Moore)

//// shafts en délit

Jansen, Fig. 9 Diagrams of piers related to those at Beaulieu Abbey (George Jansen)

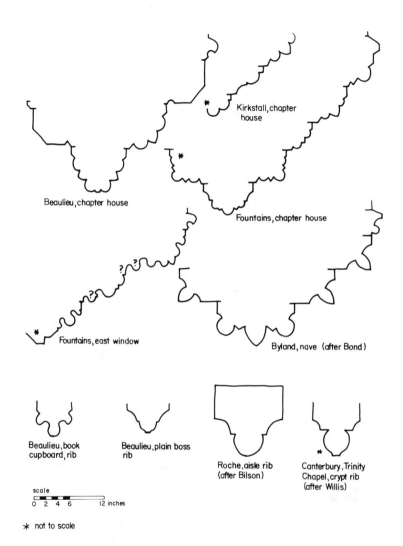

Kirkstall, chapter house

Beaulieu, chapter house

Fountains, chapter house

Fountains, east window

Byland, nave (after Bond)

Beaulieu, book cupboard, rib

Beaulieu, plain boss rib

Roche, aisle rib (after Bilson)

Canterbury, Trinity Chapel, crypt rib (after Willis)

scale
0 2 4 6 12 inches

* not to scale

Jansen, Fig. 10 Beaulieu. Moldings of the chapter house, early ribs, and comparative examples at other sites (Virginia Jansen and George Jansen)

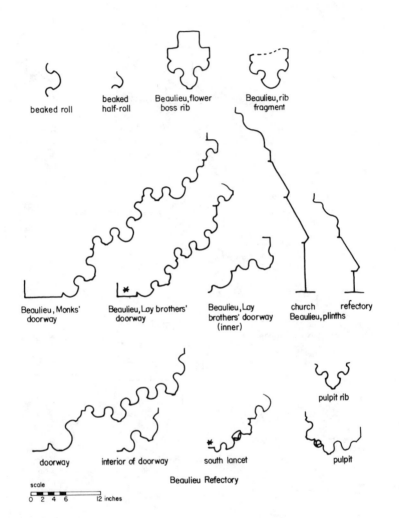

beaked roll

beaked half-roll

Beaulieu, flower boss rib

Beaulieu, rib fragment

Beaulieu, Monks' doorway

Beaulieu, Lay brothers' doorway

Beaulieu, Lay brothers' doorway (inner)

church refectory
Beaulieu, plinths

doorway

interior of doorway

south lancet

pulpit rib

pulpit

Beaulieu Refectory

scale
0 2 4 6 12 inches

* not to scale

Jansen, Fig. 11 Beaulieu. Moldings with beaked rolls and half-rolls (Virginia Jansen and George Jansen)

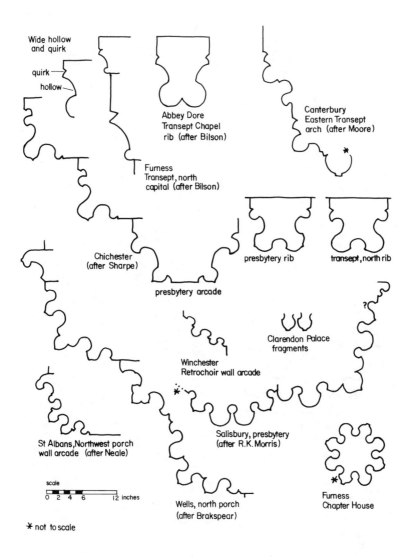

Wide hollow and quirk

quirk

hollow

Abbey Dore
Transept Chapel
rib (after Bilson)

Canterbury
Eastern Transept
arch (after Moore)

Furness
Transept, north
capital (after Bilson)

Chichester
(after Sharpe)

presbytery rib

transept, north rib

presbytery arcade

Clarendon Palace
fragments

Winchester
Retrochoir wall arcade

St Albans, Northwest porch
wall arcade (after Neale)

Salisbury, presbytery
(after R.K. Morris)

scale
0 2 4 6 12 inches

Furness
Chapter House

* not to scale

Wells, north porch
(after Brakspear)

Jansen, Fig. 12 Moldings compared to those of Beaulieu Abbey
(Virginia Jansen and George Jansen)

St Albans
Nave, arcade
(after Neale)

Boxgrove
Presbytery
(after Sharpe)

Salisbury
Eastern Transept
triforium
(after R.K.Morris)

Lacock
Cloister doorway

Wells
Bishop Jocelyn's Palace
undercroft doorway

scale
0 2 4 6 12 inches

* not to scale

Wells, west facade
doorway
(after Malone)

Jansen, Fig. 13 Moldings compared to those of Beaulieu Abbey
(Virginia Jansen and George Jansen)

Beaulieu
Refectory
stairs to pulpit

Beaulieu
fragment

Chichester
Transept, north
arcade
(scaled after Sharpe)

Salisbury
Eastern Transept
clerestory
(after RKMorris)

Canterbury
Archbishop's Palace
exterior arch

Lincoln
Nave
aisle rib

Hailes
fragment

Chichester, Nave
north aisle chapels
(after Sharpe)

Beaulieu
Lavatory
arch

Westminster
Presbytery arcade
(after RCHM)

scale
0 2 4 6 12 inches

✱ not to scale

Jansen, Fig. 14 Beaulieu. Refectory and lavatory moldings with
comparative examples (Virginia Jansen and George
Jansen)

TYPE A

pulpit | stairs
Beaulieu, Refectory

Chichester
Transept, north

Winchester
Castle Hall

Netley
(revised
after
Bond)

TYPE B

Refectory | Lay Brother's
Refectory

Beaulieu

Nave

Winchester
Retrochoir

Salisbury
Presbytery
(after R.K.Morris)

Wells
Jocelyn's
Palace
undercroft

TYPE C

Beaulieu, fragments

Hythe
piscina

Winchester
Castle Hall

Bosham
arcade

TYPE D

Beaulieu
fragment

Winchester
Retrochoir

CHAMFER STOPS

Beaulieu

* not to scale

scale
0 2 4 6 12 inches

Jansen, Fig. 15 Beaulieu. Capitals, chamfer stops, and comparative examples (Virginia Jansen and George Jansen)

Jansen, Fig. 16 Beaulieu. Some inlaid tile patterns in common with other sites. Numbers refer to patterns listed in Appendix II (Taina Rikala de Noriega)

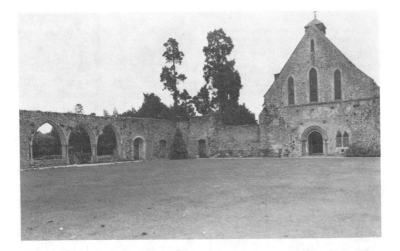

Jansen, Fig. 17 Beaulieu. View southeast across cloister to refectory and remains of chapter house arches (Virginia Jansen)

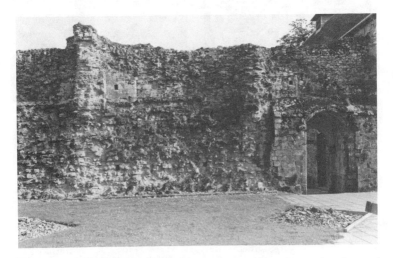

Jansen, Fig. 18 Beaulieu. Nave, remains of west end of south aisle wall (Virginia Jansen)

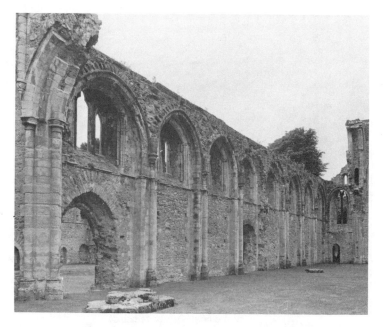

Jansen, Fig. 19 Netley. Nave looking southwest (Virignia Jansen)

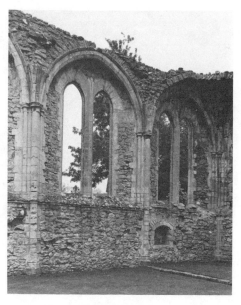

Jansen, Fig. 20 Netley. Presbytery aisle wall (Virginia Jansen)

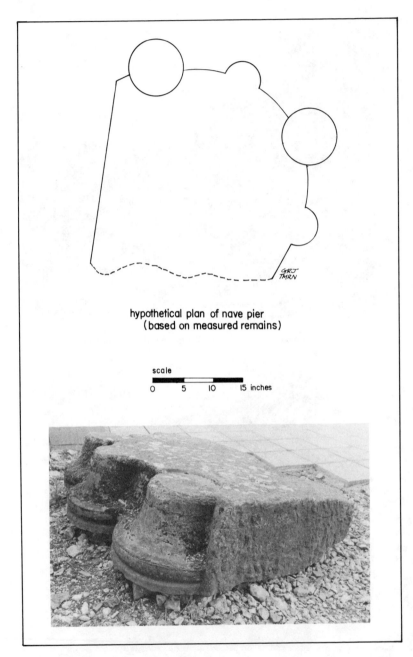

hypothetical plan of nave pier
(based on measured remains)

scale

0 5 10 15 inches

Jansen, Fig. 21 Beaulieu. Capital, probably from nave arcade
(Photo by author and drawing by Taina Rikala
de Noriega and George Jansen)

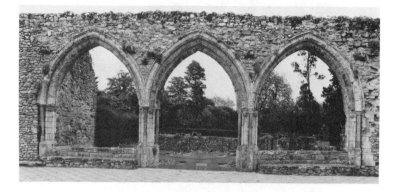

Jansen, Fig. 22 Beaulieu. Chapter house arches (Virginia Jansen)

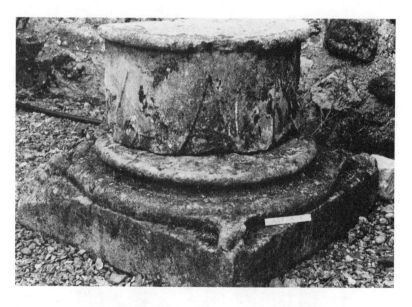

Jansen, Fig. 23 Beaulieu. Subdorter capital and base (Virginia Jansen)

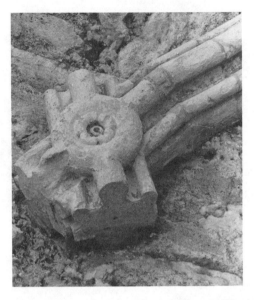

Jansen, Fig. 24 Beaulieu. Book cupboard boss (Virginia Jansen)

Jansen, Fig. 25 Beaulieu. Plain boss (Virginia Jansen)

Jansen, Fig. 26 Beaulieu. Boss with flower (Virginia Jansen)

Jansen, Fig. 27 Winchester. Retrochoir boss (with permission of
the Dean and Chapter of Winchester Cathedral)

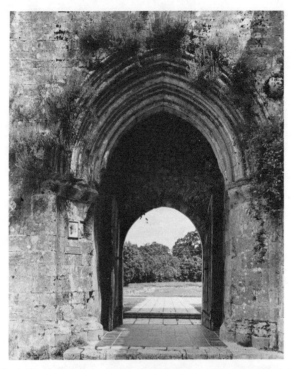

Jansen, Fig. 28 Beaulieu. Monks' doorway from the cloister to the church (Virginia Jansen)

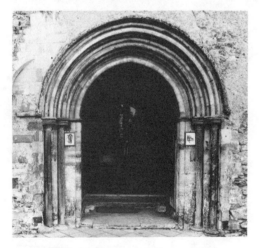

Jansen, Fig. 29 Beaulieu. Refectory doorway from the cloister (Virginia Jansen)

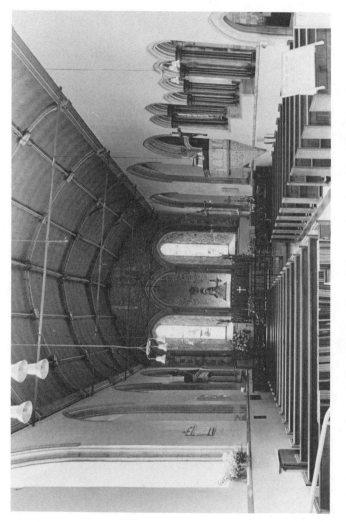

Jansen, Fig. 30 Beaulieu. Refectory interior (Virginia Jansen)

Jansen, Fig. 31 Beaulieu. Capital
of the refectory pulpit
(Virginia Jansen)

Jansen, Fig. 32 Beaulieu. Corbel of
the lay brothers' refectory
(Virginia Jansen)

Jansen, Fig. 33 Beaulieu. Corbel fragment
(Virginia Jansen)

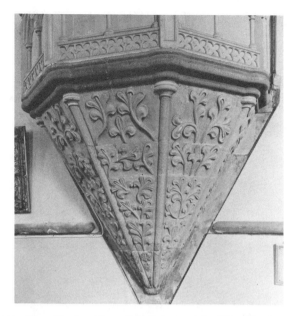

Jansen, Fig. 34 Beaulieu. Pulpit base, left (Virginia Jansen)

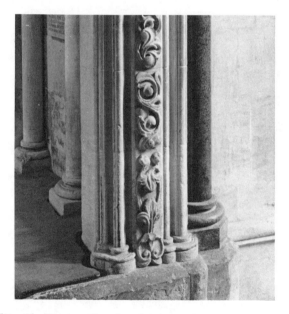

Jansen, Fig. 35 Temple Church, London. Jamb between nave and choir, right (Virginia Jansen)

Jansen, Fig. 36 Beaulieu. Capital of the lay brothers' doorway from the church to the cloister, left (Virginia Jansen)

Jansen, Fig. 37 Winchester. Retrochoir capital (with the permission of the Dean and Chapter of Winchester Cathedral)

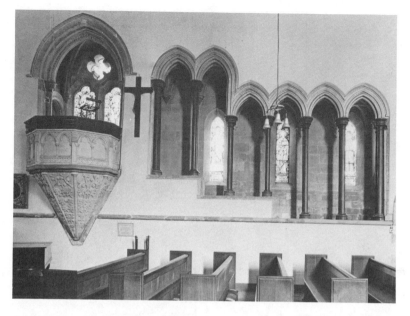

Jansen, Fig. 38 Beaulieu. Refectory pulpit and stairway (Virginia Jansen)

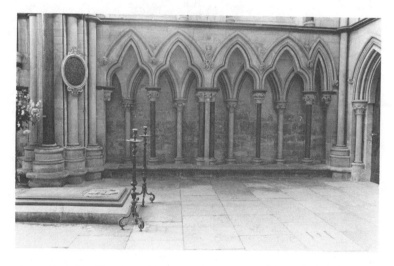

Jansen, Fig. 39 Lincoln. Eastern transept wall arcade (Virginia Jansen)

Fig. 1

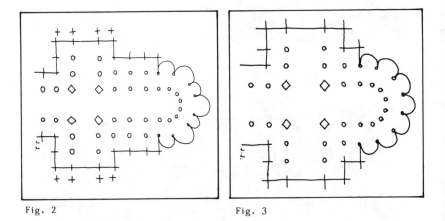

Fig. 2 Fig. 3

James, Fig. 1 Longpont. Corbel over the passage through the
 buttresses of the south transept (Drawing: James)

James, Fig. 2 Chartres Cathedral. Schematic plan of the choir
 as originally planned in 1194 [bay is 7.1 meters]
 (Drawing: James)

James, Fig. 3 Longpont. Schematic plan of the choir to the same
 scale [bay is 5.9 meters] (Drawing: James)

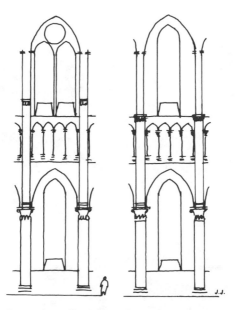

James, Fig. 4 Longpont. The elevation of the nave on the left, and the choir on the right (Drawing: James)

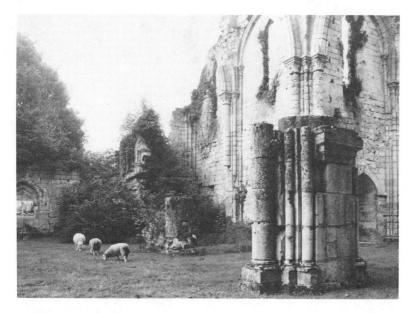

James, Fig. 5 Longpont. The western corner of the south transept (Photo: James)

Fig. 6

Fig. 7

Fig. 9

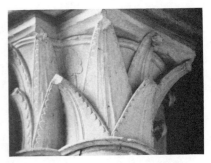
Fig. 10

Fig. 12

Fig. 13

Fig. 8

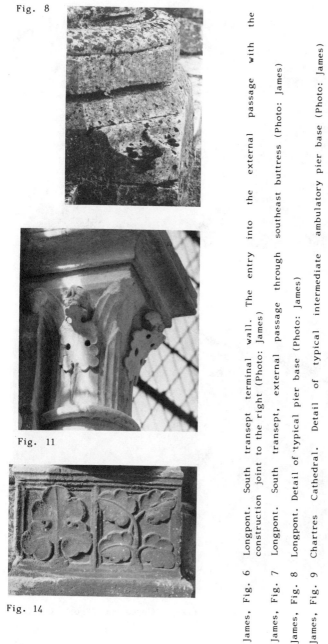

Fig. 11

Fig. 14

James, Fig. 6 Longpont. South transept terminal wall. The entry into the external passage with the construction joint to the right (Photo: James)

James, Fig. 7 Longpont. South transept, external passage through southeast buttress (Photo: James)

James, Fig. 8 Longpont. Detail of typical pier base (Photo: James)

James, Fig. 9 Chartres Cathedral. Detail of typical intermediate ambulatory pier base (Photo: James)

James, Fig. 10, 11, 12 Soissons Cathedral. South transept, aisle capital (Photo: James)

James, Fig. 13 Chartres Cathedral, south porch, capital over wall figure (Photo: James)

James, Fig. 14 Chartres Cathedral. North porch, foliated pier base (Photo: James)

James, Fig. 15 Chartres Cathedral. South porch, capital over wall figure (Photo: James)

James, Fig. 16 Longpont. Western nave, aisle capital (Photo: James)

James, Fig. 17 Longpont. Western nave, aisle capital (Photo: James)

James, Fig. 18 Longpont. Western nave, central doorway capital
(Photo: James)

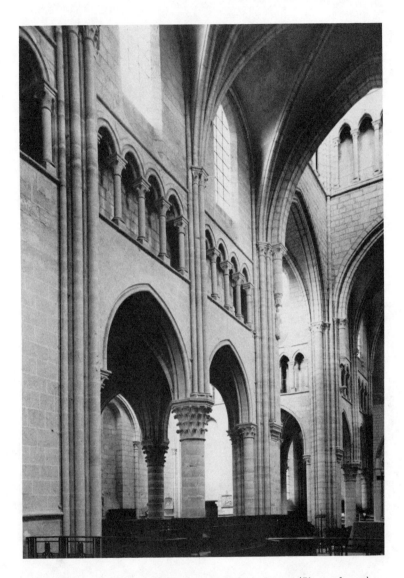

James, Fig. 19 Braine. Interior looking southwest (Photo: James)

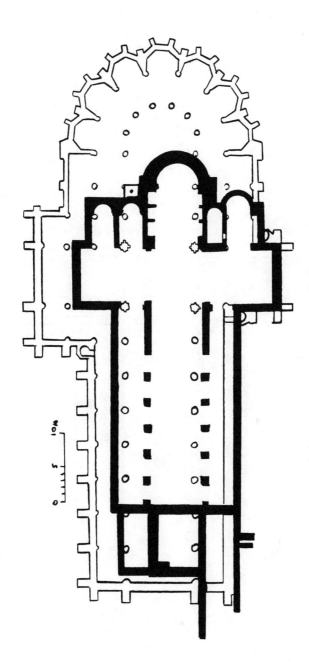

Davis, Fig. 1 Altenberg. Plan of the Romanesque and Gothic churches
(Davis, after Schaefer)

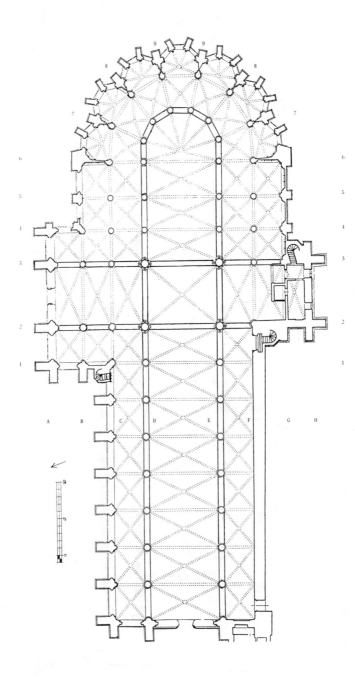

Davis, Fig. 2 Altenberg. Plan of the Gothic abbey church (Elizabeth
Pols after G. Panofsky-Soergel)

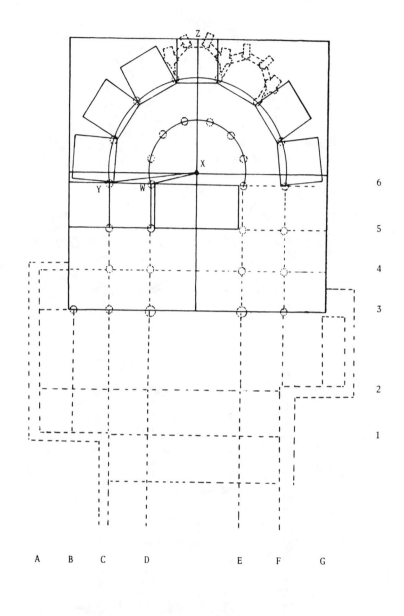

Davis, Fig. 3 Altenberg. Proposed design system of the choir
(Davis)

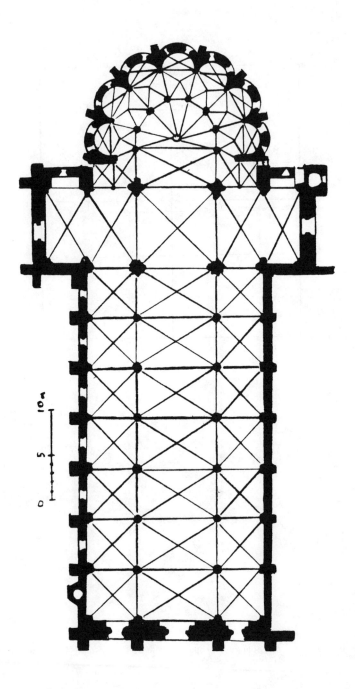

Davis, Fig. 4 Marienstatt, Plan of abbey church (Davis after
Dehio and von Bezold)

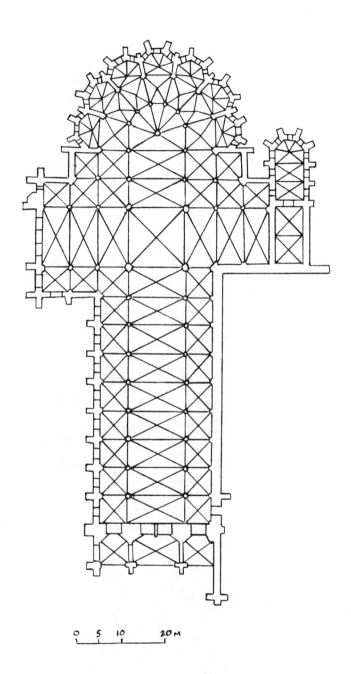

```
0   5  10      20 M
├───┼───┼───────┤
```

Davis, Fig. 5 Royaumont. Plan of abbey church (Davis after H.
Gouin)

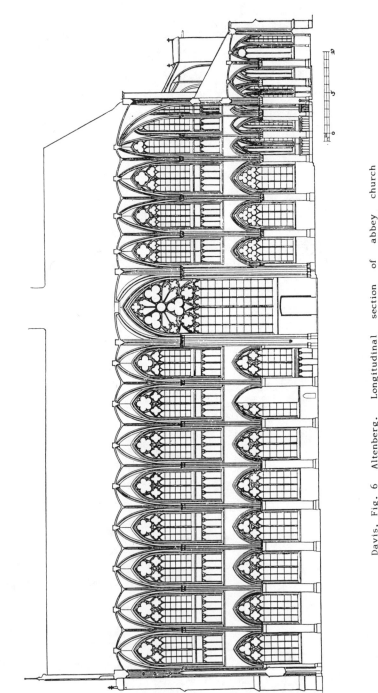

Davis, Fig. 6 Altenberg. Longitudinal section of abbey church
(Elizabeth Pols after G. Panofsky-Soergel)

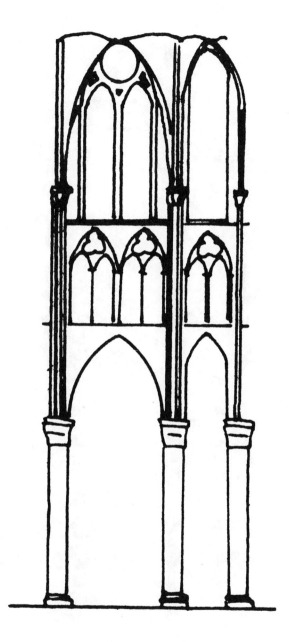

Davis, Fig. 7 Royaumont. Reconstruction of choir elevation (Davis
after R. Branner)

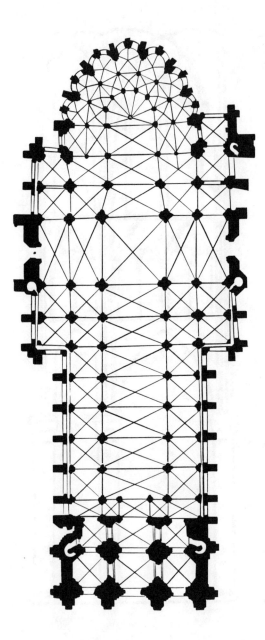

Davis, Fig. 8 St. Denis. Plan of abbey church (Davis after Crosby)

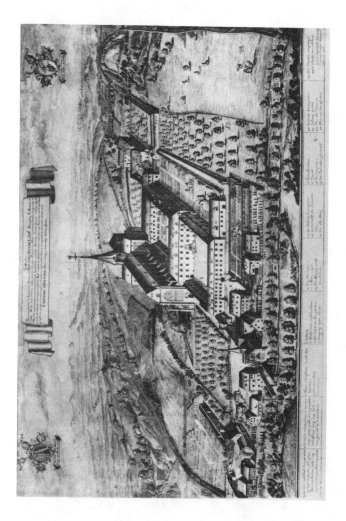

Davis, Fig. 9 Altenberg. Engraved view of the abbey in 1707
by J. J. Sartor (Landesbildstelle Rheinland, Dusseldorf)

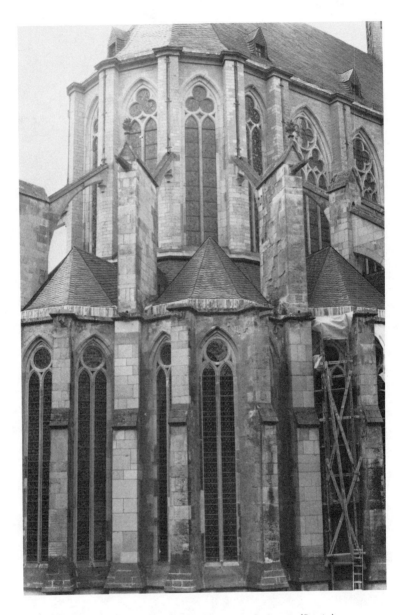

Davis, Fig. 10 Altenberg. Exterior of chevet (Davis)

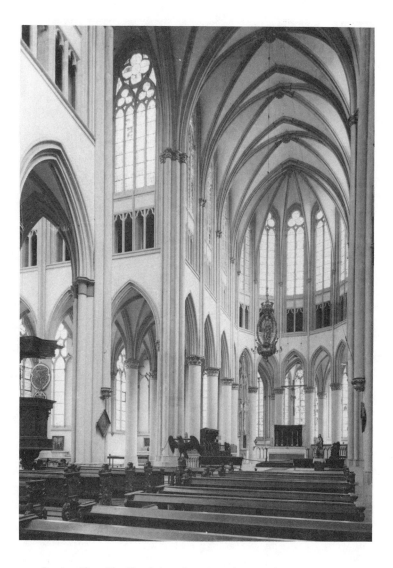

Davis, Fig. 11 Altenberg. Interior of choir (Foto Marburg)

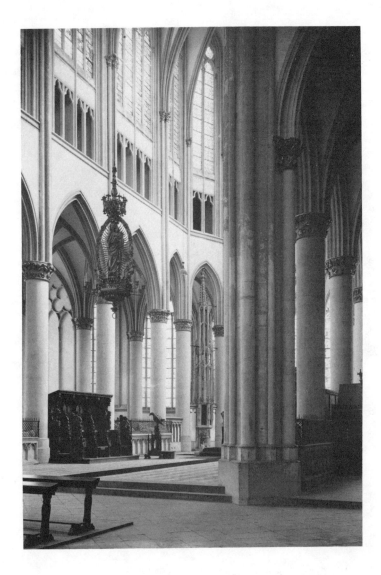

Davis, Fig. 12 Altenberg. North wall of choir (Rheinisches Biloarchiv)

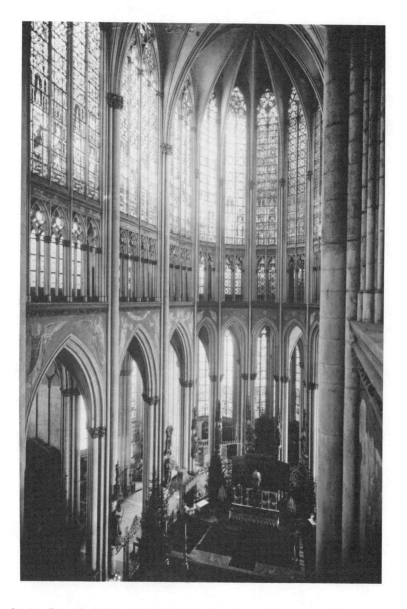

Davis, Fig. 13 Cologne Cathedral. Interior of choir (Rheinisches Biloarchiv)

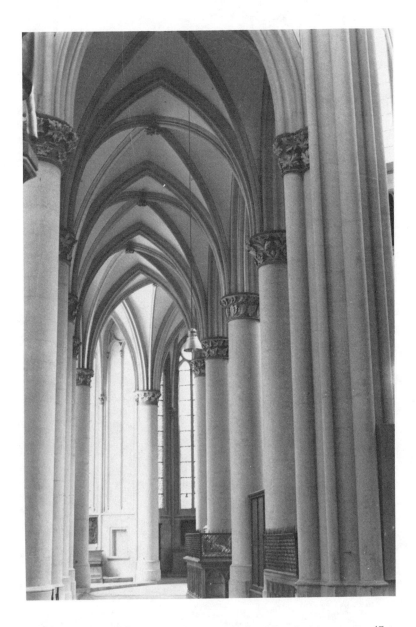

Davis, Fig. 14 Altenberg. North aisle of choir looking east (Foto Marburg)

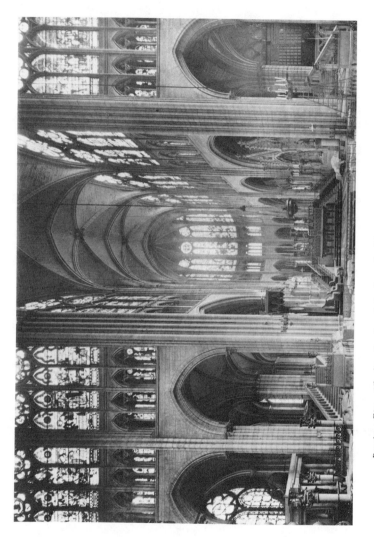

Davis, Fig. 15 St. Denis. Interior of abbey church (Foto Marburg)

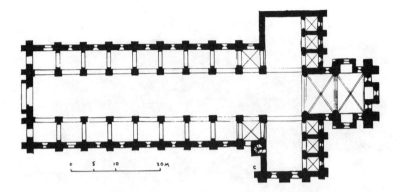

Clark, Fig. 1 Laon, Saint-Martin. Plan (after Brunet,
modified Clark)

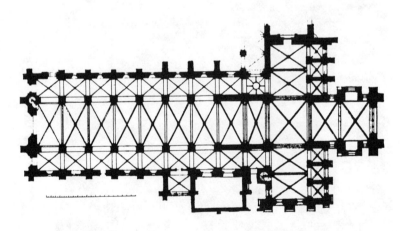

Clark, Fig. 2 Laon, Saint-Martin. Restored plan (Clark)

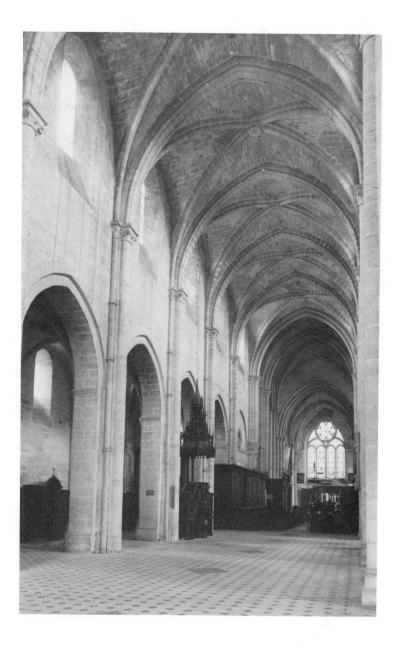

Clark, Fig. 3 Laon, Saint-Martin. Nave interior (Clark)

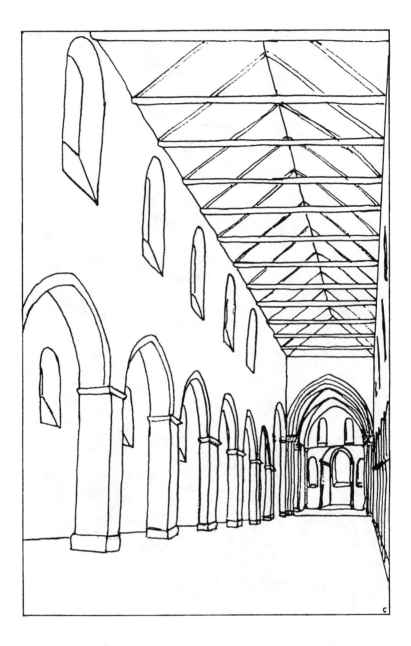

Clark, Fig. 4 Laon, Saint-Martin. Restored nave interior (Clark)

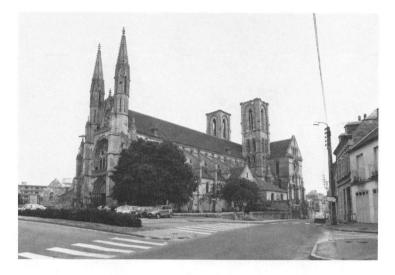

Clark, Fig. 5 Laon, Saint-Martin. Exterior from southwest (Clark)

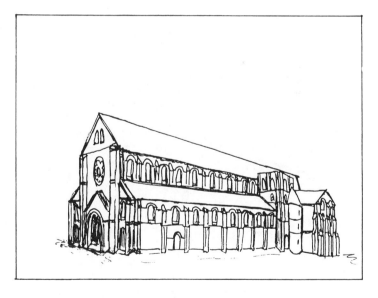

Clark, Fig. 6 Laon, Saint-Martin. Restored view from southwest
 (Clark)

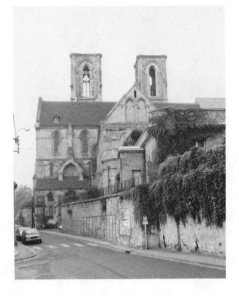

Clark, Fig. 7 Laon, Saint—Martin. Exterior from east (Clark)

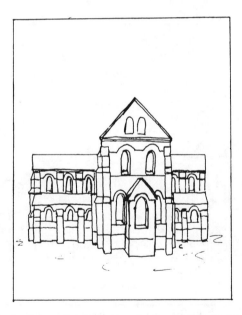

Clark, Fig. 8 Laon, Saint—Martin. Restored view from east (Clark)

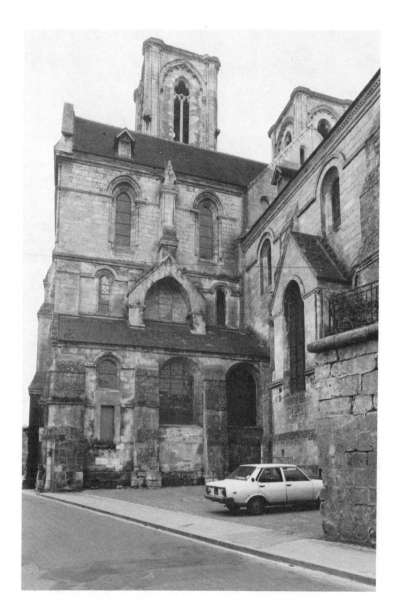

Clark, Fig. 9 Laon, Saint-Martin. South transept, east side (Clark)

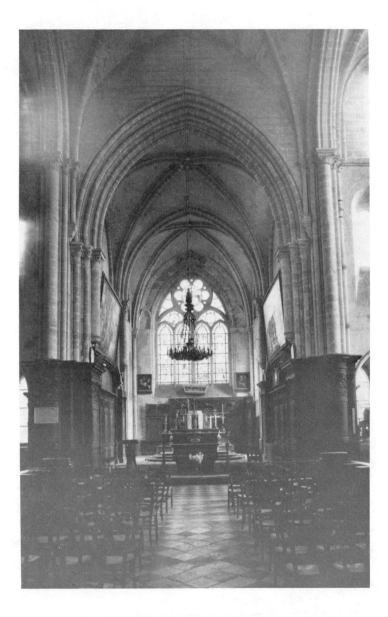

Clark, Fig. 10 Laon, Saint—Martin. Apse interior (Clark)

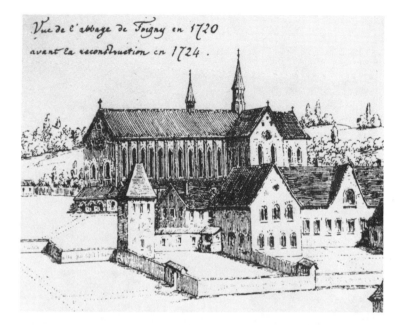

Clark, Fig. 11 Foigny, Notre-Dame. View in 1740 (after <u>Bulletin</u> <u>monumental</u>)

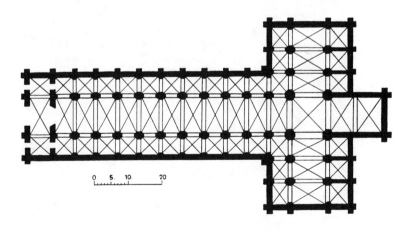

Clark, Fig. 12 Foigny, Notre-Dame. Restored plan (after Dimier, vaults by Clark)

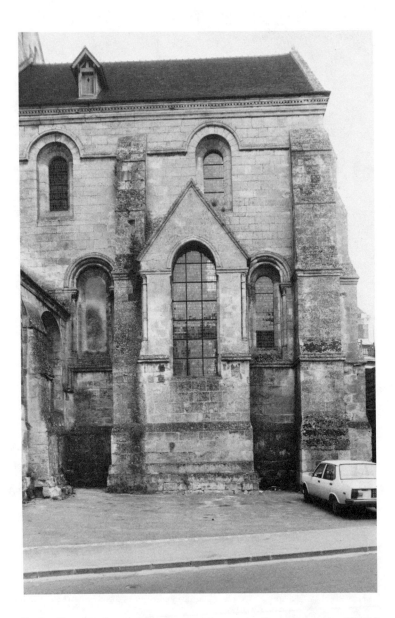

Clark, Fig. 13 Laon, Saint-Martin. Apse exterior, south side (Clark)

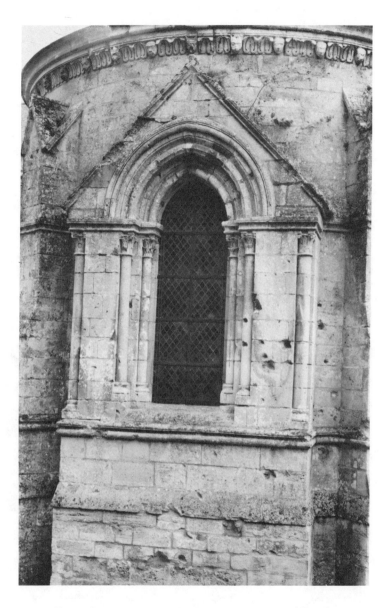

Clark, Fig. 14 Nouvion-le-Vineux. Apse niche (Clark)

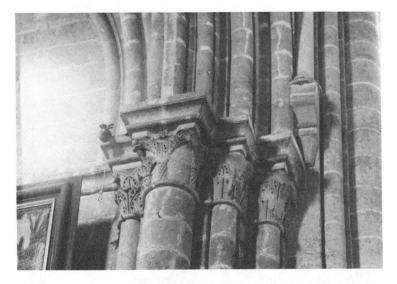

Clark, Fig. 15 Laon, Saint-Martin. Apse triumphal arch, "palm-tree" capitals (Clark)

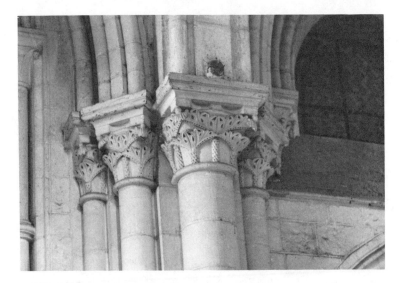

Clark, Fig. 16 Laon, Notre-Dame. North transept east aisle pier 9, "palm-tree" capitals (Clark)

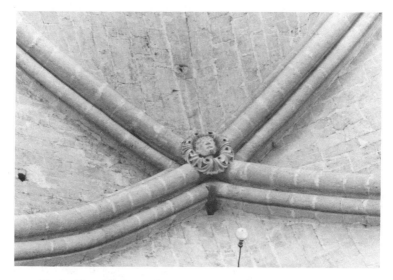

Clark, Fig. 17 Laon, Saint-Martin. Apse east bay, medallion
keystone (Clark)

Clark, Fig. 18 Noyon, Notre-Dame. Choir chapel I, medallion
keystone (Clark)

Clark, Fig. 19 Laon, Saint-Martin. Apse west bay, angel
keystone (Clark)

Clark, Fig. 20 Vailly, apse, angel keystone (Clark)

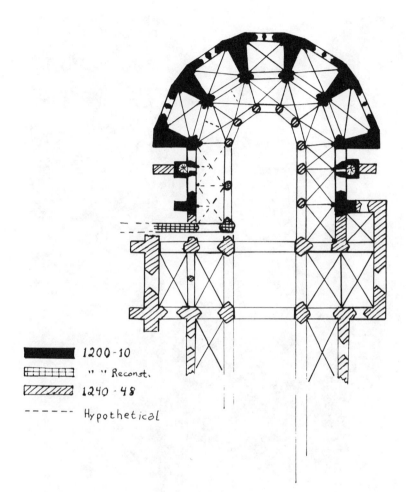

1200-10
" " Reconst.
1240-48
Hypothetical

Herschman, Fig. 1 Hambye, abbey church. Plan (Drawing: Herschman
 after Thibout)

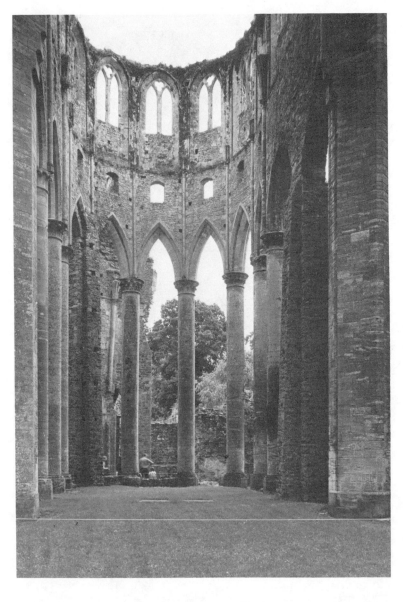

Herschman, Fig. 2 Hambye, abbey church. Choir from crossing
(Herschman)

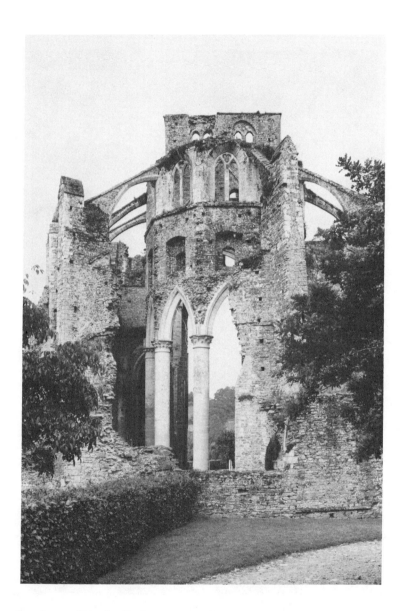

Herschman, Fig. 3 Hambye, abbey church. Choir from east (Herschman)

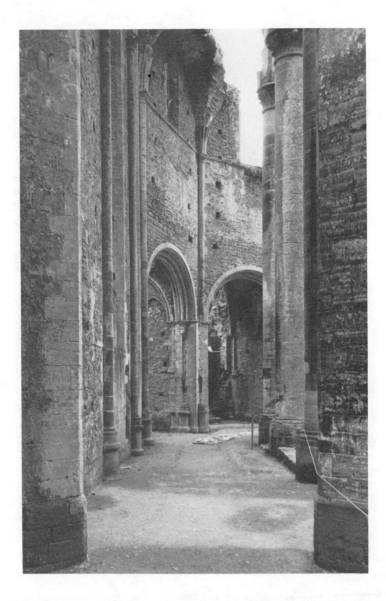

Herschman, Fig. 4 Hambye, abbey church. North ambulatory and
chapels (Herschman)

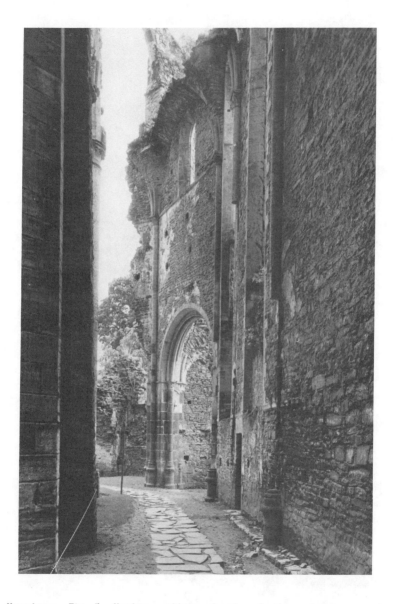

Herschman, Fig. 5 Hambye, abbey church. South ambulatory and
chapels (Herschman)

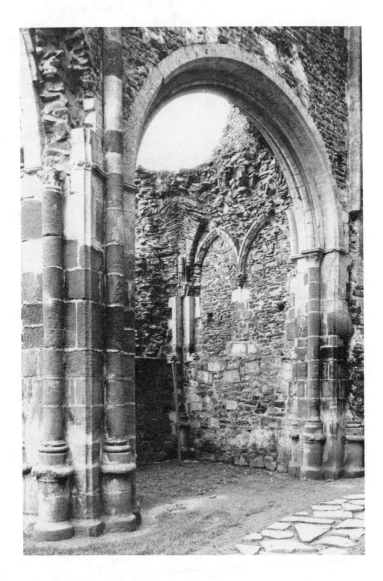

Herschman, Fig. 6 Hambye, abbey church. South radiating chapel
(Herschman)

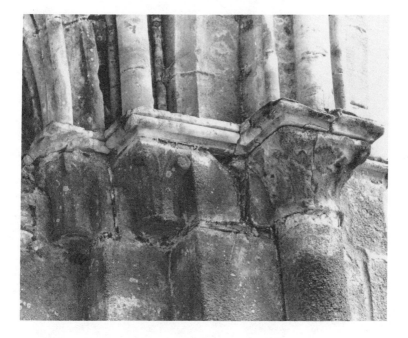

Herschman, Fig. 7 Hambye, abbey church. Early capitals in north
chapel (Herschman)

Herschman, Fig. 8a Hambÿe, abbey church. Ambulatory, high capital, north side (Herschman)

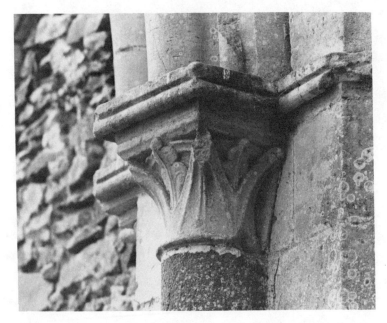

Herschman, Fig. 8b Hambye, abbey church. Capital of south radiating chapel (Herschman)

Herschman, Fig. 9a Coutances Cathedral. Capitals of north radiating chapel (Herschman)

Herschman, Fig. 9b Coutances Cathedral. Capitals of north radiating chapel (Herschman)

Herschman, Fig. 10 Hambye, abbey church. Hemicycle pier capital
(Herschman)

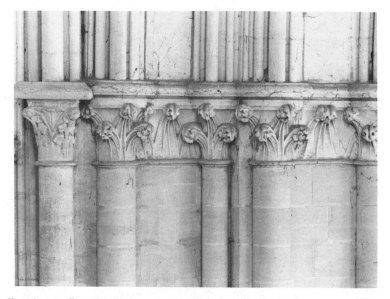

Herschman, Fig. 11 Coutances Cathedral. High capitals, northwest
crossing pier (Herschman)

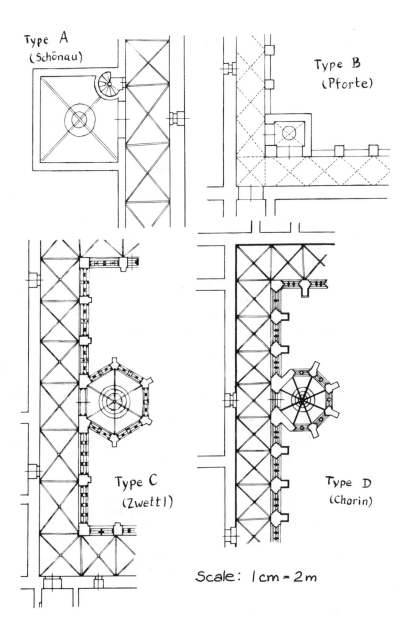

Type A
(Schönau)

Type B
(Pforte)

Type C
(Zwettl)

Type D
(Chorin)

Scale: 1 cm = 2 m

Grüger, Fig. 1 Darstellung zisterziensischer Brunnenhäuser (Re-
presentation of cistercian fountain houses [?])
Type A–D

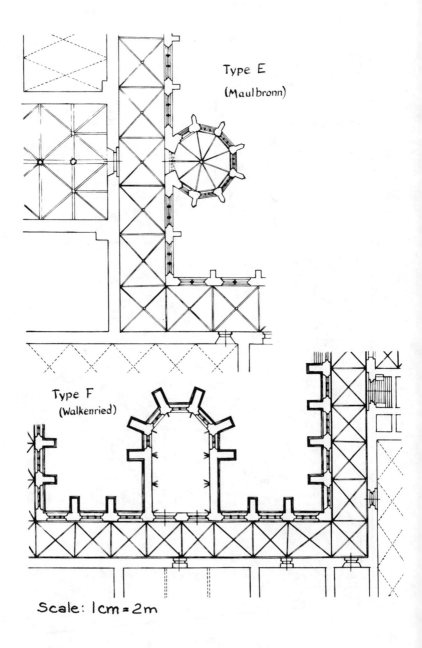

Type E
(Maulbronn)

Type F
(Walkenried)

Scale: 1cm = 2m

Grüger, Fig. 2 Darstellung Zisterziensischer Brunnenhäuser (Re-
presentation of cistercian fountain houses [?])
Type E and F

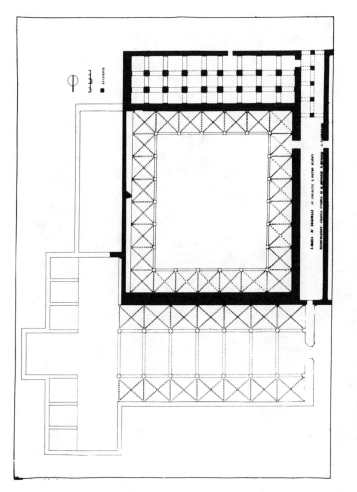

Raspi-Serra, Fig. 1 Scafati, Santa Maria di Realvalle, Ricostruzione grafica del complesso monastico (Disegno arch. R. Bignardi–C. Tamburrino) .

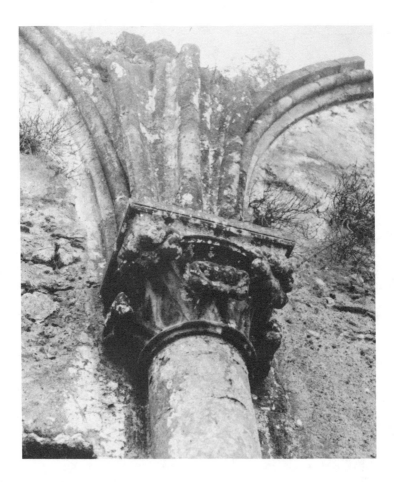

Raspi–Serra, Fig. 2 Scafati, Realvalle, chiesa, particolare del travèe della navata laterale

Raspi-Serra, Fig. 3 Scafati, Realvalle, chiesa, monofora della
navata laterale

Raspi-Serra, Fig. 4 Scafati, Realvalle, Chiostro, particolare del
peduccio

Raspi–Serra, Fig. 5 Scafati, Realvalle, Chiostro, particolare delle modanature delle crociere

Raspi–Serra, Fig. 6 Scafati, Realvalle, aula dei conversi

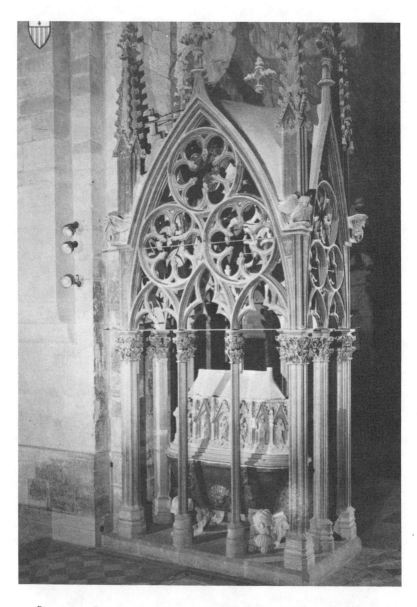

Rosenman, Fig. 1 Santes Creus. Tomb of Peter III (Foto Raymond)

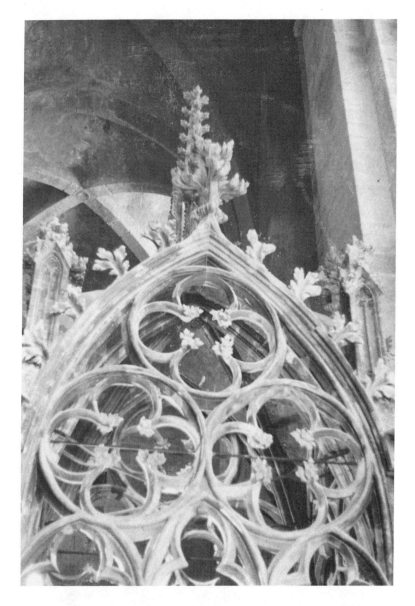

Rosenman, Fig. 2 Santes Creus. Tomb of James II and Blanche
of Anjou, canopy (Photo: Rosenman)

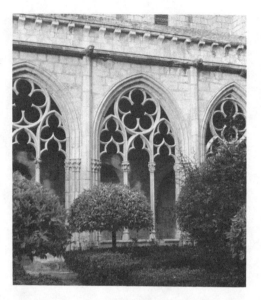

Rosenman, Fig. 3 Santes Creus. Cloister, north gallery (Photo: Rosenman)

Rosenman, Fig. 4 Tarragona Cathedral. West façade, buttress (Photo: Rosenman)

Rosenman, Fig. 5 Santes Creus. Tomb of Peter III, capital from canopy (Photo: Rosenman)

Rosenman, Fig. 6 Santes Creus. Tomb of Peter III, capital from canopy (Photo: Rosenman)

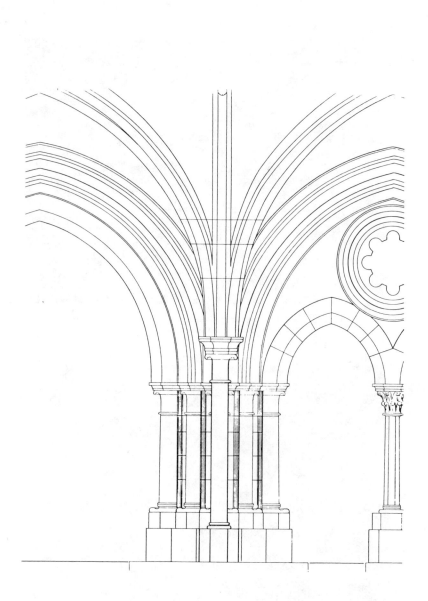

Burke, Fig. 1 Santa Maria de Ovila. Chapter house. Stone-setting diagram of exterior of entrance portal, drawn in Spain at the time of the dismantling of the monastery buildings, 1931 (de Young Museum Archives)

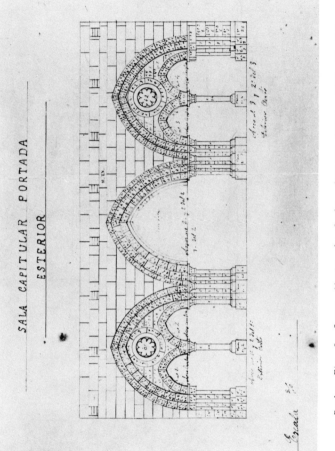

SALA CAPITULAR PORTADA

ESTERIOR

Burke, Fig. 2 Santa Maria de Ovila. Chapter house. Plan of the
carved stones (arch segments and capital) above
import of a pier of the entrance portal (Drawing:
Burke)

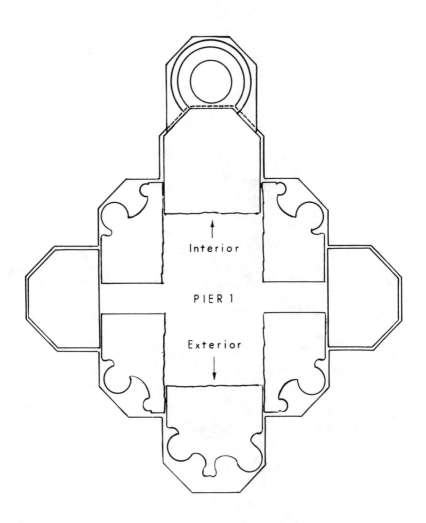

Interior

PIER 1

Exterior

Burke, Fig. 3 Santa Maria de Ovila. Plan of chapter house
(Drawing: Burke)

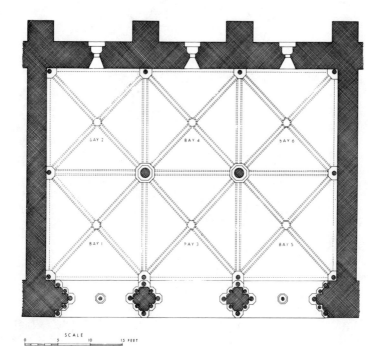

Burke, Fig. 4 Santa Maria de Ovila. Chapter house. Examples
of the three riers of carved stones of the springers
above the wall columns along plane surface of
walls (Drawing: Burke)

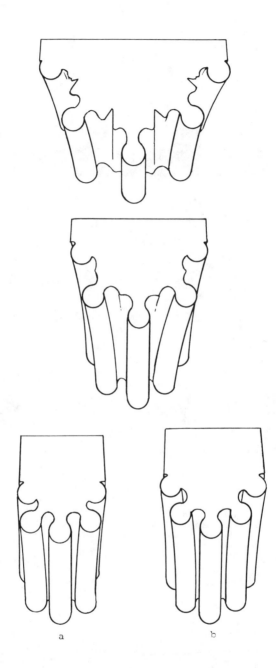

Burke, Fig. 5 Santa Maria de Ovila. Chapter house. Detail of a wall column and springer stones, showing plan of the latter at four levels (Drawing: Burke)

Burke, Fig. 6 Santa Maria de Ovila. Chapter house. Detail of
a wall column and springer stones, showing plan
of the latter at four levels (Drawing: Burke)

Burke, Fig. 7 Santa Maria de Ovila. Chapter house. Detail of elevation of west wall (interior), showing a pier of entrance portal and adjoining wall column (Drawing: Burke)

MASONS' MARKS, SACRAMENIA II '82

Bucher, Fig. 1 Tallahassee. Sacramenia rib, masons' and placement marks.

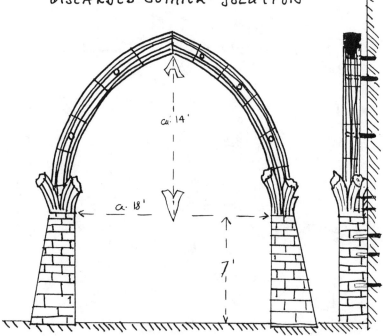

DISCARDED "GOTHICK" SOLUTION

ca. 14'

ca. 18'

7'

Bucher, Fig. 2 Tallahassee. Discarded "Gothick" reconstruction

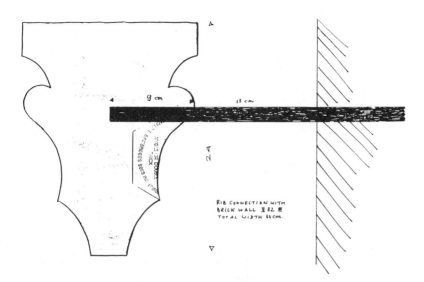

Bucher, Fig. 3 Connection of the rib with the wall with reinforcing bars.

Bucher, Fig. 4 Raymond Moss surveying Hearst crates in Miami

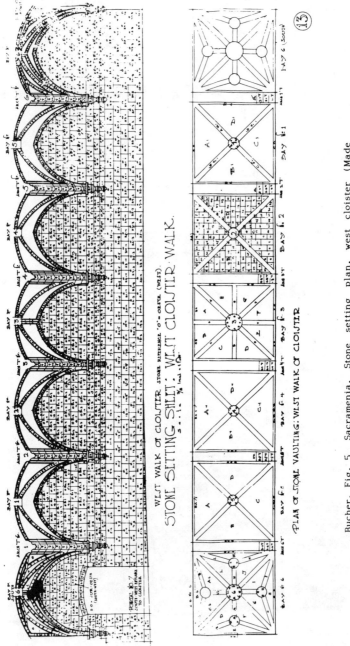

WEST WALK OF CLOISTER STONE MATERIAL 'O'-CASTLE (WEST).

STONE SETTING SHEET: WEST CLOISTER WALK.

PLAN OF STONE VAULTING: WEST WALK OF CLOISTER

Bucher, Fig. 5 Sacramenia. Stone setting plan, west cloister (Made
in Spain by Arthur Byne)

Bucher, Fig. 6 Miami. Unpacked, numbered elements rearranged

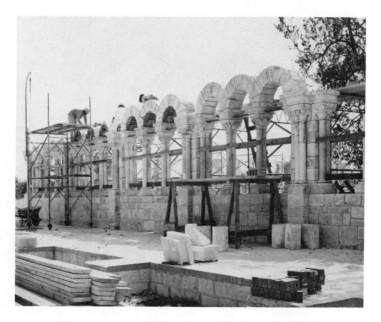

Bucher, Fig. 7 Miami. Reconstruction of the arches of the cloister

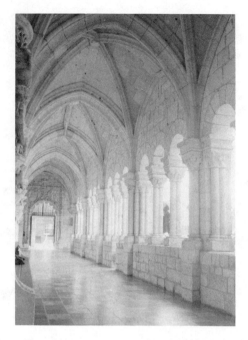

Bucher, Fig. 8 Miami. West walk of the cloister, 1982

Bucher, Fig. 9 Miami. Excavation behind the Abbey.

Bucher, Fig. 10 Miami. Laying out of excavated elements (tas de charge, rib) (Rev. B. E. Bailey)

Bucher, Fig. 11 Tallahassee. Layout of the rib on paper tracing floor (Photo: James McCauley)

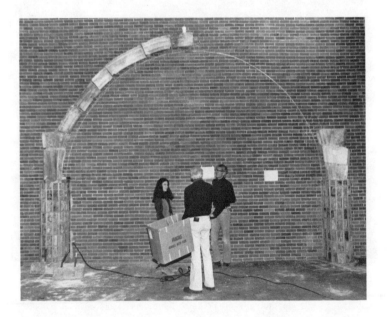

Bucher, Fig. 12 Tallahassee. Arch under construction (Photo: James McCauley)

Bucher, Fig. 13 Tallahassee. Florida State University Gallery.
Completed construction (Photo: A. Palladino–Craig)

CISTERCIAN PUBLICATIONS
Kalamazoo, Michigan

TITLES LISTING

*Texts and Studies
in the
Monastic Tradition*

* Temporarily out of Print † Forthcoming

CISTERCIAN PUBLICATIONS W.M.U. Station Kalamazoo, MI 49008